buildings
+ ideas

Robert Konieczny KWK Promes
buildings + ideas

edited by
Philip Jodidio

Contents

Introduction: Philip Jodidio	7
Robert Konieczny in Conversation with Philip Jodidio	15
Introduction: Robert Konieczny	23

Selected Projects

Aatrial House	50
Safe House	64
OUTrial house	80
Autofamily House	90
standard hOuse	102
By the Way House	112
Living-Garden House in Katowice	128
From the Garden House	142
Przełomy Dialogue Center	158
Konieczny's Ark	180
Marina in Biały Bór	200
Quadrant House	214
Unikato Housing	232
Gambit Office	246
Miedzianka Shaft	262
Art Bunker	280
Plato Contemporary Art Gallery	286
Living-Garden House near Kassel	308
Sunlite Building	316
Map of Design Paths + Building Index	322
Image Credits	328

Introduction: Philip Jodidio

The Paths of Robert Konieczny

Particularities of history have given some European countries more great architects than others. Despite its long and rich history, Poland is not usually known for its architects. Developments in the post-Soviet era have begun to change that situation. Robert Konieczny was born in 1969 in Katowice, Poland. He graduated from the New Jersey Institute of Technology (Newark, New Jersey, 1996) and obtained his Master's degree in Architecture from the Silesian University of Technology (Gliwice, Poland). Konieczny established KWK Promes in his native city in 1999 with Marlena Wolnik, who left the firm in 2005. KWK Promes has emerged through success, very unexpected projects such as the **Safe House** (2004–2008). Built on a 26,910-square-foot (2,500 square meter) site in Okrzeszyn, a small town near Warsaw, this design was predicated on the client's rather intense desire for safety. A gate marks the main entrance of the residence, a point through which visitors must pass to enter the house itself or the garden. The 15.7-inch-thick (40-centimeter-thick) moving walls and drawbridge-like elements participate in a system that allows the entire structure to close itself off from the world, or on the contrary to open outwards. Alarms complete what might be called an adventure in paranoia. Often seeking to use elements of designs in more than one way, Robert Konieczny imagined a rolling gate (45.9 by 52.5 feet [14 by 6 meters]) to open toward the garden and that can be used as a movie screen by the client, who is a film director. The architect states, "Almost all the mechanisms are based on standard systems, often industrial, which reduces the costs. Everything can be remotely controlled, and in case of loss of power, an electrical accumulator is on stand-by. Manual control is possible as well."

Nature Inside

The **OUTrial House** in Książenice, which is also near Warsaw, was built in the same period—between 2004 and 2007. The architect is interested in relating his work to its site, but in this instance, all he had to work with was 15,500 square feet (1,440 square meters) of green field land. His reaction was "to carve out

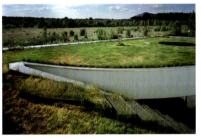

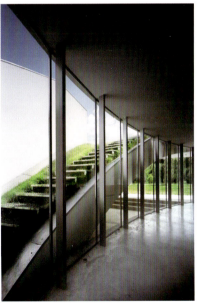

OUTrial House

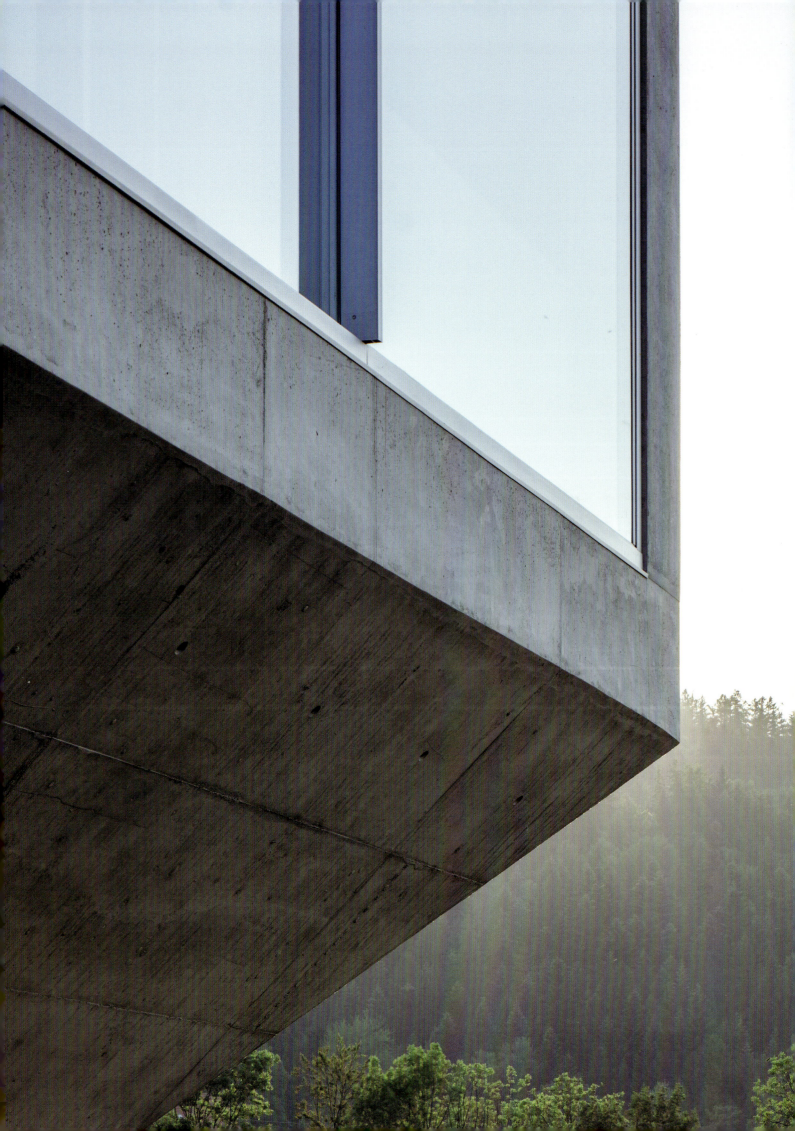

a piece of the grass-covered site, move it up, and treat it as the roofing to arrange all the required functions underneath." When the client added a recording studio to the project well after it was underway, Konieczny created an "incision" in the glass roof. He explains, "This procedure turned the roof into an atrium, as the only way to reach it was through the interior of the house. As opposed, however, to a typical atrium, the newly created space has all the advantages of an outer garden while remaining a safe, internal zone within the building." The name "OUTrial" is meant to explain the fact that the atrium is at once part of the interior and the exterior of the house. Despite being in good part "buried" in a grass mound, this house benefits from generous glazing and openings. Although the grass roof was not specifically intended as an ecological measure, Konieczny created a "green" building at the same time as he came to grips with the essentially empty site.

As it happens, the idea of integrating a house into nature was further explored by the architect in his **Living-Garden House in Katowice** (2009–2013). Demonstrating that he is more interested in a contextual approach than in any attempt to impose a specific style, Konieczny used locally sourced red brick for the walls of this house, together with local wood for a terrace and a ledge. The asphalt-lined gable roof recalls Silesian worker settlements in the region. The contrast between closed and open surfaces also reappears here—on the street side, the residence looks almost inaccessible, while generous glazing faces the garden. Thermal glass and thick walls reduce energy needs in an area that has an average annual temperature of just 46.4°F (8°C). Mirrored reflections of the grass outside and even grass inside emphasize the connection established by the architect between inside and out, between artificiality and nature. A brick volume of the house is cantilevered over the ground-level garden, creating an architectural dialogue or opposition between weight and lightness, between nature and artifice. As is usually the case in the work of KWK there is indeed a kind of willful heaviness apparent from some angles, but mirrors and floating volumes also affirm the contrary.

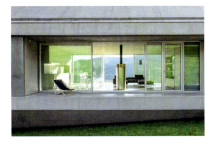

Konieczny's Ark

A Floating Ark and a Center Beneath a Square

The architect's own residence, which he calls **Konieczny's Ark** (2010–2015) is in Brenna, in the mountains of Silesia. Reiterating the concern for security seen in several of his other projects, Konieczny lifted the residence off the ground so that it only

touches down at one point of the hillside. A 32.8-foot (10-meter) wall and drawbridge mark the entrance. Again, the feeling of fortification is somehow obviated by other architectural concerns. To avoid the risk of slippage on the sloped site, the "house was treated as a bridge, under which rainwater flows naturally." Zoning rules in the mountain town gave Konieczny the idea to create a gable roof like a "typical barn," which his design certain does not otherwise resemble. Instead, as he says, the design recalls "an ark floating over the fields." The house was built by a local firm with in-situ concrete and sprayed closed-cell foam for the insulation. Despite again appearing to sometimes be entirely closed, the living spaces of the house can be broadly opened with full-height glazing.

KWK has also undertaken larger public projects, such as the **Przełomy Dialogue Center** (2009–2015) in Szczecin. A large square is the theater for a transformation located largely underground. The building lifts from ground level at one side near the entrance, leaving a sloping public area on most of the roof. Here, the entrance is formed by rotating blocks that can close the structure entirely, leaving no sign of its function or nature. The design at least partially contravenes the competition rules, another indication of Konieczny's search for unexpected and unusual solutions. Near its entrance the center faces the Philharmonic Hall designed by the Barcelona-based pair Barozzi Veiga. According to these architects, the hall was influenced by the "verticality of the city's residential buildings, by the monumentality of the upright ornaments of its neo-Gothic churches and the heavy volumes of its classicist buildings, by the towers that dot its entire skyline and the cranes of its port." Although he was not working on precisely the same site of course, it is interesting to note how Konieczny chose to create a nearly horizontal structure that blends in essentially by opposition to the vertical forms around it.

Przełomy Dialogue Center

Move with the Sun, and the Automobile, Too

As Robert Konieczny explains in his own words elsewhere in this volume, each of his designs is "supported by a strong concept, which defines the solutions applied later." This approach, called the "logic of space" by KWK Promes, "allows them to free themselves from formal preferences and venture into the unknown," sometimes leading to "truly innovative solutions." In the interview that accompanies this text Konieczny states, "When I was a young architect, I made up a saying that I want to

race with the whole world, even if the world doesn't know about me. I realized that I live in a country that is under the architectural radar. But I knew that to change this, you must show this world something interesting, something of your own, that the world has not yet seen." The conceptual "paths" that KWK follows tend to inverse the architectural process that sometimes consists of designing a form (or reusing an old one) and then making it fit its context and its planned function. Instead, Konieczny gives location in the deeper sense—genius loci—the protective spirit of a place, the leading role in his designs. Even an open green field has a possible message for architecture in this system of thought. After the site perhaps there is what the building is meant to do, or what the client wants—safety for example. Finally, there are societal factors that appear to have been set aside in modern architecture. What to do with the ubiquitous automobile—rather than leaving it under a make-shift cover, why not bring it right into the house, acknowledging its central role in daily life. Or why not make the very path that a house is set on **By the Way House** (2008–2016) into the path itself, a continuous band of road, folded and bent into a residence.

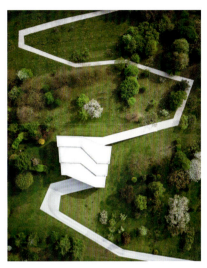

By the Way House

The ideas expressed by Robert Konieczny are quite radical and surprising—his forms are unexpected, and often closed or heavy at first sight. Though the Polish context, in terms of climate, history, and sociology may imply such solutions, KWK has laid out a series of concepts that could readily be applied to other places, surely generating other types of buildings. This is not a style so much as it is an intellectual construct. What do this site, this client, this set of circumstances say to the architect and how can an original solution be found that addresses each element of the equation, sometimes adding in societal considerations that are not really seen as being part of house design—such as the automobile? Weighty as many of his buildings may appear, there is also a strong sense of spatial play in the work of Robert Konieczny. His **Quadrant House** (2013–2019) can literally move and transform itself according to the position of the sun. The architect takes delight in presenting his work in both the closed and open positions, sometimes in the same, moving image.

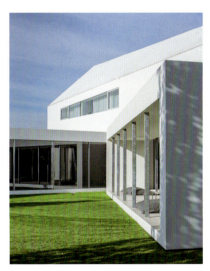

Quadrant House

Digging for Something New

Though he admits to the relative isolation of Polish architecture, it is a fact that the internet has brought ideas and architects from around the world together.

One architect who is admired by Konieczny is the French designer of the National Library in Paris, Dominique Perrault. In a very interesting gesture, Perrault noted that much of modern architecture seems to fear digging into the earth, sitting instead lightly above the ground like Le Corbusier's Villa Savoye. Instead, Perrault resolutely dug into the site of the national library to create the central garden. He likens this space, which is meant to be observed and not used, to the original Garden—the place from which all history and thought, and thus books came. Although not cited specifically by Konieczny, the American architect John Hejduk (1929–2000) also looked deeply into what architecture means and where it might go. In an article written for *Lotus International* in 1981, Hejduk suggested that "a deep search into the 'nature' of a program might perhaps be attempted … a search towards the possibility of renewal … a program that perhaps had something to do with the spirit of our times." Hejduk did more theorizing than building, and in that respect is quite different from Konieczny, but it can be suggested that the paths of Robert Konieczny represent a more practical but equally deep search into the nature of architectural programs, creating works that have "something to do with the spirit of the times." This is unexpected, this is not what we imagined we would find looking at the houses and other buildings of Robert Konieczny. Perhaps his goal was formal evolution from foreign and Polish models, some variety of new regionalism? No, instead, his is an approach that digs deeper and further into just what a building is about, deriving its form entirely from a concept that is of the site, of the client, of the purpose of the building, something new.

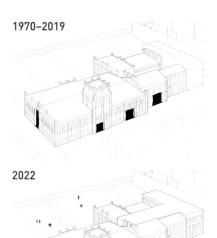

Plato Contemporary Art Gallery

Philip Jodidio
Lausanne

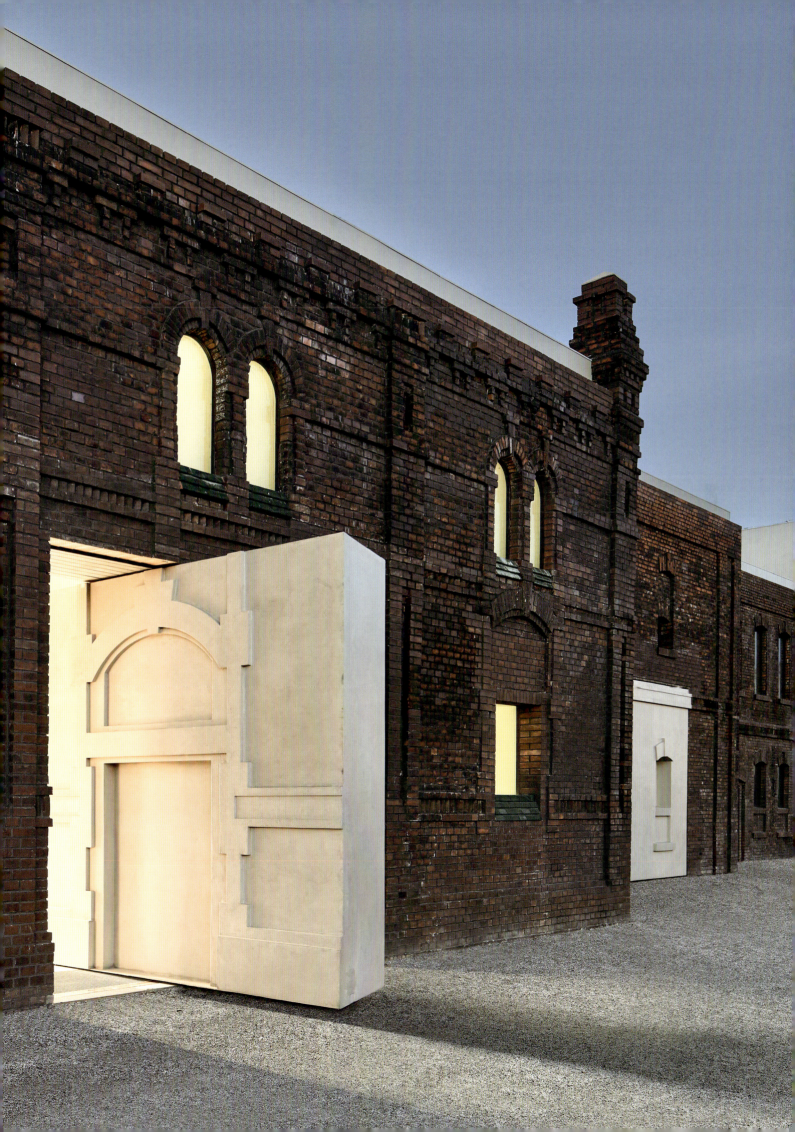

Robert Konieczny in Conversation with Philip Jodidio

Why do you feel that it is better to describe your work in terms of "paths" instead of simply using the ideas in a classified way (that is, Topography, Immateriality, Mobility, Context, History, Iconography, and Gardens)? What is it about architecture that implies paths and not a series of concepts applied to each project in an appropriate way?

I use the name "paths" because they illustrate a certain process, a path and its evolution. Successive projects are somehow better, I'd say, more perfect. But for the term paths, the categories themselves would not emphasize the continuous progress resulting from the evolution of projects.

Interestingly, the history of these paths was also influenced by a certain mishap—a Polish critic once alleged that the **Przełomy Dialogue Center** was inspired by Rem Koolhaas's Casa da Musica. It was only when he showed me a photograph that I found out there was a curved square around the building with a shop hidden underneath. In response, I wrote an article showing a number of our designs that led to the concept for the Przełomy Dialogue Center, including the oldest—the **Temple of Divine Providence**, in Warsaw. It was with that early competition entry that, we, as young architects, were inspired by Dominique Perrault and his Olympics sports complex, in Berlin, as well as the National Library of France, in Paris. The latter led to our creative evolution of an idea. Later, however, we followed our own design paths on subsequent projects. This situation forced me to systematize our designs, but it also triggered something interesting, that is, the further analysis that resulted in the crystallization of these paths.

On the one hand, the paths explain our projects, and on the other, the fact that we started to define and classify them gave rise to our greater design self-awareness: analyzing the paths, arriving at certain solutions, and categorizing them paid off in future designs.

Most importantly, when starting the project, we do not know which path it will take. First, we search for a concept, an idea—a solution to all emerging design problems. I am a conceptualist, and this kind of design is most appealing to me. I try to start every project from the proverbial blank white sheet.

Przełomy Dialogue Center

However, over the years, we have created many solutions with great potential. At first, our designing was intuitive, but a lot has changed since we defined those eight paths. Now, once an idea emerges, we can easily spot the motives behind certain paths, what allows us to redevelop the solutions we have developed. Who knows, maybe some new thread will emerge that will set a new path?

The fact is, however, that we have had many discussions in the studio about whether to emphasize the individuality and uniqueness of each project or to focus on their interconnectedness. This shows how important design paths have become in our designing. In the end, also following a discussion with you, it was decided that the main part of the book is a presentation of nineteen different projects, where each of them is told as an independent story. In the introduction, however, I focus on the paths that show the evolution of those ideas.

Przełomy Dialogue Center

Many projects belong to several paths concurrently. This is shown best by the connection map we have created, where these projects are like stops that lie at the intersection of different design routes. You can easily see that, for instance, the autofamily houses are also situated on a topographical path, or sometimes a mobile path, or a historical context, given these paths are much more capacious in terms of different solutions. And the autofamily path focuses on one new spatial solution to increase functionality and convenience for the residents of these buildings.

In your lectures it seems there's less focus on functionality, the comfort of users, or the aesthetics of buildings. Don't you sometimes try to make your projects attractive for reasons which are not strictly related to the main idea of the project? What about the Vitruvian triad—utility, durability, and beauty—do your paths address it?

As a conceptualist, whenever I describe my designs, I tend to focus on one main idea and the process of coming up with that idea, which then affects the whole project. Maybe that's why I don't mention other aspects so much in my lectures, like Vitruvius's ideals. But for me they are the foundation of every design—they are the ABC of an architect's work, like the fact that a building must comply with building standards and the structure must be feasible in terms of statics or gravity.

Your question about functionality is valid, however, and it reminds me of two past situations. In a lecture, a client once asked me why, when talking about

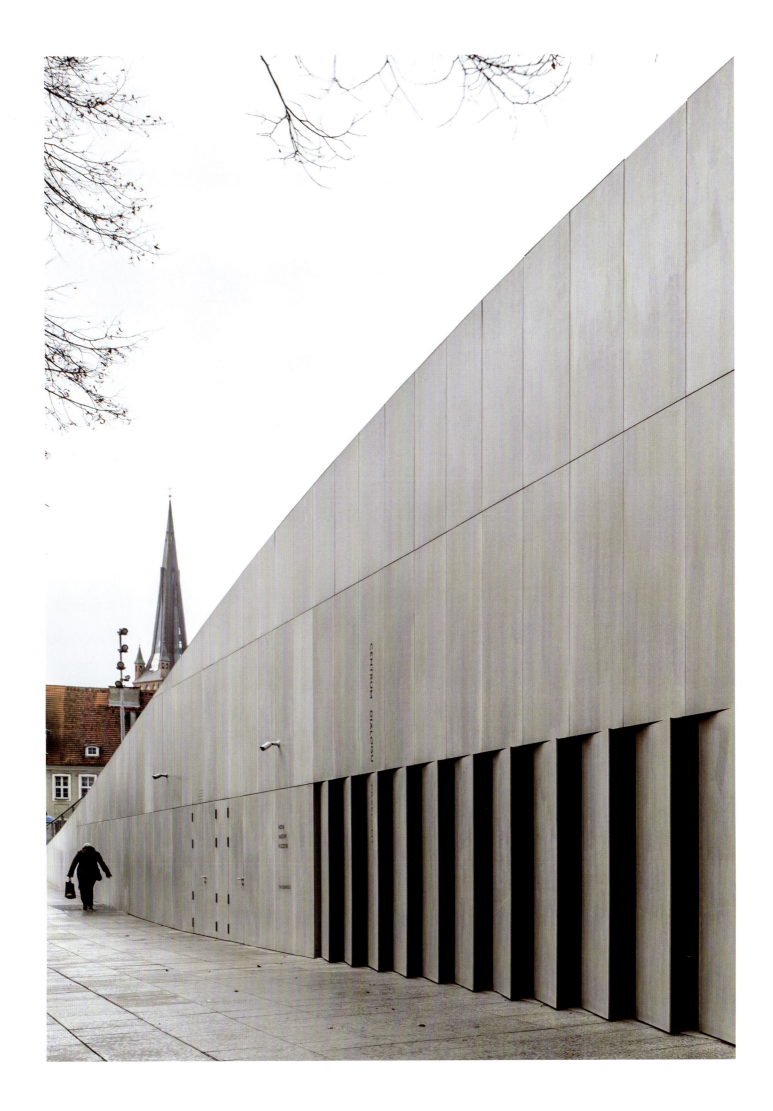

a house I had designed for him, I didn't mention how much time we had spent working on making it simply comfortable for him to live there. I explained that in lectures I focus on the added value of each project, which makes us gain something more, or which makes the object innovative. In the second case, a Polish architecture critic claimed in her book that people in our buildings must adapt to our abstract design ideas. However, it is completely the opposite. Yes, the idea is paramount for us, but it always arises from human needs. Our conceptual process never proceeds with the user or groups of different users in mind, as is the case with public buildings. At KWK Promes we do not create art for art's sake. Architecture is a deeply utilitarian art, and I cannot imagine a project that is beautiful but not functional.

Of course, it doesn't mean that we design irrespective of aesthetics. I probably don't talk much about it since I was educated at a university where aestheticism was usually frowned upon. But beauty is important in our architecture, albeit not the starting point in our design process. As the concept develops, aesthetics become an integral part of the design. We strive for good proportions, divisions, reduction of unnecessary elements so that each building is transparent—I usually say "clean"—and the realization is visually pleasing. The main idea behind each of our projects always goes hand in hand with aesthetics. For example, when we created the **Safe House**, our first building that you write about, we wanted the house to be minimalist, brought down to the simplest form. That's why the thickness of the shutters corresponds to the thickness of the walls, which, when closed, makes them flush with the façades, making the house look like a perfect monolith.

Safe House

What are some of the influences that you can name—architects, buildings, cities?

Just like any young, budding artist I was looking for my own paths, role models, and authorities. From the very beginning, projects where architecture blurred with topography appealed to my heart. That's why, when I discovered the works of Dominique Perrault, it began to strongly shape my way of thinking about architecture at that time.

Certainly because of the school and the Dutch influence our department was under, I was fascinated by Rem Koolhaas's approach and his subversion of the established order of things.

At the opening of our exhibition at the Galerie d'Architecture de Paris, our special guest was Jean-Philippe Hugron, from the magazine L'Architecture d'Aujourd'hui, who said that Rem Koolhaas is an architect who works out of context—by choice. But that KWK Promes, on the other hand, does it because there is no other choice—because there is no good context in Poland. I don't entirely agree with him, since no context is bad and anything can be inspiring, which we often show in our designs on the path of contextual transformation.

Since I was young, I was fascinated by Sir Norman Foster and his architecture. It was pure, logical, clear, and resistant to fads. His Torre de Collserola in Barcelona is pure engineering, and therefore architecturally beautiful, without any unnecessary elements. The competition design for the German Reichstag was sheer poetry. The huge canopy that was supposed to cover the enormous space around the building was something fantastic for me. I regret to this day that it was not realized in this form.

I have always appreciated SANAA's projects, because I like their design method, in which, apart from good proportions and formal purity, clear ideas always prevail. The architects I mention here (maybe with the exception of Dominique Perrault) have not directly influenced our work, but their way of thinking has always been close to me.

Philip Johnson's Ash Street House

Now I watch a lot less than I did at the beginning of my journey, because we focus on our own work, we do our own thing. I've learned that not only in architecture, but in everything around us, you can spot an interesting motif, and then translate it in some way into a design.

House near Barcelona

While I've noted that Dominique Perrault's buildings influenced my early work, in fact there are only a few buildings that really fascinated me. I remember when I was in New York (for the **Governors Island** competition project), I went into one of the architecture book stores and got hold of a book about American houses of the twentieth century. And I saw an amazing sketch by Philip Johnson: A fence wall, surrounding a plot of land, also becomes a house through a simple operation—placing a flat roof upon it and adding a glass partition. This motif—ingenious in its simplicity—impressed me greatly and over the ensuing years, I referred to it in some way in my designs, for example, in the **Safe House**, in which the relationship between the house and the fence is also crucial. The same is true of the **House near Barcelona** and **Open House near Bremen**.

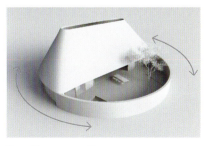

Open House near Bremen

The way of designing that I have taken a liking to, which is to search for ideas, quickly pulled my attention away from watching or looking for classical architectural inspirations. And in that sense Jean-Philippe Hugron was right not to see strictly architectural references in our designs. Yet it does not mean that I am not inspired by the context. It's just that sometimes it is so prosaic and banal that in an architectural sense it has no value and is not worth mentioning.

As you may recall, during the exhibition in Berlin called "Moving Architecture," Ulrich Müller was curious about where my inspiration for mobility came from. He thought that it stemmed from some kind of architectural fascination. Meanwhile, here in the book I explain (both in my introduction, and in the first two selected projects chapters) that there would have been no **Safe House** (our first mobile design) had it not been for the **Aatrial House**. And it was only that idea, which emerged at that time, that made us need to take an interest in mobile architecture, which we had virtually no idea about before.

What are the specificities of Polish architecture in your opinion—if you identify with Poland, what are some of the characteristics of your work that you relate to your own country?

When I was a young architect, I coined a saying that I wished to compete with the whole world, even if the world didn't know about it. I realized that I lived in a country that was under the contemporary architecture radar. But I believed that to change that, I had to show the world something interesting, something of my own that it hadn't seen before. At that time, it bothered me that there was so much repetitiveness in Polish architecture, and in the 1990s we were in a difficult period of political transformation. I was aware that only your own (good) ideas can make this world curious about you. And I have stuck to this principle consistently, to this day.

Aatrial House

Interestingly, many of my friends have wondered why I did not leave Poland, despite being an Italian citizen. Our family originates from Comelico Superiore. After many years, some of my relatives—children of former emigrants—returned there to be close to our roots. However, I have always felt that my place on earth is here, and from the perspective of time I can see— and maybe it sounds lofty—that I have a mission to fulfill here. Despite the fact that we are a global office, because we design outside Poland and collaborate with architects from around the world, we also do most of our projects here. I have always said that it is

important to be innovative and seek your own ideas. In the Polish architecture environment, this was initially received with some resistance, incomprehension, or even reluctance. However, I can see that, years later, after the international successes of our studio, we have found a greater understanding and there is more discussion of our Polish identity in architecture.

Do you feel that you are part of a more global change in sensibility that may have been evidenced in the work of other architecture you can name—you refer to BIG, Mansilla+Tuñón, and Lacaton & Vassal—are there others, or what do you really feel you have in common with these practices—one of which, BIG, employs hundreds of people in New York and Copenhagen?

In my introduction, in the section on conceptualism, I refer to the book European Architecture since 1890 by Hans Ibelings, who mentioned us alongside the aforenamed studios. Ibelings collected material for his book in the first decade of the twenty-first century, when all the studios listed here were at a different stage of development. In fact, BIG has become really "big" since then, but I think I'm personally closer to the work and scale of Peter Zumthor's office. I need to personally supervise every single project and concept. I get involved in the smallest details. And this scale of office suits me best.

In terms of a global shift in sensibility, I instantly think of climate catastrophe awareness and response. You can see from our recent work that we have been trying to participate strongly in this space. I believe that along with the fact that we all should build smarter and greener in some way, the best findings should focus on innovative solutions that can push architecture in the direction it should go. In the last two years we have been thinking a lot about what else can be done to make architecture less of a burden on the environment. I hope that the ideas of living-garden houses and sunlite buildings will not be our last, as more ideas are born.

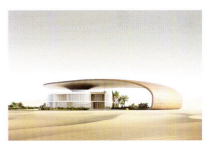

Sunlite Building

Introduction: Robert Konieczny

When Philip Jodidio suggested a monograph on my office, I thought it was fantastic! I have been thinking about such a book for many years. However, I did not want it to be a typical volume, but a book in the form of a lecture. Why such an unusual formula?

I've learnt that even though people had seen KWK Promes designs in various magazines, books, or websites, it was all too often only after my lectures that they finally understood what our architecture is about. Before, they had only seen pictures, but they might not have realized what was behind the designs. My ambition has always been to make people understand our designs. If they just liked them, that would be nice, but I wanted more—I wanted to speak to the ideas and logic behind the designs. Hence why lectures are the best way to explain why these designs are the way they are.

Philip Jodidio is famous for his well-crafted books, so to avoid turning his idea upside down I thought it might be even more interesting to combine the two concepts into one: an album formula with a lecture, open to all. I was curious if the idea of combining a book with a lecture would appeal to Philip. We prepared a draft of the crazy story of my Ark as a sample. Philip welcomed this concept with appreciation, and offered some valuable tips: first of all, not to "clutter" the book with unnecessary graphics, and secondly to keep the kind of humor that I sometimes use in my lectures.

The result is an indepth discourse of nineteen selected projects, interspersed with many other descriptions of works that are depicted on our website.

Lecture in the Royal Academy of Arts, London 2017

Conceptualism

I begin every lecture by saying a few words about myself, and I will do that now. I am a conceptualist, and the studio I run—KWK Promes—is a conceptual office. A few years ago, in his book *European Architecture since 1890*, Hans Ibelings classified our office as conceptualists. KWK Promes was placed alongside such studios as Lacaton & Vassal (France), BIG (Denmark), and Mansilla+Tuñón (Spain). The way

I work is based on looking for one overriding idea, which makes the process of further designing start to "work itself out." The right idea is like taking a path: It is important to stick to it and reject all unnecessary elements. Finding such an idea, one that provides answers to all design challenges, problems, and questions, is our goal.

What attracts me about this kind of design is that one must break away from formal habits. As you follow an idea, you make design decisions that are sometimes against your own preferences, leaving you unaware of what lies down the road. You are guided by the power of iron logic. I sometimes call it the logic of space, where every step in a design must have an explanation. If there's no explanation, we will continue the search from scratch. If there is a logical argument, we take the next step. In this way one can explain the whole design step by step—even someone with no idea of contemporary architecture can understand it, because they are provided with a logical argument.

This power of logic can sometimes lead to new, fresh, sometimes even surprising solutions, even for me. I owe my conceptual approach to architecture largely to the people I met while studying at the Faculty of Architecture at the Silesian University of Technology in Gliwice. The conceptual trend was strongly present there at the time, thanks to professors who had studied at the Berlage Institute in the Netherlands. Consent for experimentation went together with logical and pragmatic design.

When I was still a student, I wanted to challenge the world, even if the world had no idea I existed. I was aware that by living in Poland, I was a bit on the sidelines of the architectural mainstream. But I had the ambition to make things that were not copies of anything. I wanted to design in my own way, to discover new things, to make the world interested in my projects.

With time, having gained a certain maturity, I began to value most those designs of ours that have the potential to become a kind of universal solution. It was as if I had written a formula for architecture that could be applied to different places and different subjects. The form doesn't matter then, it's secondary. This formula can also be used by other architects and developed in their own ways.

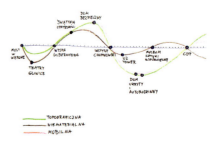

Design paths, first sketches

Design Paths

Over the years we noticed that many of our works, despite formal differences, would share common concepts.

Some motifs are visible at first glance, such as blurred architectural boundaries in the topography, but also the way one arrives at the inspiration for the project, for example, by exploring the deep past of which no tangible traces remain.

At first I grouped the designs ad hoc for the sake of lectures, when it was necessary to find a narrative for the coherence of the story. Over time, however, we took a closer look at them to sort them out. We called these various, often non-obvious connections "project paths." We consider their very definition as a big step forward in our approach to design, achieving something that could be called design self-awareness.

Today, we do it deliberately and purposefully. We assign our emerging designs to specific defined paths, and thereby use certain concepts more consciously. "Well-trodden" design paths do not mean repetition. For us, it means the evolution of thoughts.

All KWK Promes designs can be depicted on a map of such paths (see pp. 322–327 for illustrated details referring to each of the projects outlined below). Initially inspired by a metro map, we started to treat the projects as stations; and we placed those that are multithreaded at the intersection of several paths. With the timeline, the whole thing gained the character of a diagram. The map represents a certain intellectual and conceptual continuity. The paths show that each design has its own history, is explainable. You can go back in time by moving along a chosen design path and get to where it originated. I do not think that the map of paths we present here is something closed and finite. You can move freely on such a map, jump between projects, and discover your own connections.

We ourselves have defined eight paths. Some are fully autonomous; some are derivatives or forks of some previous path. Here we present them in the chronological order as we discovered and defined them.

Design paths, final map

Topographical Path

One of the themes that has preoccupied me since the beginning of my practice is the blurring of buildings with their surroundings, in other words blurring the boundaries of architecture. This is how the topographical path was inspired, and now it strongly influences the thinking about space at KWK Promes. Although this approach is multithreaded, three dominant approaches can be distinguished.

The first motif is combining artificial topography with classical architecture. These are often early attempts to integrate still quite typical buildings more strongly into their surroundings. The second motif is characterized by a fully mature idea of artificial topography, buildings that are basically "made of soil," or that are an element of processed topography, such as a green hill. The third motif is, in turn, an atypical topography, which consists in blurring the boundaries of architecture in a less obvious way.

Interestingly, I had already been thinking "with" topography during my studies. In the design of the **House of the Rising Sun** modified the classical layout of a Dutch house with two parallel walls. I placed one wall leaning against the other and covered with grass the newly formed slope of the roof going all the way down to the ground. The house thus became an extension of the mountain landscape. After several decades I appreciate this design even more, because it is like a simple pictogram that shows the combination of classical architecture and topography.

It was in the early competition projects that we started to develop the potential of topography. In the gigantic **Temple of Divine Providence** in Warsaw, we wanted to hide the surrounding elements, so that the conical form of the church would sound better as the denouement of the whole concept. Hence, we placed all the facilities under the floor of the rising square, the arched cross section of which referred to the rainbow—a symbol of hope. The rainbow was the dominant theme of the whole project, running through the various levels. Thereby we combined artificial topography with architecture. The concept of a rising square also appeared in the design of the **German Embassy in Warsaw.** We wished to build a bridge over the embassy fence in order to symbolically connect Germany and Poland—countries that had been at war many times in the past. Thus, a kind of curved floating square was created, above which the building would levitate.

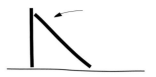

House of the Rising Sun

Temple of Divine Providence

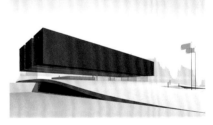

German Embassy in Warsaw

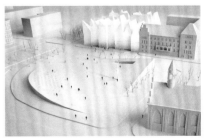

Przełomy Dialogue Center

Our experiences with the temple and the embassy contributed to the **Przełomy Dialogue Center** (pp. 33, 38, 39, 158) in Szczecin. I feel that this design is more mature than its predecessors, as it emerged purely from processing the topography. We hid the museum underground so as not to compete with the iconic philharmonic hall standing adjacent. But our building marks the uplift in space, which at the same time creates the outline of the old, densely built prewar quarter creating a hybrid of the square and building. We worked in a similar way, using only topography, in the design of the extension of **Art Bunker** (pp. 33, 280) in Cracow. In order not to obscure that brutalist gallery we took a courageous step: instead of building upon it, we went underground and hid the new exhibition part under the street level.

Concurrently with the urban topographical designs, we also created ones in the natural landscape. In the **Meeting House in Biały Bór**, we wanted to level the scale of the house for a family of forty people, which could overwhelm the area with its scattered buildings. Hence, we had the idea of hiding the common area under an artificial hill, while the landscape features only eight small houses with a private/night area for each family. With their scale and shape, the cottages refer to surrounding buildings.

We took a similar approach in the design of the **Hotel in Czorsztyn**. The artificial topography helped to hide the large volume of the building. We combined it with processed regional architecture, referring to the old cottages with high roofs in the neighbourhood.

By manipulating the topography, we can also solve the functional problems of the plot. In the **Aatrial House** (pp. 36, 43, 50), which had a troublesome access on the southwest, we inserted the road in a trench to separate it from the elevated garden and thus provide full intimacy for the residents who would be unwinding there. However, the Aatrial House was still a "classical" architecture placed upon a modified topography.

In the design of the **Snail House**, whose plot had the same disadvantage, we went a step further. Here, we recessed the road likewise, but in contrast to the Aatrial House its shape is soft, which enables a smoother movement. The lump of the building is no longer an add-on to the topography, but a direct result thereof—it is like the earth "pushed" out of the excavation, which creates the architecture.

The experience gained in the Aatrial House and Snail House bore fruit in the **Autofamily House** (pp. 43, 90) in central Poland, where we elaborated on the problem

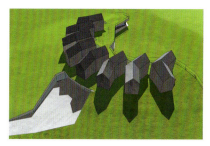

Meeting House in Biały Bór

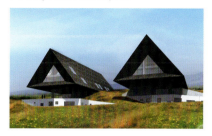

Hotel in Czorsztyn

Aatrial House

Snail House

Autofamily House

of access into the house on the south side. There we covered the recessed road with a green roof and created a tunnel, and its extension forms the body of the house.

These last two designs have now been created purely from topography, just like **Aura Aparthotel** in Poznań. Inspired by the basin of a stadium with grassy stands, we stretched them higher to create two artificial hills with residential units.

Even when there seems to be no context and only a surrounding meadow, it is possible to draw from it and to create architecture. This was the case with **OUTrial House** (p. 80). We lifted a piece of green land and put a living space underneath. The result is a house with an unusual atrium that leads the residents out onto the roof.

A similar way of thinking resulted in a nonstandard solution in **Marina in Biały Bór** (pp. 33, 200). We were supposed to build a house with a marina there, but the law forbade creating private zones in the coastal strip, which would be a common space.

To ensure the intimacy of its residents, we created an artificial plot of land elevated on a platform above the parcel. A public marina is maintained at the bottom, a private house above, and both zones are connected by drop-down stairs.

This design touches upon the third motif of the path, the unusual topography. It was initiated by the **Safe House** (pp. 32, 36, 64) which at first glance may not be associated with topographical designs. Its mobile façades, when opened, merge with the fence, providing intimacy for the garden, while at the same time providing a link between the building and the street. It is then unclear where the house ends and the fence begins—the boundaries of architecture blur.

Another example of this unconventional approach is the **By the Way House** (p. 112), which we formed entirely out of a trivial element of topography—an ordinary road. Thanks to this, the architecture blends in with the surroundings, but is also stretched to the maximum.

The initial fun of digging buildings into their surroundings, or blurring them, brought about a mature reflection over time: while architecture is usually an act of violence on space and nature, a topographical approach can lead to a balance of the dissonance in the landscape as well as minimize the negative effects of building.

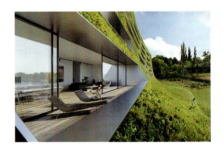

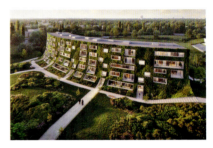

Aura Aparthotel

Immaterial Path

An immaterial path was created alongside the topographical path. While the former is related to physicality, the latter touches upon immaterial phenomena that complement architectural matter. Sometimes these are natural phenomena, such as sunlight or wind, and in some designs the immateriality results from the use of advanced technologies. Sometimes it is a combination of both.

When designing buildings, the factor of sunlight is always considered, but consciously employed sunlight can also become a component of architecture. An example is the **House of the Rising Sun**, which initiated this path. At certain times the rays pierce the building thoroughly. The house then acts like a sundial, setting the rhythm of its inhabitants' lives.

Sunrays are also the main motif of the **Temple of Divine Providence** and the **U2 Tower in Dublin**. In the former, we placed tiny openings at the top of the church and positioned them so that on important days in Polish history the sun's rays would penetrate the interior and hit the prism suspended under the vault. The split light would illuminate the aisle with the glow of a rainbow. In the latter design, it was only the sun piercing the tower that brought out its inner, hidden structure from the apparent monolith.

Another intangible phenomenon—wind—completed the design of the **Chopin Institute** in Warsaw. We shaded the glass façades of the superstructure with long flexible blinds. When windy, they would move like leaves and the building would behave like the trees all around. The waving light strips of the blinds would expose the dark glass, so there would be an additional musical association with a piano keyboard.

I keep saying at my lectures that it's a pity we didn't deliver this competition entry on time. A few years later such precursory superstructures of old buildings were created as CaixaForum by Herzog & de Meuron or the Columbus Museum, a work by Peter Zumthor. Then I go on to joke that our superstructure would at least be moving.

Along with natural motifs, we ventured into immaterial solutions based on high-tech motifs. In the early design of the **Gliwice Theatre**, we wanted the public life in the building to be reflected in the façades. Thanks to polymers embedded in glass, the façades of the theater would become a screen, displaying images from thermal-imaging cameras. The more people, and the livelier the reactions, the more intense the patterns.

House of the Rising Sun

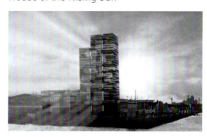

U2 Tower in Dublin

Chopin Institute

Gliwice Theatre

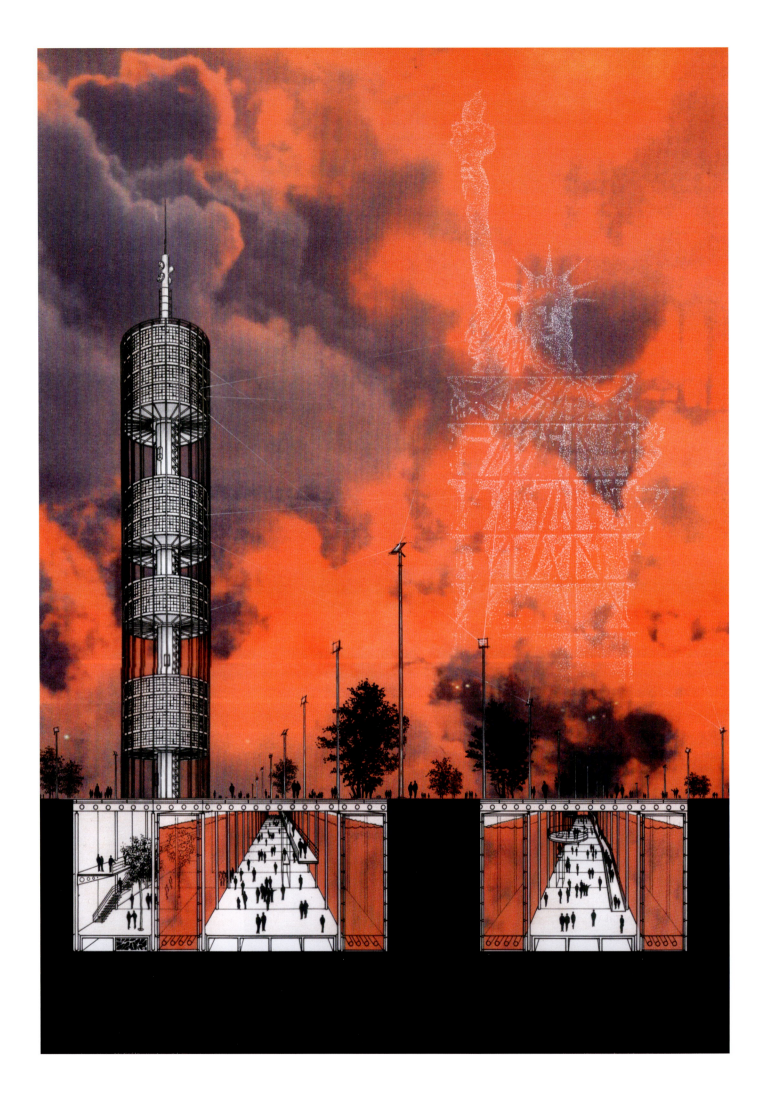

Thinking about architecture in a broader sense than just physical construction was crucial in our first competition designs. In the **Bridge in Verona**, we reached out to history. We have discovered that before the great flood in the nineteenth century, the city was more open to the river. Aiming to bring life back to the embankment, we designed a bridge in the form of a vast glass square that would also be a virtual museum. Using VR goggles (standard today, but only experimental in the 1990s), visitors would be able to travel to any time in Verona's past, all the way back to antiquity, and compare these images with current-day reality.

In the competition for the development of **Governors Island** in New York, we searched for an idea for a new function for the former military base (which was to be sold). A series of associations and ideas came to mind: Every product that is sold has a barcode with information recorded that can only be read with a laser. We decided to treat the island in a similar way. We used technology known from Jean-Michel Jarre's concert settings to be able to "read" the history of both the island and New York. In the middle of the island, we put up a tall tower that emits laser beams falling on evenly spaced poles with mirrors that reflect the beams and display the image on a "screen" made of artificial fog. An enormous, virtual museum was created, showing New York's history in a nonstandard way. Viewed from a distance, the island would disappear into the fog.

Governors Island

Based on this idea, after the World Trade Center terrorist attacks, I imagined that luminous ghosts of the towers could hover over the island, too. A few years later the Blur Building by New York studio Diller Scofidio + Renfro made a splash at the Expo, and once again I thought that it was a shame our project remained only on paper.

In the design of the seat of the **Contemporary Art Museum** in Wrocław, we mixed the motifs of natural phenomena and high-tech. Similar to the Gliwice Theatre, here the façades are screens showing the processed image from inside, with the aim of making art more accessible and visible to passersby as well. Following the example of the neighboring buildings, the façades would be overgrown with vines, so that we would slowly lose control over what we could see. Nature would enter into a dialogue with high-tech and we would obtain astounding images.

The immaterial path began with a house that featured the sun, yet the building was passive towards it. It was only years later that we created the **Quadrant House** (pp. 33, 214), which actively responds to the movement of

the sun and whose idea, thanks to advanced technology, was further developed on a much larger scale in the **Sunlite Building** (pp. 33, 316).

Immateriality is another way of extending the boundaries of architecture. In the topographical path we sometimes physically stretch the buildings into the environment. Here, in contrast, intangible phenomena are a fully fledged part of the architecture, complementing it and giving it a deeper meaning.

Upon reflection, we noted that all our immaterial cultural objects have one concept in common—their existence is visible in the public space, which we believe has significant value, and we are now consciously pursuing such democratic solutions in our mobile projects.

Mobile Path

It was with our first design on the mobile path that we discovered that the mobility of architectural elements can interfere with the space around the building, modifying it temporarily. With time we understood that mobility allowed us to create new relationships between architecture and the environment and to blur even more the barrier between inside and outside.

Interestingly, all our mobile projects temporarily interfere with the environment to a greater or lesser extent. In the **Safe House** (pp. 36, 64), which initiated this path, it is particularly evident. The mobile elements of the building—two huge shutters—change the functioning of the plot. When they move away from the house, the building connects to the street while maintaining the privacy of the garden. After closing all shutters and sliding walls the building looks like a monolith.

Safe House

Shutter House

In contrast to the Safe House, in **Konieczny's Ark** (pp. 37, 180) and **Shutter House** we dispensed with standard fencing altogether in favor of mobile elements placed within the contours of the house. In this way, in both designs we were able to minimize the interference in the landscape and avoid erecting barriers to animal migration, while at the same time the mobile solutions provide intimacy for the residents at the right moment. For example, when opened, the custom shutters in Shutter House act as screens, separating the garden from the street. On a daily basis, I myself appreciate the lack of a fence around my Ark, especially as the neighbor's sheep bail me out of mowing the lawn.

However, a common feature of Konieczny's Ark and **Marina in Biały Bór** (p. 200) is the elevation of the living space above the ground. In the former, the link to the ground is a drawbridge-terrace, and in the latter, a drop-down staircase connects the private part with the public space below. When the marina owners leave, they pull the stairs up, but the quay below their house remains open to the public. A home's classic fence and waterfront location would cut off a section of the quay. With a vertical layout of the functions and mobility, we reconciled the intimacy of the house with the public accessibility of the marina.

Mobility allows some of our buildings to respond more flexibly to environmental conditions. The motif of the rotating element in the Shutter House was previously used in the **Quadrant House** (p. 214). Part of the building follows the sun, increasing both the functionality and the energy balance of the house. This translates into comfort for the users. A movable terrace attached to the living room shades it on hot days. There is no need for roller blinds; the views of the garden are maintained while the interior is pleasantly shaded and ventilated. Mobility allows the building to adapt quickly to changing weather conditions, but also to its residents' needs.

Quadrant House

The solution applied to the Quadrant House inspired the **Sunlite Building** (p. 316), a versatile design intended to be built in hot regions. The rotating element constantly protects from the sun while drawing energy from it. We are now developing this concept particularly strongly, as we believe it could be one of the ways to build in the context of rising temperatures on Earth. This building looks to the future the most, which is why I finish the presentation in this book of nineteen selected projects with it.

Sunlite Building

Mobile solutions allowed us to develop the openness of our public spaces, which I mentioned on the immaterial path. The **Przełomy Dialogue Center** (pp. 38, 39, 158) gave us an idea: can the exhibition space relate to its surroundings more closely? How to perforate the partitions, so that the museum can be viewed directly from the street, without barriers in the form of a hall and cloakrooms? This was partly achieved in the **Art Bunker** (p. 280) in Cracow. The underground gallery gained an open roof in the form of a raised section of the square, giving passersby an unusual visual contact with art. And since the building is located on a popular pedestrian route, many people would encounter the exhibitions presented there for the first time. The hermetic contemporary art, so far confined behind concrete walls, is now revealed to the city. The raised roof would intrigue and attract lookers-on.

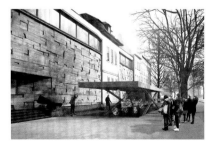

Art Bunker

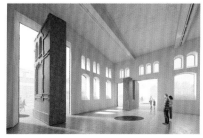

Plato Contemporary Art Gallery

33

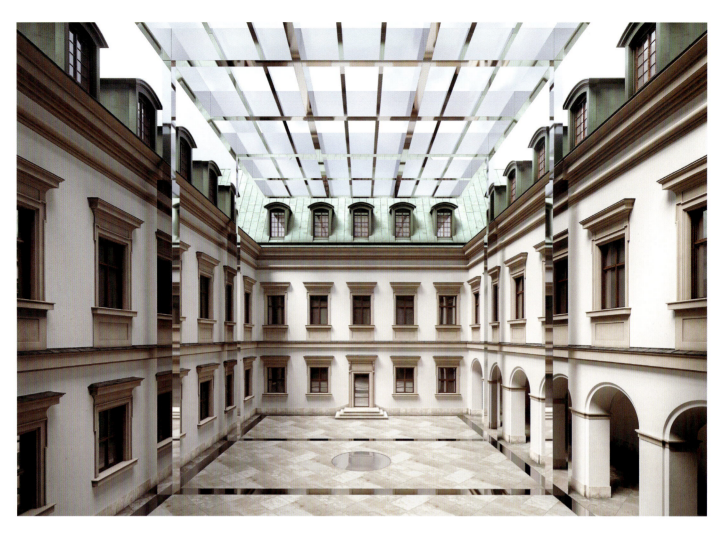
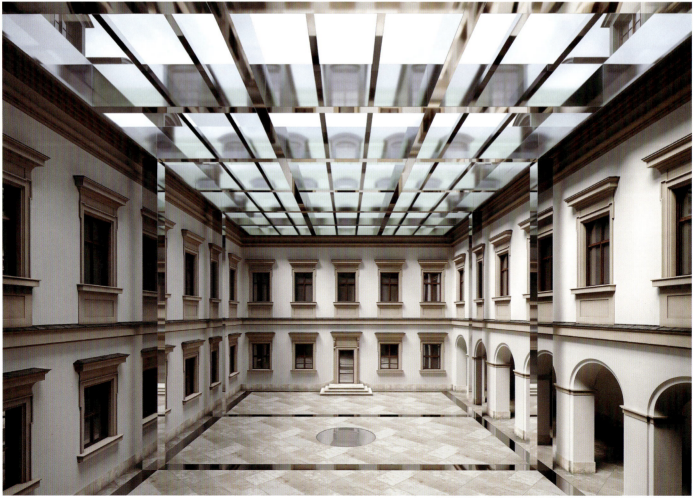

In the Art Bunker the moving element only allowed you to look inside, but not to enter. We decided to go the whole hog in the **Plato Contemporary Art Gallery** (pp. 38, 286) in Ostrava (Czech Republic), currently under construction. Thanks to the rotating walls, art can literally go out into the city space. Not only can passersby look inside the exhibition halls, but also walk through the moving façades, thus opening up the cultural institution more fully to people and the city surrounds.

This way of thinking about mobility—opening up public buildings—is particularly close to our hearts. By increasing openness and blurring boundaries, culture, and knowledge in the broad sense have the potential to become more democratic and accessible to new audiences.

Our latest design on this path, the roofing of the courtyard of the **Ujazdowski Castle Center for Contemporary Art** in Warsaw (see photos, opposite) is intended to work in a similar way but on a slightly different basis. We decided to avoid a typical glass roof that would permanently close the courtyard. We opted to combine the qualities of open and closed spaces. We created a raised grillage that would be lifted on hot days, providing natural air ventilation, and would open the courtyard on rainy days. We are considering placing similar constructions in the park around the castle to create space for open-air exhibitions, concerts, or art lectures so that artists can go beyond the walls of the building.

Path of Contextual Transformation

Of course, the work of an architect is to enter into a relationship with the local context, to engage in a dialogue with it or to deny it, as made famous by the Rem Koolhaas quote, "Fuck context!". But for us, the key word here is "transformation," which means processing archetypes and what has been done before.

Sometimes it can be about transforming something that is usually rejected from this context.

In Poland, the typical cube houses that were built during the socialist period represent a unified and commodified modernism. Cursed by many, for us they are inspiring.

One such example is the **House from the Silesian Land**, which also fits on the topographic path as it combines artificial topography with classical architecture.

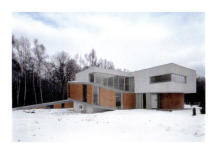

House from the Silesian Land

The plot, however, had suffered significant mining damage, which combined with its surroundings full of Polish cubes, directed us to deconstruct this typical form, and we've now wrapped it with a proverbial ribbon emerging from the land.

Our innovation started with a drawing mistake. We presented the client with a concept featuring a ramp running around the high living area; but only later did we notice that the necessary stoops were missing. We found the concept still worked well and set about executing it. As a result of bending the ramp planes, we achieved straight outer edges—without a zigzag of stoops that would have spoiled the formal purity.

Even my childhood home used to be a typical Polish cube (though later it was destroyed by mining damage). I built the **House with the Capsule** in Ruda Śląska for my parents and grandmother. In the old house, the most important space was the kitchen, where family life took place. Thus, the new building has a spatial arrangement that is a transformation of the family home. In its center there is a capsule housing all the practical functions, that is, the kitchen, the pantry, the bathroom, and the fireplace as an alternative source of heating. Therefore, at each exit from the house there are nets for storing firewood, which serve at the same time as an openwork screen for terraces.

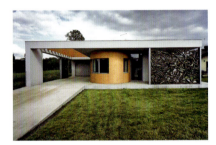

House with the Capsule

The shapes of **Aatrial House** (pp. 43, 50), **Safe House** (p. 64), and **Komoda House**—among others—are all processed Polish cubes. The first home is a kind of architectural origami, where the whole structure could be assembled from a single sheet of paper. In the second, we continued to transform the Polish cube creatively by transforming the form into a perfect monolith. In the third example, we recreated proportions of the old, demolished house, but we treated it like a chest of drawers, from which we have removed the drawers to enlarge the living space.

Komoda House

The motif of the transformation of the cube—due to the prevalence of this archetype in our landscape—is one that we constantly apply and develop in various ways, for example in the **From the Garden House** (p. 142).

Moreover, in Poland we live at the meeting point of two cultures—influences from the West and East mix together. The differences are particularly visible in the way their high-pitched roofs are built. One that has no eaves is found particularly in regions under German influence. The other type has wide eaves, a visible sign of Eastern influence.

I find this second archetype particularly inspiring. It is in opposition to the roof without eaves, which has been popular for many years, especially since the time Herzog & de Meuron's famous Rudin House, in Leymen, was built. However, when I spoke about such a typical Polish roof with eaves in the office, I usually heard derisive comments. The young architects preferred the fashionable "modern barn" to which they had become accustomed. But I believed in the potential of this Eastern form for it is strong, striking, and, at the same time, familiar.

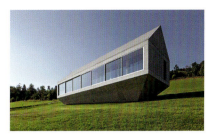

Konieczny's Ark

I realized its potential back at the end of the last century in the **Flight House**. As the name implies, the house looks like a hang glider that has landed on the side of a mountain. The far-reaching slopes of the roof shade the terrace and glazing of the living area, protecting the building from overheating. It is only now that I am showing it publicly, because back then I gave in to the majority conviction that eaves were bad.

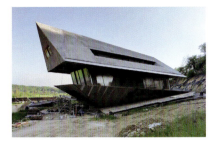

By the Wind House

Over time, however, I started to explore the Polish roof theme more strongly, and in the following years we based many designs on that motif, such as the **Hotel in Czorsztyn**, mentioned in the topographic path, or **By the Wind House**. The latter is an evolution of **Konieczny's Ark** (p. 180), although this one stemmed from the eaveless tradition, as did the **standard h0use** (p. 102).

This path also contains quite a few projects inspired by their surroundings, such as the **House near Barcelona**. Here we exploited the archetype of a Spanish house surrounded by a high wall. But as the plot of land was sloping, we tilted the wall in line with the topography, providing the house with a wide view even from the rooms on the ground floor. We drew inspiration for the office and industrial building for **Gambit Office** (p. 246) from the classic farmhouse style prevalent in its surroundings. Even bland or less interesting neighborhoods can spark a transformation. The multifamily building for **Unikato Housing** (p. 232) in Katowice is based on the basic (and inexpensive) elements found in the locale's prewar tenements. It has a simple layout of windows and protruding balconies that are quite functional—they catch the light much longer once it no longer streams into the flats. The new structure's corner position demarcates it as a strong neighborhood reference point. And we made the façade black, thus blending the building into the post-industrial city.

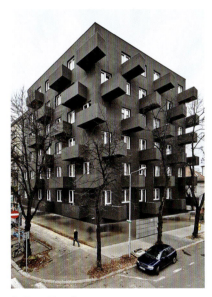

Unikato Housing

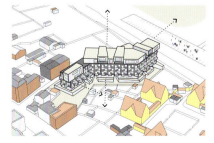

Baildomb

The context was extremely difficult at **Baildomb** in Katowice, which was built in a degraded district comprising a chaotic blend of buildings. So we asked ourselves: what shall we refer to? The result is that Baildomb gathers the various houses from the neighborhood into

one building-collage character. To stop the blocks from obstructing each other's view of the nearby park, we put them on top of each other. On the ground floor there are small flats with gardens, the next floors up include classic residential units, and the top floor contains urban villas. I was against the idea of bringing this building down to a single material—its layered and very diverse model fits best in such a complex context. At the same time, the diverse typology of dwellings attracted people of different wealth categories and created a sound social mix.

At times the context is so defined and iconic that it would be best to recede into the background. However, in the case of the magnificent modernist **Health Resort** in Ustroń, which had been destroyed for years by the chaotic, incongruous developments emerging there, we decided to do things differently. The new buildings relate in a very contemporary way to both the existing and the planned buildings there. In this way, we reinforce the entire landscape layout, while at the same time weakening the spoiling, mismatched surroundings.

Literal transformation—rebuilding—is also an important element on this path. Based on the old structure, we transform its elements and thus the existing object gains new value. Reconstruction means acting "on a living organism," as in the case of **MM Petro**, where we added a new office part to the old, ugly hall for the whole to be unique. In the **Plato Contemporary Art Gallery** (p. 286) we made use of as many elements of the old slaughterhouse building as possible. We transformed its imperfections, such as the punched holes in the walls, into the concept's main theme. Rotating elements made of new, contrasting material will increase its functional potential.

Along with literal transformations, I particularly like to focus on those designs in which, by exploring the context of the site, we can also discover the oft invisible or unobvious things. This was the case with the **Mobile Pavilion of the Museum for Contemporary Art** in Warsaw or the **Przełomy Dialogue Center** (pp. 39, 158) in Szczecin. In the former, we referred to something that has not yet been built, that is, the new museum designed by Christian Kerez, with characteristic exhibition space in the form of vaulted naves. We transposed the cross section of Kerez's intended building by folding its space. This is how a cave-tunnel was created using inflatable tent technology. As with Kerez's design, the formal richness of our idea would only be visible from the inside. In Szczecin, on the other hand, we were inspired by the history of the city's existing public square (Solidarity Square) at the project's location; the physical traces of the historic events that happened there had vanished long ago. More on this context, next.

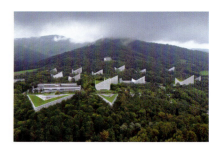

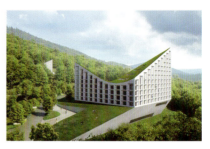

Health Resort

Museum of Modern Art in Warsaw by Christian Kerez

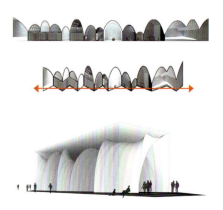

Mobile Pavilion of the Museum for Contemporary Art

Such discoveries are particularly appealing to us. Without them, the next path would not exist either.

Path of Historical Context

As I mentioned in the previous path of contextual transformation, our design process is not an abstraction detached from the environment. Context is usually our initial database. However, sometimes we reach for a deeper context, until we come to a story whose physical traces are no longer visible in space. This is how the path of historical context was born with designs inspired by the distant past. Why go back in time? Because it gives us a completely different perspective on "place."

Such thinking was already apparent in our early competition design for a **Bridge in Verona**, which I mentioned in the discussion on the immaterial path. We were inspired by an old black-and-white photograph showing Verona as it existed prior to the great flood disaster of 1882. At that time the waterfront was vital; it often meandered close to houses, with some homes built on stilts in the water. This historical record led to an impulse for us to bring people and life back to the river. We translated this story into the urban planning of the whole solution. It precipitated the idea of the square being suspended by the river, but also for an unusual museum, where visitors would use VR goggles to immerse themselves in the city's past. It was a competition for young architects, and we did not have the confidence to show it to anyone beyond the competition entry. We hid the boards under the bed. But when the prize came and there was interest in the project, we were encouraged, and we began to use the study of the history of a place in design more and more boldly as one of the stages of a project's initial analysis.

For the competition entry for the **Przełomy Dialogue Center** (p. 158) in Szczecin, we were the only participants to reach back into the prewar history of the project's location. At a time when Szczecin was within the German territory, the site featured a compact quarter of elegant tenement houses. Allied air raids during World War II reduced them to rubble, and a square was later built there. We opted to reconcile the site's two divergent narratives: the present (the square) with the past (when it was occupied by dense buildings). Our idea was to hide the museum underground, and on the surface we added the uplifts to mark only the outlines of the former quarter.

Observing similarly obliterated traces of the past completely changed the design of the **Miedzianka Shaft** (p. 262), which was borne part archaeology and part urban investigation. An old mining map revealed

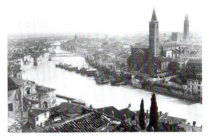

Project site before the flood in 1882

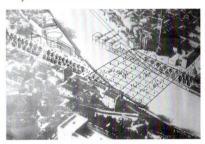

Bridge in Verona

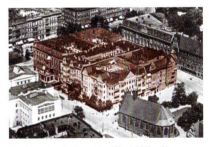

Project site before the World War II

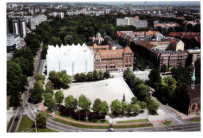

Przełomy Dialogue Center

the original purpose of mysterious stones found on the plot: they were to be the foundations for a mining shaft. We wanted to fulfil the destiny of this abandoned site and built a vertical building form that depicts a strong industrial character and used concrete blocks to activate the memory of the original foundations.

Although our architecture is not associated with historicism per se, we are not ashamed to draw from the past. By looking into the past, we ensure the place is imbued with a cultural and historical continuity, particularly for sites that have been interrupted by calamity or rapid civilizational change or decline. And although I always stress how important progress in architecture is to me, at the same time I do believe that it must be built on the solid foundations of the past.

Iconographic Path

While preparing a design we examine not only the material and historical contexts, but also the cultural context. These may include folklore or legends, or symbolic references, or imagery that holds particular significance on the iconography of the place or representation of an event from the past.

Temple of Divine Providence

As young architects, we were fascinated with Dominque Perrault's work on the podium for the National Library of France, in Paris; this prompted the idea of transforming views with volumes that also refer to a symbolic and monumental aspect of the work. In the **Temple of Divine Providence**, we looked for a symbolic reference that would best express the purpose of constructing this church, which is a votive offering of thanksgiving by the nation for Poland's regained independence. We compared the end of Poland's long captivity to the end of the biblical flood and used the idea of a rainbow to herald this new era as a symbol of hope and reconciliation between people. The rainbow theme features in the urban design of the church, which comprises an arched-shape or curved-bow of a monumental square over which the building sits. The rainbow theme is the main hero of the church aisle interior, where an intangible flash of light beams on selected festive days.

You never know what might inspire you: it might be a historical image, or even a chemical formula memorized at school. This was the case with the headquarters of **MM Petro**, a company in the fuel industry, which directed us to the concept of benzene—a fuel additive with a hexagonal pattern. Half of the shape reminded us of the gable wall of the original hall, to which we were going to add an office

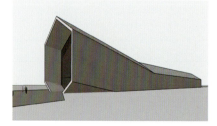

MM Petro

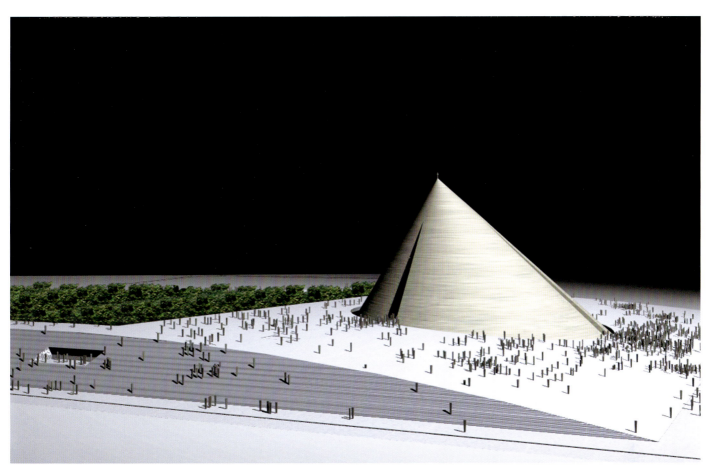
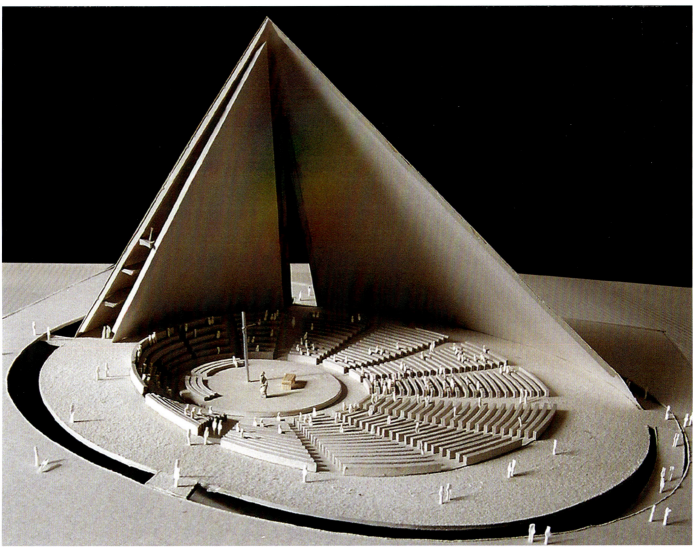

building. At all costs we wanted to avoid gluing the new form in place. The benzene theme appeared helpful, it was enough to pull the hall upwards, extracting the whole hexagonal shape from the ground. The result was an emblematic building with the uniform form of a pipeline rising out of the ground.

I like the definition I once heard: that a good architect is someone who can combine everything with everything. In my office I often initiate brainstorming sessions, encourage discussion, and encourage people not to be ashamed of even seemingly silly thoughts or associations. When we were working on the competition project for the **Wielkopolska Uprising Museum**, someone suddenly pointed out that the insurgents, as well as the people who stood in solidarity with them, wore national bows pinned to their garments. As such, they seemed to be a beautiful symbol of community. So we decided to transfer that tiny bow to an architectural scale and transposed its red colour into a material—traditional brick. As a result, the body resembles a bastion, which perfectly fits the theme of the museum and the context of the place.

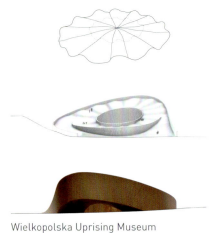

Wielkopolska Uprising Museum

The key for us is not to spoil iconographic ideas later on—we cut away everything that is superfluous in order to consistently pursue the original vision.

Path of Autofamily Houses

We have noticed a certain paradox—since residents of suburban homes are mainly dependent on cars, we usually enter the home through the garage, while the main entrance remains unused. Everyday our first contact with the house means squeezing through technical, sometimes dirty, spaces. This is how the idea of connecting the entrance with the driveway was born—to make the moment of coming home a pleasant experience.

Is combining the entrance and the driveway a good solution, since cars pollute the air? It's important to remember that when we came up with that idea a good dozen years ago, eco-friendly cars were not yet on the market. However, we thought then that it was only a matter of time before cars would be developed to reduce their emissions to zero and maybe we should respond with architecture to suit what is going to happen anyway.

To illustrate it better, let me give you another example. The kitchen has evolved from a dirty and smoky room into an open island in the living area. And this is all thanks to technological advances. This small improvement has completely transformed our lifestyle and the way we use our homes.

We developed the solution for the autofamily house gradually by elaborating on certain concepts. For instance, for years we had been concerned with the moment of accessing the house. In our early designs of the houses, we would separate the access road from the garden in parallel to create a recessed common space for pedestrians and motorists, as in the **Aatrial House** (p. 50). It was still just an unconscious nucleus of the idea of the autofamily house. However, it initiated a new way of thinking that has been fostered in subsequent designs. In our approach to the **Autofamily House in Radlin**, the entrance and the driveway are again one space, which is additionally roofed over to protect it from the weather. This leads to the building situated above the road. This part of the entrance looks as if a fragment of its body has fallen and merged with the street level.

Autofamily House in Radlin

In these two designs, pedestrians and motorists approach the building via a common route, but thereafter they are separated by the door and garage gate. It is only in the **Autofamily House** (p. 90) that we removed the wall dividing the entrance hall from the garage, in a similar way as the partitions dividing the living room from the kitchen are being demolished in contemporary designs. In that design, we finally defined the principle of the autofamily house. We understood that this minor functional change would translate into greater convenience for the user. We leave the car, like a coat or an umbrella, in the hall. It's more convenient to unpack shopping there than in an unheated garage. It's easier to return to the car to retrieve the briefcase left behind, even while wearing a dressing gown. Interestingly, sometime later the owner of that house replaced the cars with electric ones. He did not want exhaust fumes in the entrance hall, which the garage had de facto turned into.

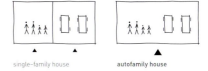

This concept can be applied to various situations and its principle can even solve functional problems of plots of land, as was the case with the **Autofamily House in Katowice**. Although it seems insane, it is completely logical at the same time. The unrealistic wish to fit a circular driveway with a garden on a small plot of land sparked the idea of wedging the driveway into the night zone. This dovetailed with the lifestyle of the client, who only had time to enjoy the living area at weekends.

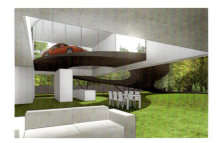

Autofamily House in Katowice

You can see the grass in the interior visualizations of that house. It's not a graphic designer's mistake. After a while we ascertained that if we had an elevated driveway with greenery underneath, why couldn't it penetrate all the way to the interior of the house? The living space could then function like in the Living-Garden projects, which I discuss in the next path.

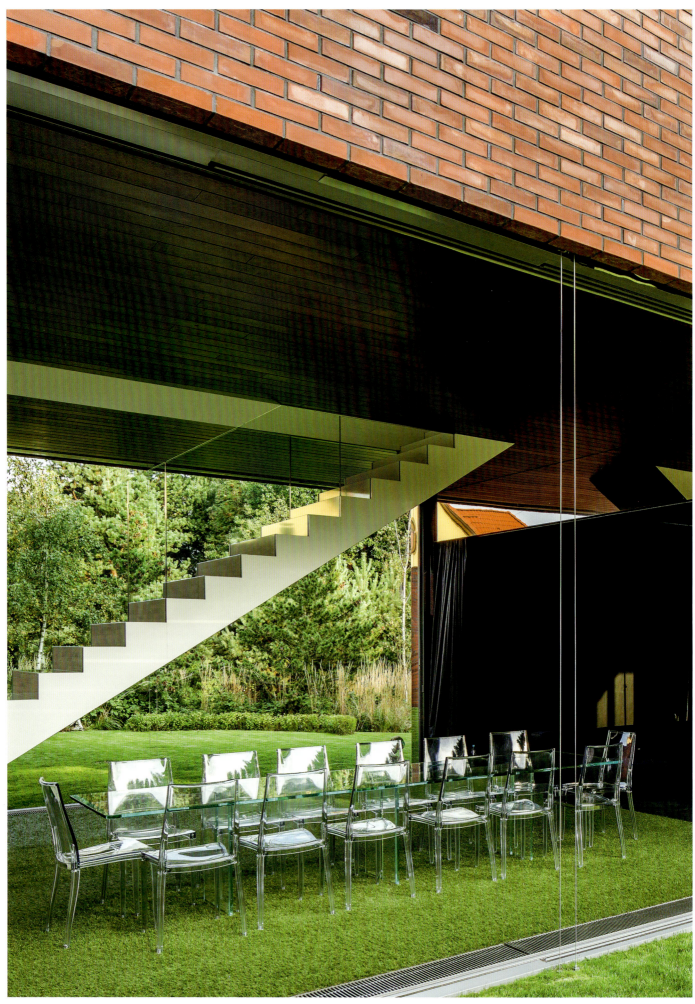

Living-Garden House in Katowice

As I said, the principle of autofamily houses is universal. Basically, it can be applied to ordinary, small houses as well. These days, green cars or even cars that clean the air are increasingly available. So why not treat the car as a mobile piece of furniture that is nearby? Therefore, we are developing the concept of autofamily houses further, and perhaps it will encourage others to swap their combustion engine car for an electric one.

Path of Living-Garden

The final path is the result of many years of reflection. I have always tried to blur the boundaries of buildings. This was the theme of the topographical path that we started with. But over time, a separate route has developed, with designs that combine architecture and nature in an unprecedented way.

typical house **living-garden house**

In these designs, we eliminate the barrier between inside and outside as much as possible, allowing nature to penetrate inside. The first thing that pushed us to do this was to create a space that gives the feeling of living in nature. With time, we realized that this solution could give much more—clean air and a pleasant interior microclimate.

It all started with the **Living-Garden House in Wrocław**. To avoid dividing the garden into two parts, we raised the body of the house from the south. Under the overhang of the house, we located a fully glazed living area, which visually connects the two gardens. At this point an idea popped up—what if we let this garden inside? We placed artificial grass on the floor, which was reminiscent of nature and gave us the feeling of being in a garden.

Living-Garden House in Wrocław

At the time, we didn't quite know where that would lead us. We repeated this motif in the **Living-Garden House near Warsaw**, but in the **Living-Garden House near Cracow** grass appeared even in the private spaces. At the time we felt that perhaps we had gone too far. Here, the private area was incorporated into the living-garden concept, too. We saw a dichotomy: it is in human's nature to need contact with the environment during the day, but at night we seek a secluded retreat to rest. The Living-Garden House responds to this duality with a living room that is completely open to the garden, with only glass partitions protecting it from the weather, but which disappear on sunny days. In contrast, the private area remains as introverted as a cocoon, in which we close ourselves off, just as early humans hid in caves or trees after dark, in a way cutting themselves off from a wild and untamed nature.

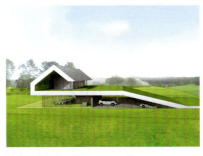

Living-Garden House near Cracow

In the **Living-Garden House in Katowice** (p. 128) we have consciously implemented this idea. The residents practically live in the garden for half the year. And because I repeatedly received enthusiastic phone calls from those clients who told me how great it was to live there, I recognized that it was worth developing such a house formula in future designs.

However, as is often the case with me, after I completed my next project—the **Living-Garden House in Izbica**—I soon started to feel that I had missed out on all the opportunities this new type of building offers. The feeling of being outside in the garden was no longer enough for me. I wanted the building to provide what living in nature gives—clean air and a healthy microclimate.

The first mature building of the concept was the **Living-Garden House near Kassel** (p. 308), in which, thanks to advanced technology, living nature penetrates the interior without having to give up the comforts of a twenty-first-century home. It occurred to me then that the first modernists were already striving to blend the inside with the outside, but the technology of the time did not allow them to progress further. Today, with smart glass that can react to the sun and transition as required, for example, these dreams are within easy reach.

In the Kassel project we realized that it was a universal idea and that it didn't only need to apply to houses. Housing estates, schools, kindergartens, or office buildings could be formed in the same way. If they offer a pleasant microclimate and the structural solutions reduce the need for air conditioning or mechanical ventilation, how much electricity could be saved? Living-Garden takes us out of the artificial and closed environment of modern houses, and at the same time ensures contact with real greenery, which can undoubtedly have a beneficial effect on our health, including our mental and physical well-being. The latter aspect was made clear to us by the pandemic and further lockdowns, when we remained confined to our homes, away from parks and forests. Thanks to new technologies, we can return to nature.

We now know that the designs on this path have much more potential than we initially thought. We do believe that looking for such new solutions will help us build a balance between civilization and nature.

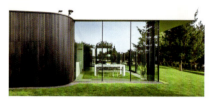

Living-Garden House in Izbica

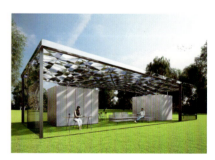

Living-Garden House near Kassel
(above and opposite)

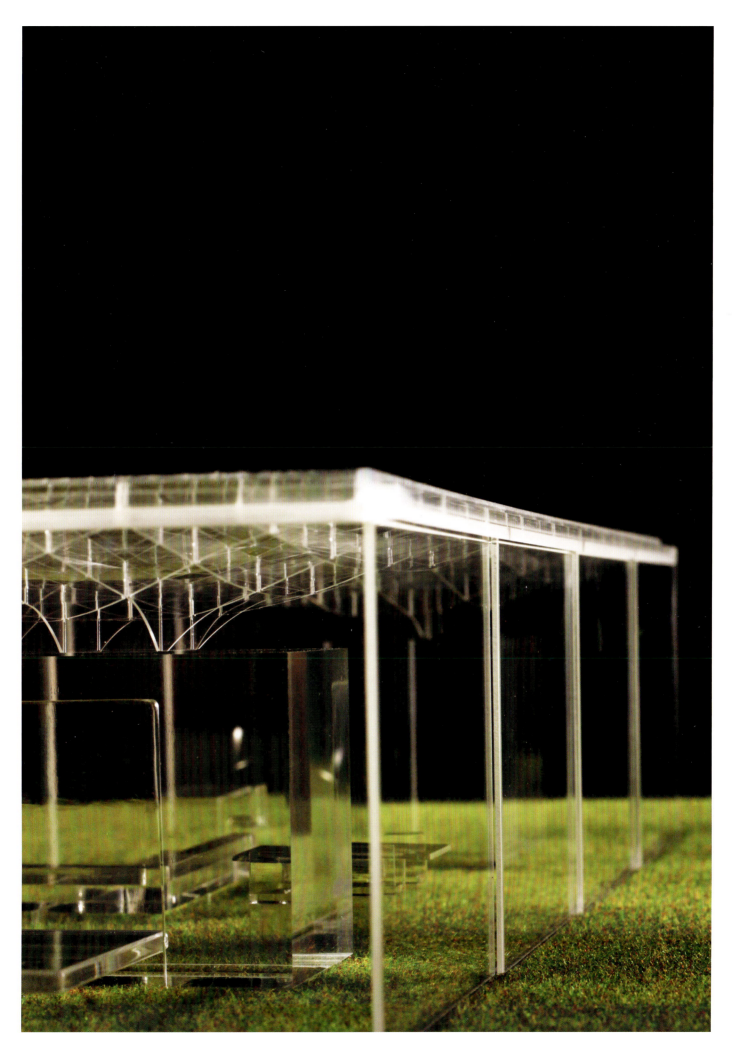

Selected Projects

2002–2023

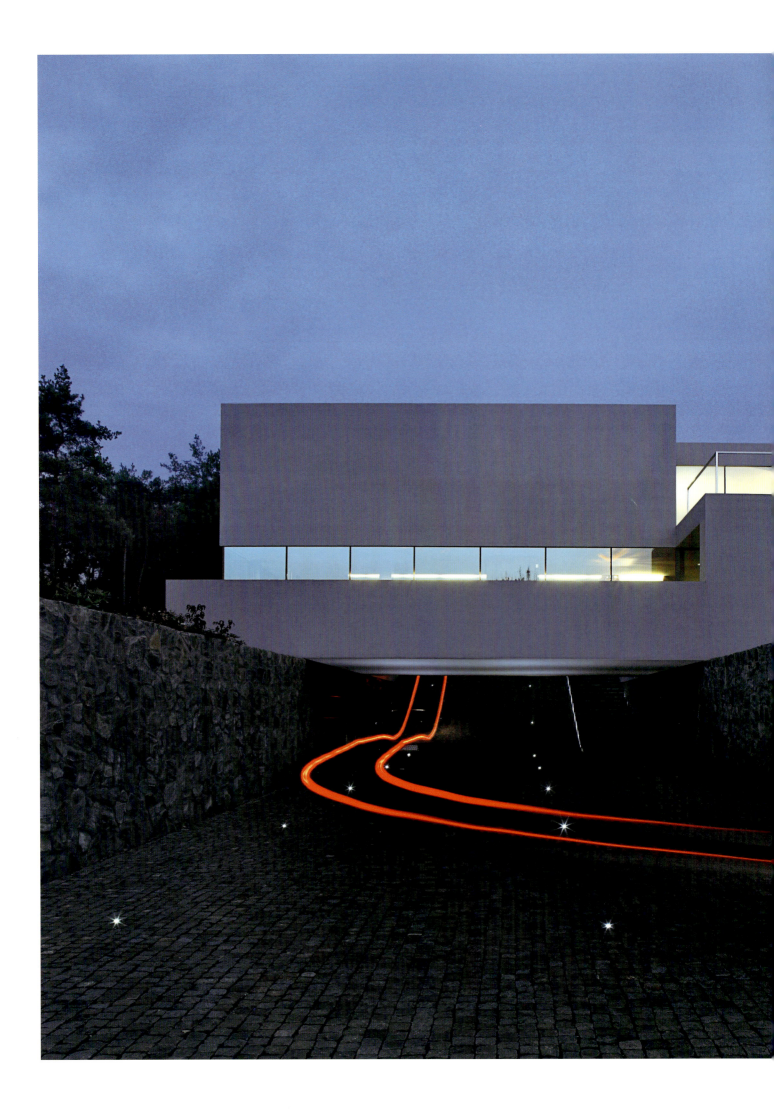

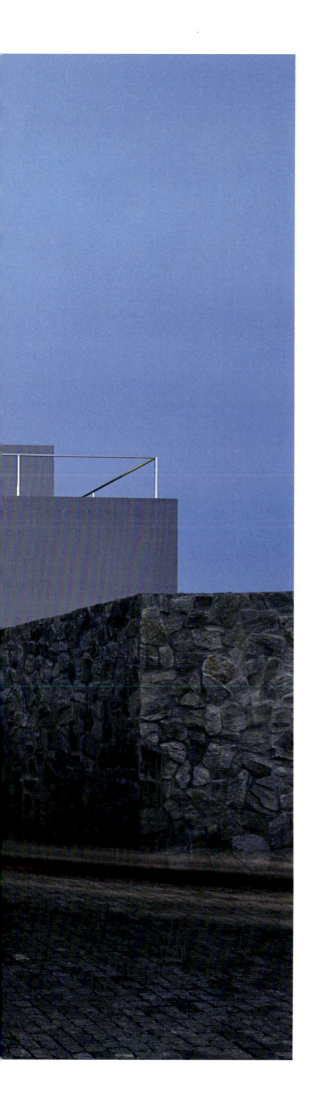

topographic | contextual transformation | autofamily

Aatrial House

2002–2006

When the clients for Aatrial House came to us, our studio was still in the basement of my in-laws' house. Seeing that, they said they wouldn't sign a contract unless we presented them with a cool idea …

We created the final sketch two weeks later, two hours before their arrival, driven by a surge of panic.

The idea was to lower the road compared to the garden ...

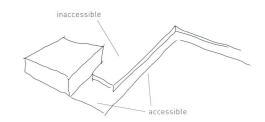

... because the plot had one drawback: access from the southwest, which is where the garden should ideally be located.

We positioned the house for the garden to be as big and sunny as possible.

We developed a road up to the house, lowering its level to ensure the intimacy of the garden ... →

... yet a functional problem has arisen: how do you conveniently get into the house above? ↙

That's when the idea of carving out an atrium emerged, so that the road itself could rise to ground-floor level. →

Thus, we can enter the house without having to use the stairs.

The two-story house is the final design, yet we had started with a single story.

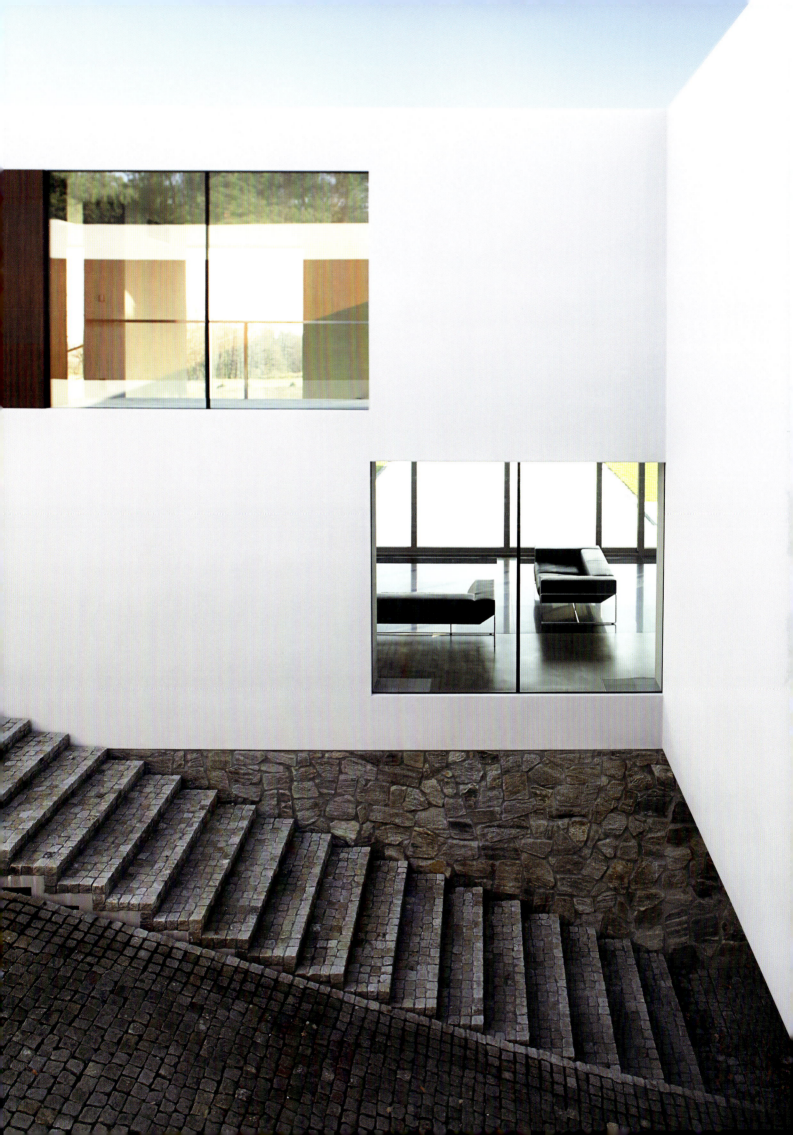

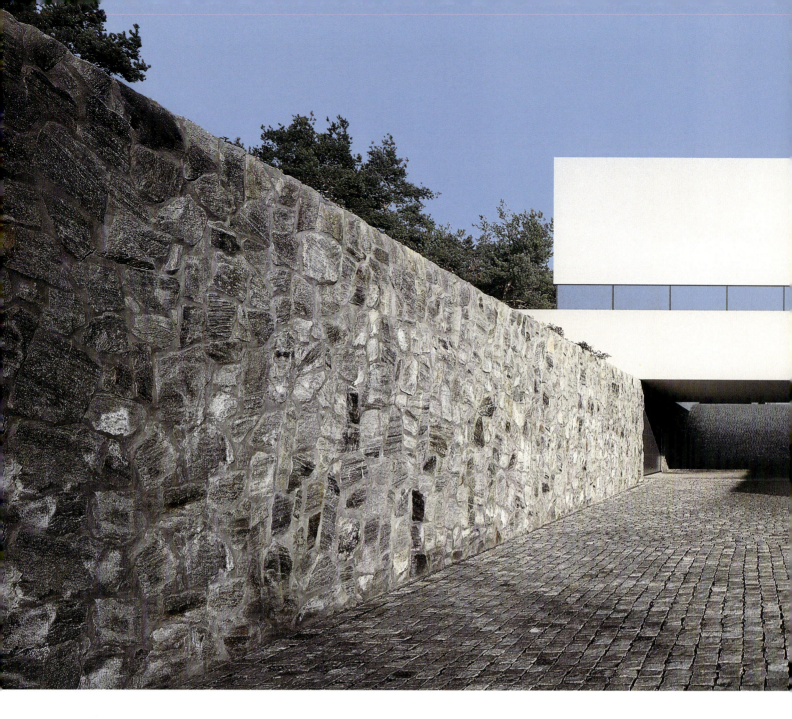

We referred to the neighboring Polish cubes (p. 36), so the structure of the building is ...

... a transformed box. In the overhanging section we placed the bedrooms ...

... which, thanks to the incline of the terrain, have been lifted off the ground. We have achieved the intimacy of the night area as if it were on the first floor.

The idea initially delighted the clients, but on their way home they called us to say they didn't really want it. The mother-in-law had told them she feared it was going to break off.

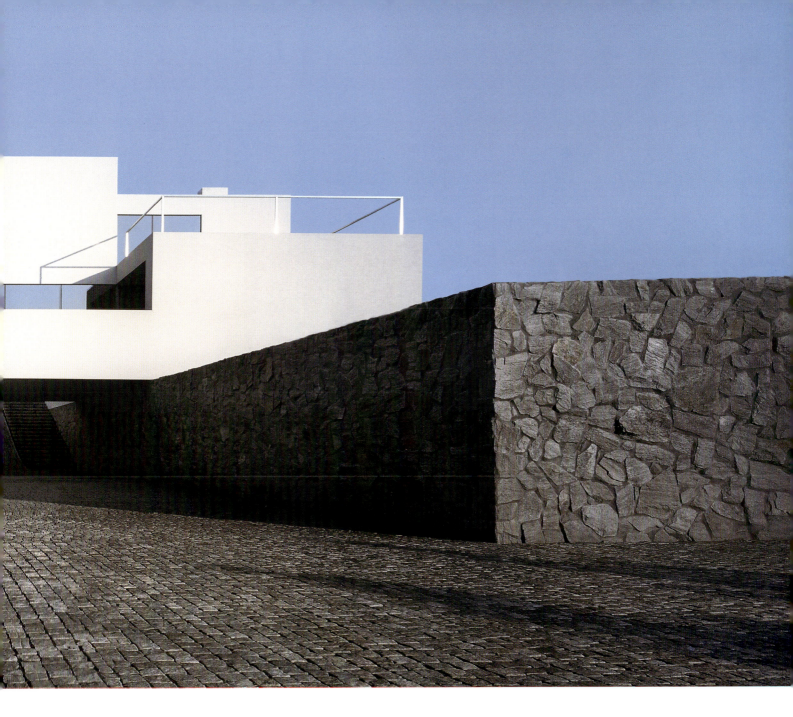

So we returned to the cube—this time a two-story version—because that was the wish of the investors.

They wanted the box to be more complex, so we started deforming it.

Cutting and bending it …

… led us to the final structure, to which we assigned one material: concrete.

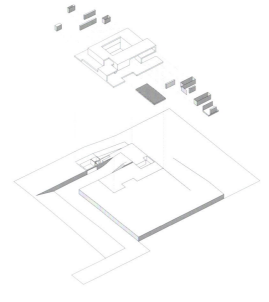

We treated the furniture as a whole, as wooden cubes complementing the concrete structure.

Our clients needed time to understand that at that point we had also completed the interior concept.

atrial house

Our design is the opposite of a typical atrial house with an intimate garden inside.

Aatrial House

Here the intimate zone is outside, and we enter it through the atrium, hence the name of the house.

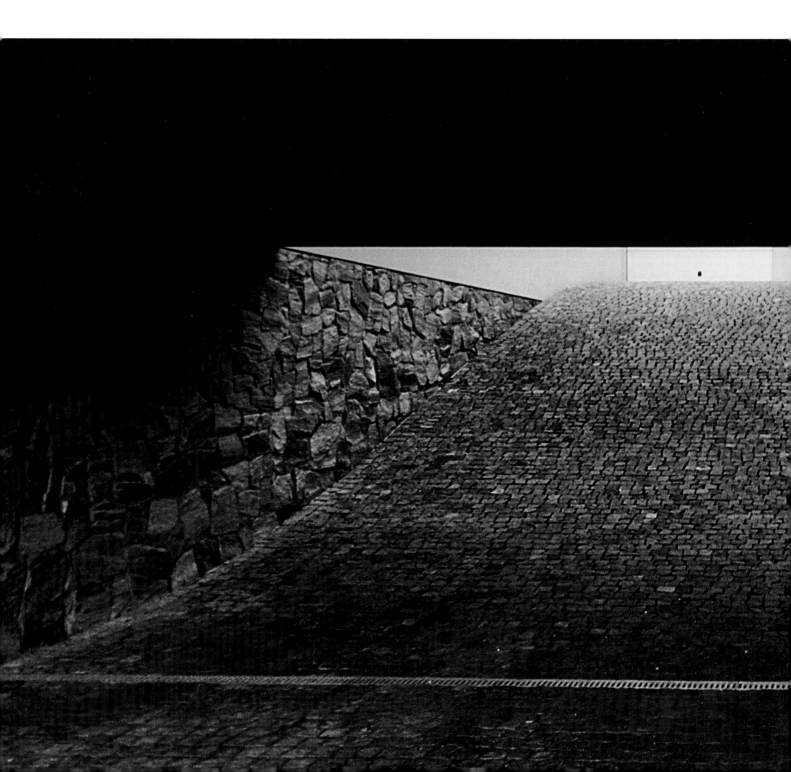

site plan 0 30m

The access road leading to the atrium is a public space accessible to everyone.

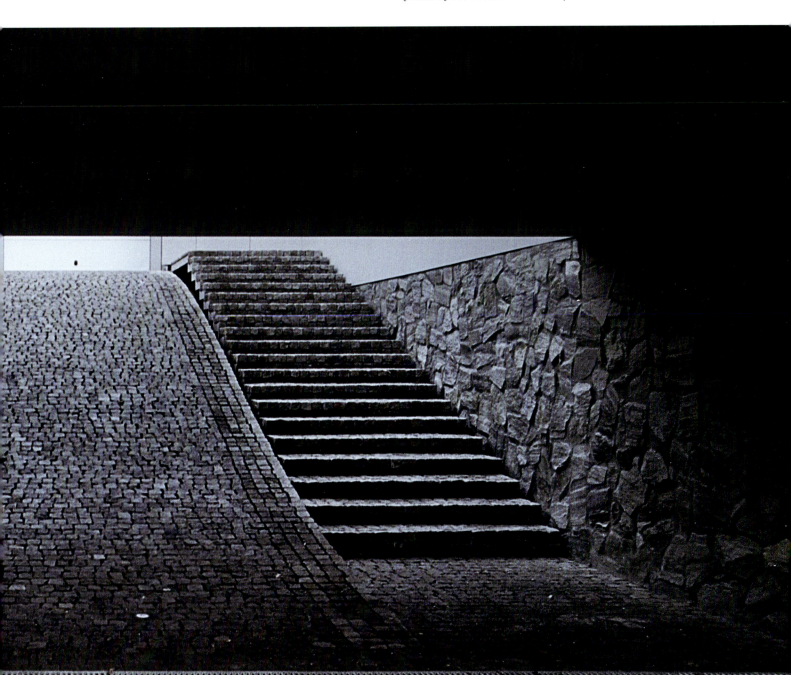

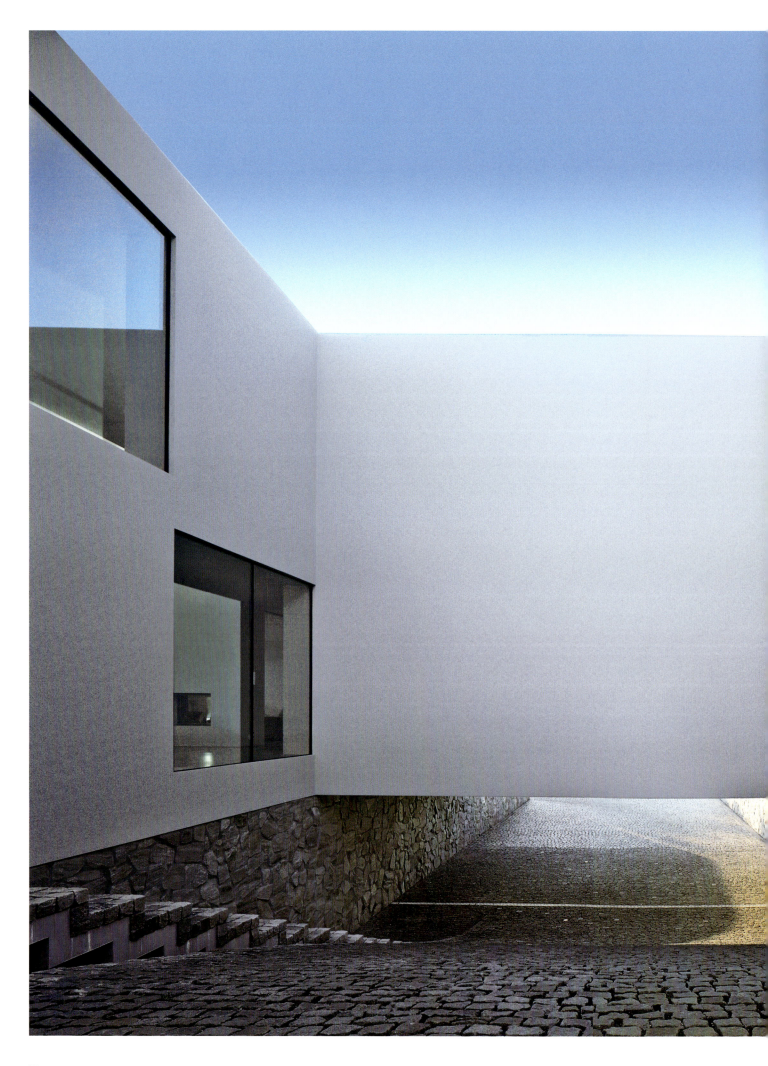

The enclosed nature of the atrium provides privacy for the residents, protecting them from sidewalk lookers-on.

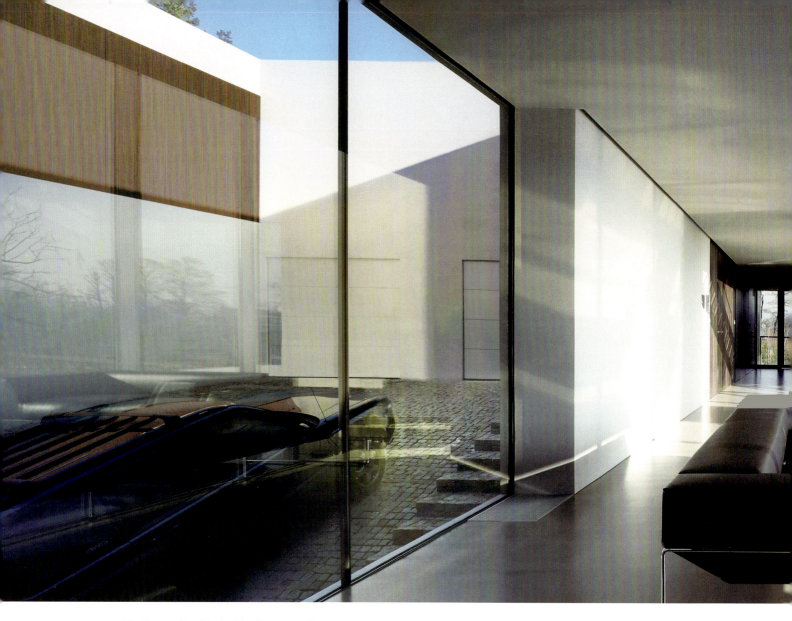

The house is a kind of buffer zone that you must pass through to get from the public area to the intimate garden.

section

The building has an additional, third, lowest level ...

level -1

... that we have hidden in the topography of the site.

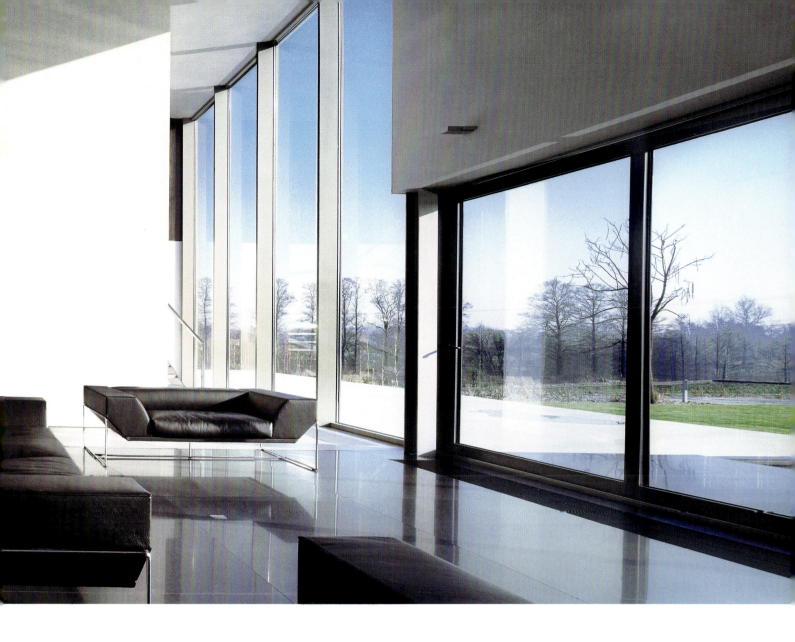

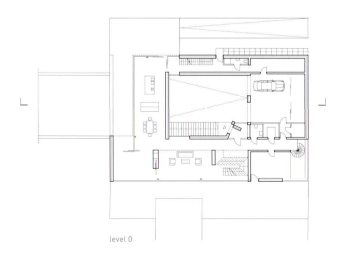

level 0

The form of the house thus combines topographical motifs (p. 26) ...

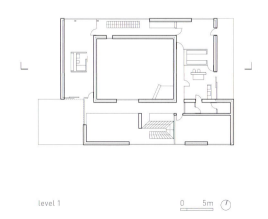

level 1 0 5m

... and the contextual transformation (p. 35).

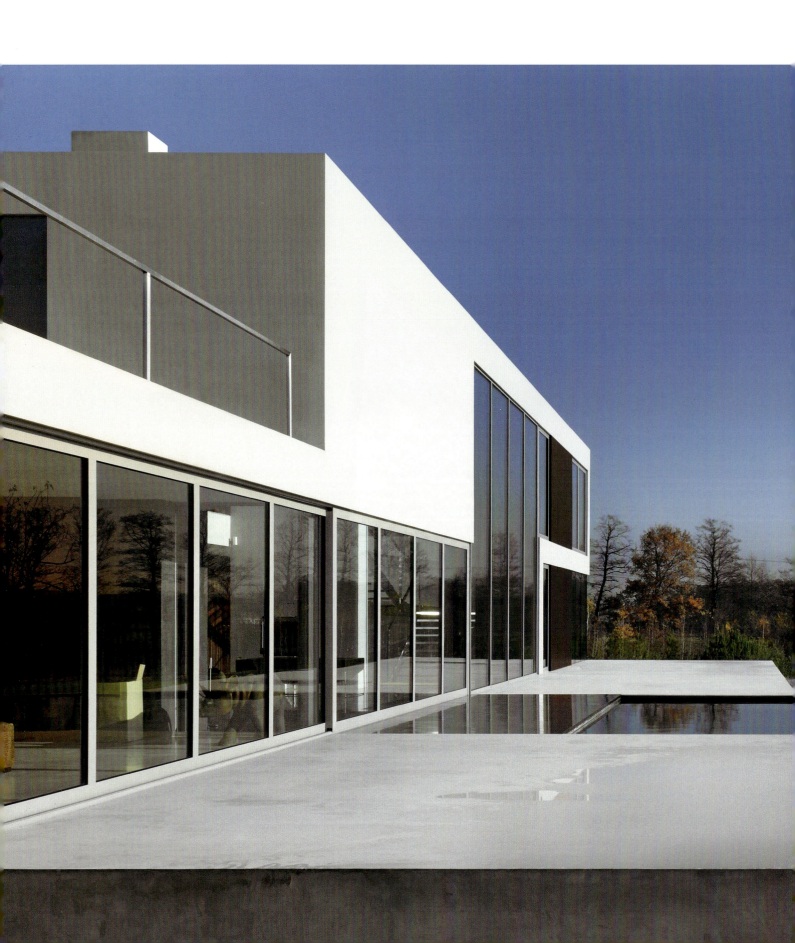

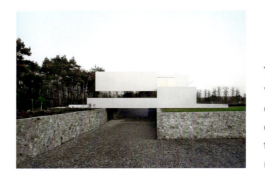

The zoning of the space that we designed here was later developed in a number of other designs. The first of these was for the Safe House (pp. 28, 32, 36, 64).

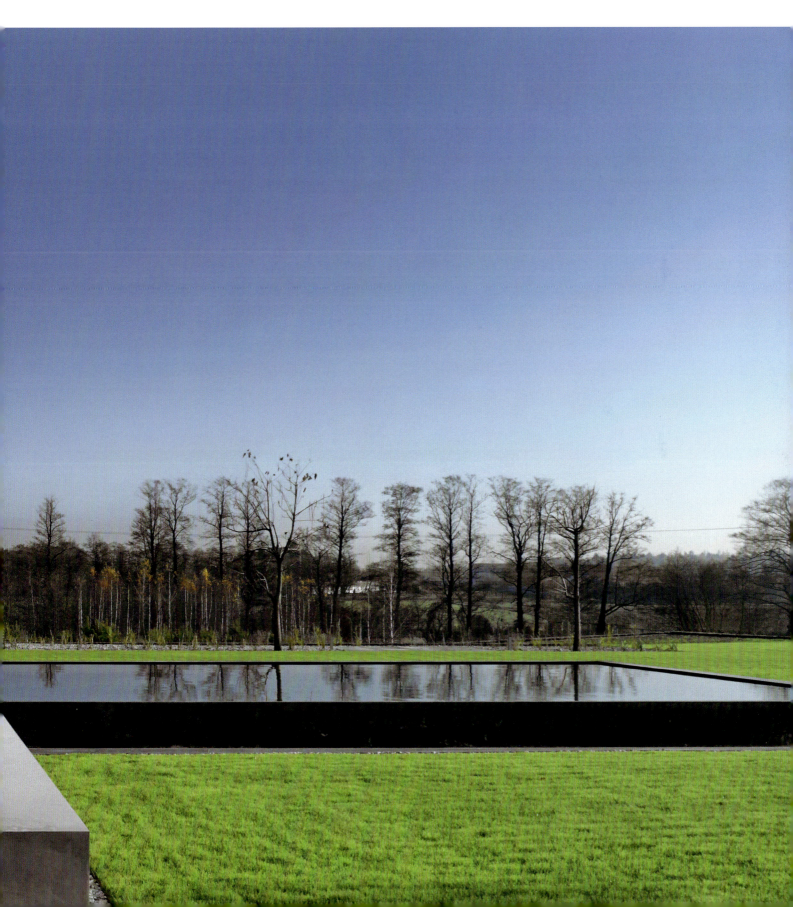

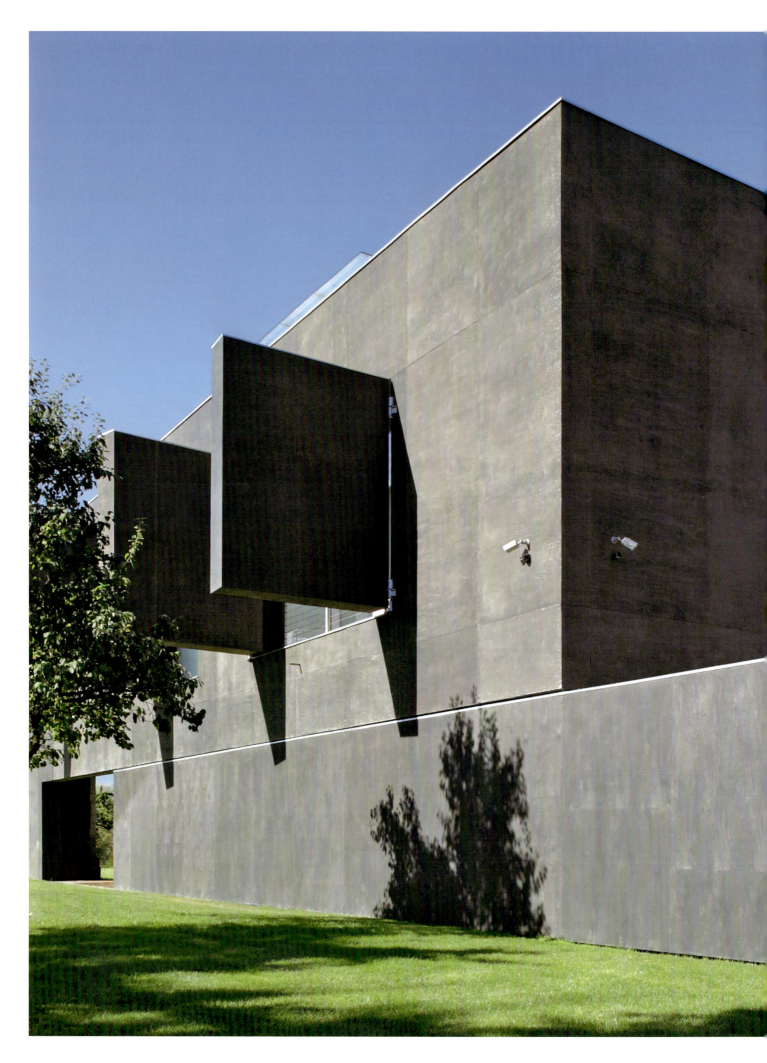

topographic | mobility | contextual transformation

Safe House

2004–2008

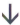

The initial concept of the house looked completely different. However, the owners had rejected that design as it did not meet their specific safety requirements.

Aatrial House

At that time the Aatrial House (pp. 27, 36, 43, 50) was still under construction. I still had in my mind its access road, which is a public area, as opposed to the garden, which ... ↓

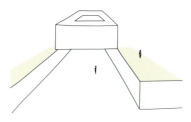

... is elevated.

Safe House

While working on the second version of the Safe House, I was constantly drawing that perspective, however here everything was on one level.

All of a sudden, it struck me: what if those walls disappeared? And that was the breakthrough ...

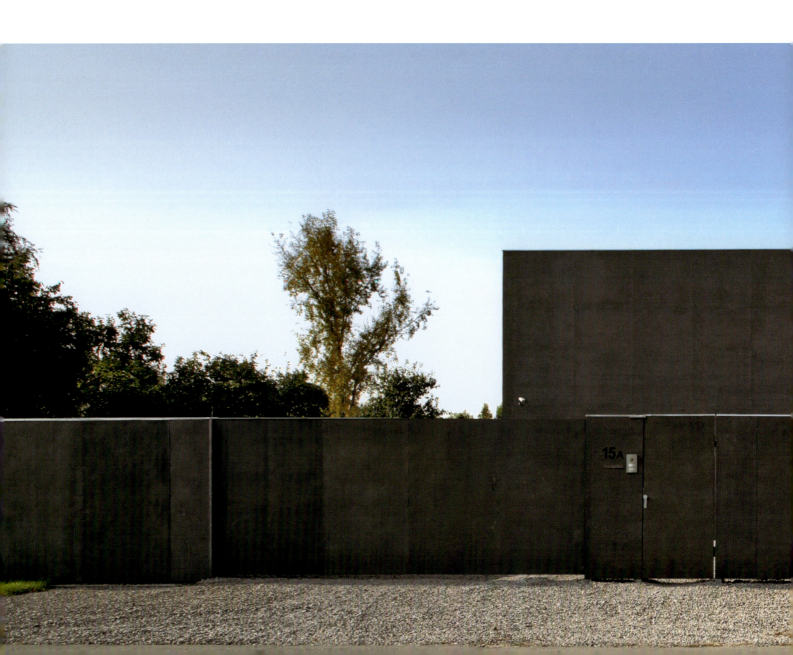

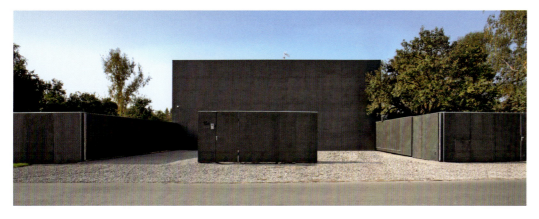

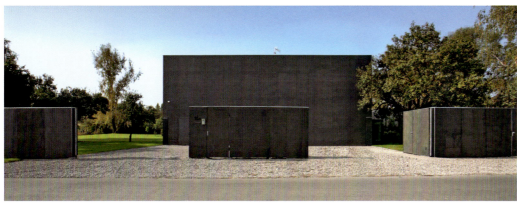

... from which originated the principle of the Safe House and its mobile elements, which temporarily zone the space around the building.

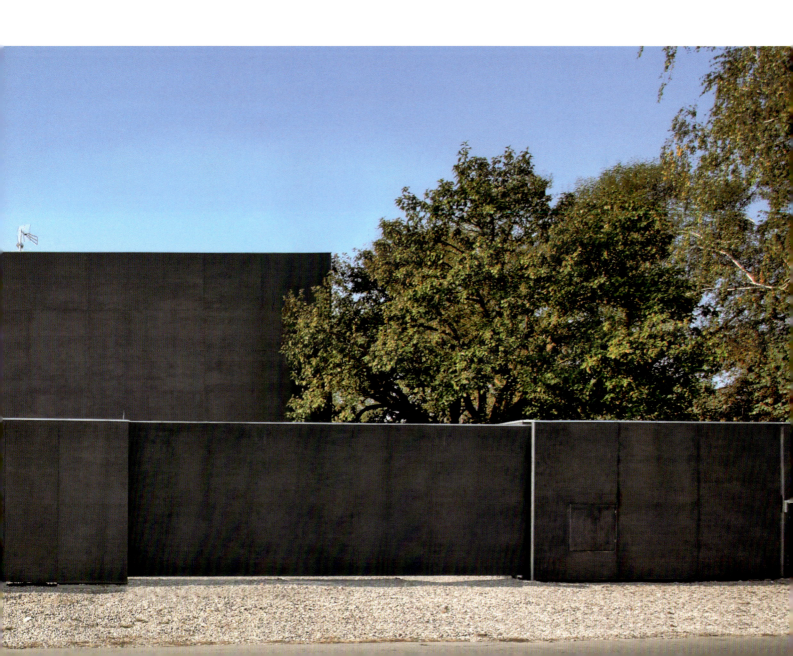

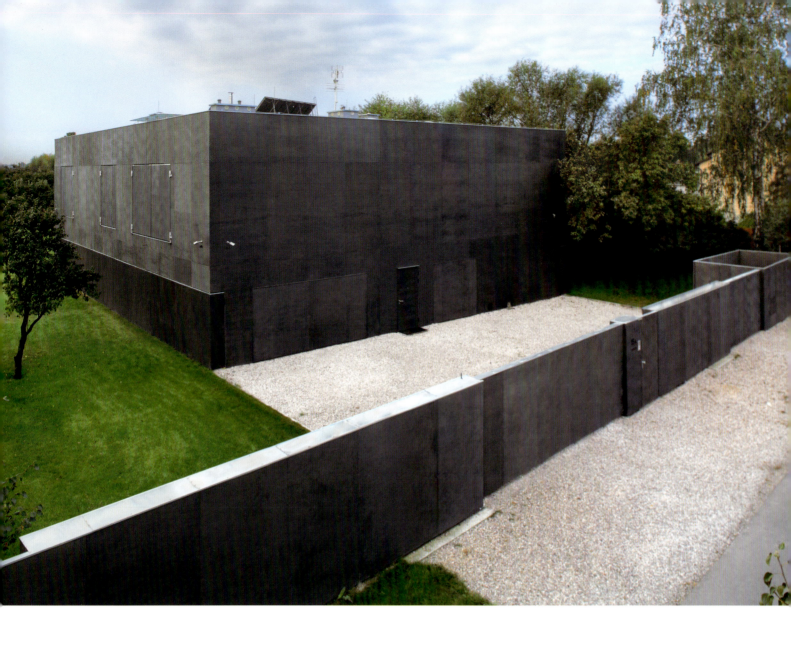

When the house is enclosed, it is a standard freestanding building.

However, when its residents open the home to the outdoors each day, the sliding shutters reach the fence. The house merges with the public space of the street, and the garden becomes an intimate zone.

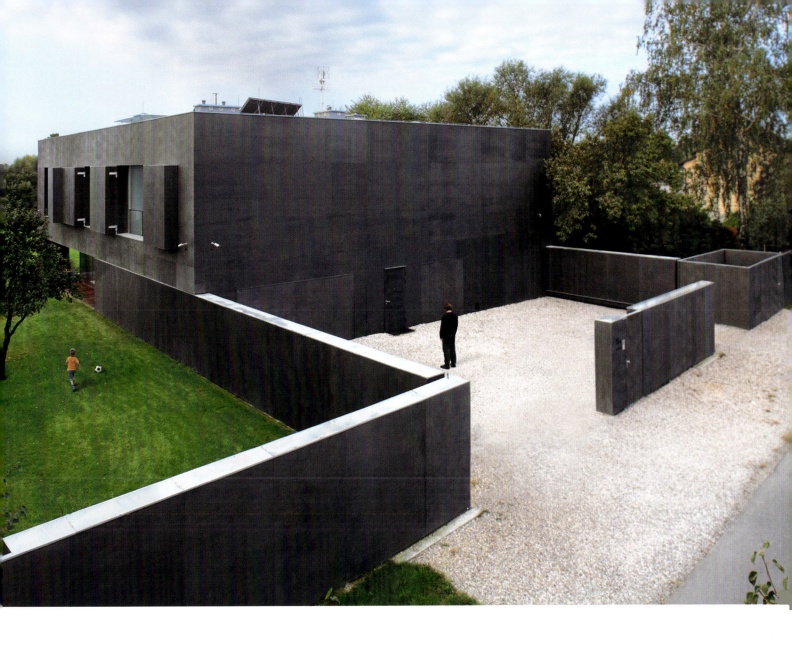

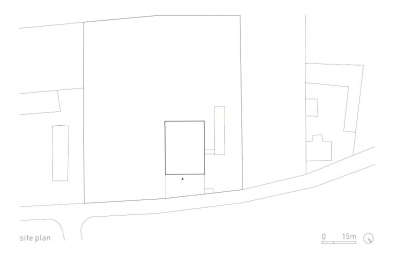

site plan 0 15m

When the building connects to the fence, it becomes its extension, and the architecture extends into the topography.

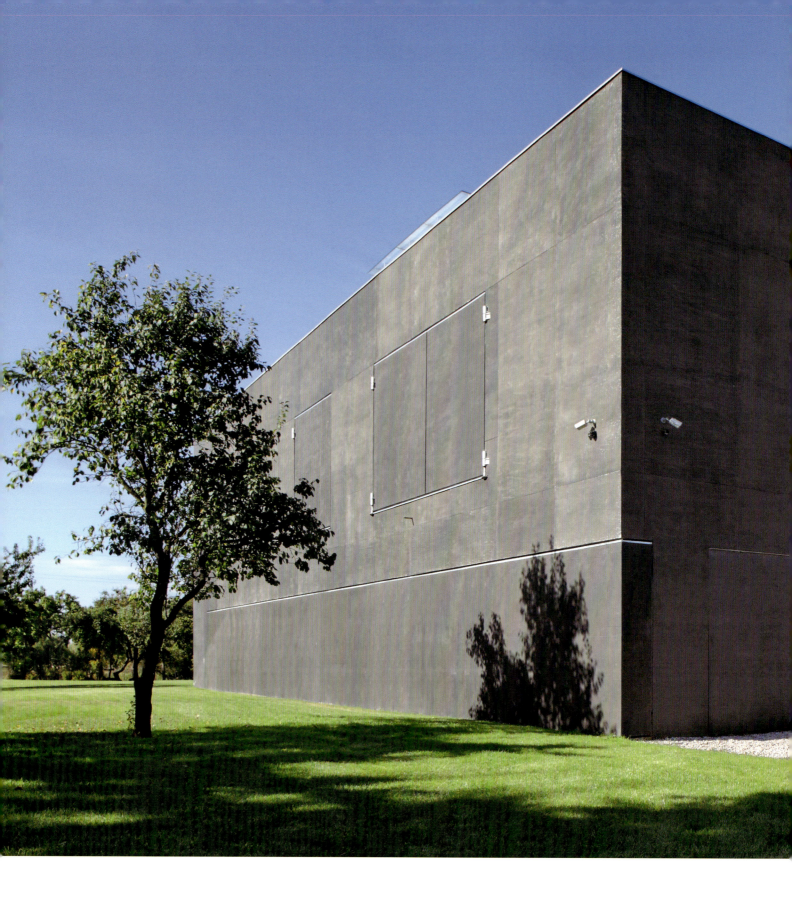

As in the Aatrial House, it becomes a buffer zone between the public zone and the garden. The Safe House we created ...

... could also look like that, because the most important aspect here is the variable zoning of space, independent of form.

The house refers to the surrounding Polish cubes (p. 36). Together with the owners, the film director and set designer, we aimed for the impression of a perfect monolith …

… therefore, all the shutters maintain the thickness of the walls and when closed, they align with the walls inside and outside.

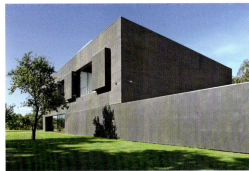

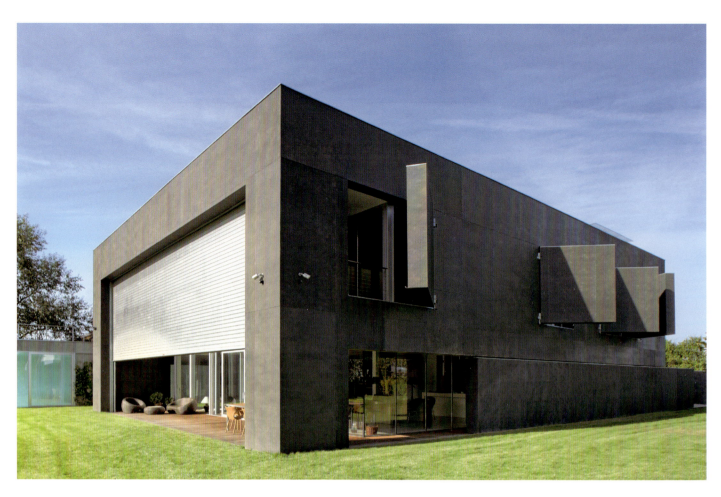

The only exception to this rule ...

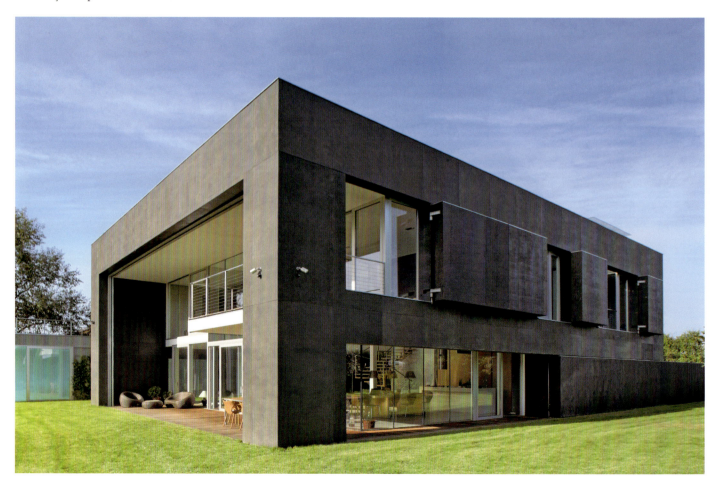

... is the roll-up gate on the south side, 45.9 x 19.7 feet
(14 x 6 meters) in size. We wanted it to...

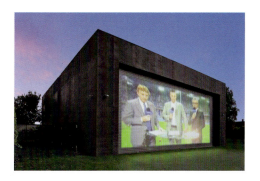

... be used as a screen for summer showings of movies in the garden.

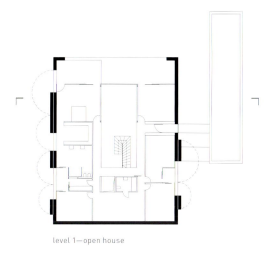

level 1—open house

The house is finished with plywood, and we used the 17.7-inch (45-centimeter) thickness of the shutters to add in extra insulation. →

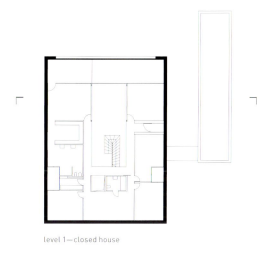

level 1—closed house

Thus, when closed, the building stores energy perfectly.

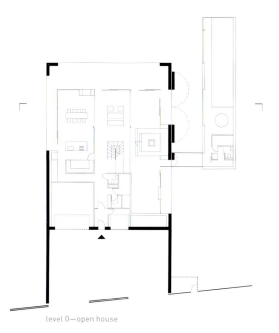

level 0—open house

Initially, the recreational area with the swimming pool was planned within the contour of the building ...

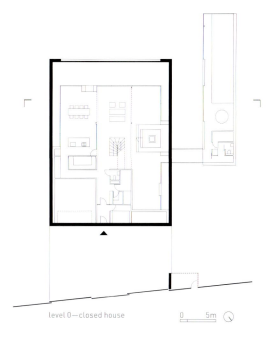

level 0—closed house

... but eventually, at the owners' request, it became a separate pavilion. On its roof there is a terrace that ...

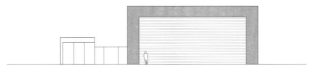

southwest elevation—closed house

... can be accessed via a specially designed drawbridge. →

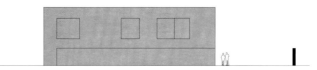

southeast elevation—closed house

Sliding, noncontact walls with a maximum length of 65.6 feet (20 meters) ... ↙

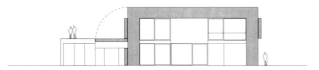

southwest elevation—open house

... and shutters with an overhang of 12.1 feet (3.7 meters) are also individual designs. →

southeast elevation—open house

Only the roll-up gate on the south side is a standard solution.

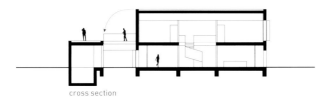

cross section

The gate was purchased from and installed by a company that ...

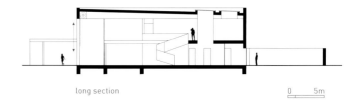

long section

... collaborates with airlines and NASA on a daily basis.

It was our first contact with mobility in architecture. We were young architects who did not realize the level of complication such an idea would bring about.

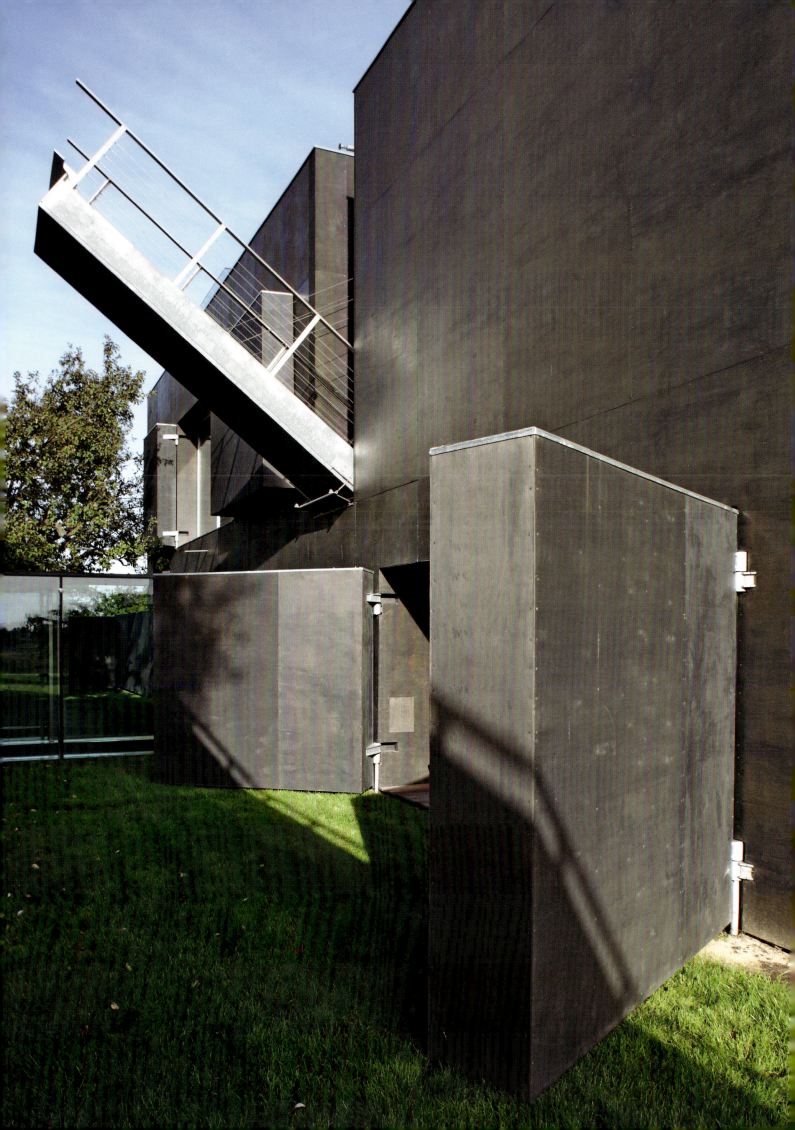

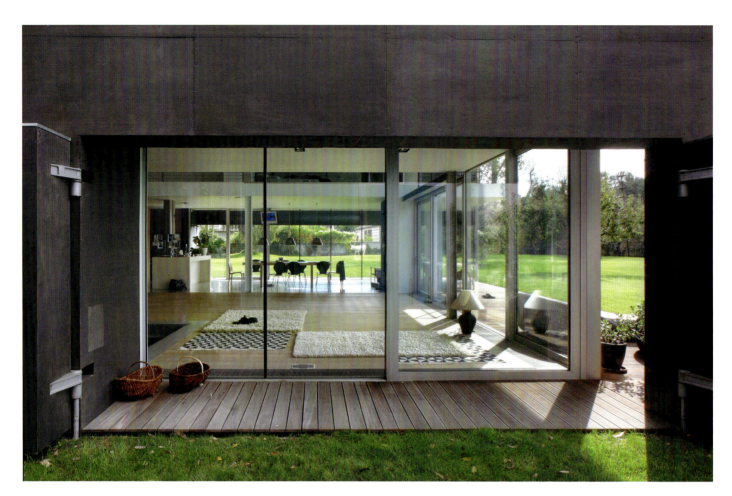

At one point, I was banned by the owner and ordered to stay 546 yards (500 meters) away from the construction site. I had to respect it, even though I feared for the completion and final finishing of the home.

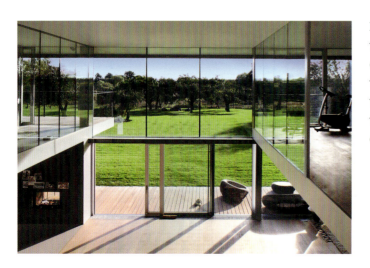

I was invited, however, to visit the building on the occasion of a photo shoot. My final thoughts were that I probably would have done some of the finishing touches a little differently ...

... but they don't really impact that much in the perception of the whole.

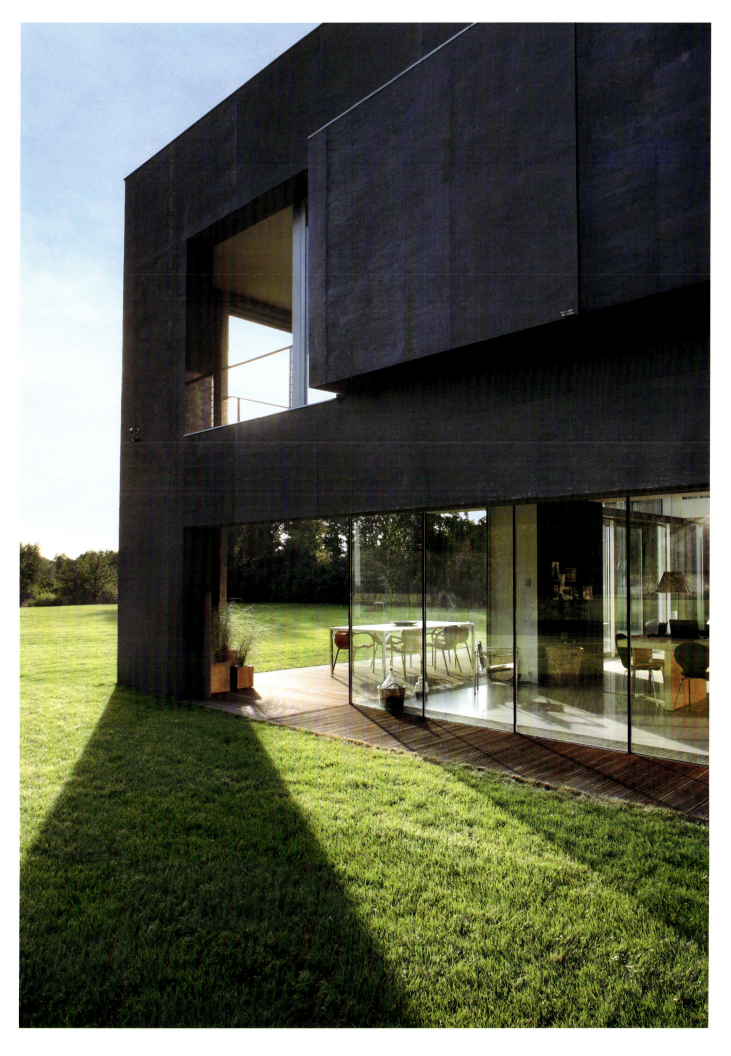

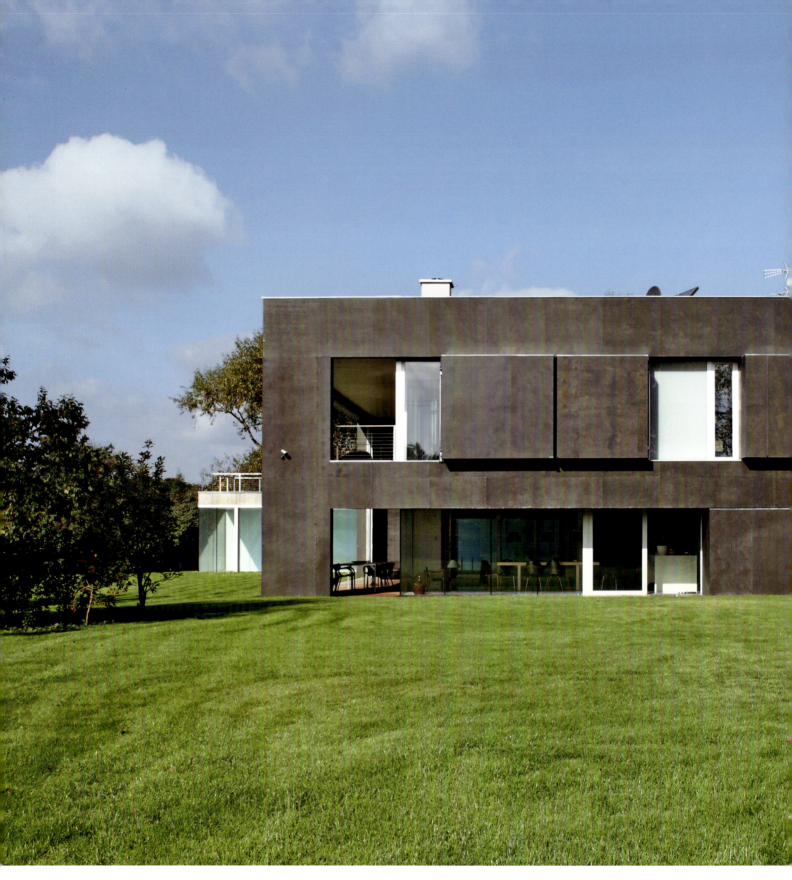

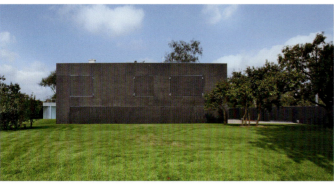

Only by designing this house did we understand that mobility allows us to create a new relationship between architecture and the environment, which initiated further mobile solutions.

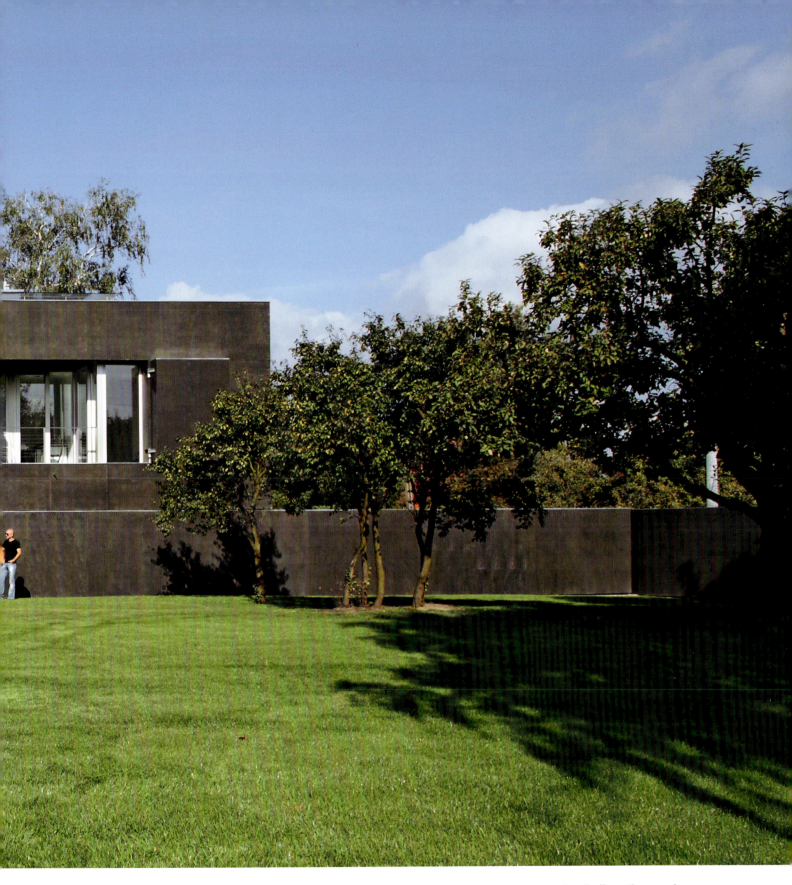

Ironically, a theme whose premise was a certain kind of enclosure led us to solutions in which architecture opens up more and more unconventionally to its surroundings.

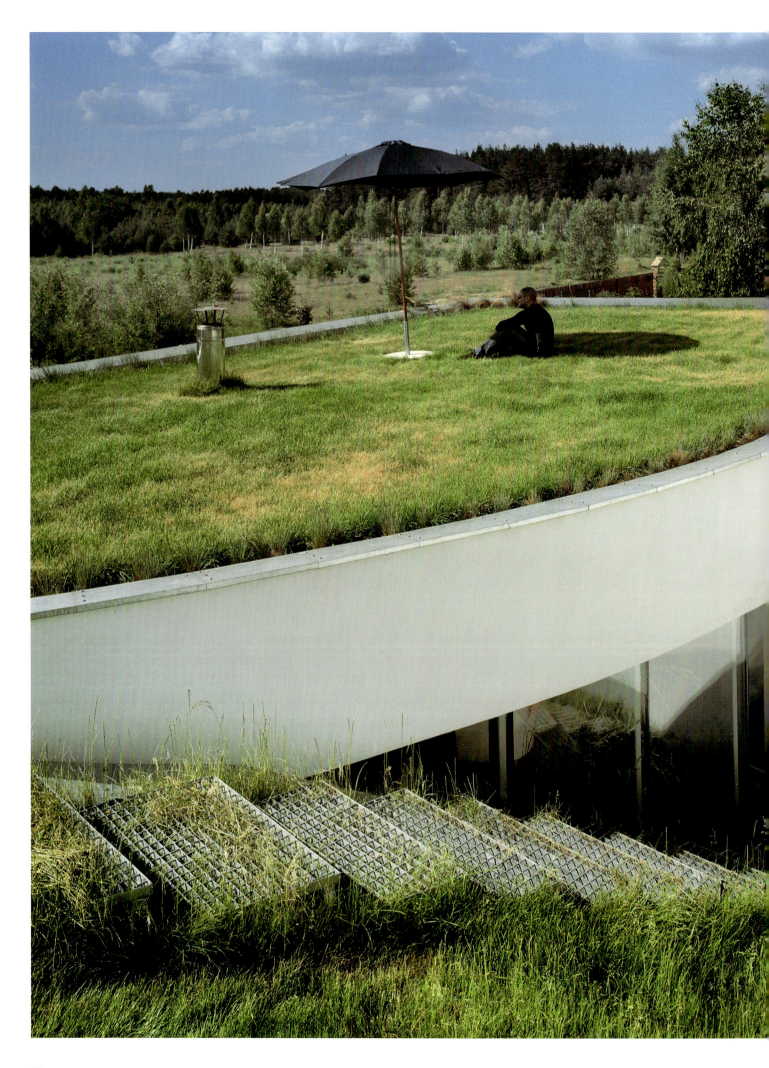

topographic

OUTrial house

2004–2007

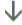

The guitarist of a well-known Polish rock band commissioned us to design a small, low-budget house.

 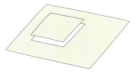

However, his plot had no architectural context at the time ...

... hence the idea to carve out and raise a piece of meadow to place the house underneath. ↓

So I came up with the idea to cut part of the roof and make a green ramp, bringing the greenery inside.

The other incised section was lifted up to house a small studio, separate to the other spaces.

During the concept presentation, however, his girlfriend suddenly said that she would still like a conservatory and he would like a recording studio.

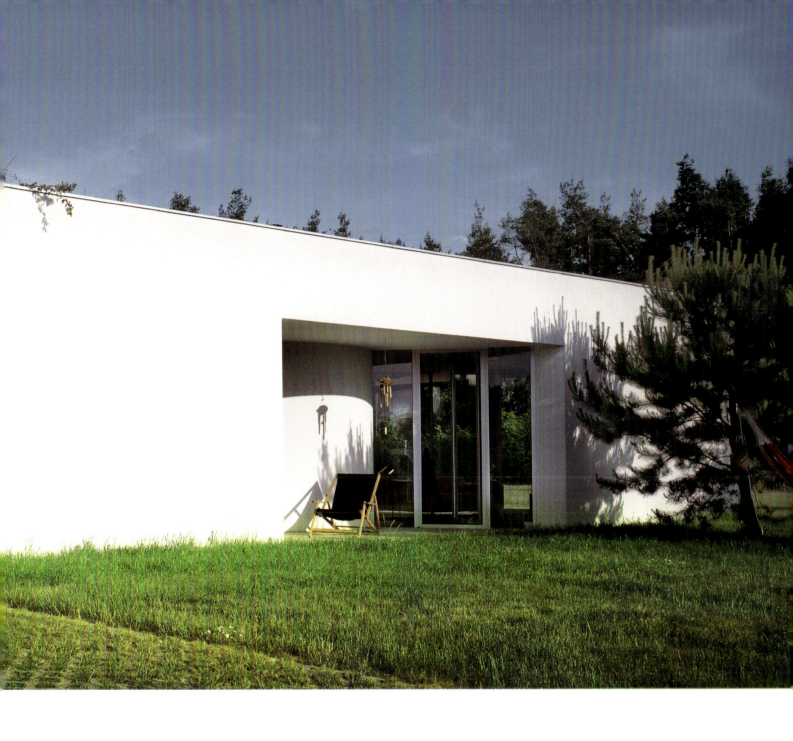

In the rectangular block of the house that emerged, we cut a corner to leave space for the birch tree growing next to it.

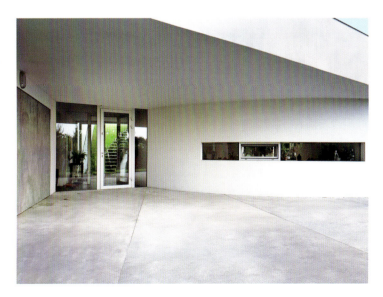

The rounded wall guides those entering to an unusual atrium ...

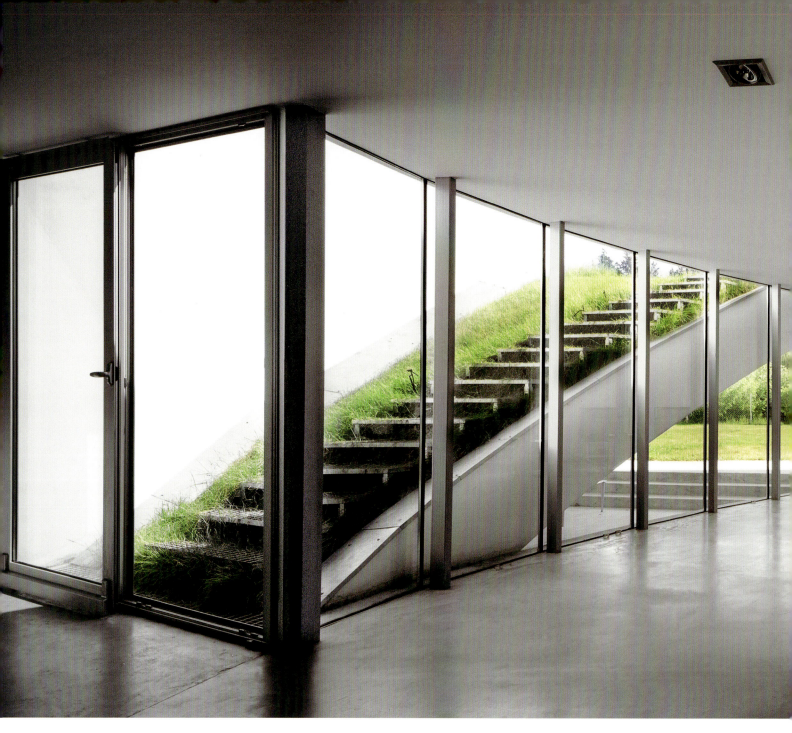

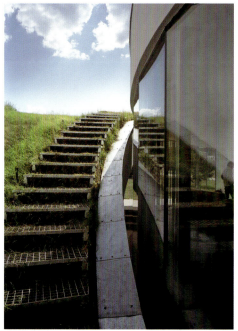

... that houses a green ramp that softly leads to the roof.

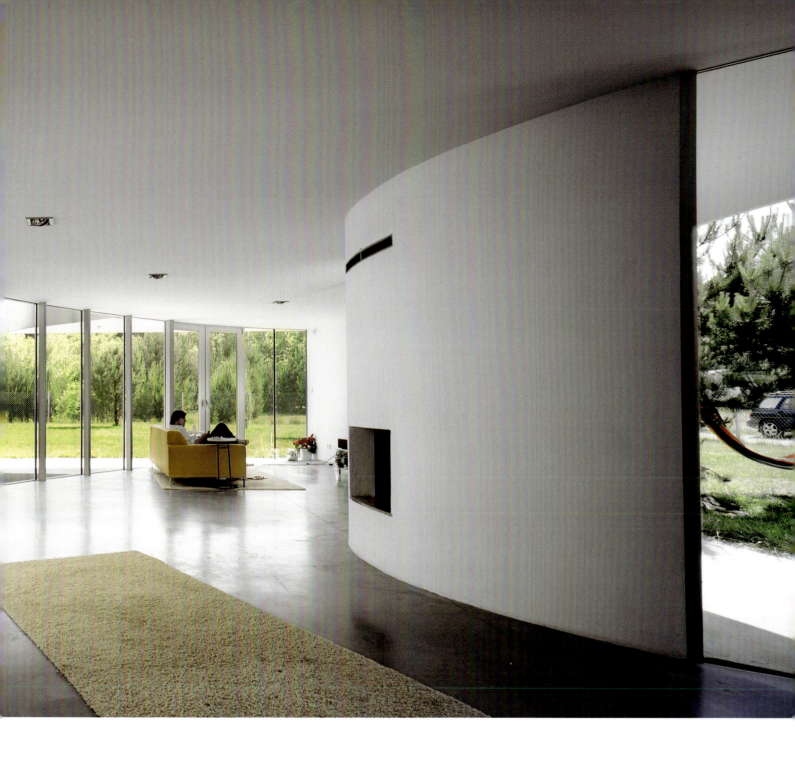

atrial house

When we thought about the name of the house, we pointed out that it is another variation of the atrial house. The classic atrium is enclosed within four walls ...

OUTrial house

... and here the ramp extends it with a green roof that becomes a part thereof. So, now, we are in the OUTrium, since we have a magnificent view to the outdoors.

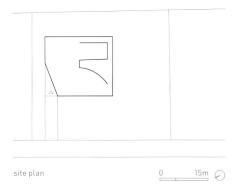

site plan 0 15m

More houses in the neighborhood were built at a later stage ...

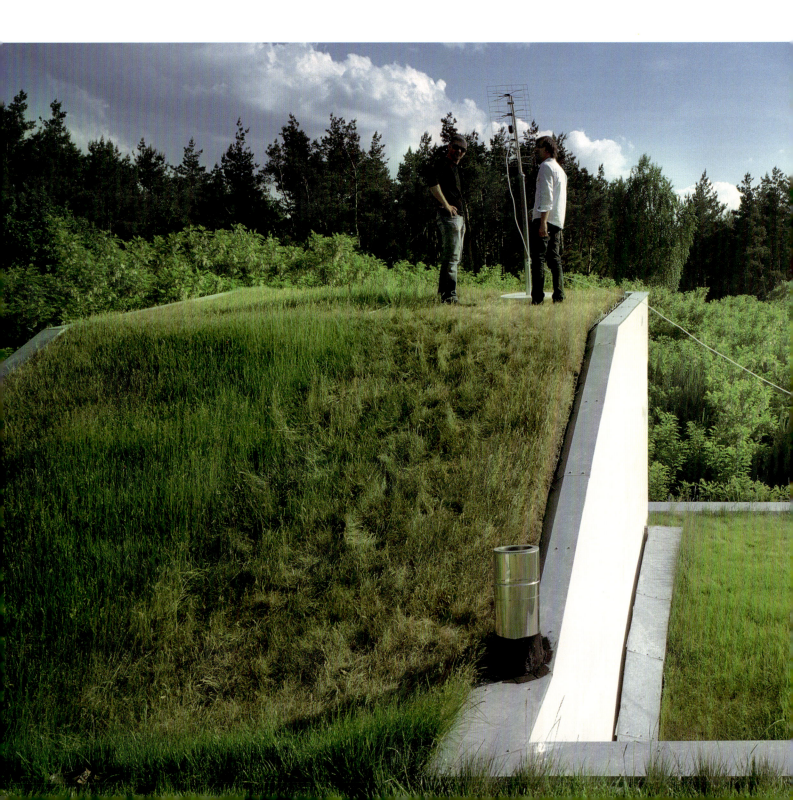

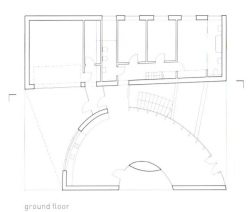

ground floor

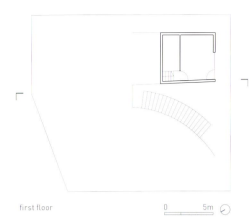

first floor 0 5m

... but ours is the only building with a green roof, which ...

... is conveniently connected to the interior. This solution encourages the residents to climb up ...

... to enjoy an alternative garden.

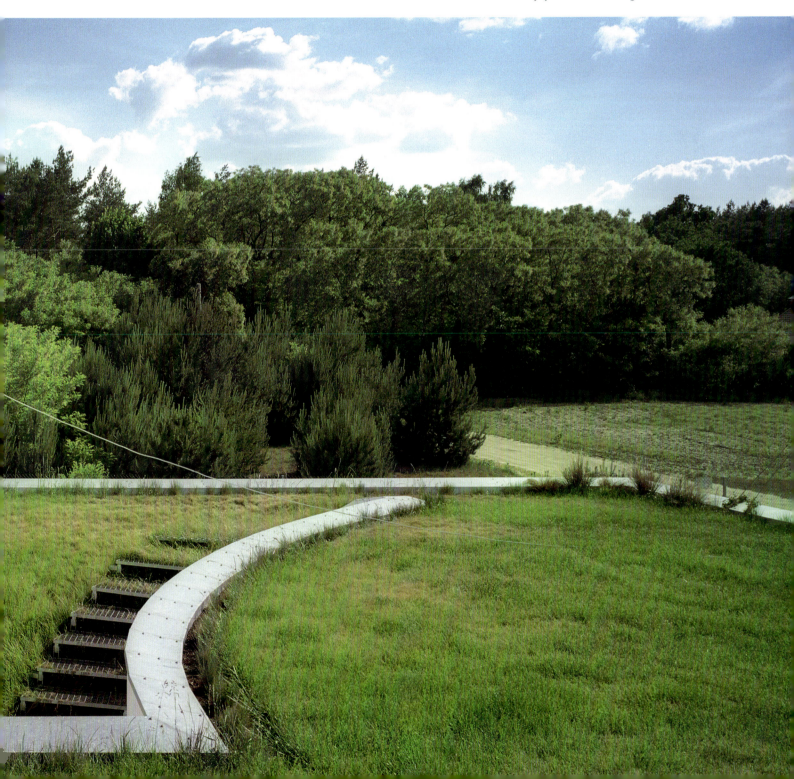

section 0 5m

The slope in this case provides
a canopy for the terrace ...

... but we designed it so that
it should also provide living
space underneath.

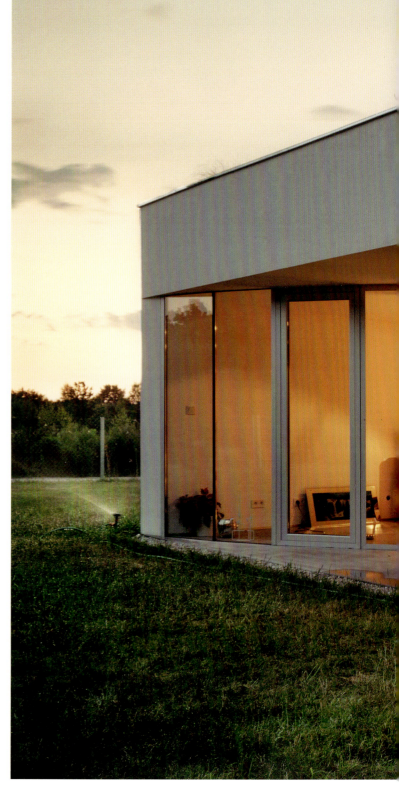

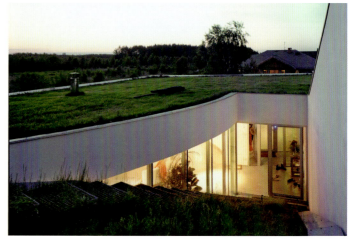

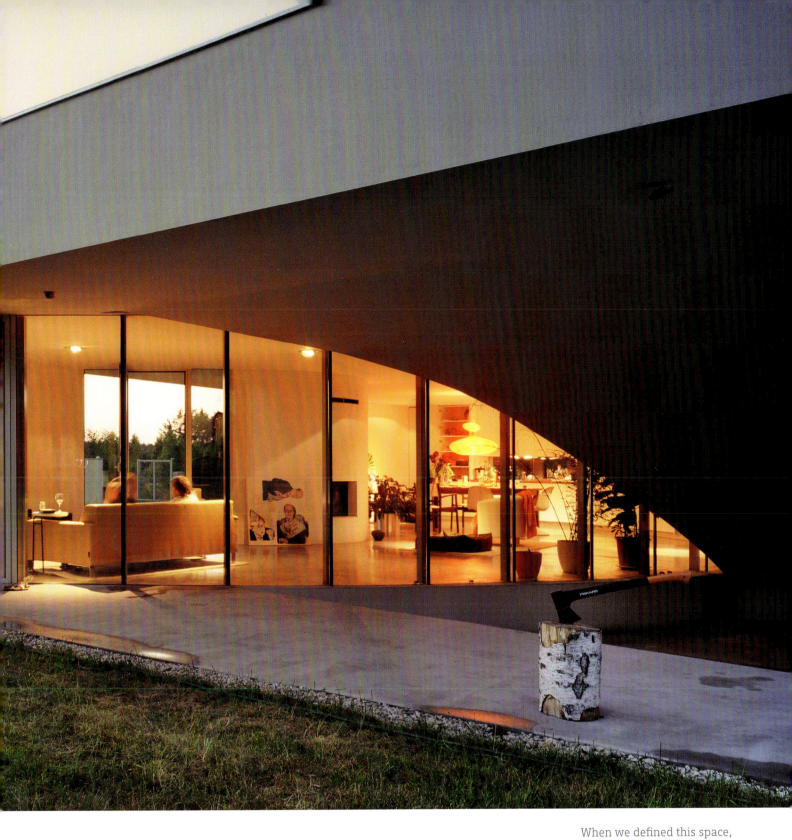

When we defined this space, we understood that it was a universal solution, one that could be specially dedicated to small plots where there is not enough space for a garden.

topographic | autofamily

Autofamily House

2007–2012

An art collector commissioned us to design this house. The result was a new solution for the entrance and driveway area that was unprecedented in single-family residences at the time.

Access was only possible on the south side, where a garden would be situated in the future. →

The plot had a drawback similar to that of Aatrial House (pp. 27, 36, 43, 50) and Snail House (p. 27). ↙

We leveled the site and designed two zones: an area open to the public and an intimate garden with space for the house, to which we also needed an access road.

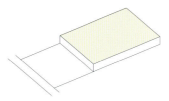

The rising road is flanked by walls and a green roof, thus it does not cut into the garden as it does in the Aatrial House, and those coming into the home are not able to peek into the garden. →

We applied the ideas from Snail House, where the road curves gently so that it would lead seamlessly into the living area and beyond. ↙

The result is a tunnel, combining entrance and driveway, of which the house is a logical extension. →

Here we proposed a variant of the Aatrial House, with a covered atrium opening around the entire perimeter to the garden.

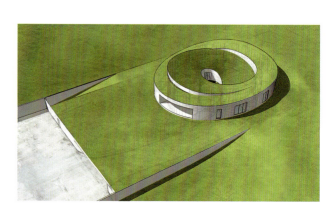

Unfortunately, the bids for the project were cost prohibitive. When the owner was about to give up, I suggested simplifying the construction. ↙

The principle of shaping the space is the same, only the emerging tunnel is based on a simpler geometry and forms a storied structure.

The rectangular plans proved to be a recipe for success.

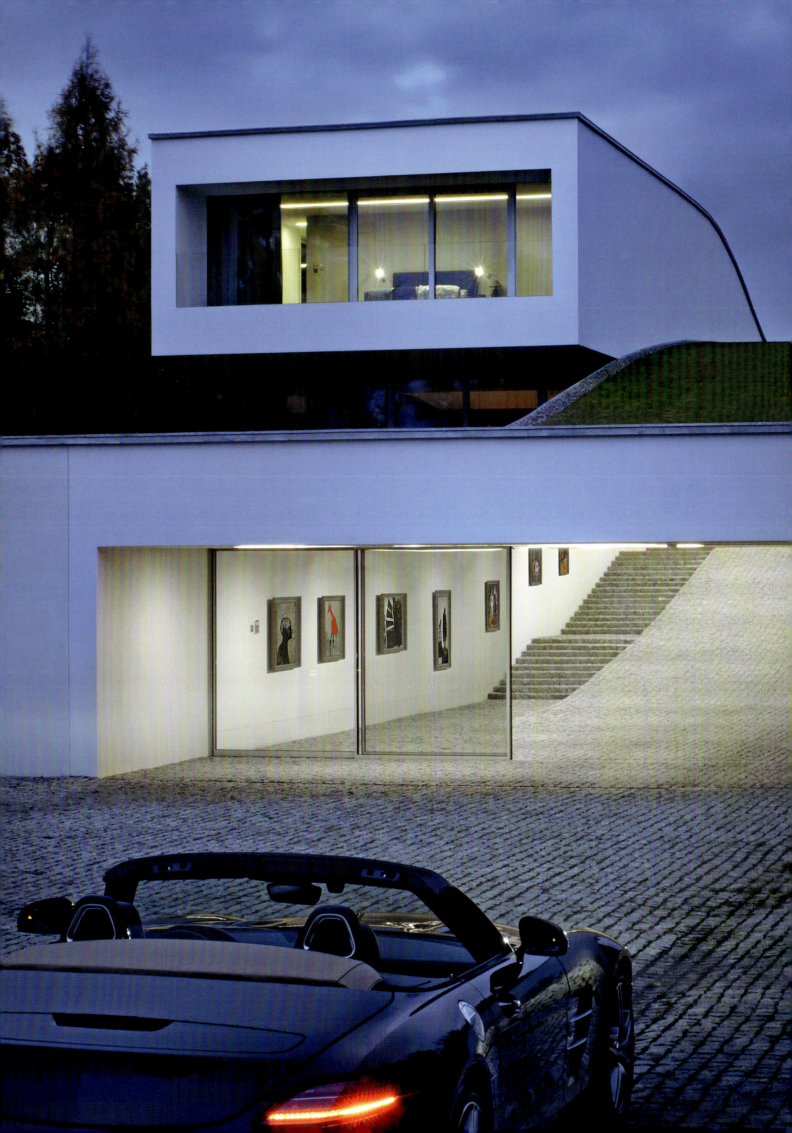

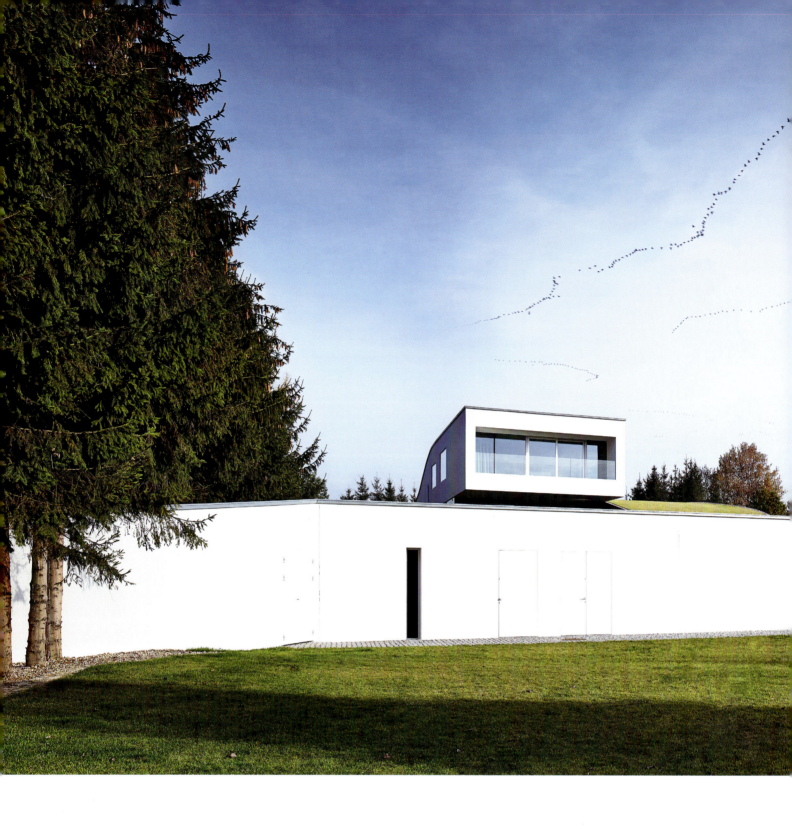

single-family house

When this idea was born, zero-emission cars were not yet available for sale. So we wondered if it was a good idea ...

Autofamily House

... to combine entry and driveway into one enclosed space, since cars pollute the air. However, we then determined that it was only a matter of time ...

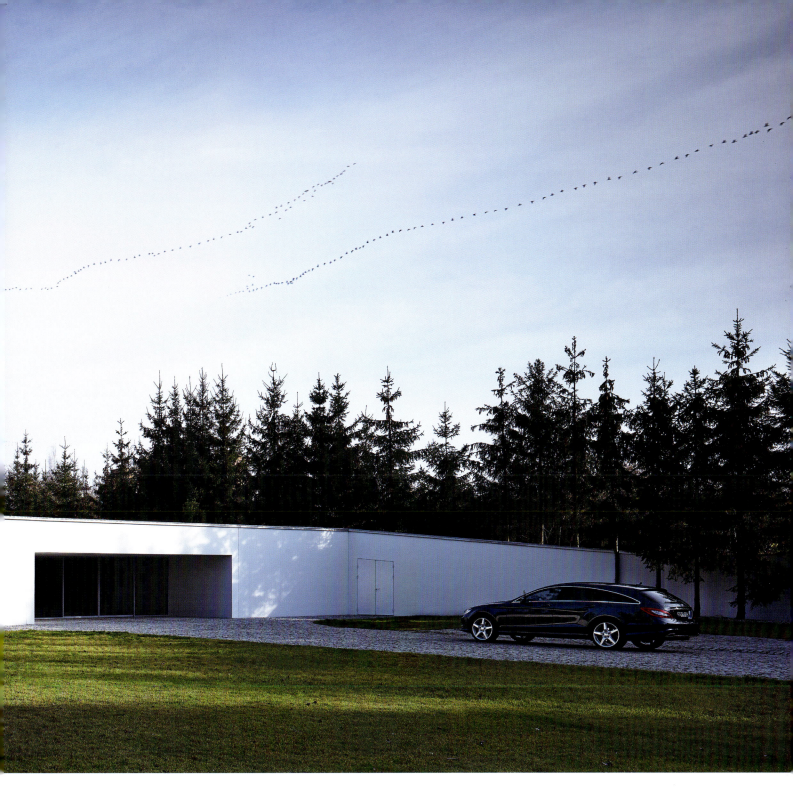

The glazed wall that is both the front door and the access gate …

site plan 0 10m

… before car technology would improve and change, so perhaps it is good that architecture is responding to such potential advancements.

... conceals a gently rising entrance hall. Visitors and the owners conveniently park at the residential level ... ↓

east elevation

Moreover, we thought that given the owner is an art collector ...

section A-A

... and the car becomes a form of "mobile furniture." Unloading the shopping inside becomes a much more convenient prospect.

... why not use the driveway entrance hall space as an art gallery?

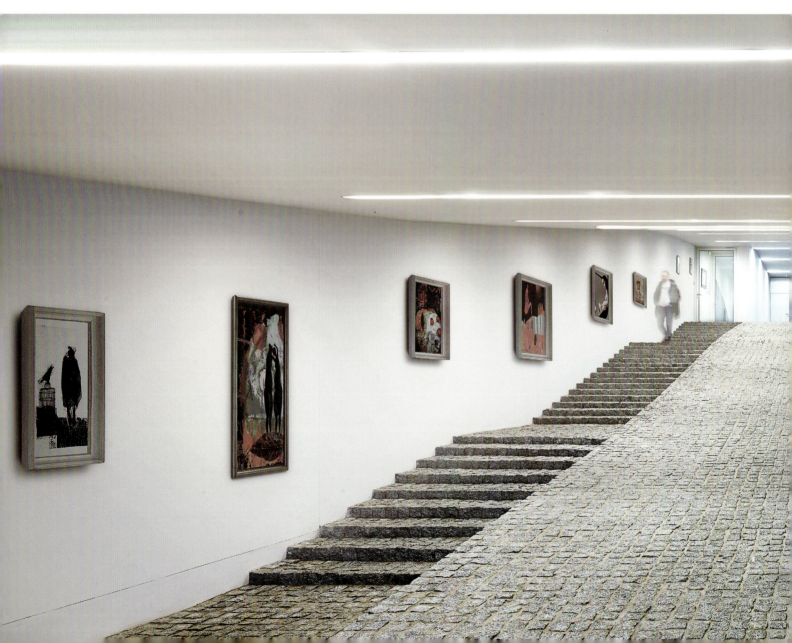

west elevation

The window arrangement is designed to complement the arrangement of the collector's paintings, which ...

section B-B

0 5m

... continue to feature throughout the rest of the home.

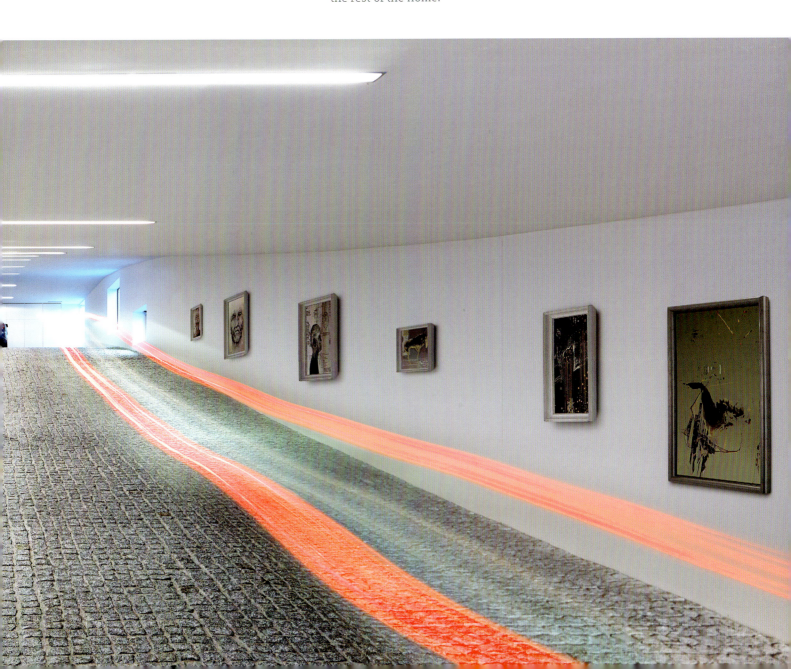

level 2

In the Autofamily House, as in the Aatrial House, to access ...

level 1

... the elevated, intimate garden ...

Level 0

... from the communal area below, residents and guests are required to walk through the building.

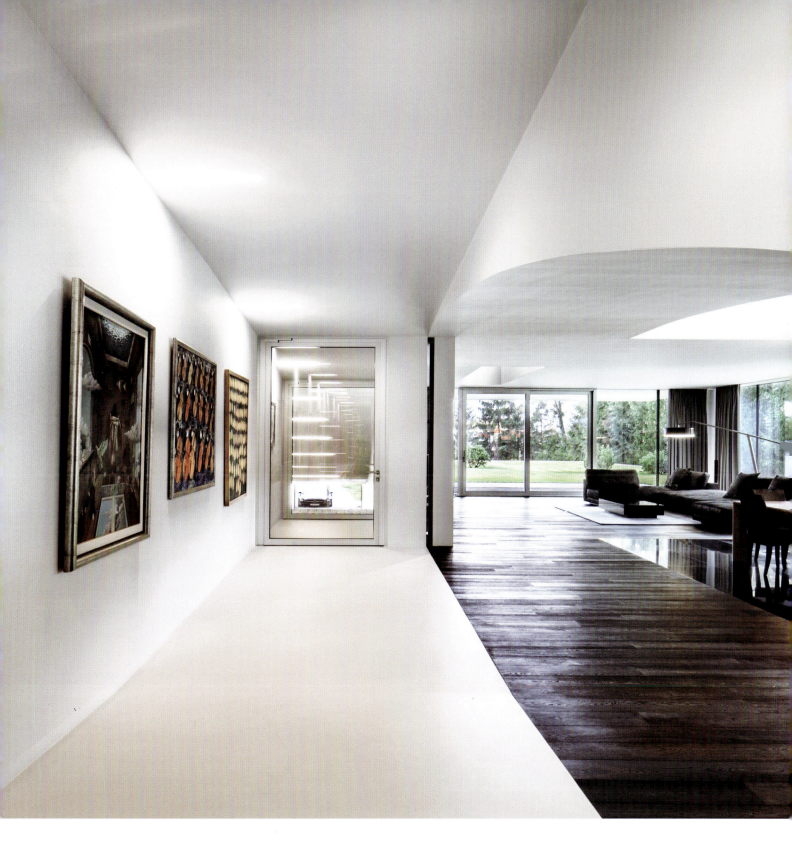

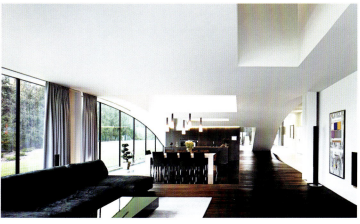

The upper-floor space is a continuation of the tunnel. It breaks away from the ground and covers a section of the garden with the living area. We sought to emphasize this ...

... by suggesting the use of artificial grass on the living room floor ... but for the owners this idea seemed a bit too much.

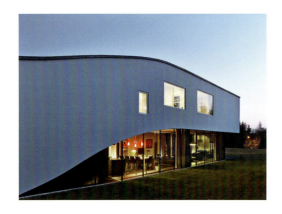

However, the structure of the Autofamily House shows a similar design approach for the living zone as we had found in the Living-Garden design path (p. 45), which came about at the same time.

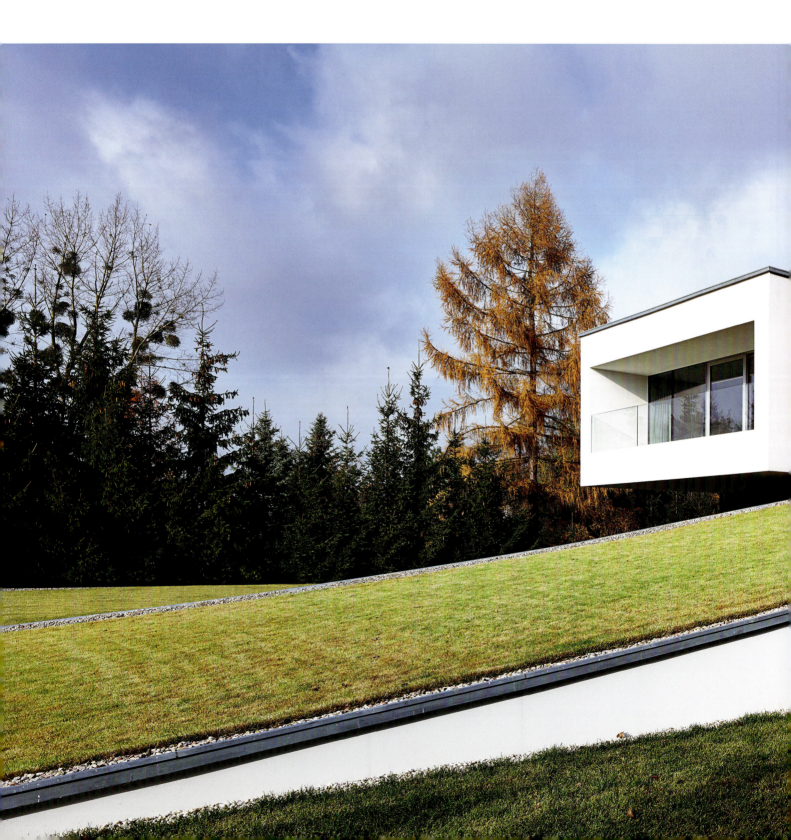

Interestingly, after some time, car companies started to show eco-friendly models in this building, and the homeowner himself changed his cars to zero-emission ones.

The new type of entrance and driveway area designed here is now also successfully being applied in small suburban houses.

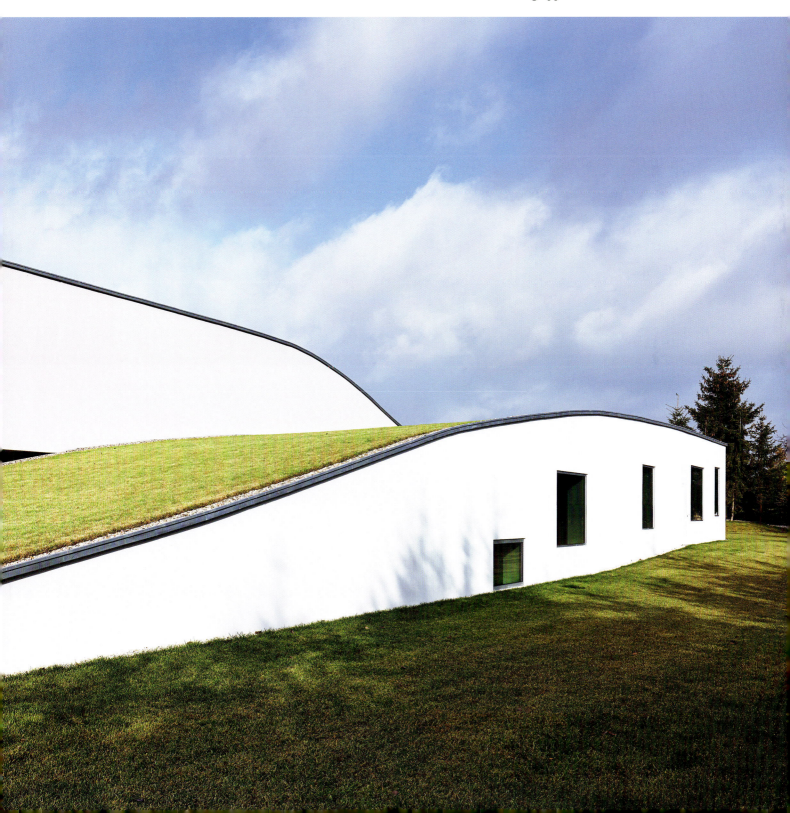

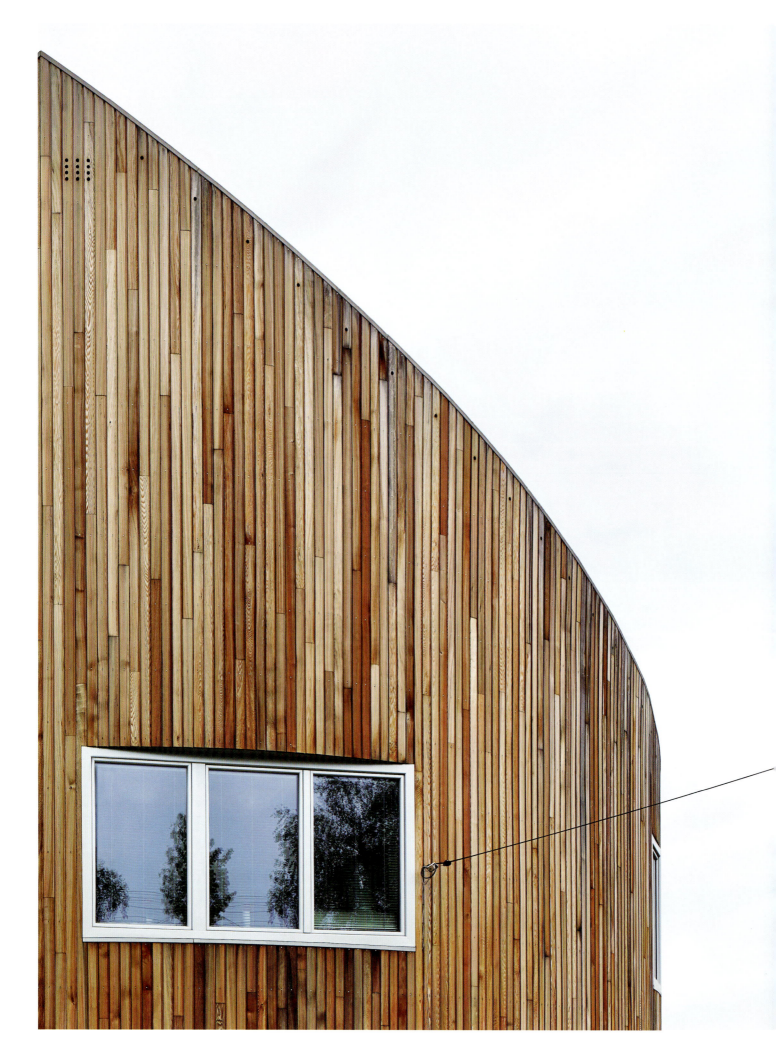

contextual transformation

standard h0use

2007–2011

We were commissioned to create one design for a house to be built in two different locations, in Pszczyna in Poland and near Berlin, but in Germany the clients had not yet acquired the plot.

So how in the world do you design a house that will fit on a plot of land for which no specifications are yet available?

My solution: the shape of a circle fits seamlessly into almost any kind of figure.

Then I realized it might be an opportunity to create a "standard" house design that could be incorporated into a plot of land of almost any shape (and size) ...

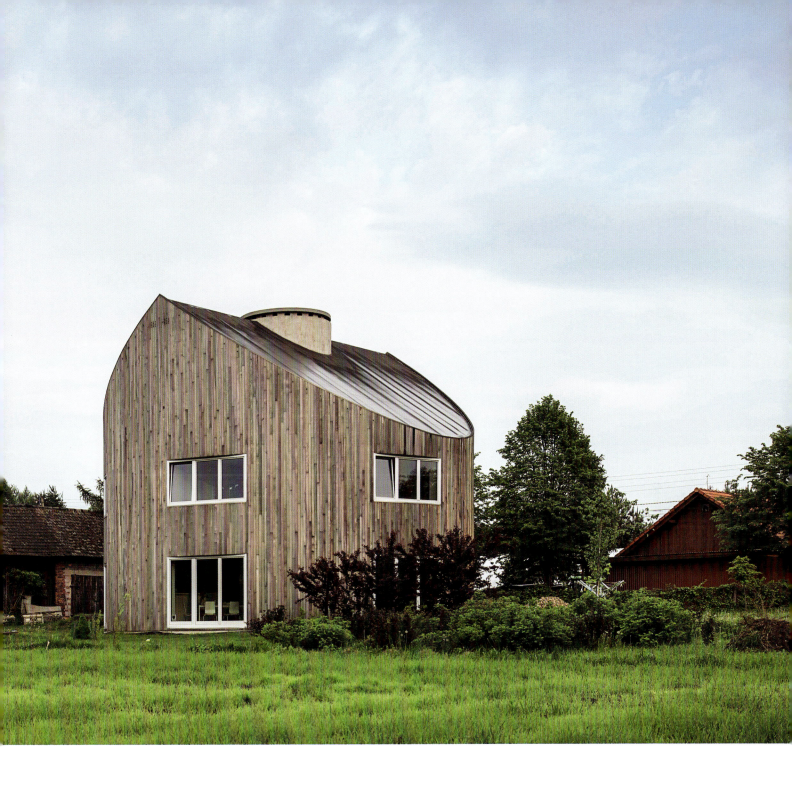

... and which would fit into any context, including with the possibility of different roof shapes and finishings.

Here, due to the local surroundings, we went for an eavesless roof and wood on the façade.

The aim was to create a freely configurable interior. The structure of the building consists of the ...

... intercommunicating staircase and the perimeter of the house. The remaining walls are laid out perpendicular to them, so that any common furniture can be accommodated.

site plan 0 15m

The first and second floors can also be rotated and positioned independently of each other, enabling them to each be adapted to suit the best aspect and the residents' preferred exterior viewpoints.

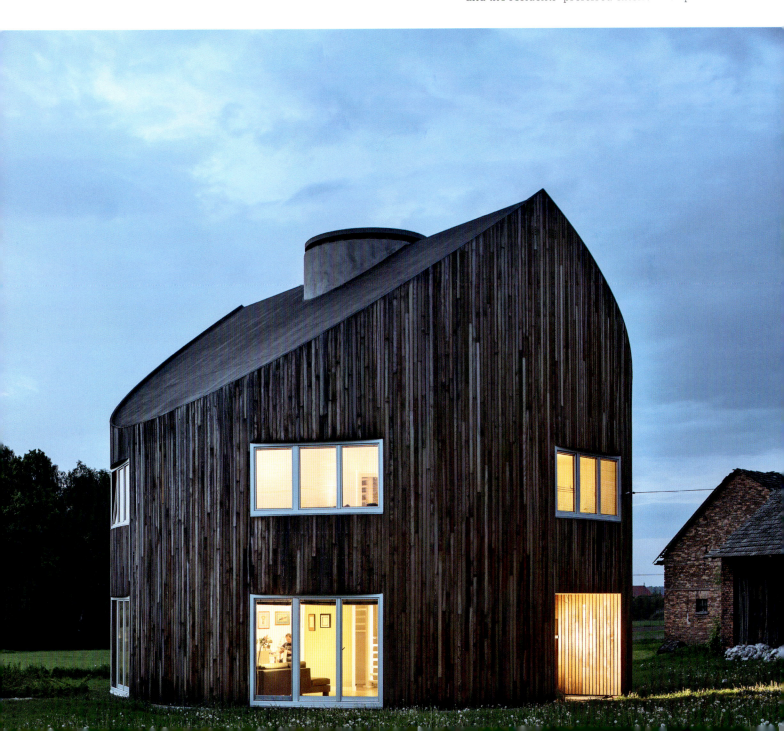

attic

These houses can be built using various technologies. →

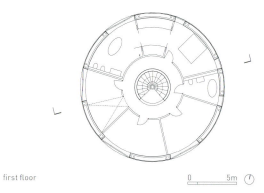

first floor 0 5m

Here we used a prefabricated wooden structure.

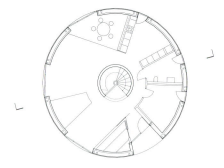

ground floor

Only the intercommunicating staircase is made of concrete.

section

It also serves as a gravity ventilation chimney.

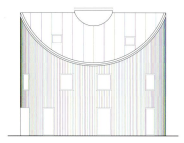

east elevation

In the case of houses with mechanical ventilation …

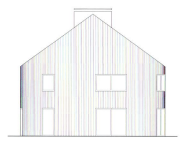

north elevation

… the chimney would not protrude from the roof.

We optimized the limited budget by incorporating standard windows into the body of the house.

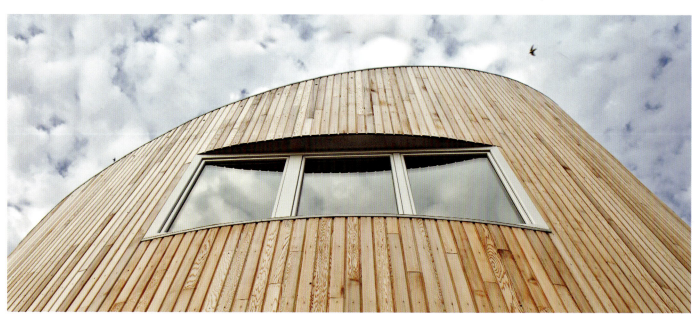

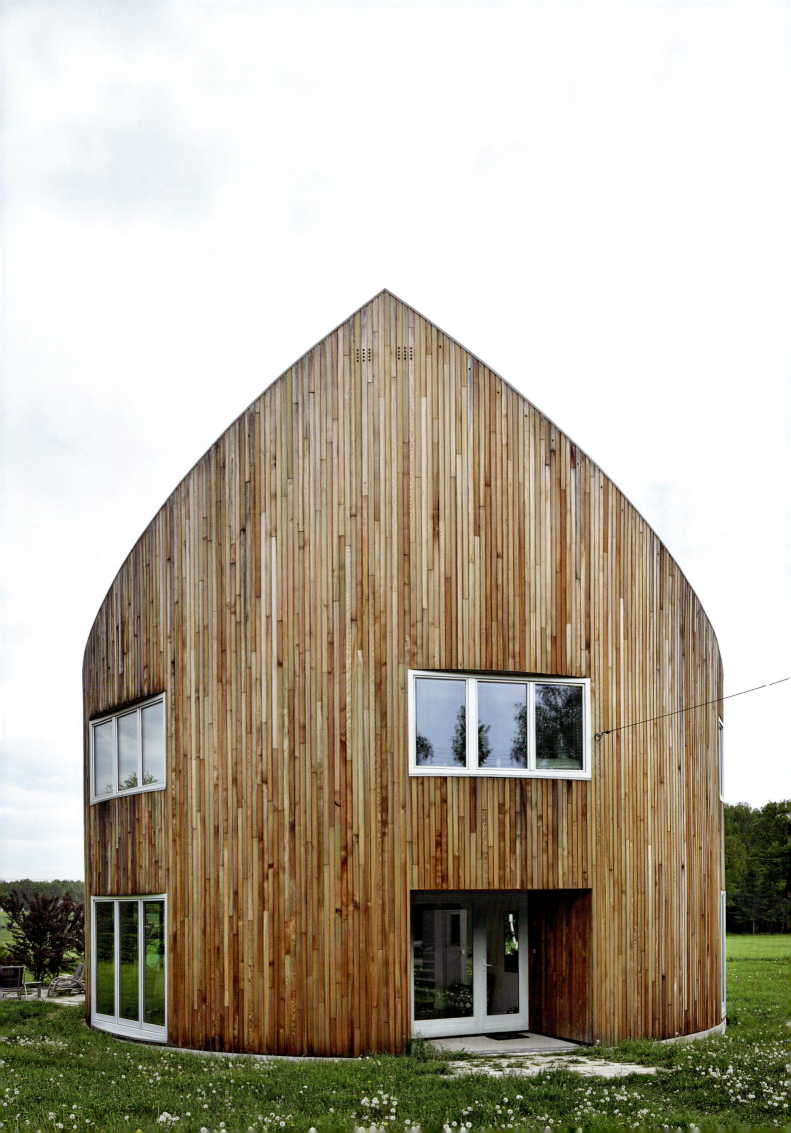

Ten years of living in the building have proven that it is really economical. Its optimum shape and wooden frame, with much thicker insulation than required, made it close to the parameters achieved by passive houses.

The concept of placing a building on an unknown plot and optimizing the functions in relation to the sun (and other environmental aspects) were later applied in our design of the Sunlite Building (pp. 32, 33, 316).

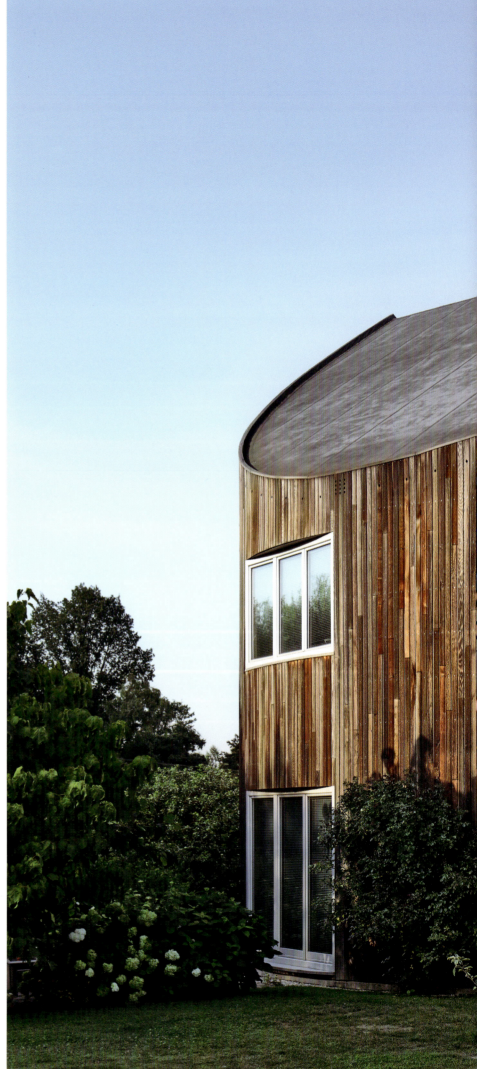

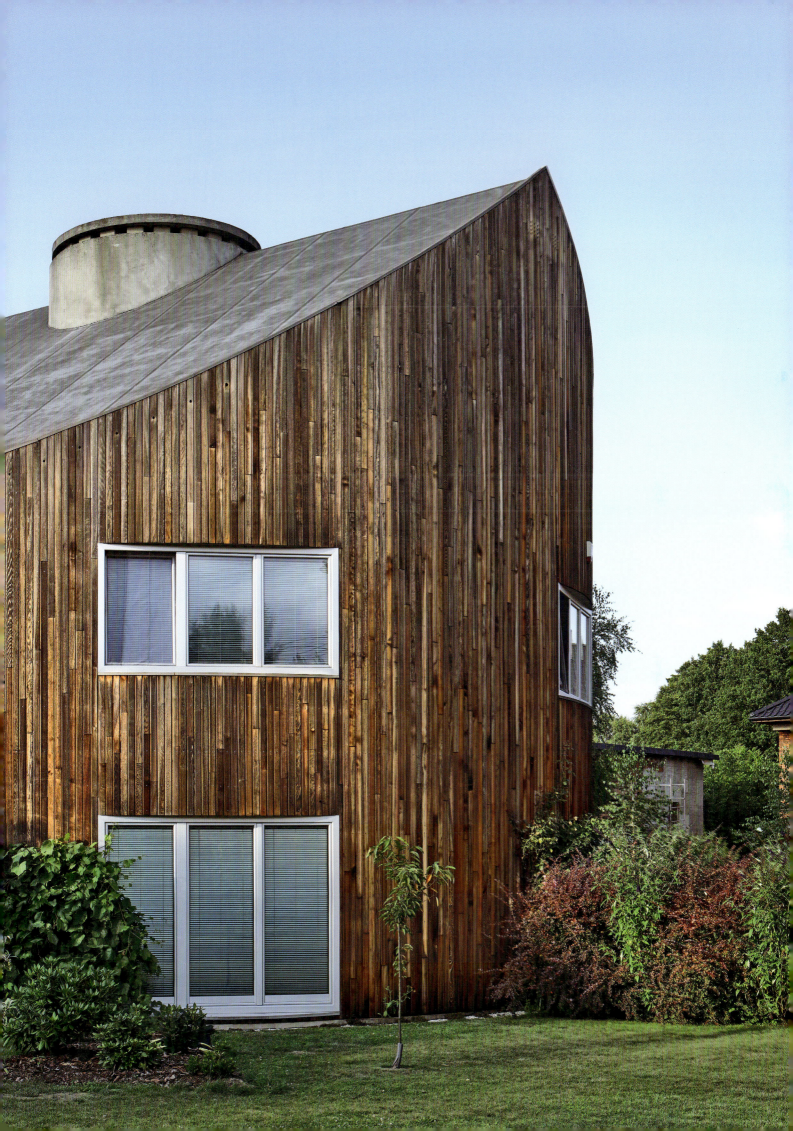

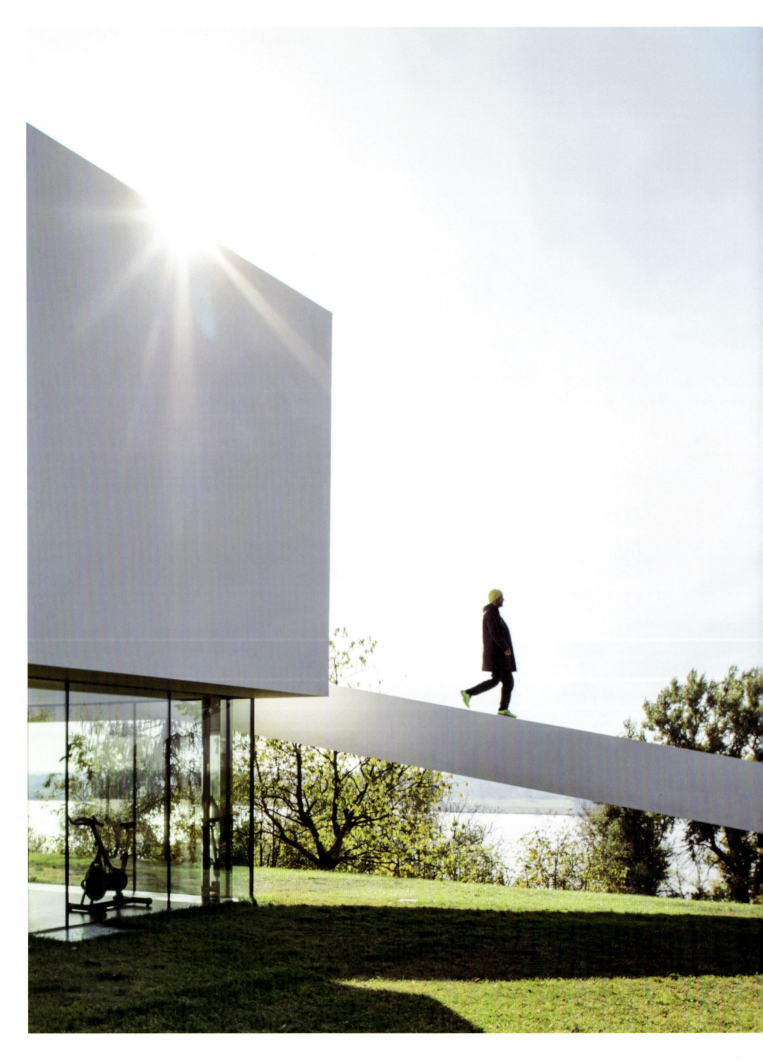

contextual transformation | topographic

By the Way House

2008–2016

During a meeting with a client, he started drawing a plan of his new house, and at some point I realized he was sketching the interior of where we were actually sitting.

I told him that it might be possible to design it better. He replied that it was possible, but that he didn't want to risk it because he was comfortable living there.

He added that he wished to raise the living area to the first floor (for safety reasons). He went on to show me some of his ideas, which were less than ideal in my opinion as the house and garden remained disconnected, thus I concluded that this was not a task for us.

He insisted, however, that it was for us to design, and that it was intended to look like that!

client's sketch

He indicated where we were to locate the house and the boat pier by the river.

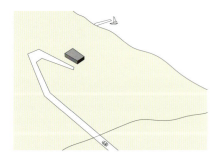

So, I thought, since we need to bring the road to the house anyway, let's make that the main theme of the project ...

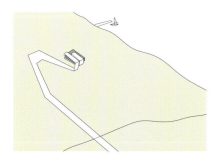

... by wrapping the road around the then somewhat unattractive, garden-detached house (to hide it) ...

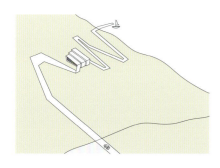

... and then leading the road away from the first floor into the garden and wending it down to the water.

The wrapped road contoured the house, and inside the home maintained the client's dream functional layout.

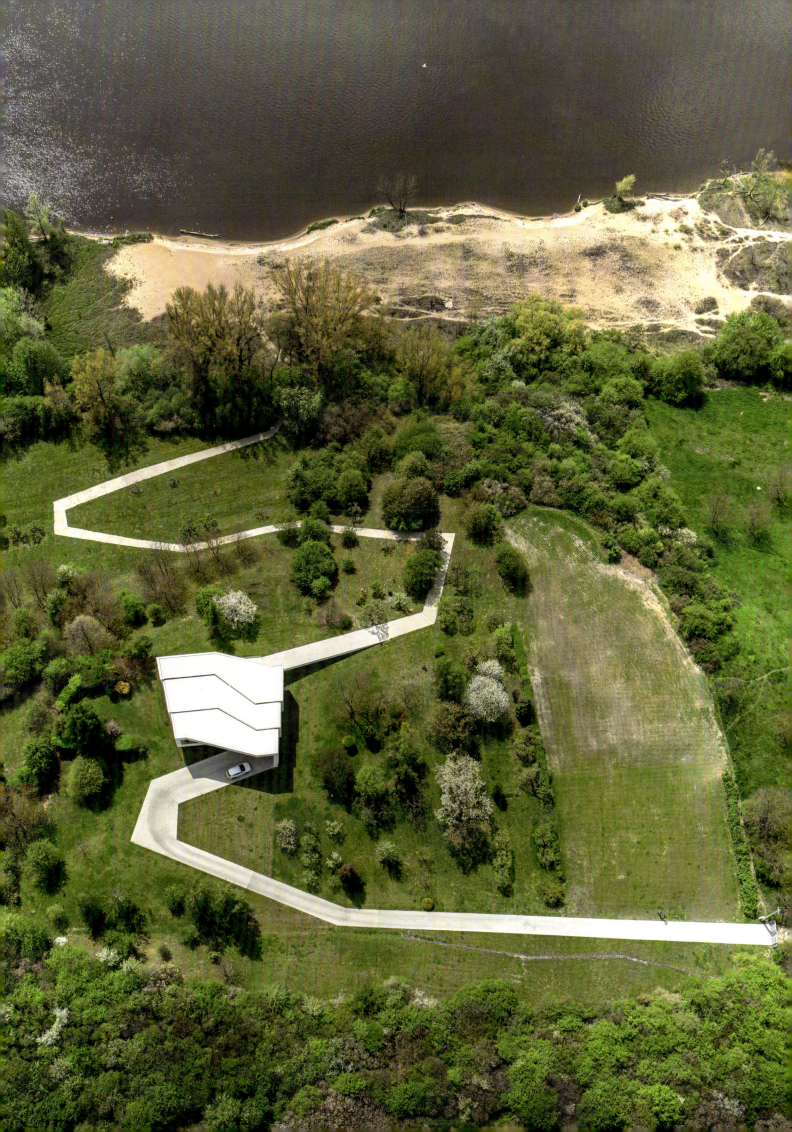

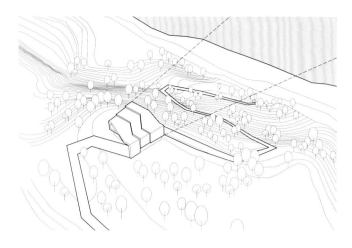

The road runs through the orchard, skirting the trees. It rises, wraps around the upper floor and opens up to views. It becomes a footbridge and gently connects the living area with the garden.

We included the footbridge because it would provide those mooring on the river there access to the house.

We designed the whole thing with one material—the light concrete characteristic of the roads.

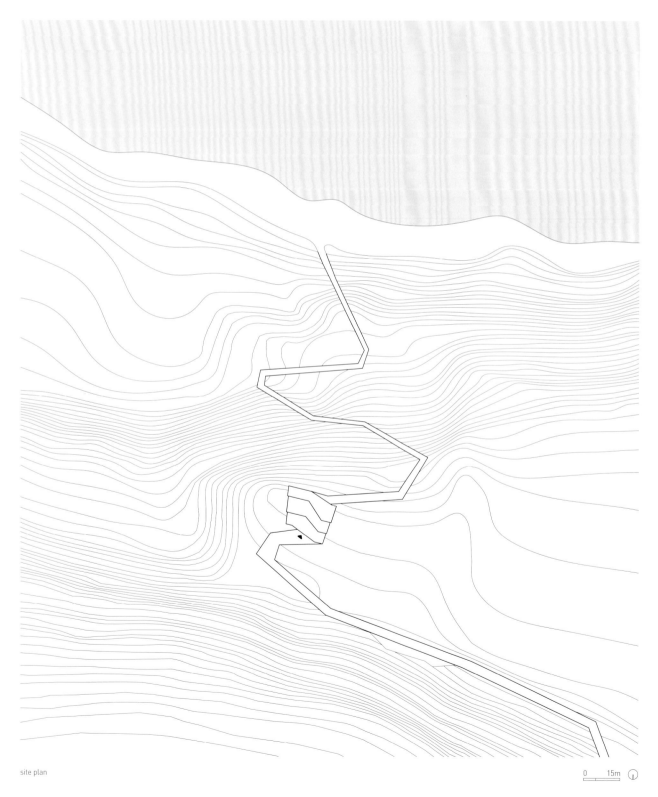

site plan

0 15m

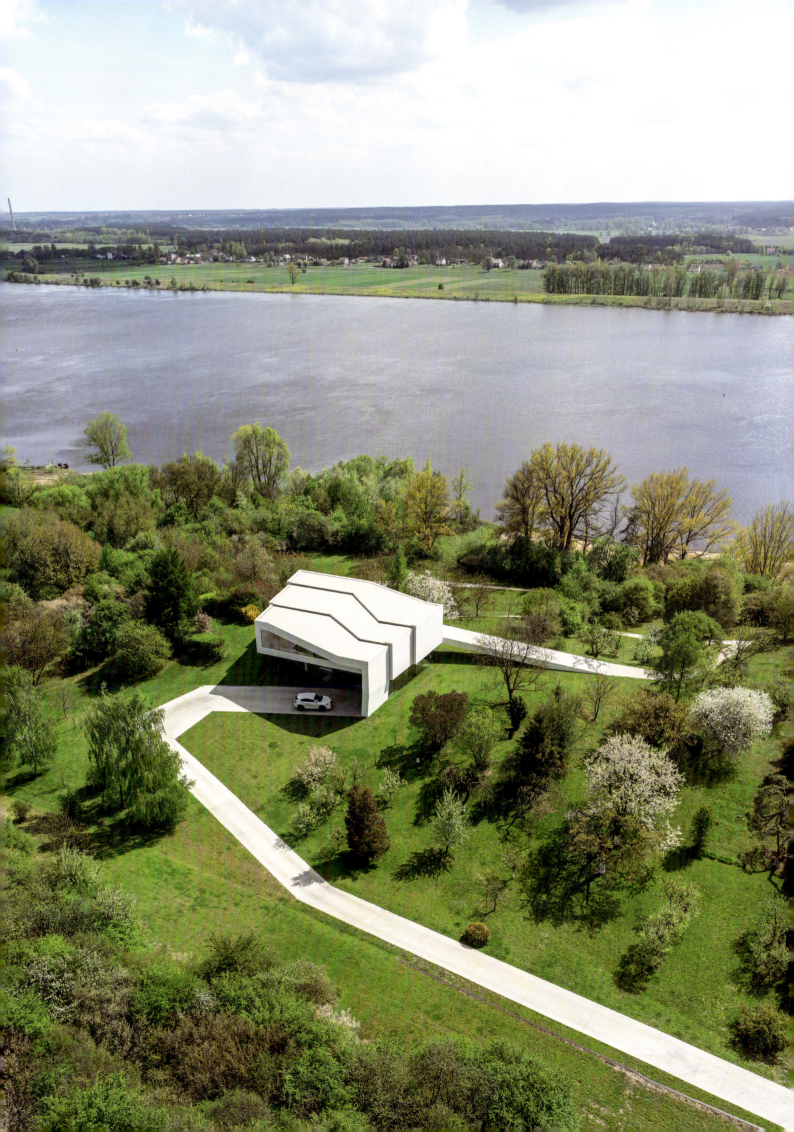

To enhance the motif of a "ribbon," the home's internal partitions were made of wood in a color contrasting with the concrete.

The rising driveway segues into a wall and roof over the entrance area, providing protection from rain and strong winds.

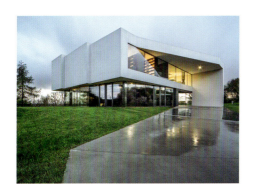

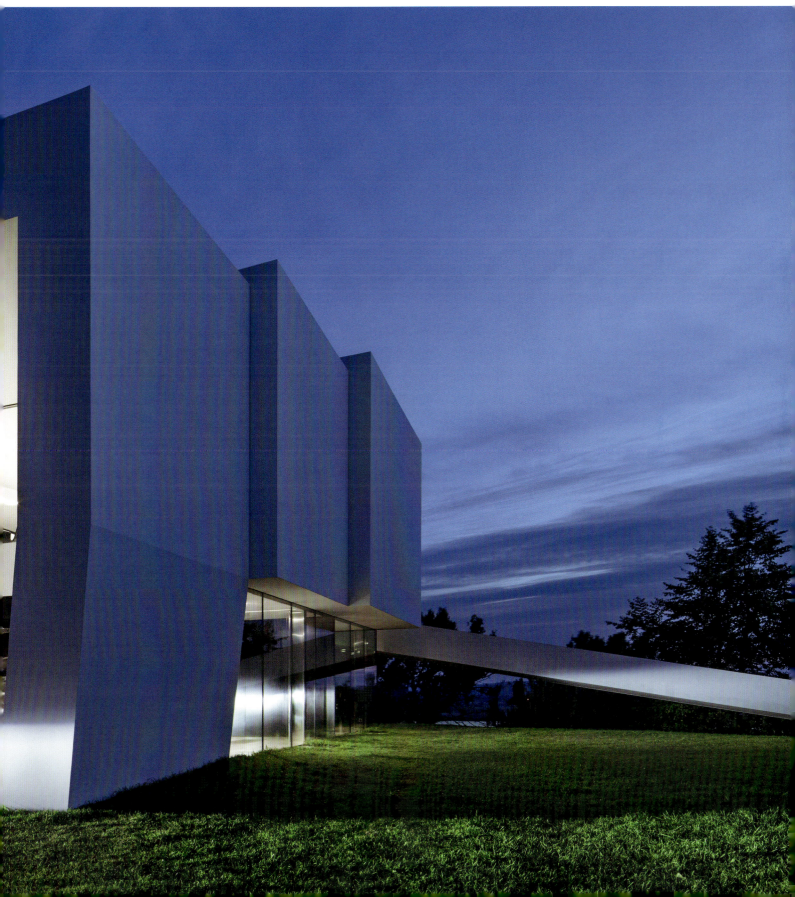

first floor

ground floor 0 5m

The ribbon wraps around the upstairs living area, opening up toward the river. We considered spreading it out and providing a view to a side aspect, but the client said that would disturb his sense of intimacy.

On the lower floor there is a gym, guest rooms, and a garage. As they are under the braided ribbon, they could be surrounded entirely by glass ...

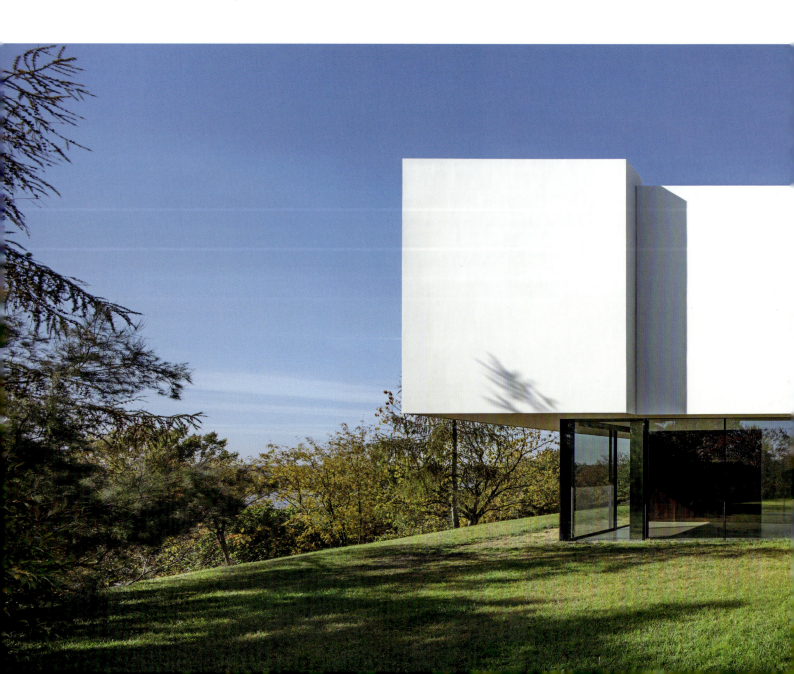

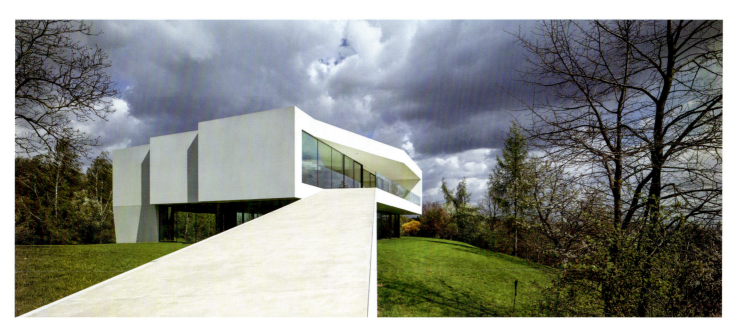

... so the lower floor has a perfect connection with the surrounding greenery of the garden. In some respects while this ...

... limits the view here, as we ascend ...

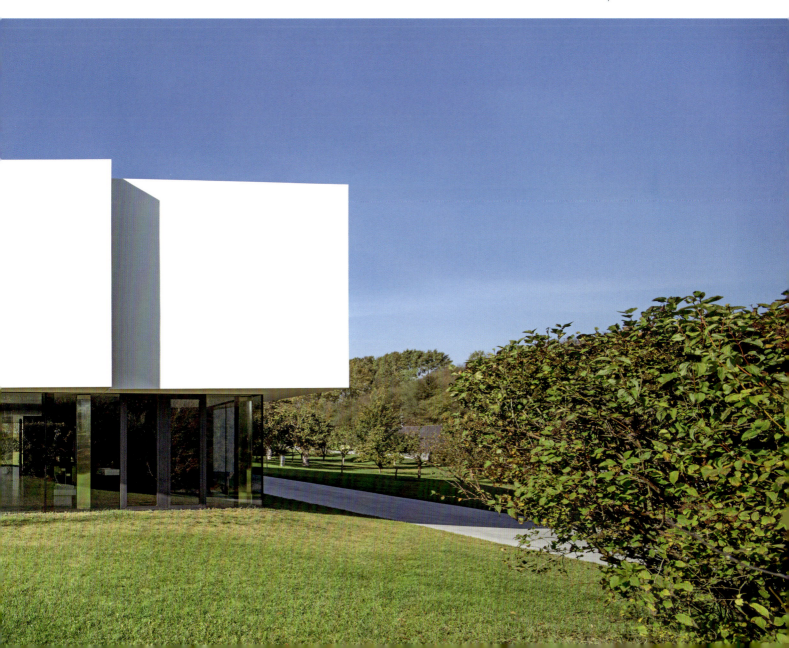

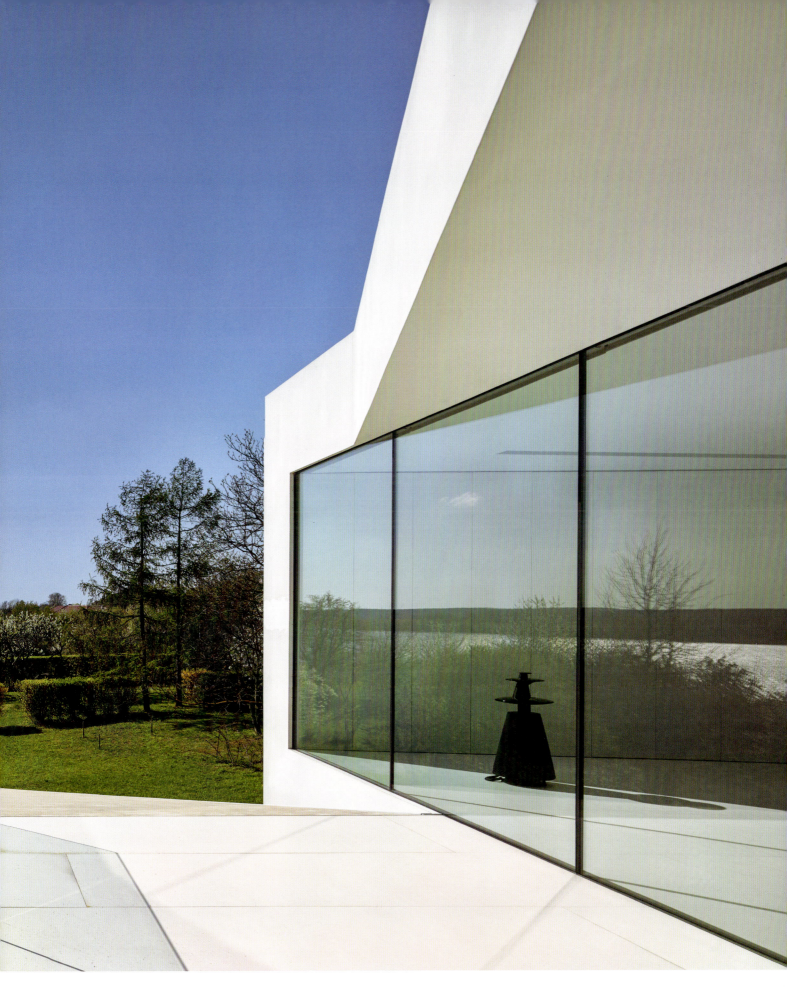

... the situation changes. From the living area on the upper floor we have an open perspective across the river, with sweeping views over the treetops.

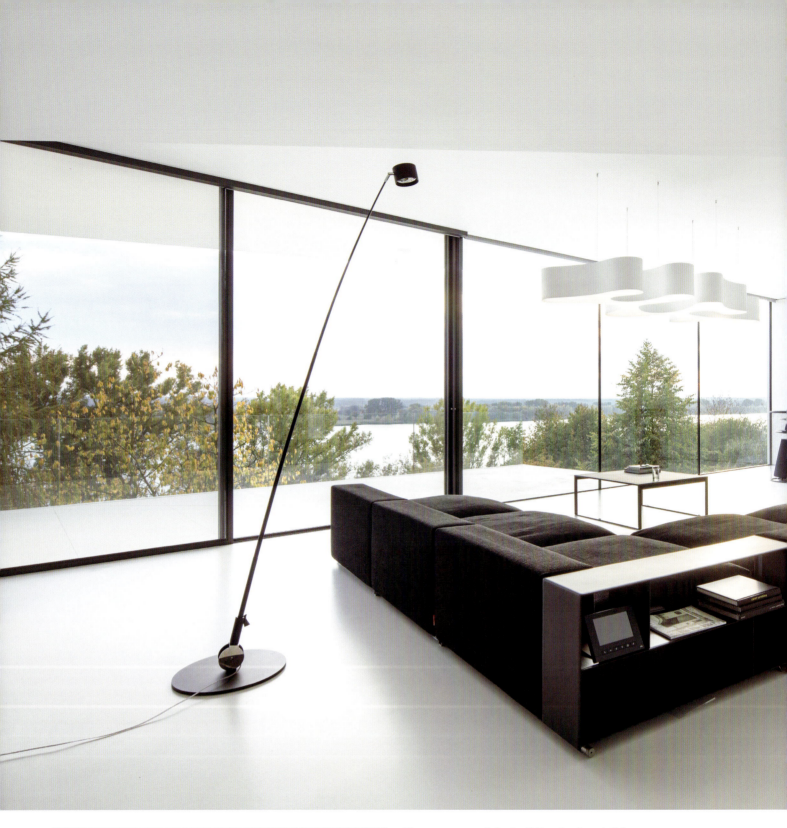

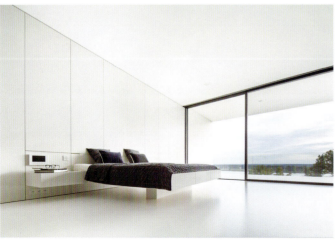

The structure of the building is also visible inside. We emphasized this by hiding some of the furniture into the walls, which merge to become part of the ribbon. ↗

The internal structure's interlocking and fault lines were used to conceal lighting and ventilation slots. We had progressed from an overarching concept to the fine-tuning of the smallest details.

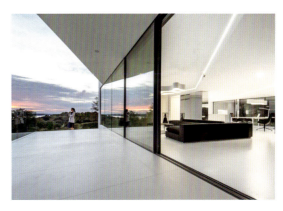

Interestingly, the client also contributed to the minimalist interior design by completely changing his way of thinking as a result of our long-term collaboration.

The house extends into the topography. The footbridge connecting the residence to the garden turns into a ground-level path of rough concrete, adapted to the steep slope and undulating terrain.

section 0 5m

From the garden below, only the upper floor is revealed, while the lower one remains secluded behind the trees. We reflected on our initial design response and how it forced us to forge ahead to develop a design concept with such perfect viewpoints.

Motivated, we came up with an idea whereby it was possible to keep the connection between the living room and the garden and get even more.

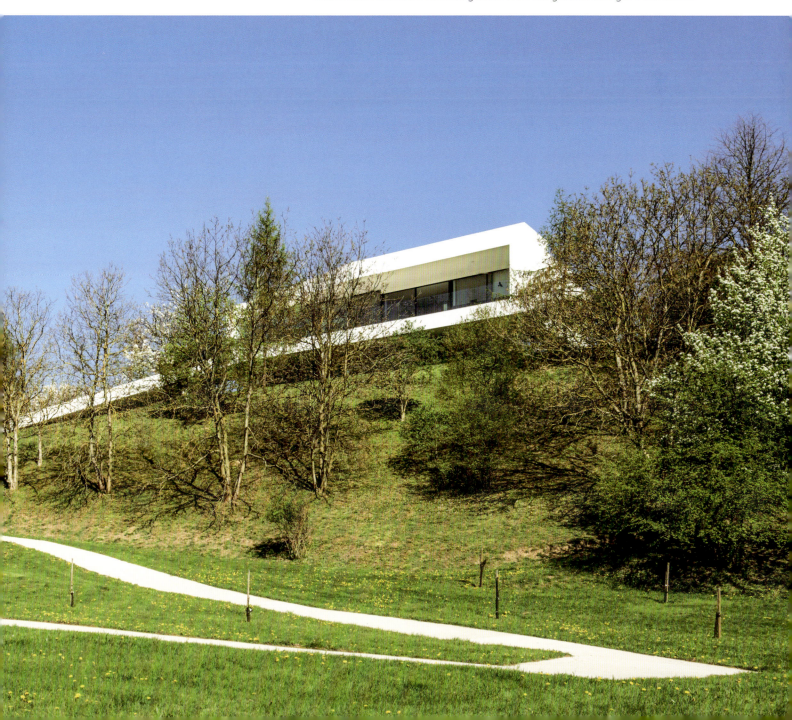

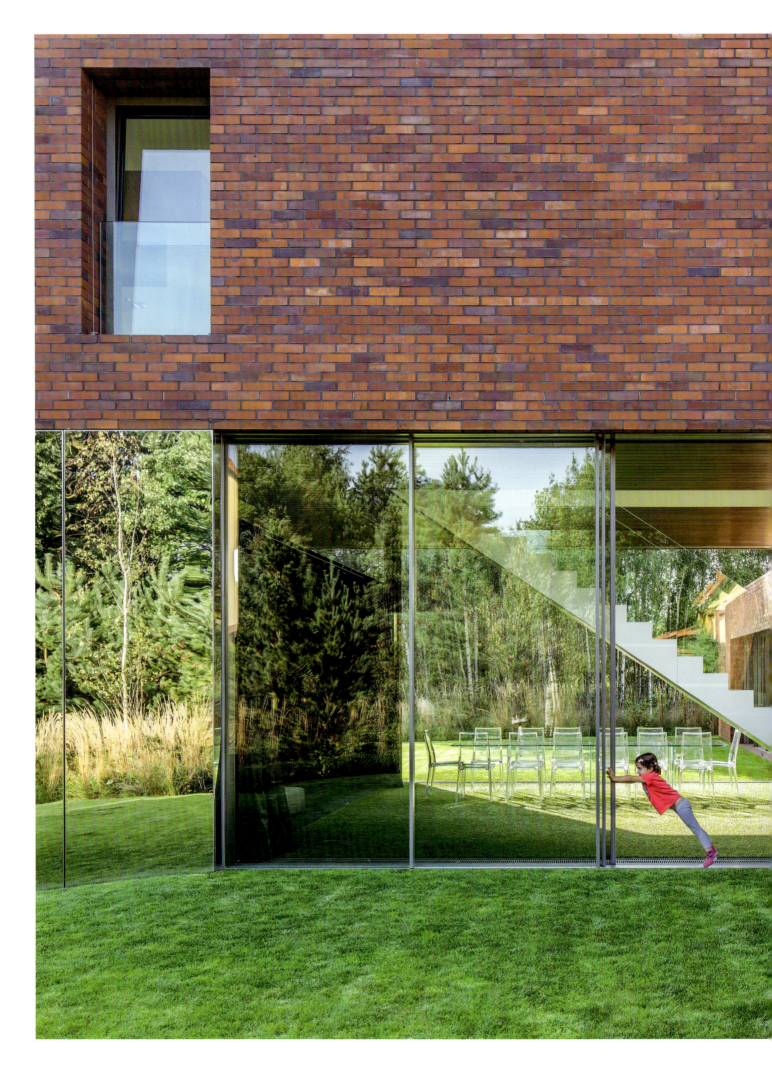

topographic | contextual transformation | living-garden

Living-Garden House in Katowice

2009–2013

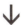

We have been working on the concept of the living-garden house for many years. When I saw this plot, I thought it would be the perfect place to finally bring this concept to life.

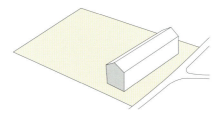

To fit into the context, we reached for brick and a pitched dark roof. We positioned the building to provide privacy in the garden. →

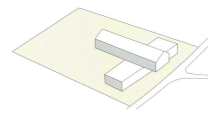

We twisted the block of the upper floor to roof part of the structure ...

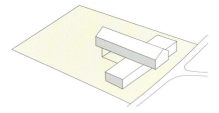

... and separated the living-garden area with glass. Concerned at the lack of privacy, the client asked us ...

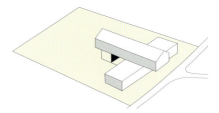

... to enclose it with walls. We covered them with mirrored sheet metal on the outside to leave the impression of the garden flowing under the building.

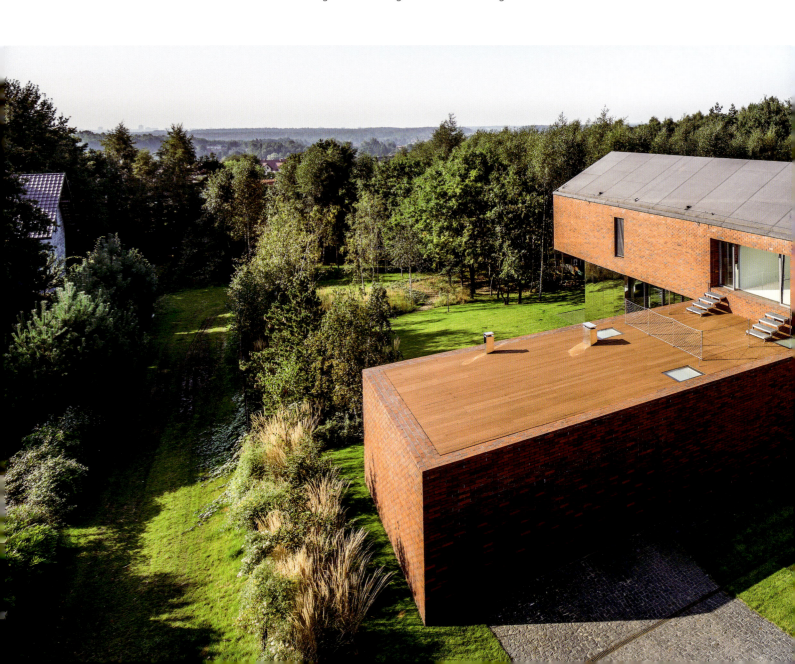

site plan 0 15m

The idea of the living-garden house corresponds to human nature. In the daytime, we yearn for contact with our natural surroundings, with ...

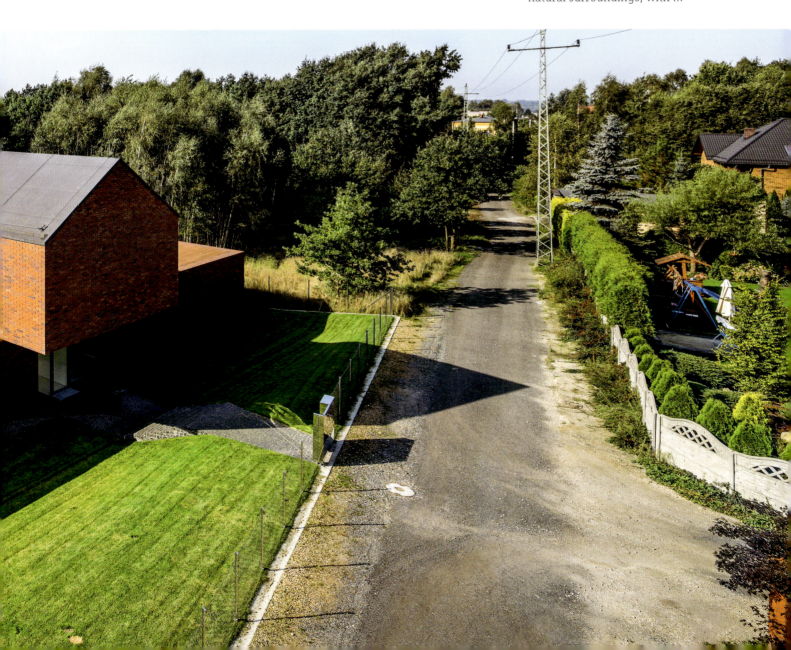

ground floor

... openness provided by the living zone, which is part of the garden. The floor made of artificial grass is an extension of the lawn. →

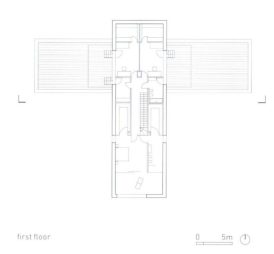

first floor 0 5m

At night we seek a secluded retreat to rest.

section

The 'living room' is turned into a 'living garden' and thus offers a feeling of living among nature.

west elevation

Only in bad weather do glass partitions appear.

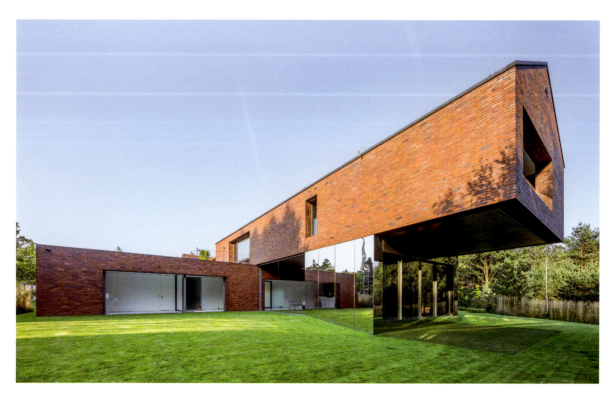

The lawn is also extended by the floor of the terrace covered by the overhang of the upper floor.

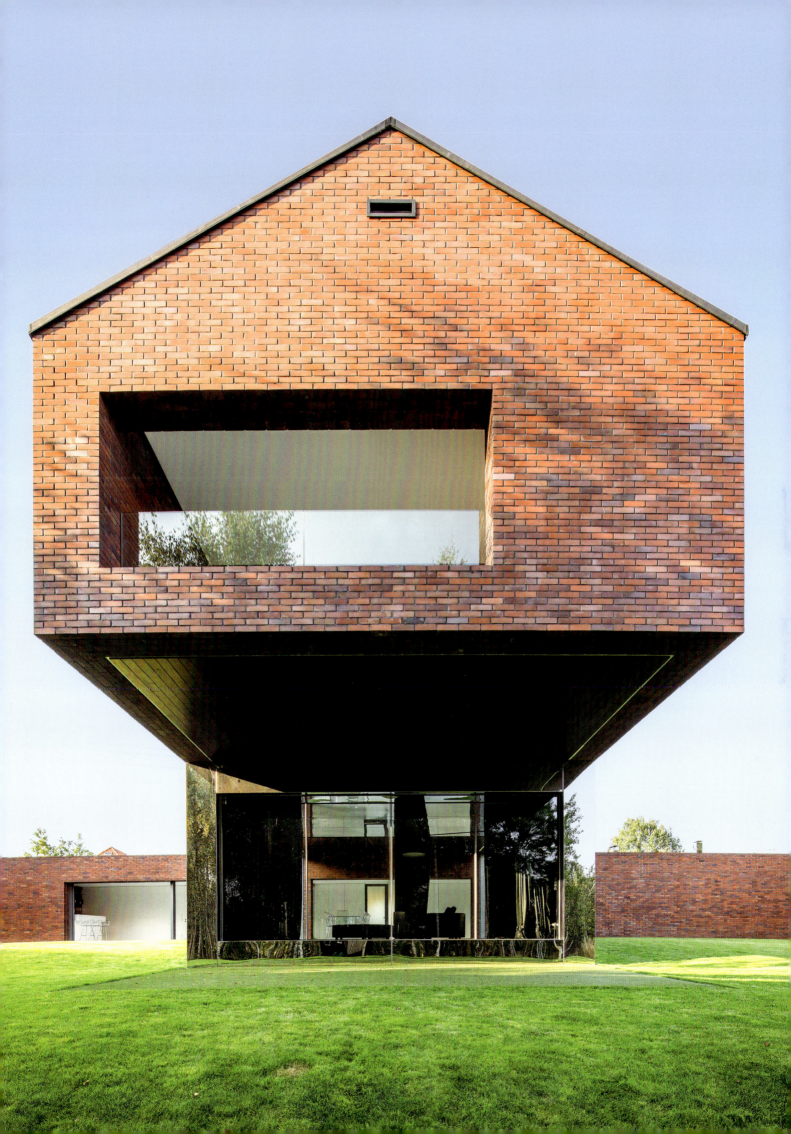

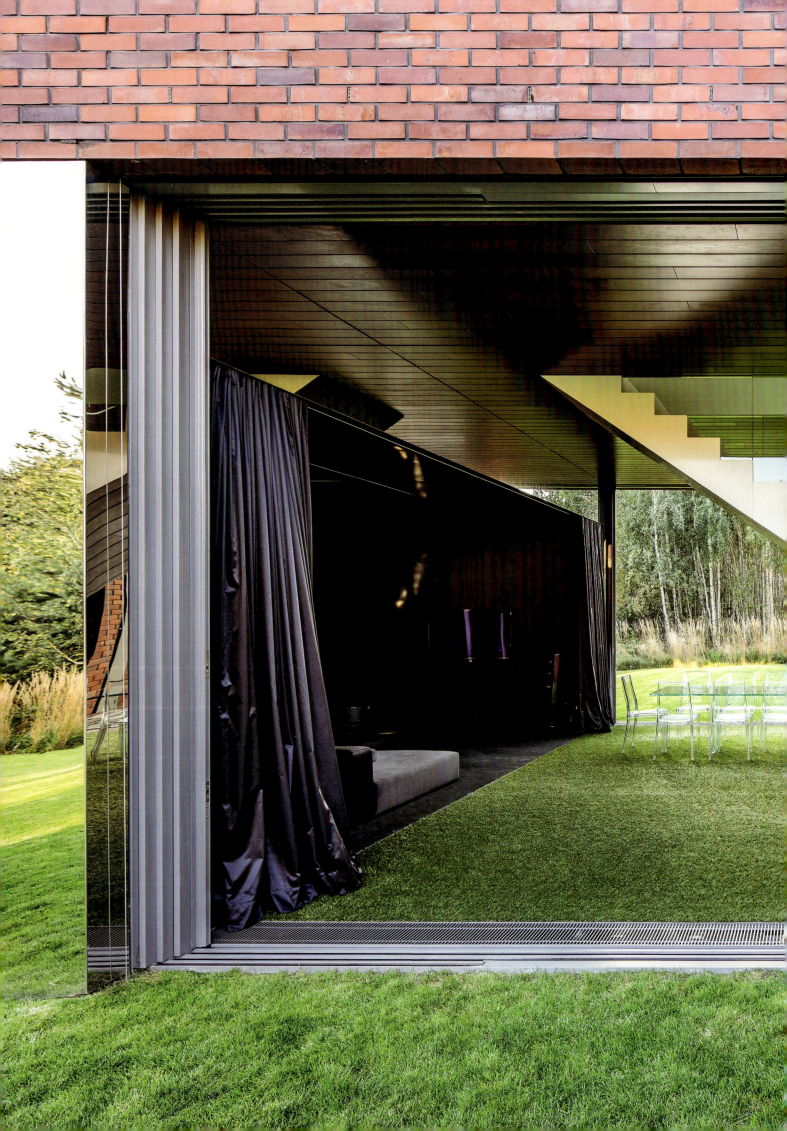

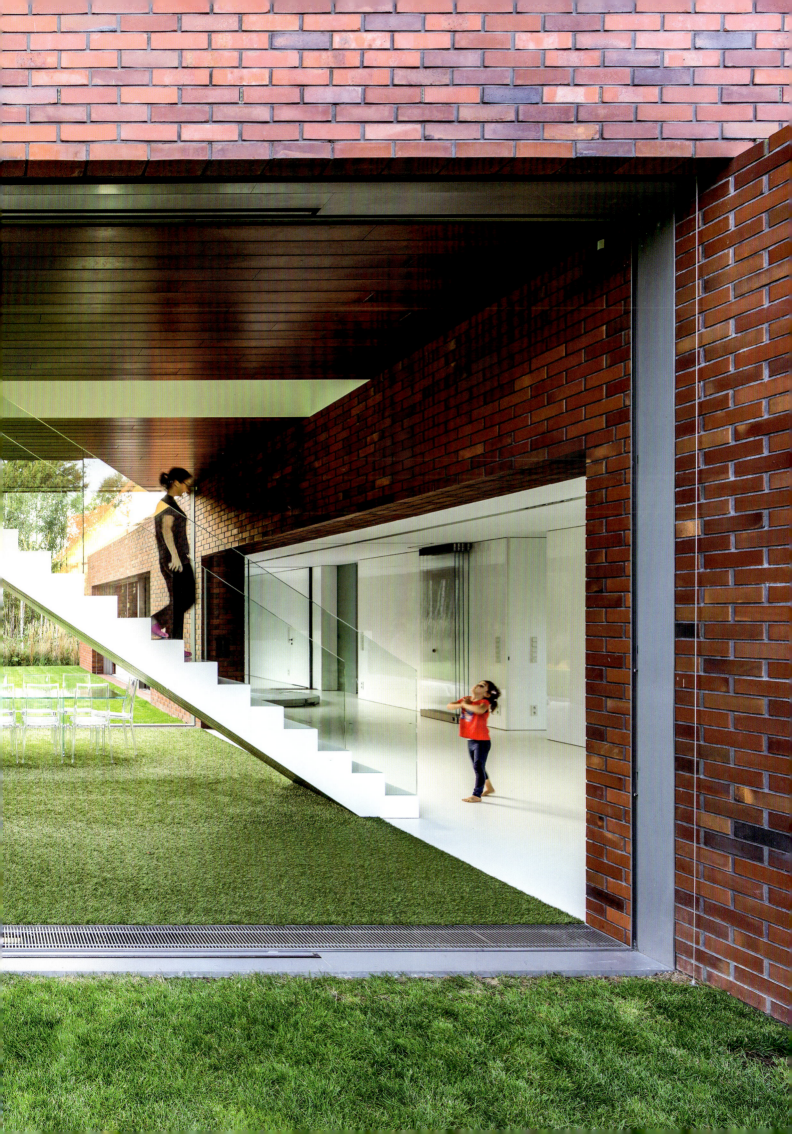

typical house

It seemed that from the outset our clients appreciated the differences between an ordinary house ...

living–garden house

... and the living-garden house, which blends into the garden in such a unique manner.

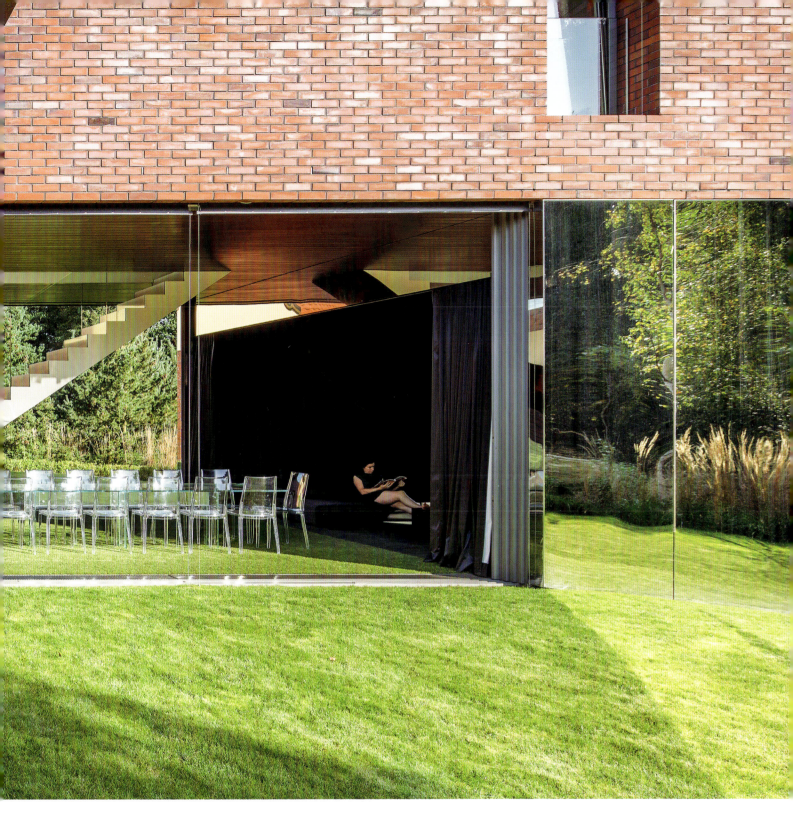

However, when we suggested putting artificial grass in the living room, they objected. So, I told them "Let's buy the cheapest! If you are not satisfied we will throw it away."

On the very first day, I got a phone call from the clients, who said "Robert, it's a pity we bought the cheapest artificial grass!"

After time, it became clear that the advantage of the living-garden house was not only for the psychological comfort of living in a garden, but also for the energy savings.

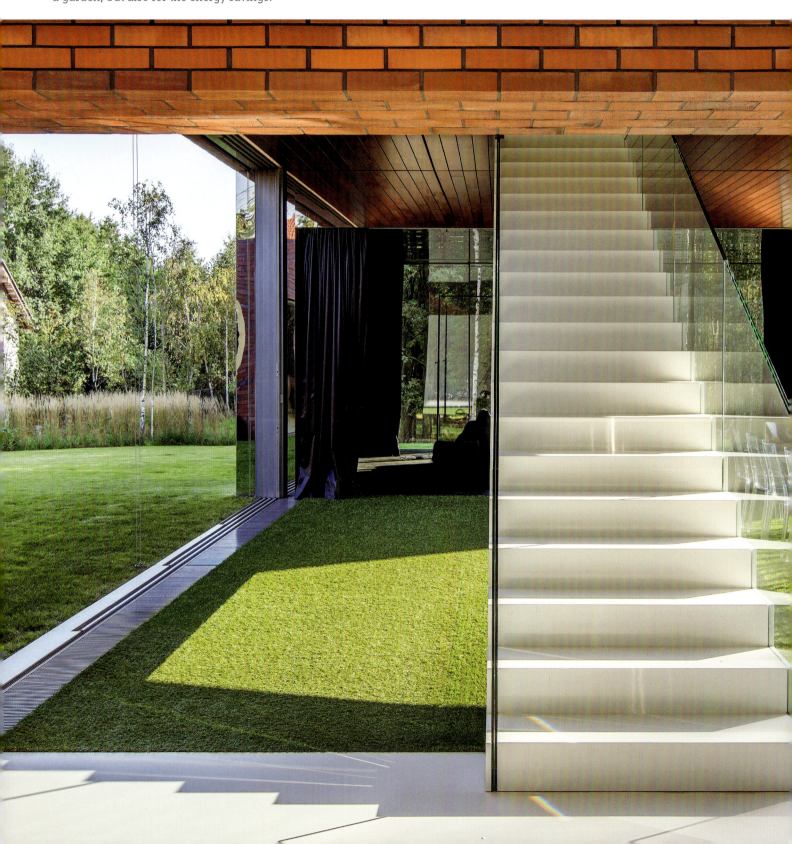

Natural ventilation in summer and energy gains in winter with the closed glazing mean that artificial cooling, ventilation, and heating systems are hardly used ...

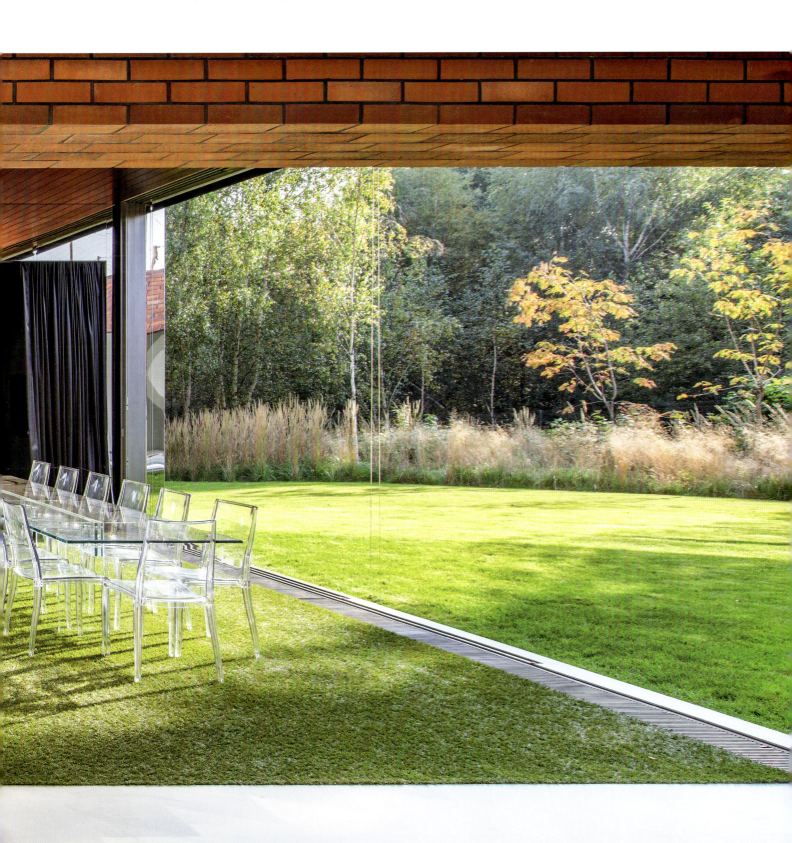

... but I wanted to look beyond that. I was keen to create a house that would no longer just give us the feeling of living in a garden, but truly provide all that nature offers.

We were able to make it happen in an experimental Living-Garden House near Kassel (pp. 46, 308).

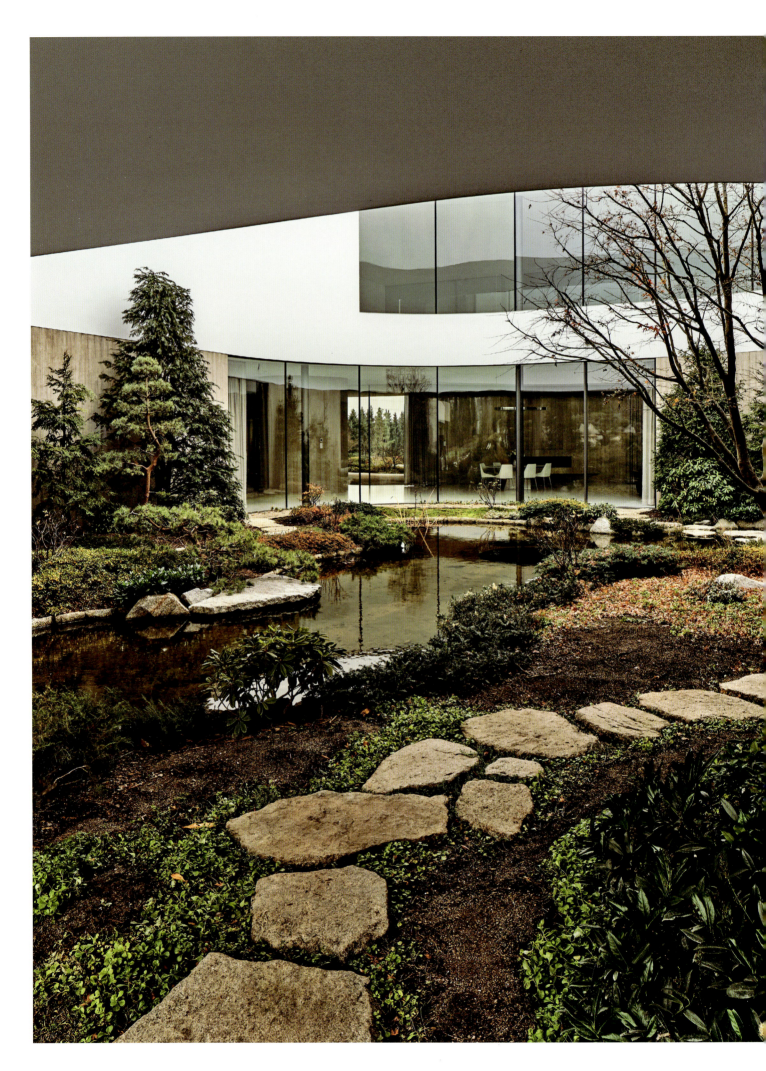

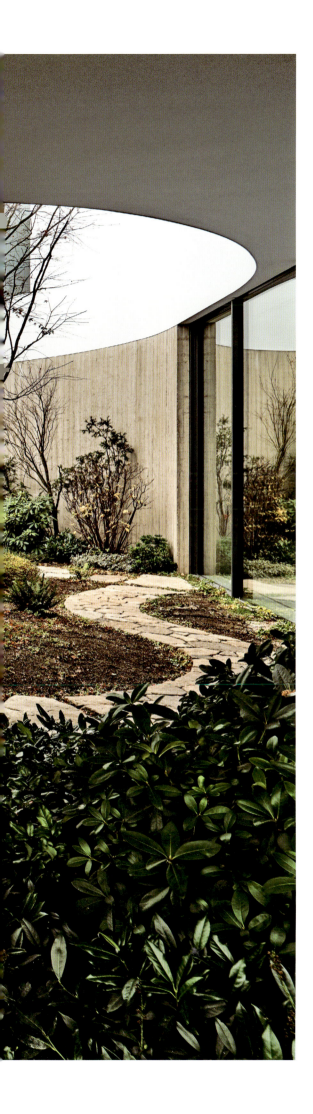

topographic | contextual transformation | mobility

From the Garden House

2009–2021

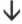

The owner arrived with a ready design of the garden, which was well under way, and asked us to design him a house to go with it. I thought he must have gotten the order of operations mixed up.

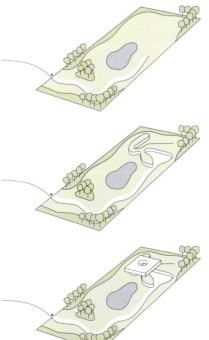

After planting many trees and creating an artificial lake on the plot, our client led us along a winding road to where the house as well as an art gallery was to be located.

We were inspired by the curves he'd imposed, so the ground floor of the house with the living area became a continuation of these curves.

We overlaid the topographically shaped ground floor with the cubic mass of the upper floor. These two different geometries are connected by a softly cut atrium.

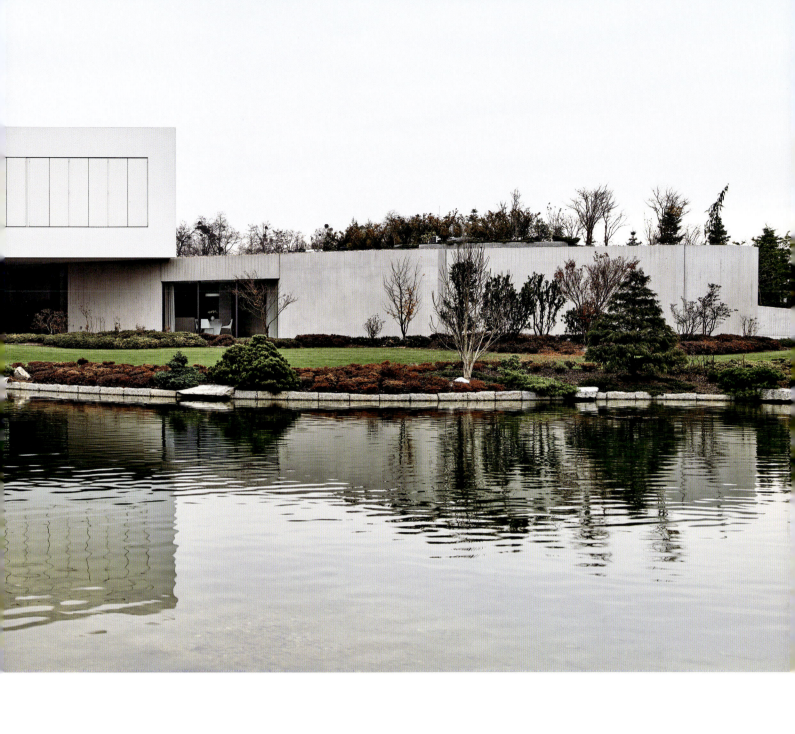

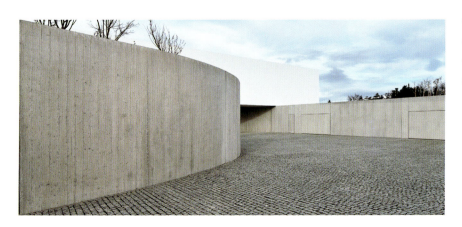

To make the roadside blend in with the landscape, we continued with the shape of the road and used its color and rough texture ...

... hence the timber-printed concrete on the ground floor façade. The soft shaping of the ground floor allowed us to separate the driveway ...

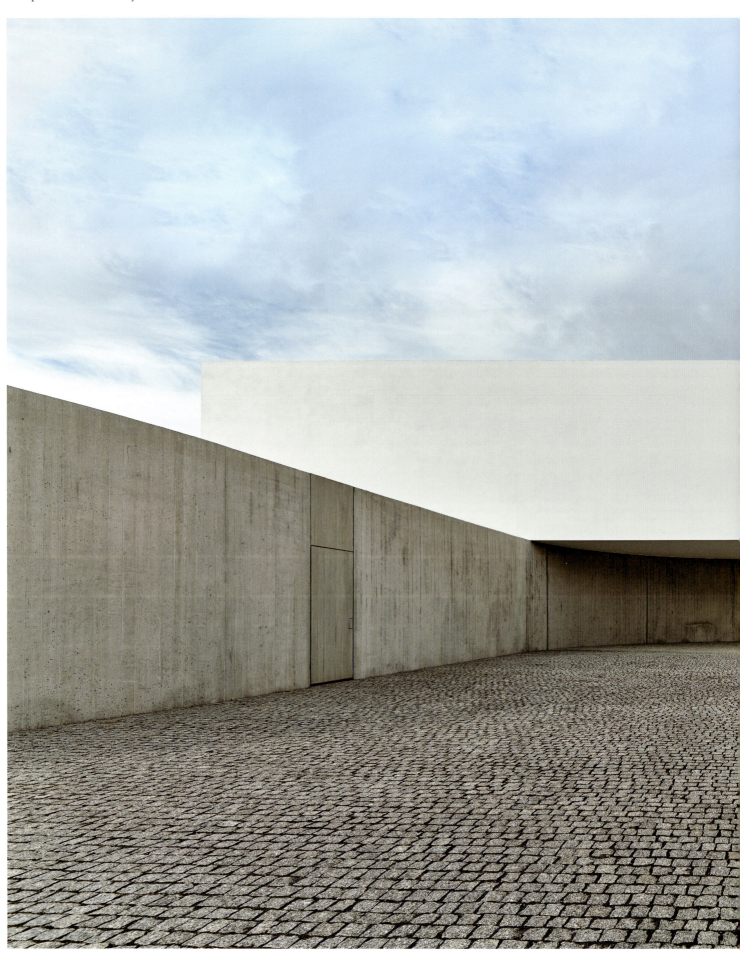

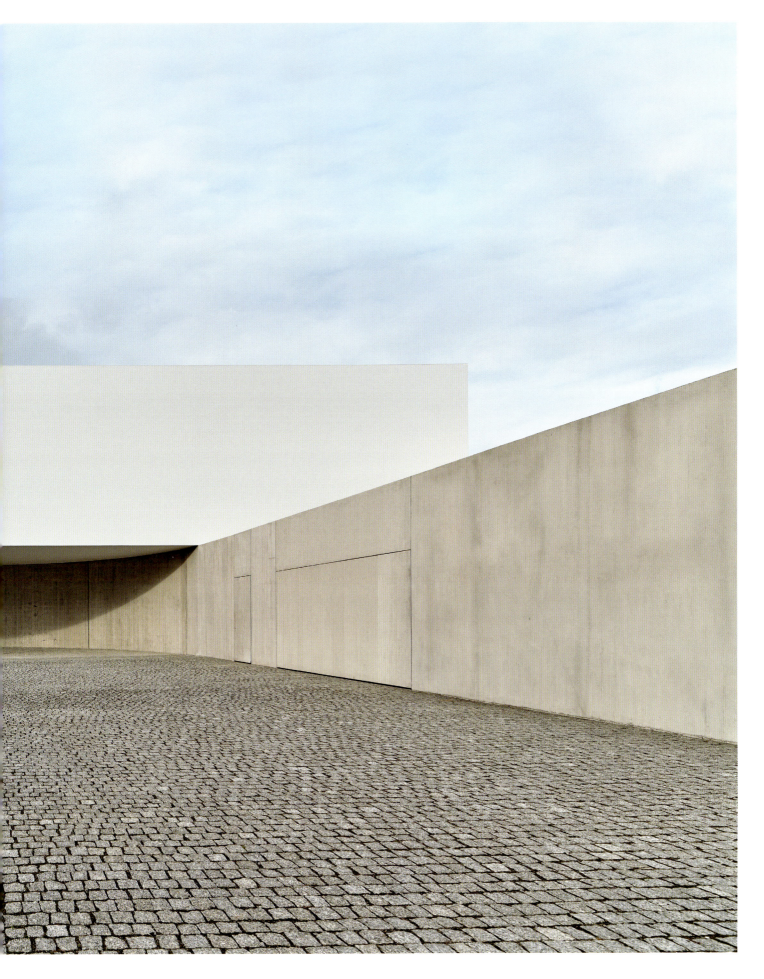

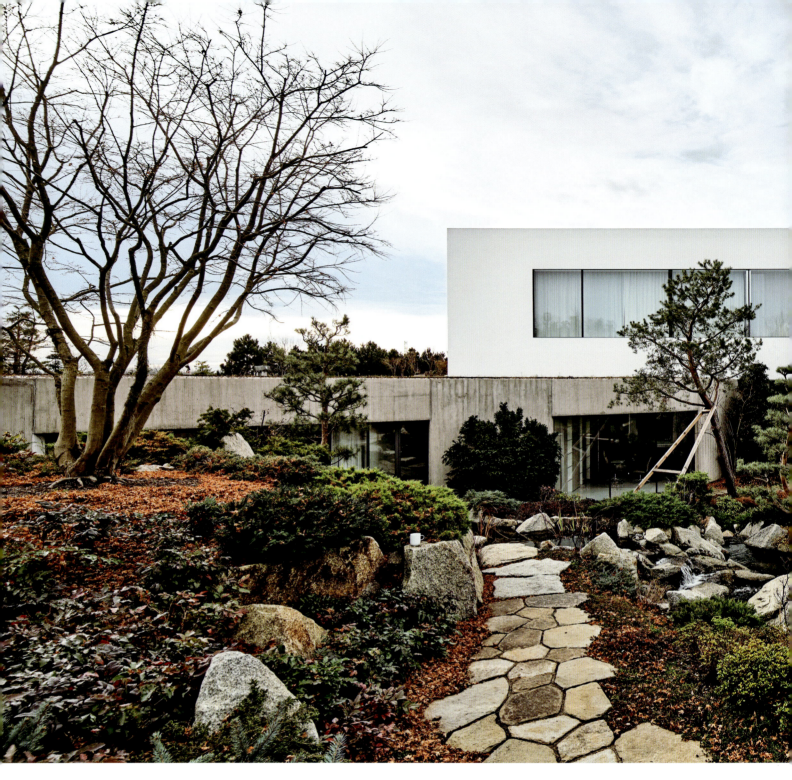

... and bring the garden almost into the house.

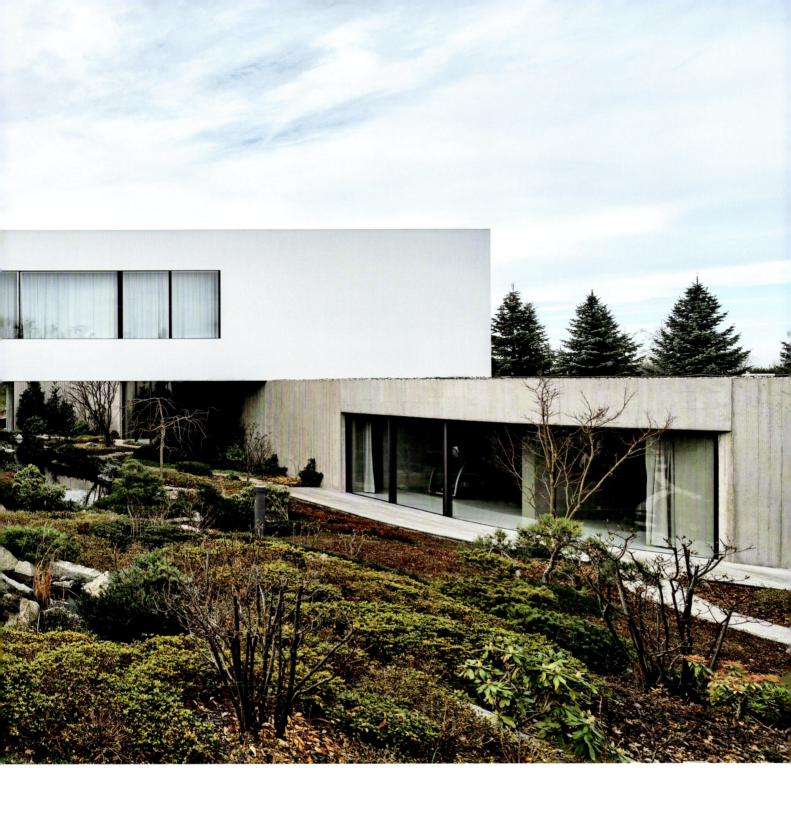

situation

At the house design stage, the landscaping was still in progress by a Japanese gardener ...

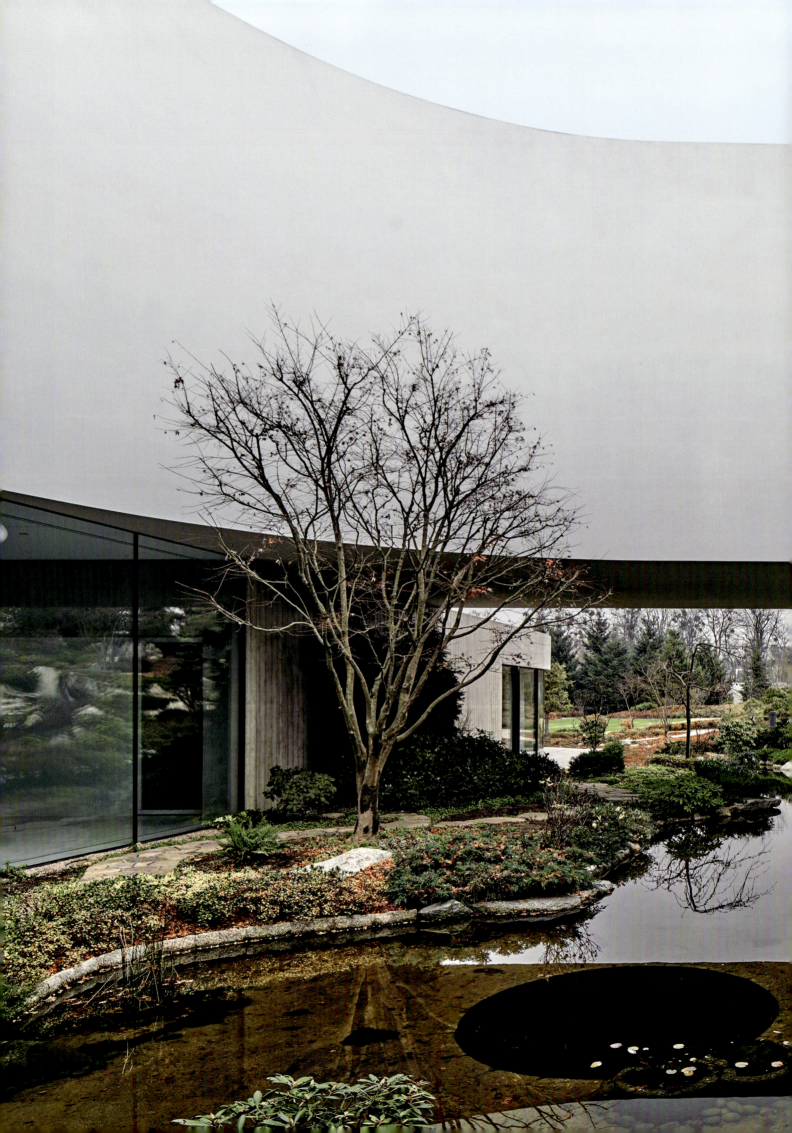

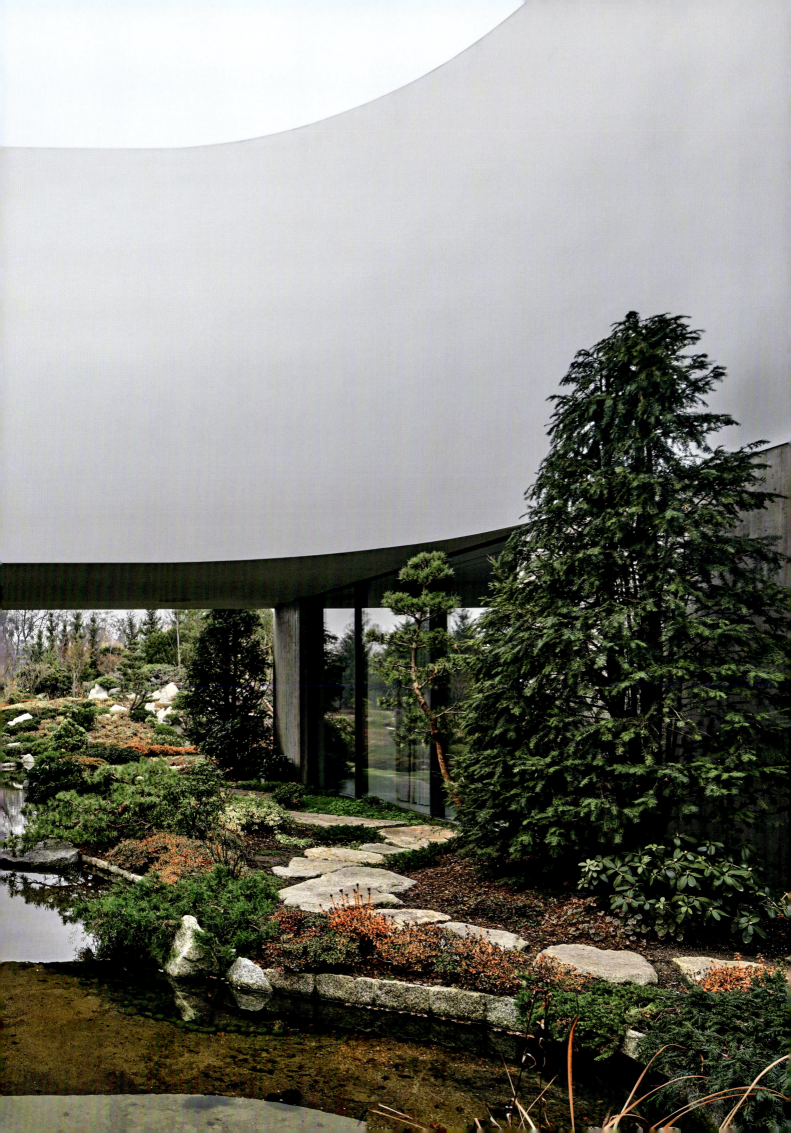

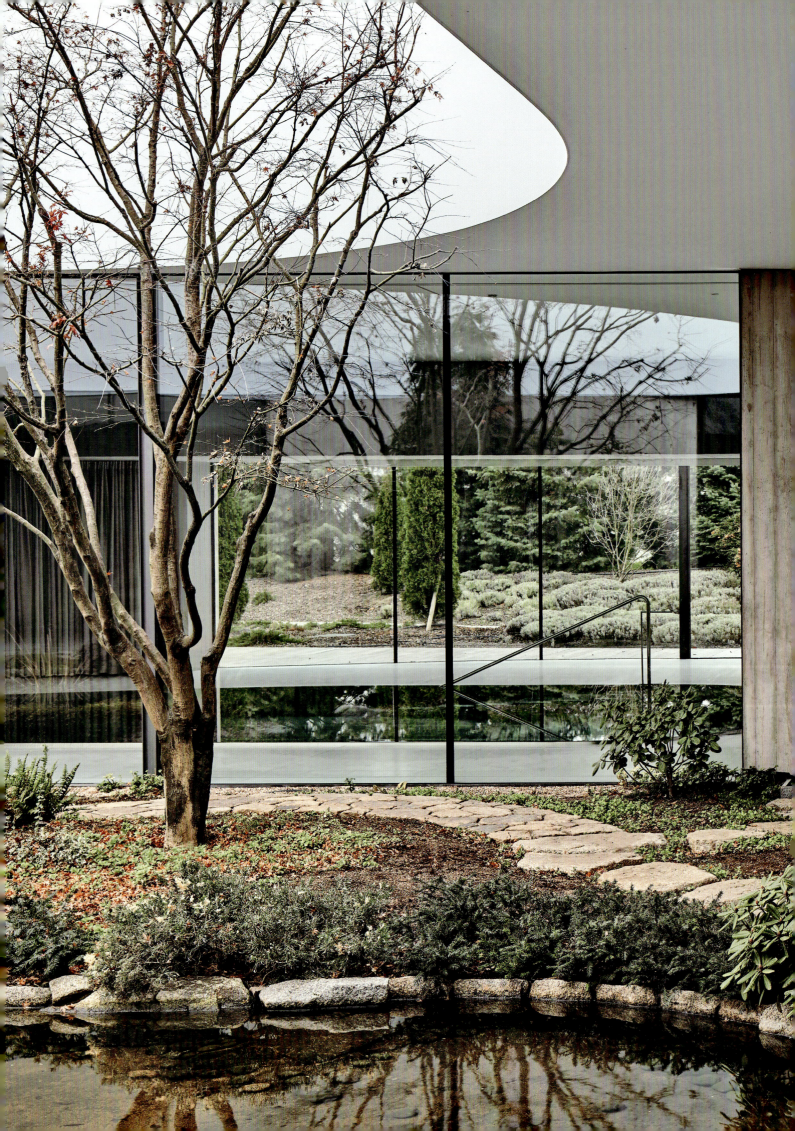

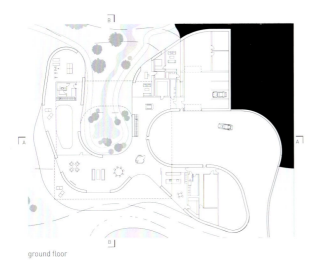

ground floor

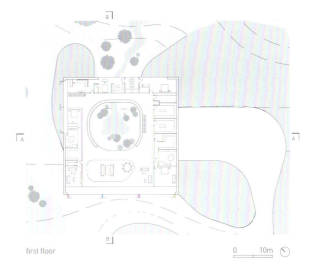

first floor

0　10m

The Japanese man spoke only his mother tongue and avoided all contact with us; moreover, the client asked us to ... →

... not bother him, because he might stop the gardening work and leave.

southwest elevation

northeast elevation

Thus, it was inevitable that the garden ...

... would be just like an existing element of the natural landscape.

northwest elevation

southeast elevation

The huge house and the extensive garden function pretty much as a self-sustaining organism ...

... that generates its own electricity, heat, water, and treats its own wastewater.

section A-A

section B-B

The semi-open atrium on the ground floor and the introduction of greenery with flowing water create a pleasant microclimate and constant ventilation ...

... that supports the natural ventilation of the surrounding rooms.

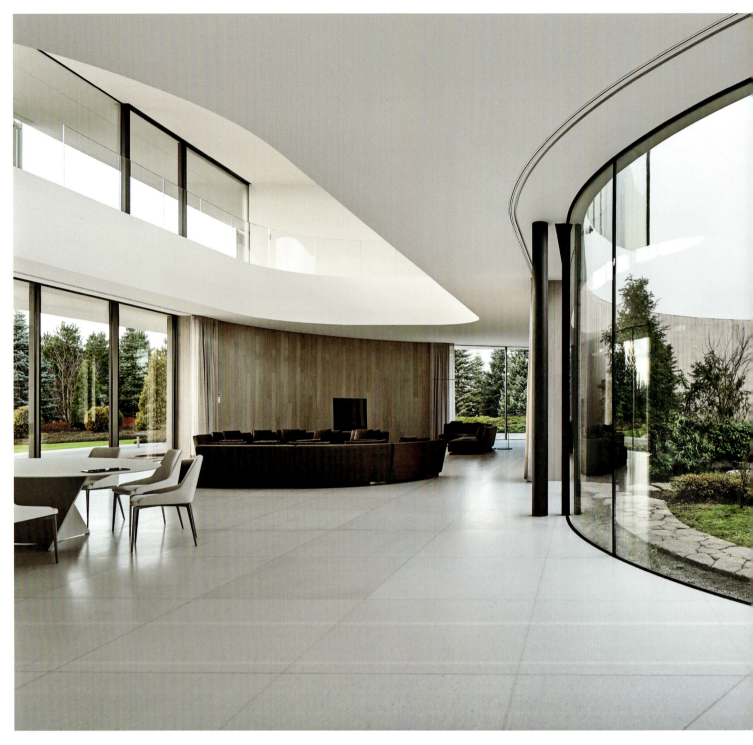

The overhang of the block over the living area protect the interiors from overheating ...

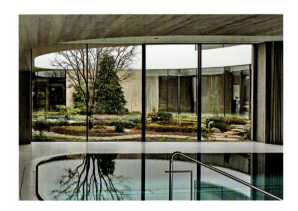

... and in the colder months, the low sun penetrates inside and warms up the rooms.

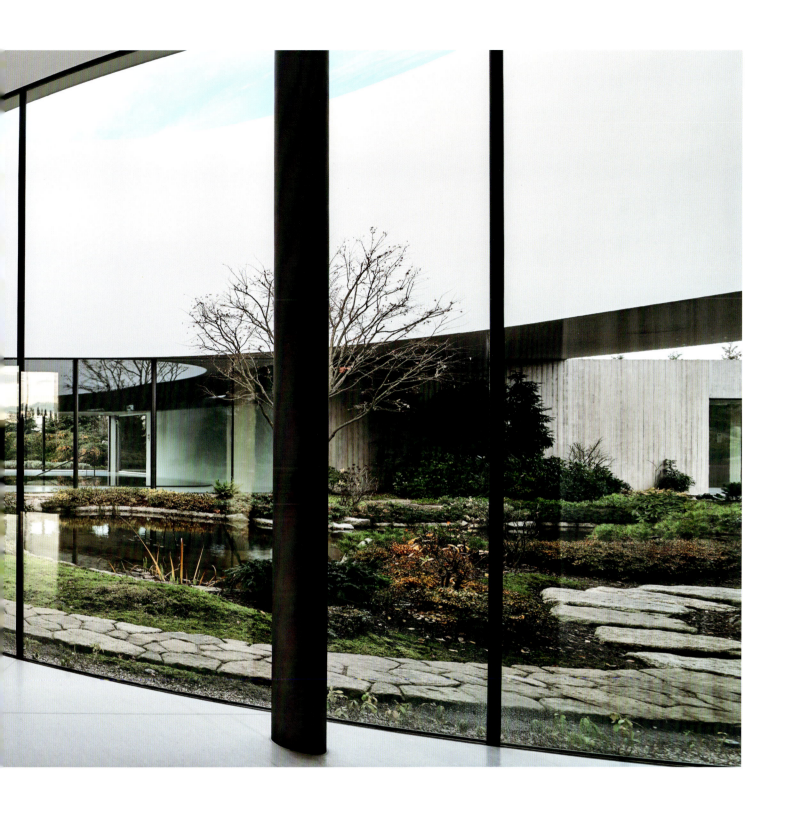

The owner is an art lover. The upstairs gallery includes a large terrace for guests to attend vernissages; and the shutters protect the valuable art collection from UV radiation.

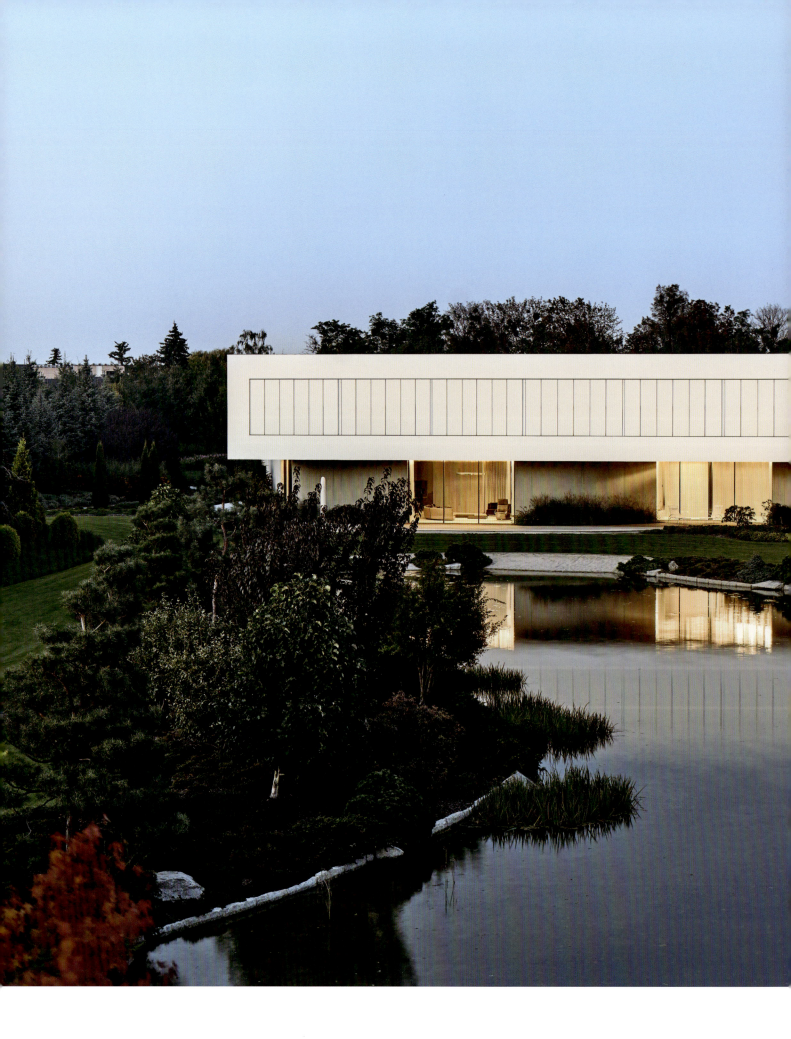

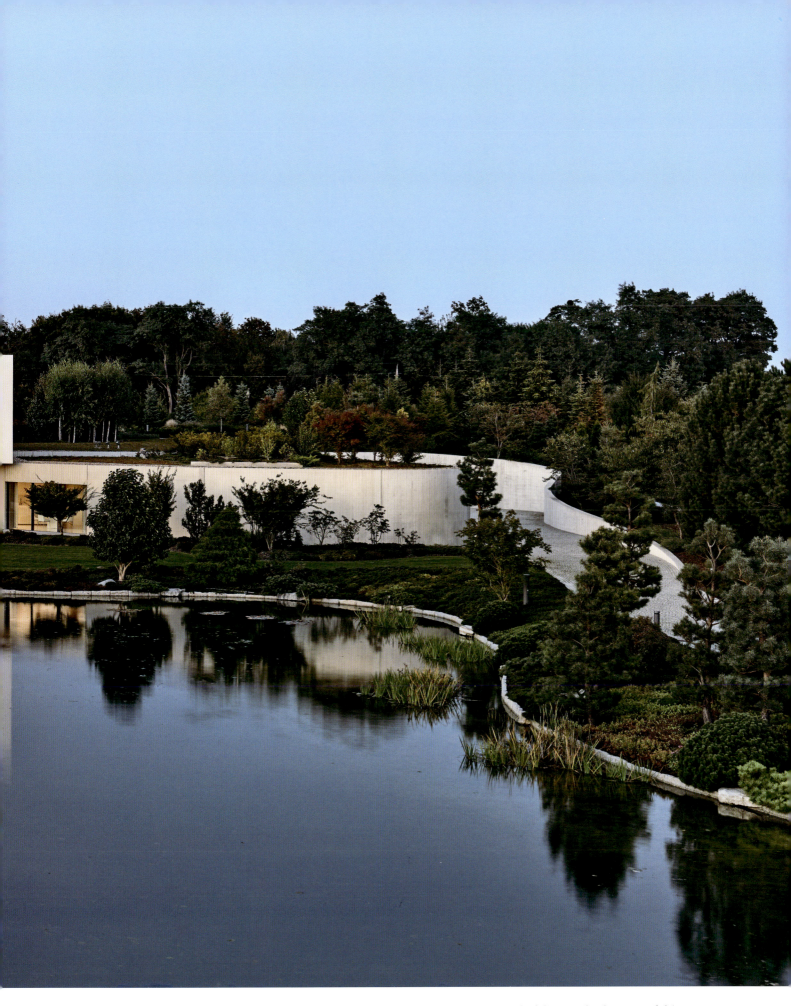

What at first seemed like a ludicrous reversal of the standard course of things, finally turned out to be quite logical. The owner wished to be able to enjoy his garden to the full as soon as the building was completed. And it worked perfectly!

topographic | mobility | contextual transformation | historical context

Przełomy Dialogue Center

2009–2015

Our museum, the winner of an international competition, was created in Szczecin (Poland), which had been a German city before World War II.

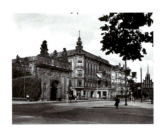

On the site of our building there used to be a prewar tenement housing quarter ... ↓

After the war, when Szczecin became a Polish city, this site had become a makeshift square, where riots broke out with the police in which sixteen people were killed.

... that had been pulled down during the war. ↗

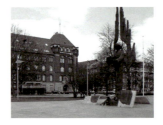

Since then it has become a public memorial site. Hence the idea to create a museum focusing on the history of Szczecin there.

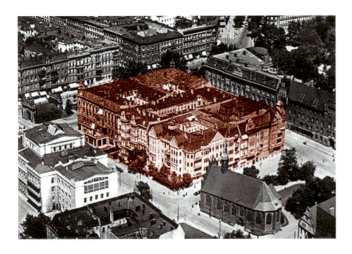

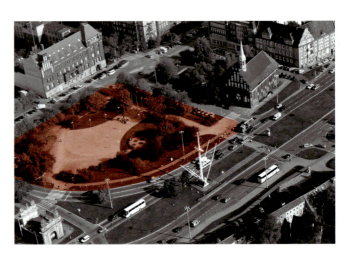

Nearby, the construction of a Philharmonic Hall designed by Barozzi Veiga had begun. We felt that the building would become iconic, so we decided to relegate our museum to the background. ↙

We decided to combine the two juxtaposing traditions of the place—the prewar tenements ...

... with the postwar square.

1944

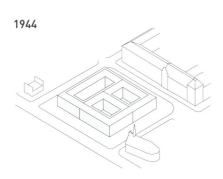

2009

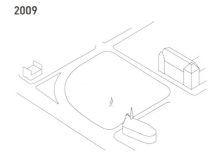

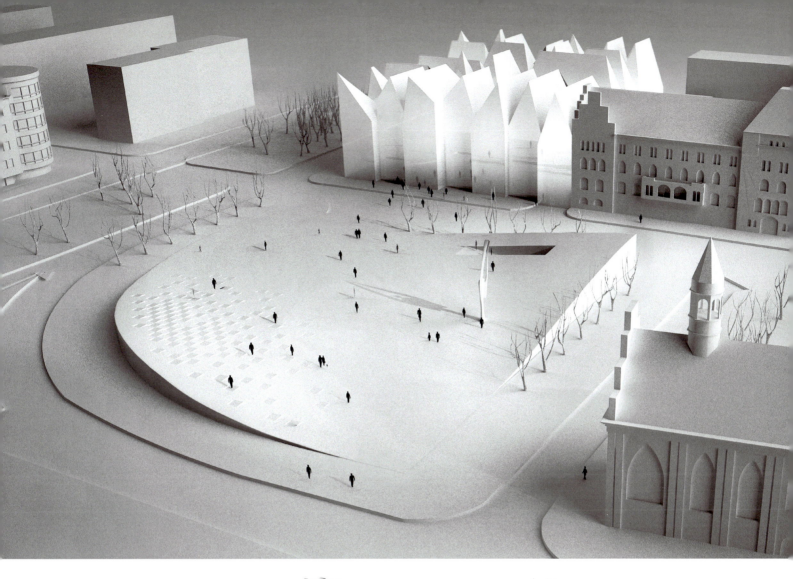

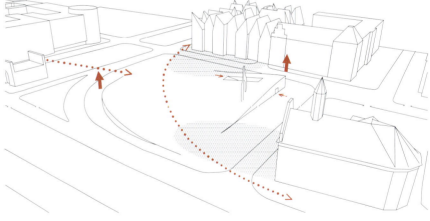

The effect was to create an urban hybrid of both—a quarter and a public square.

In front of the Philharmonic Hall and the church we needed a foreground; and where we could re-create the old quarter, the square rises gently. On the right we placed the museum, and on the left a hill emerges, separating the square from the traffic.

2015

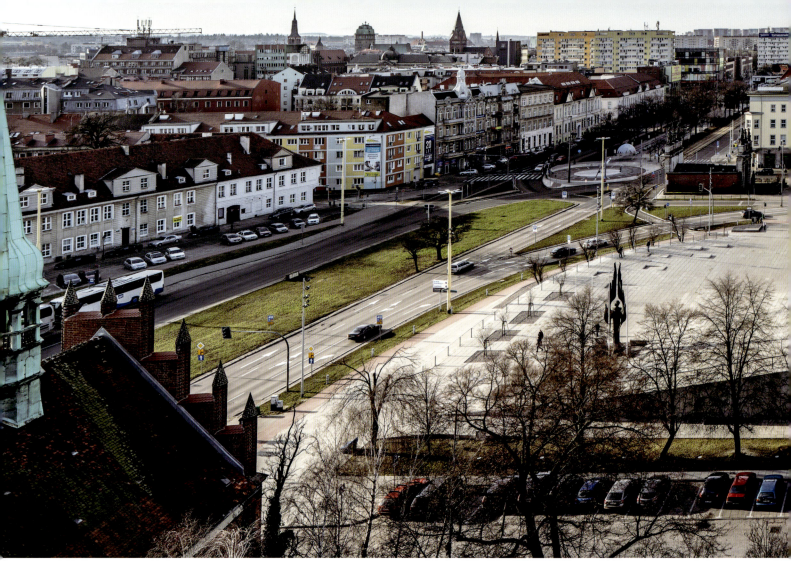

We aimed to give the amphitheater-like space of the square a uniform, monolithic character, so we used one material—concrete.

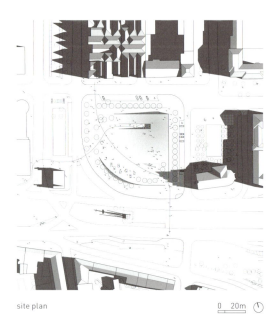

site plan 0 20m

Looking at this site plan, it's difficult to comprehend how much space our museum occupies under the square.

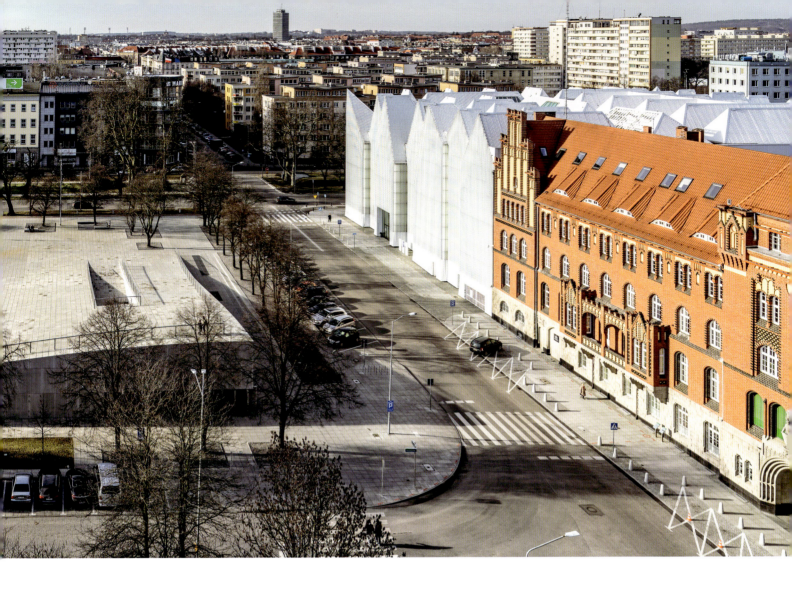

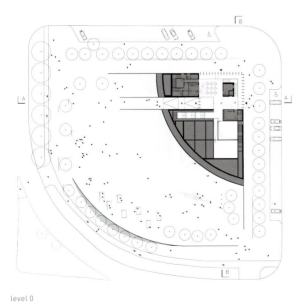

level 0

Only the cross section of the first level shows just a small part thereof. For this was the area of the square contained within the competition project.

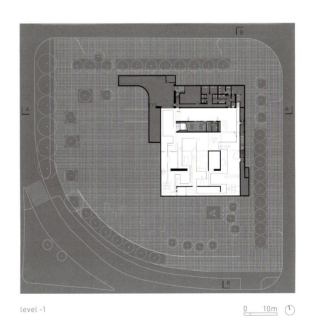

level -1

We decided to design the whole square, breaking the contest rules, which the jury happily appreciated, yet the budget for the project remained the same.

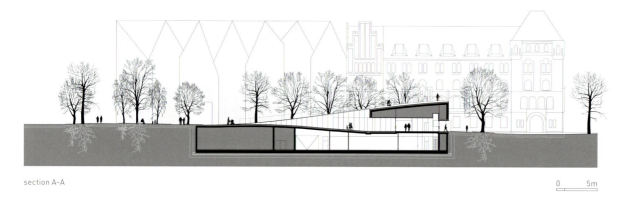

section A-A

The entire exhibition area is located on level 1. The ground floor of the building is an extension of the square and is mainly the entrance area.

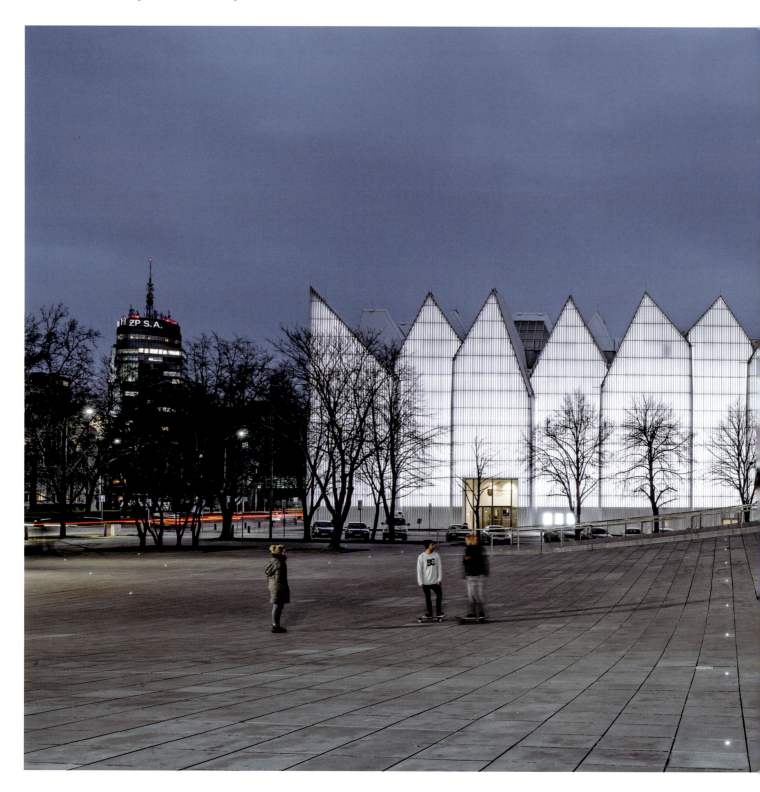

Standing in front of the Philharmonic Hall, we can see a flattened square, forming its foreground. A similar flattening occurs in front of the church.

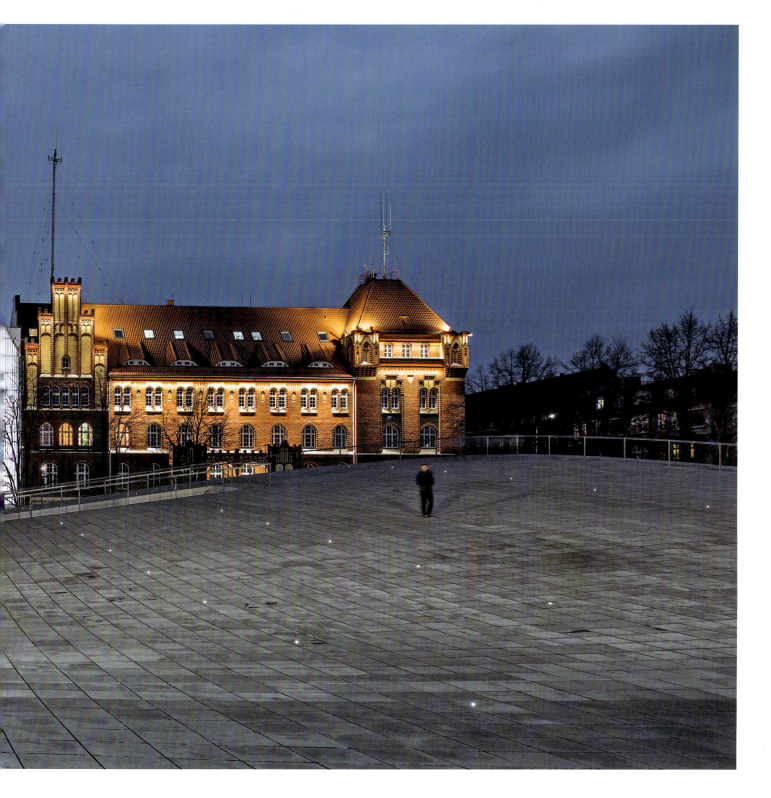

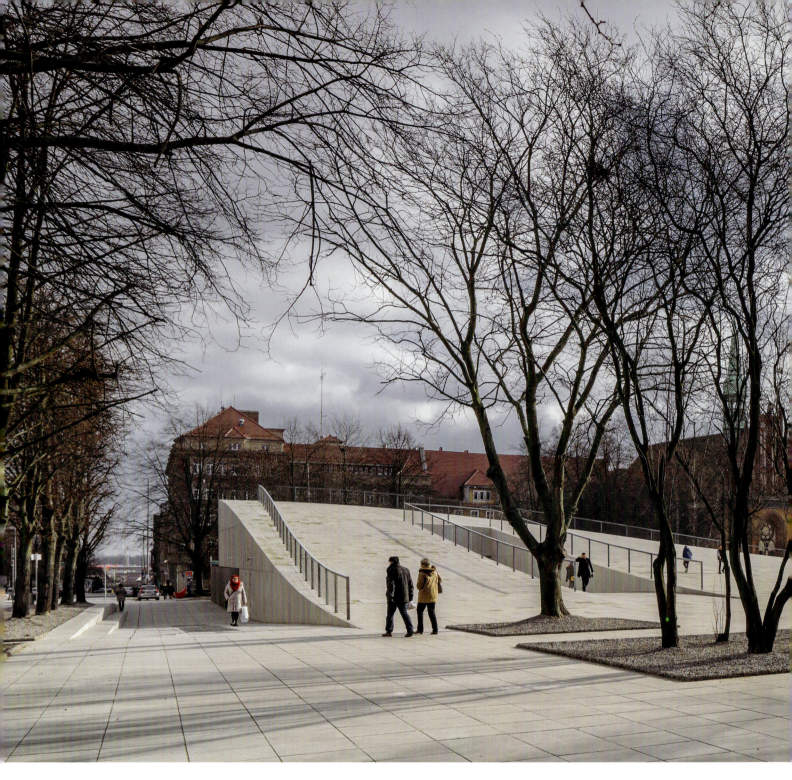

Looking from the side of the Philharmonic Hall, on the right there is a hill cutting off the square from the traffic, and on the left ...

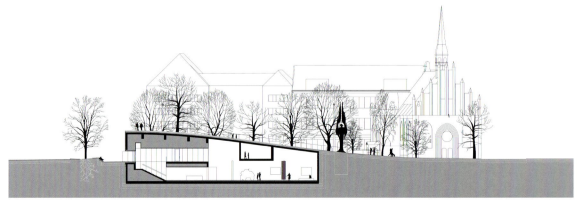

section B-B

... there is a gently rising corner of the square with the museum hidden therein.

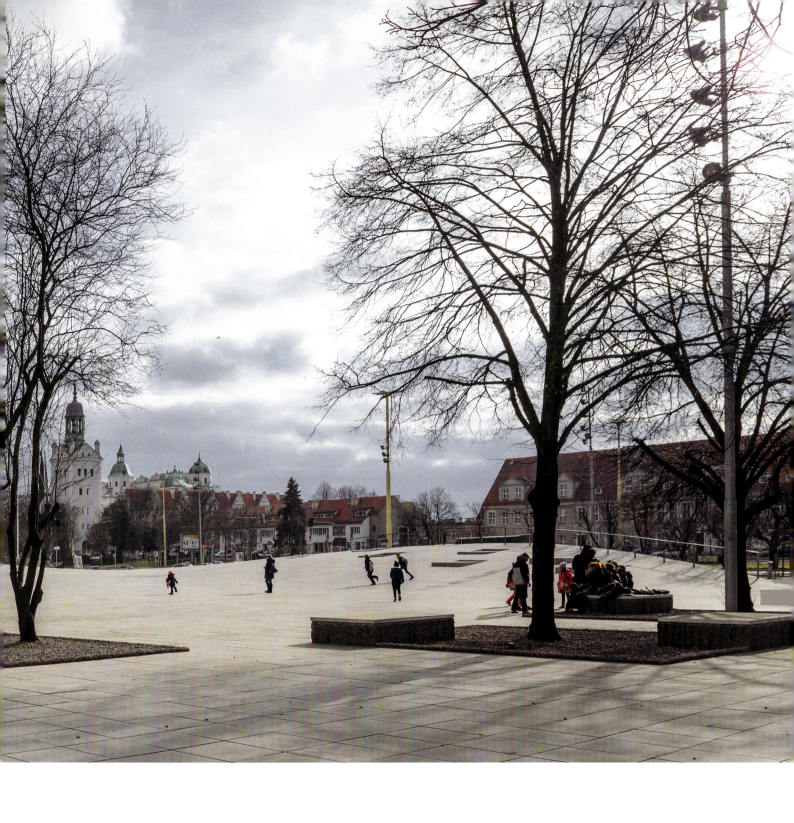

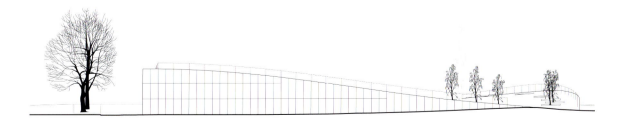

west elevation　　　　　　　　　　　　　　　　　　　　　　　　0　5m

Entrances lead into the museum from both the corner and the square.

It was quite a challenge to design the installation so that there would be no technical infrastructure visible in the square, leaving the space clear, open, and unobstructed for the public.

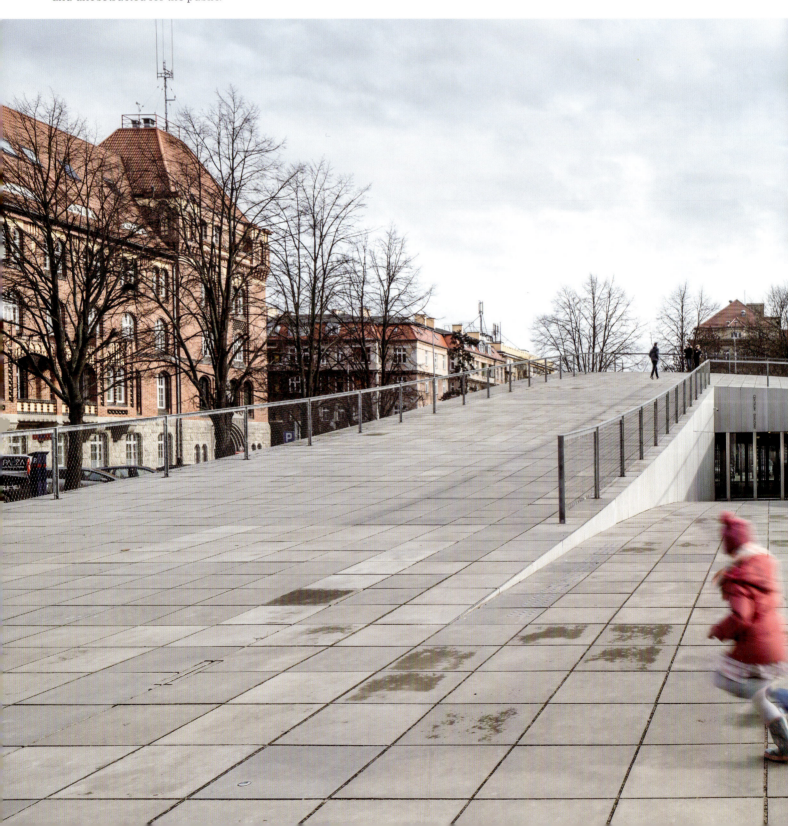

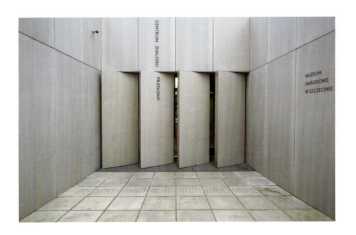

All entrances to the museum are hidden behind ...

... rotating walls.

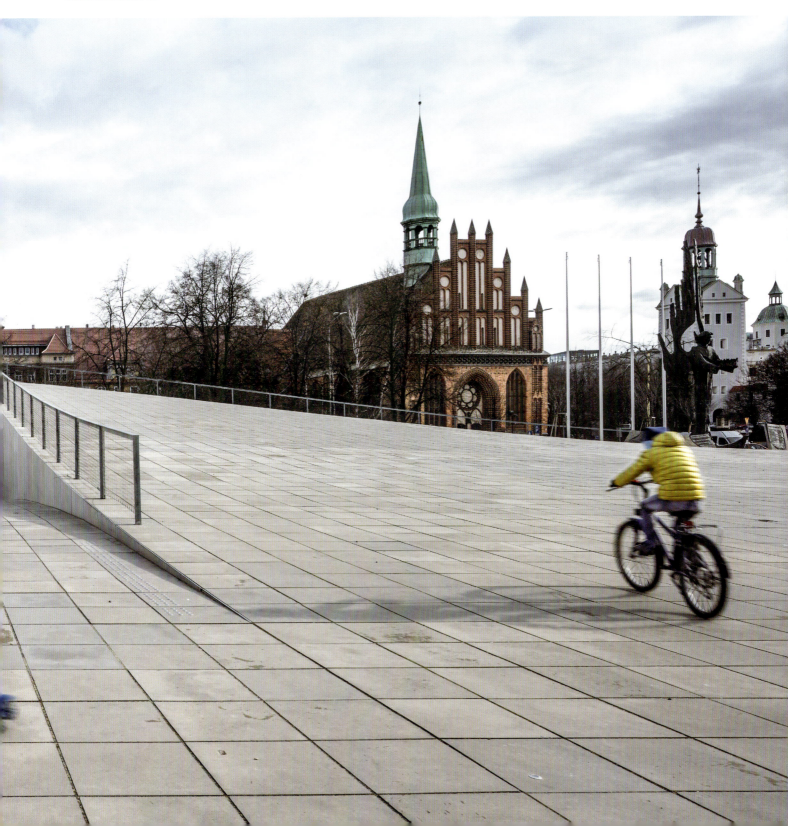

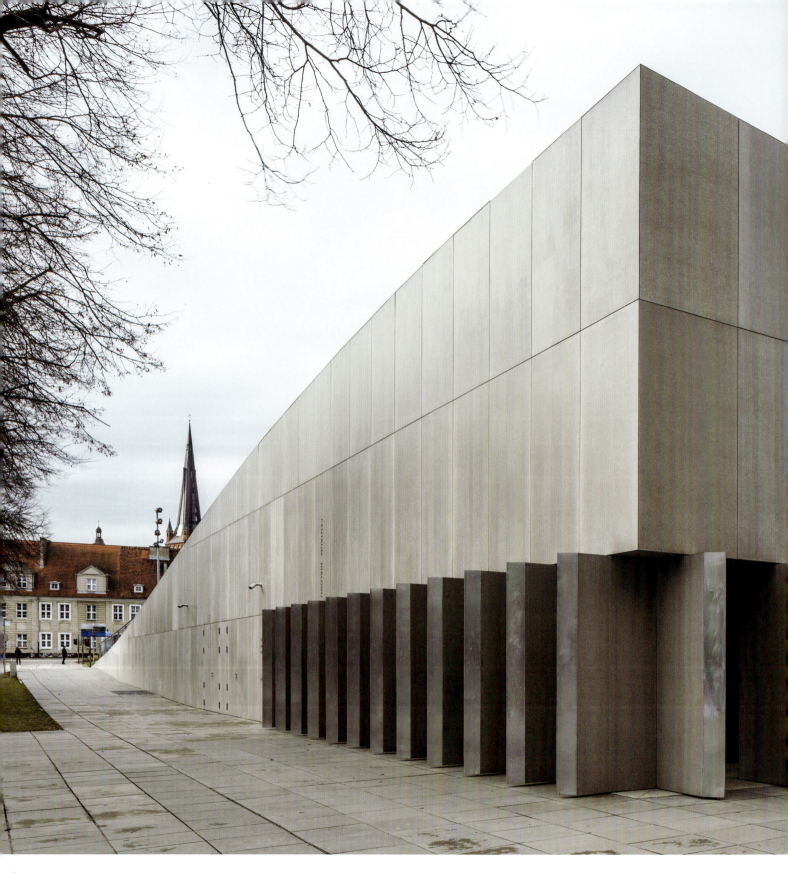

When the walls are closed, the structure appears as a monolith made of concrete blocks, which ...

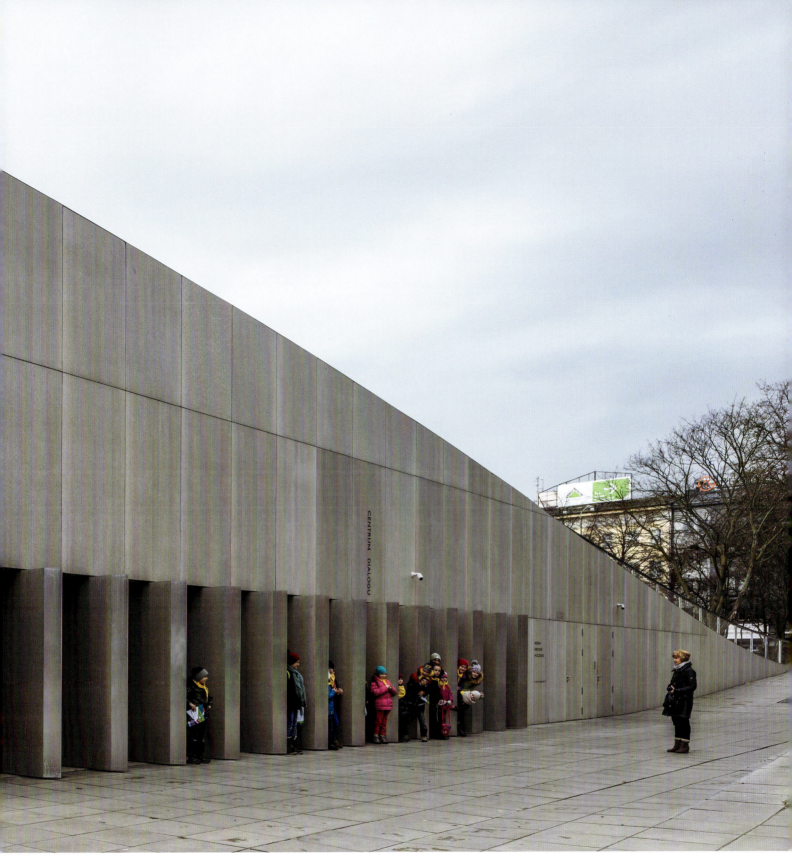

... is achieved when the divisions of the slabs from the square fold into the divisions on the façade ...

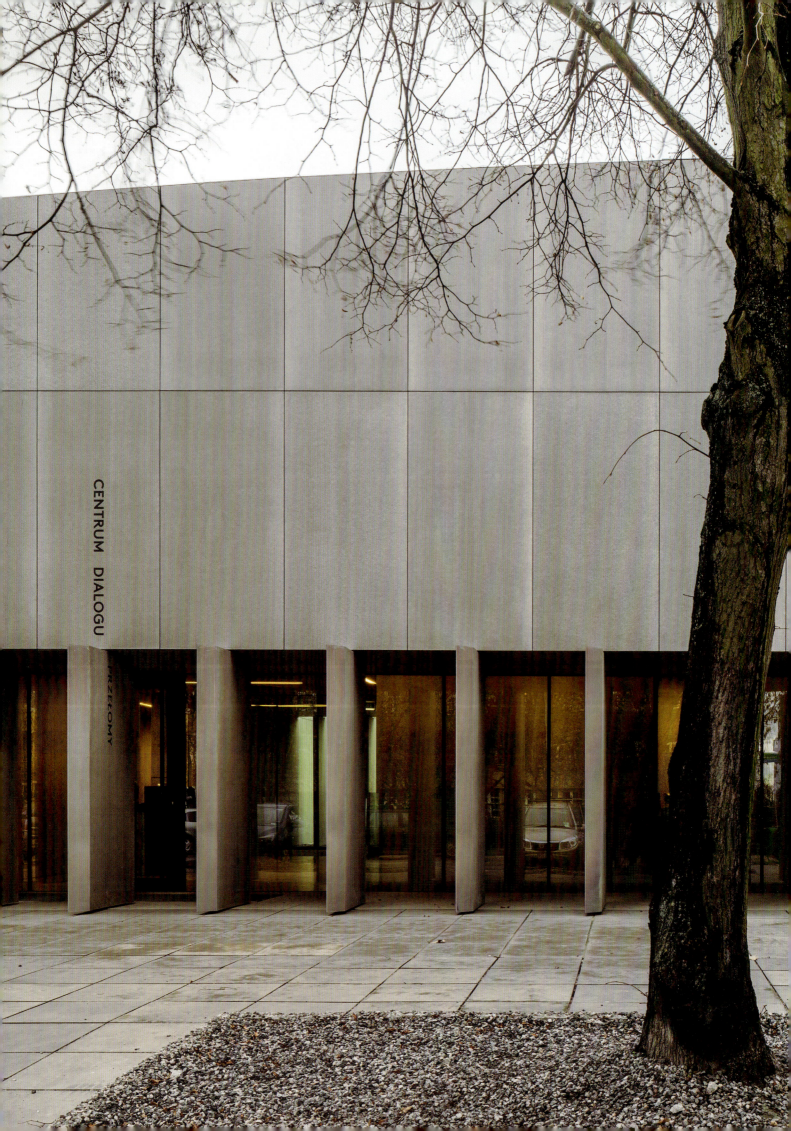

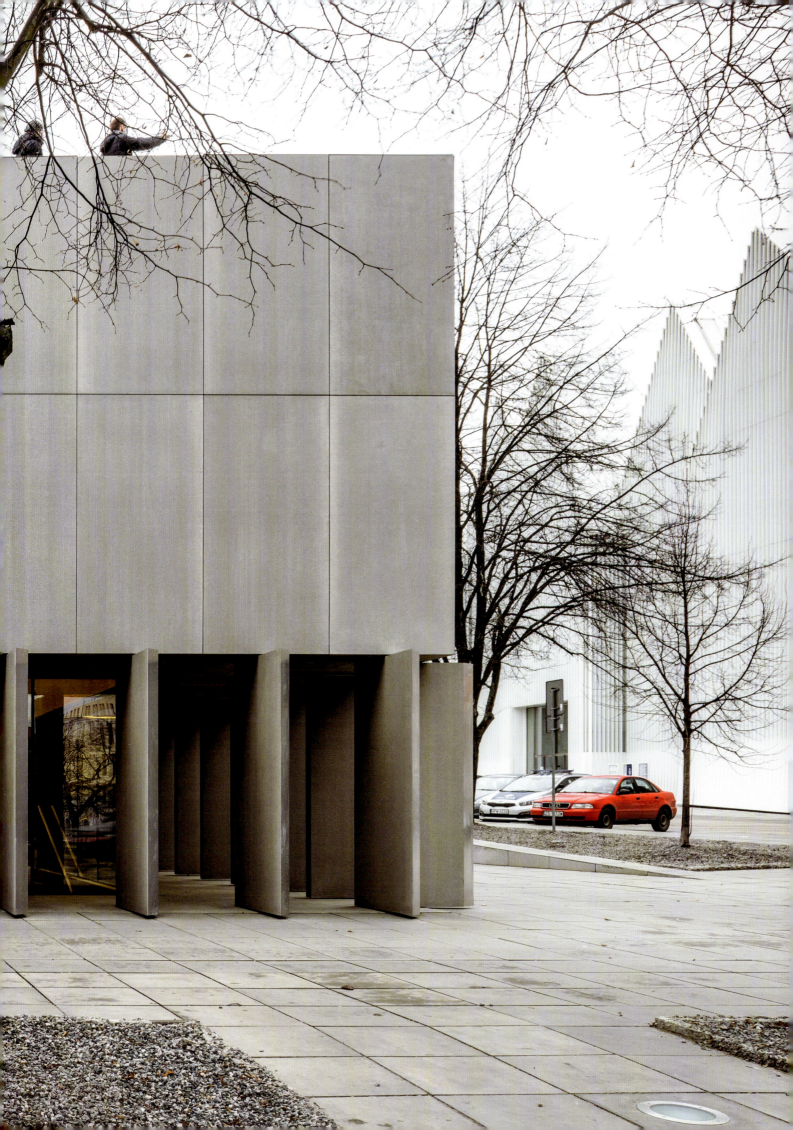

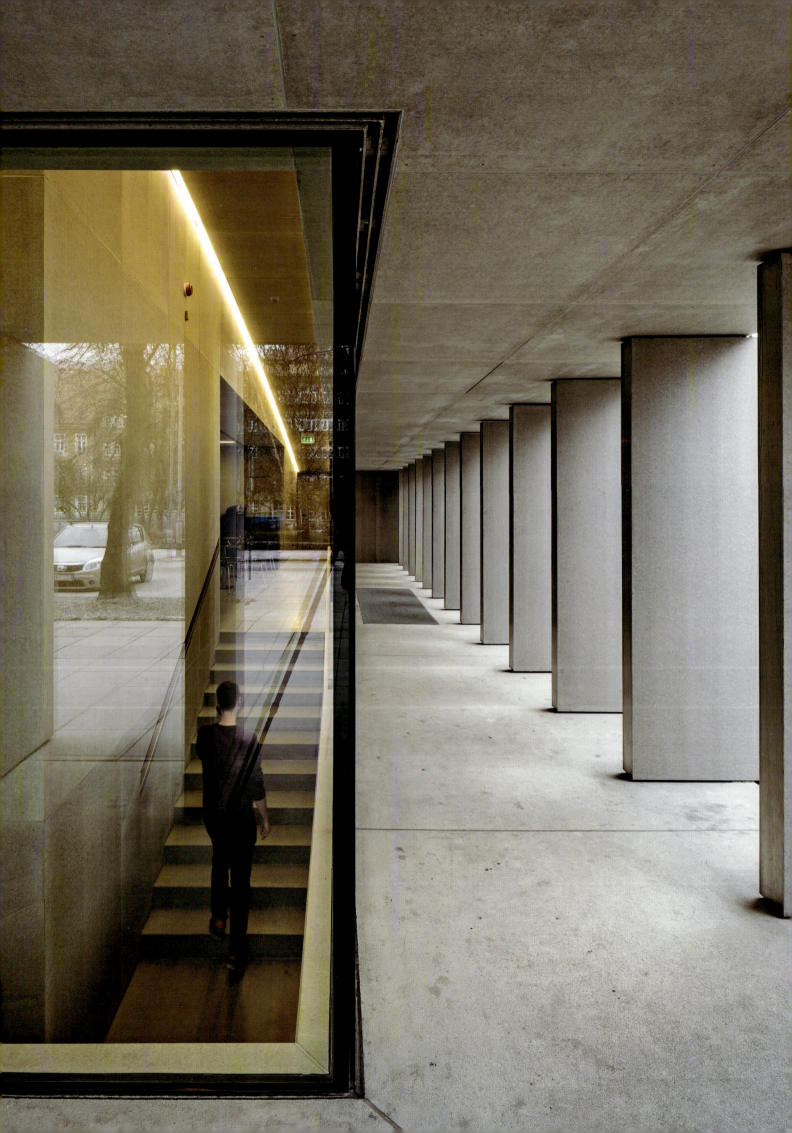

... blending seamlessly with the interior, which is made of the same concrete slabs. Above the glazing, we hid ventilation slots to draw in air so as not to disrupt the façade.

The descent to the exposition is like crossing a border between two worlds. We were required to collaborate with the exhibition designers, whose ideas veered toward installations with scenographic motifs. We felt very strongly that ...

... the simple use of black as a backdrop throughout would make a much stronger visual statement. We convinced the designers to discard the somewhat intrusive scenography and replace it with artwork on the black walls, particularly art that adds to the story in a nonliteral way (many contemporary artists joined the project).

The result is much more impactful, and in this way we created a historical museum that is also an art museum.

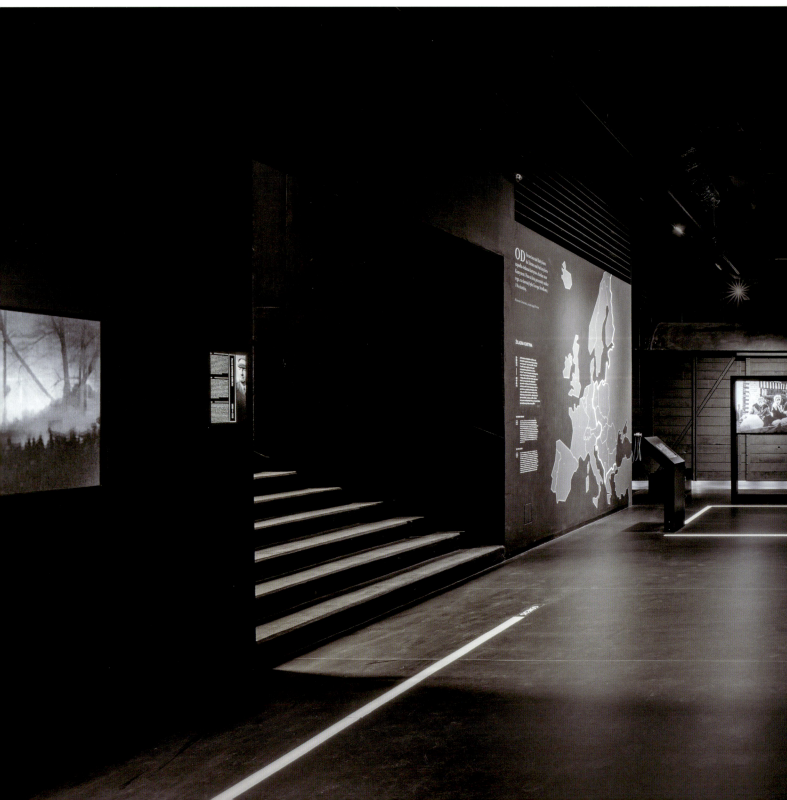

The exhibition exit point is bathed in light, the direct opposite of the entrance, which is cloaked in black.

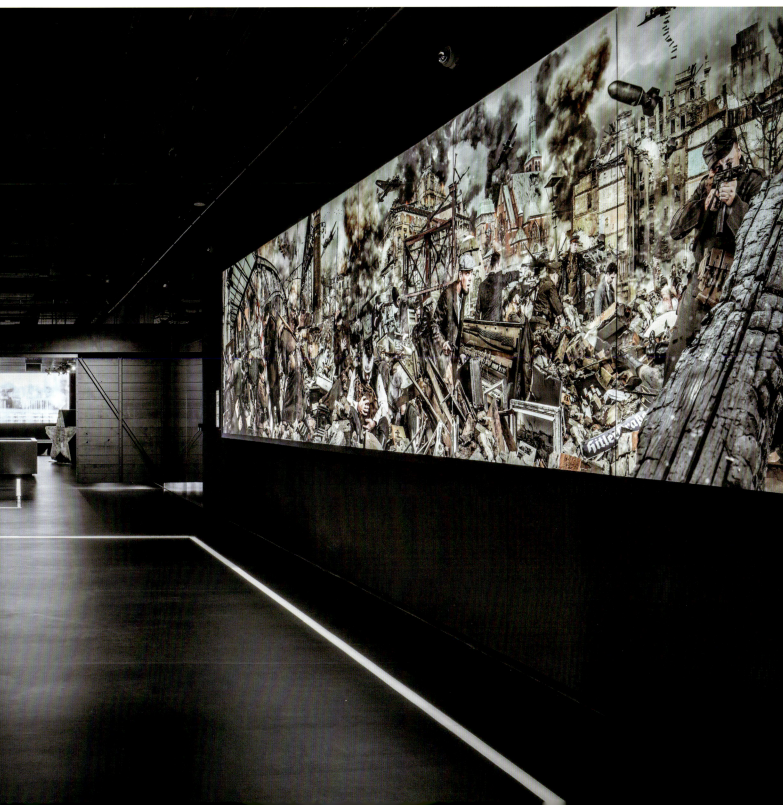

When the museum closes, life goes on in the square. It is now a favorite spot for young people to congregate. It is worth noting that ...

... we were forbidden to use ground materials that would encourage sports to be played, given the space is to be respected as a place of remembrance.

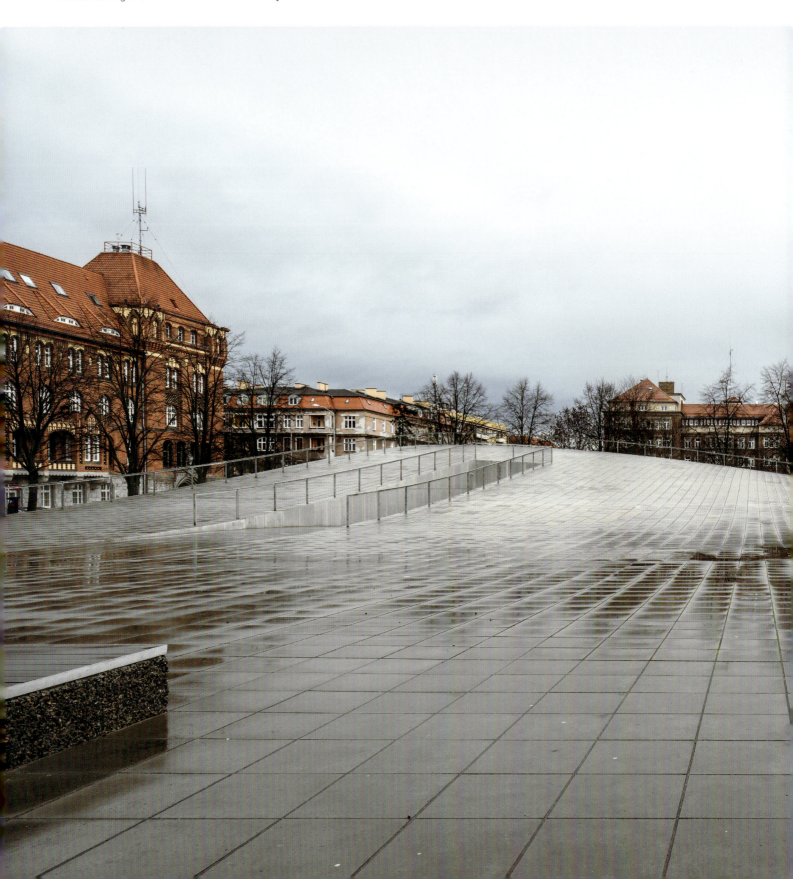

Still, the square's surface area and shape did cause some consternation. During the square's inaugural ceremony, high-ranking VIPs stood ...

... at the bottom of the square; the least important were at the top. Soldiers marching across the slanting surfaces would trip over throughout the ceremony.

In time, however, both the city authorities and citizens understood that this was a place for spontaneous demonstrations, concerts, entertainment, and ...

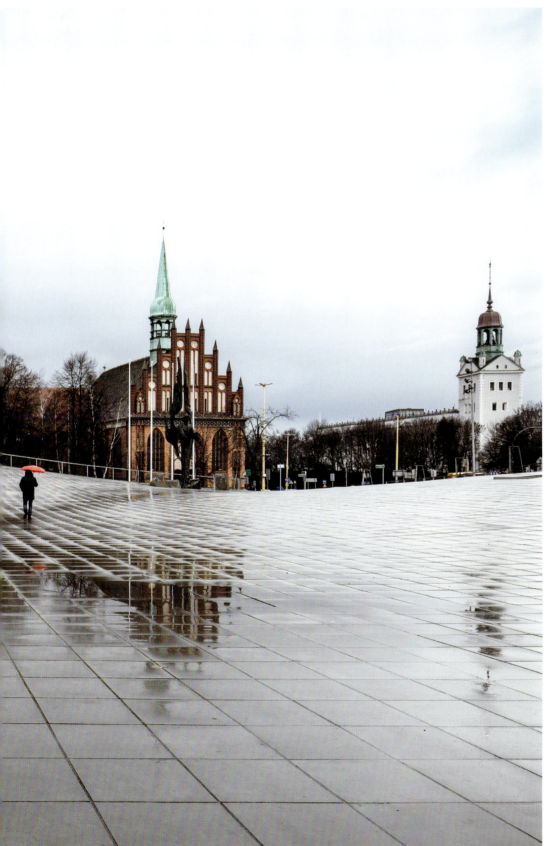

... exhibitions. That's when we developed the idea that ...

... through the use of mobile walls the exhibition halls could also be opened up, providing artists with new exhibition possibilities. In fact, this was only achieved at the Art Bunker (pp. 27, 33, 280) in Cracow.

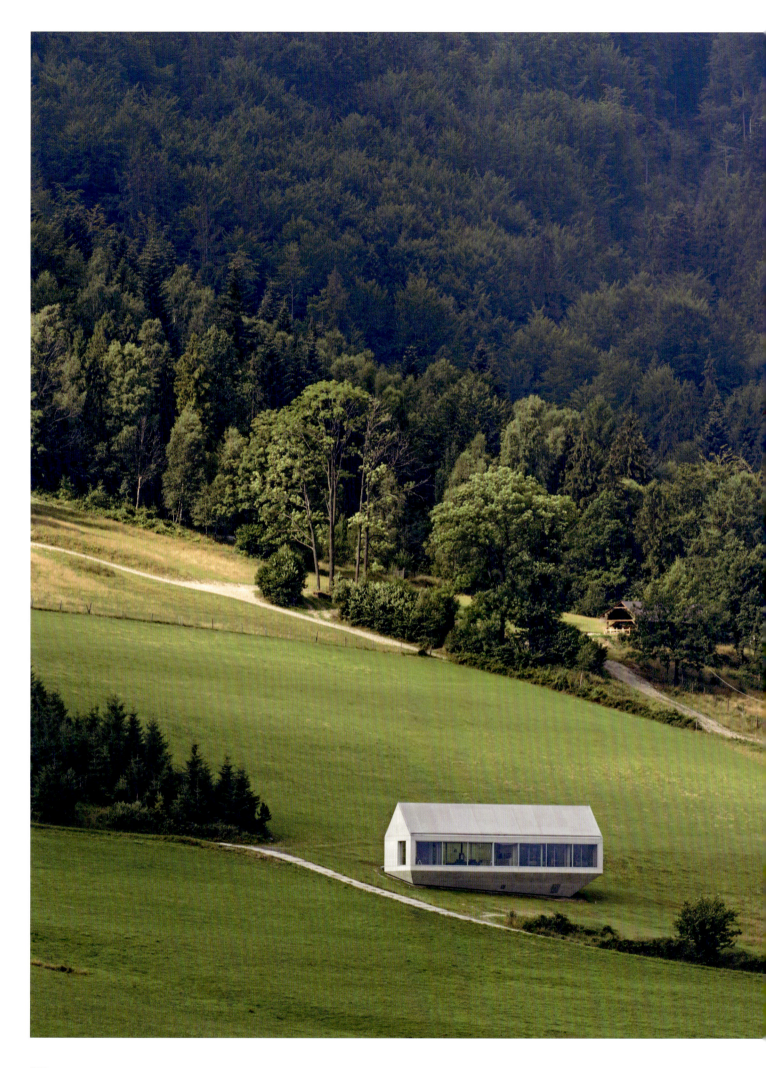

mobility | contextual transformation

Konieczny's Ark

2010–2015

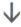

The story of the design and construction of my own house might seem pretty crazy ...

My wife persuaded me to find a plot with a view, where we could build our house. Within two years, I created the project, inspired by a traditional Polish countryside dwelling. ↙

When the construction started, there was a series of serious landslides in Poland, a phenomena unknown prior to these events ... I started to fear that it might affect my house, too, since the project interacted with the ground in a significant way.

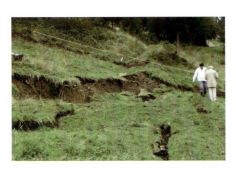

THREE DAYS!

It was stronger than me! To my wife's horror, I decided to stop the excavation and change the whole project. And prompted by my fear of her, I promised that I would make a new design within the next three days, so that the builders wouldn't run away.

I had to reset my objectives and recall what was the most important for us—the view! The house was supposed to be a kind of a frame for the landscape.

I decided the best solution would be a one-story house. However, my wife didn't agree, fearing the wilderness.

Thus, I came up with the idea to slightly rotate the house away from the slope. Only one corner was in a direct contact with the site and the bedrooms were safely suspended above the ground.

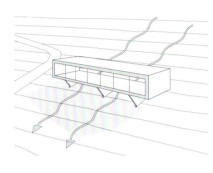

To mitigate against possible future landslides, I decided the house would be a sort of a bridge, supported on three triangular walls (minimal impact on the ground, but maximum support)—under which, the rainwater can flow freely.

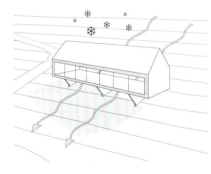

A gable roof was the most obvious way to deal with heavy snow falls in the winter as well as comply with local planning regulations. No eaves allows snow on the roof to melt and flow under the house.

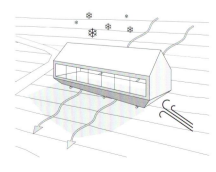

I needed some technical spaces, so I closed the void under the building with a series of planes, referring to the shape of foundation walls. The house started to resemble an ark.

It had been three days since I started the design.

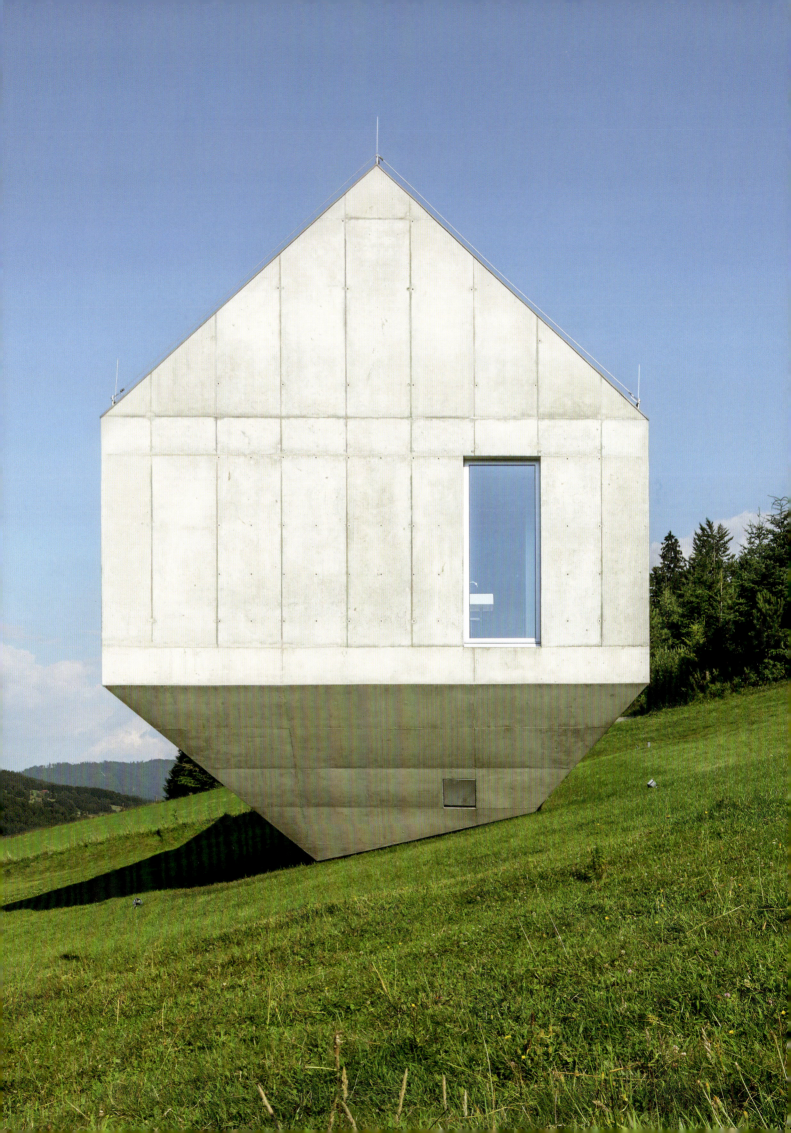

The plot around the house looks as if it has
no borders, but this is just an illusion.

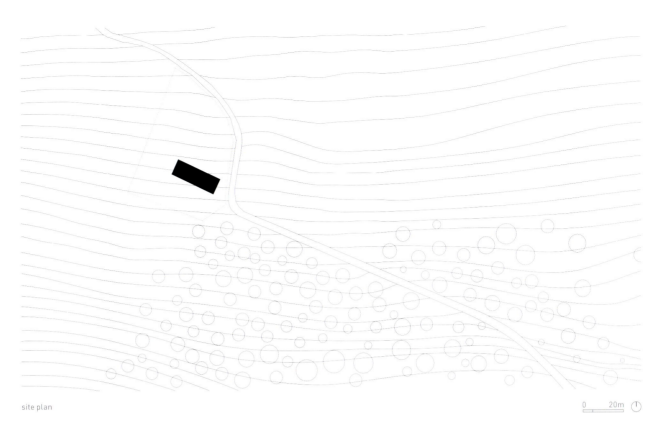

site plan 0 20m

Actually, the plot is quite small. At some point I realized that the house should be a part of the nature surrounding us. That is why I gave up on the idea of a garden and fence.

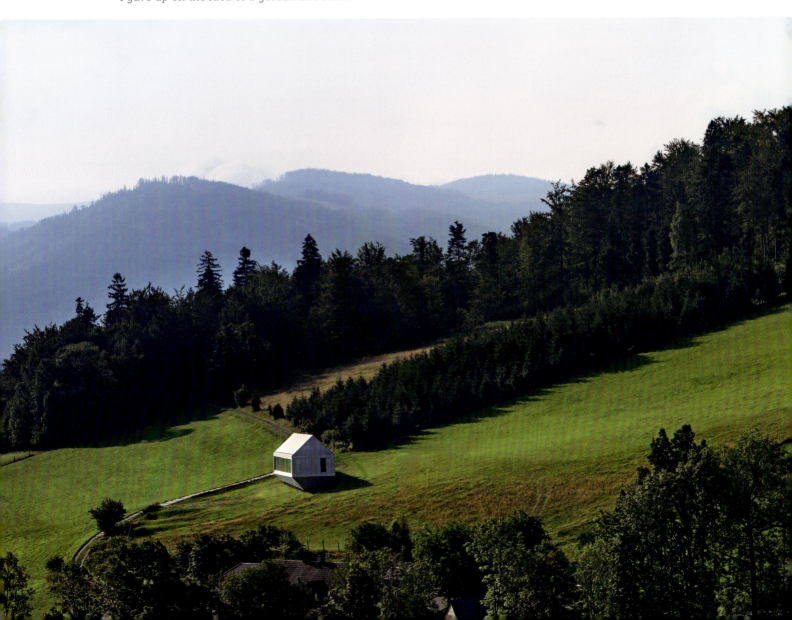

This also influenced the design of the entrance to the house.

Abandoning the fence ...

... resulted in imagining that the only borders were the outlines of the building, which let nature reach the house.

I came up with the idea of a drawbridge ...

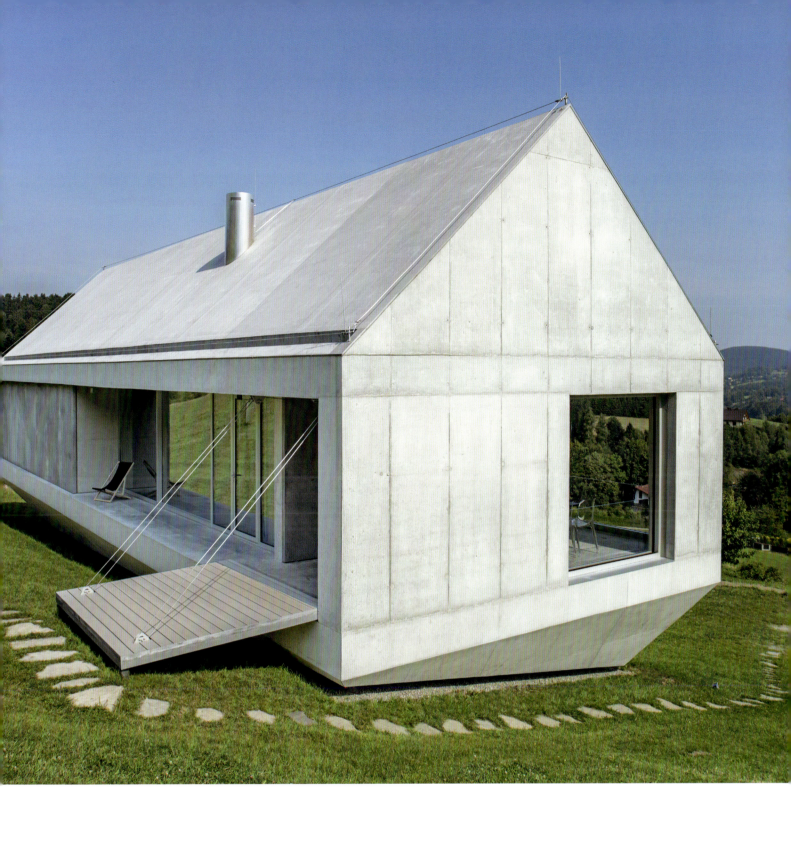

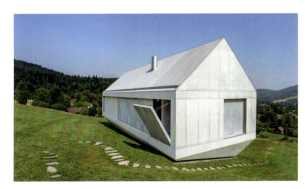

... that is both an entrance to the house and acts ...

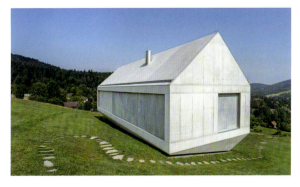

... as a shutter that protects the house from the south.

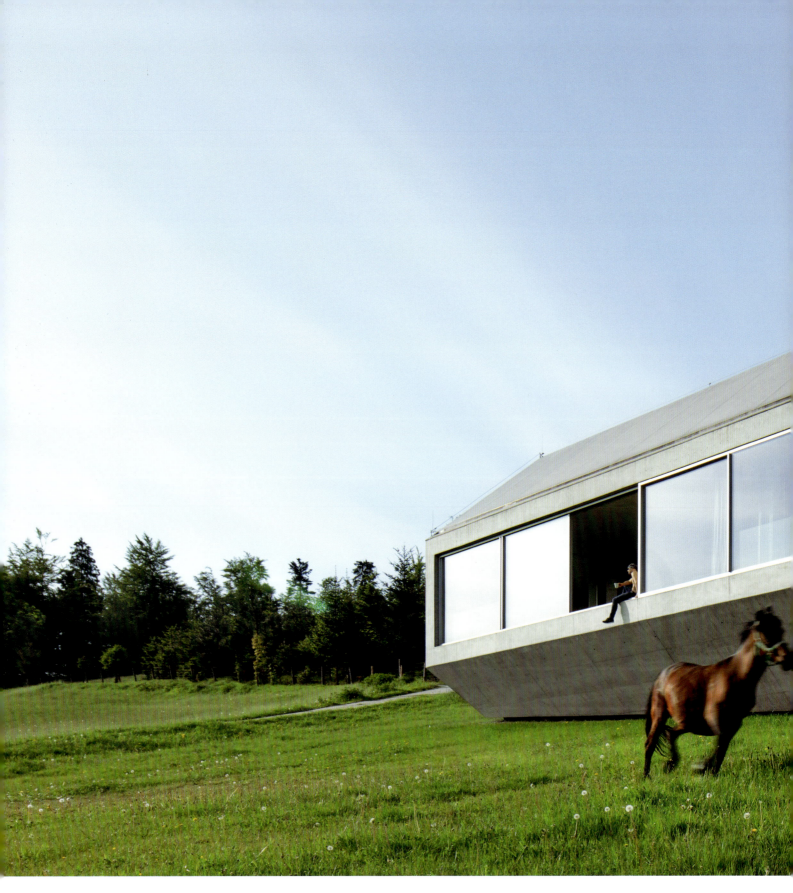

What's more, there is a natural symbiosis with animals, grazing around, eating the grass, and mowing our lawn at the same time. When there is rain or wind, they treat the space beneath the house as a shelter. The Ark thus took on a real and even sublime meaning.

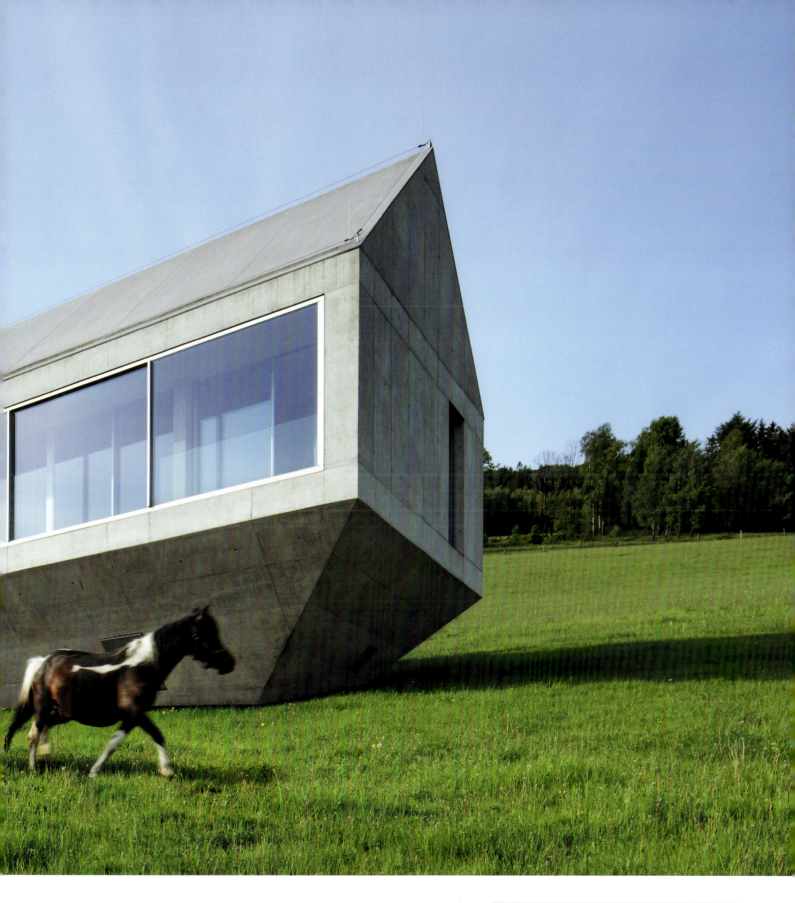

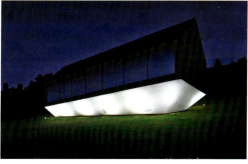

In order not to invade the beautiful landscape with lamps illuminating the plot, I used the casing of the Ark as a reflector that emits light.

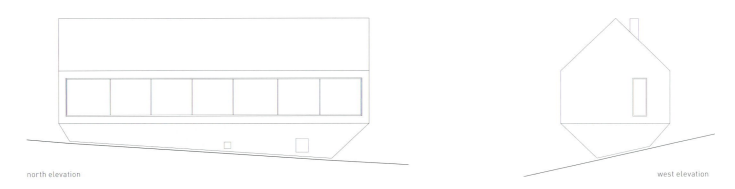

north elevation

On the north side, all the rooms open up to the view ...

west elevation

... because they are raised well above ground level.

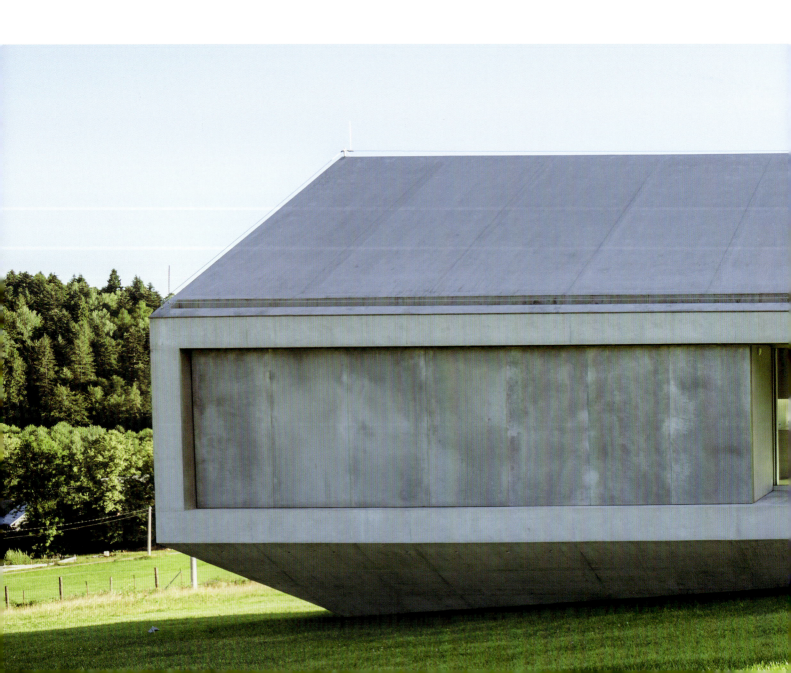

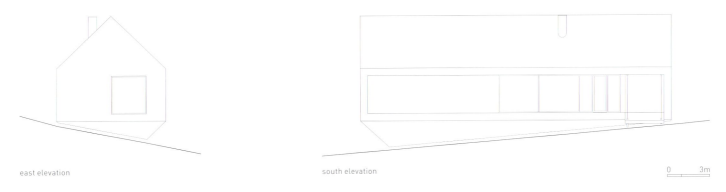

east elevation

south elevation

0 3m

From the east and ...

... from the south, the house has a longer connection with the ground ...

... so at my wife's request, I closed the view to the bedrooms.

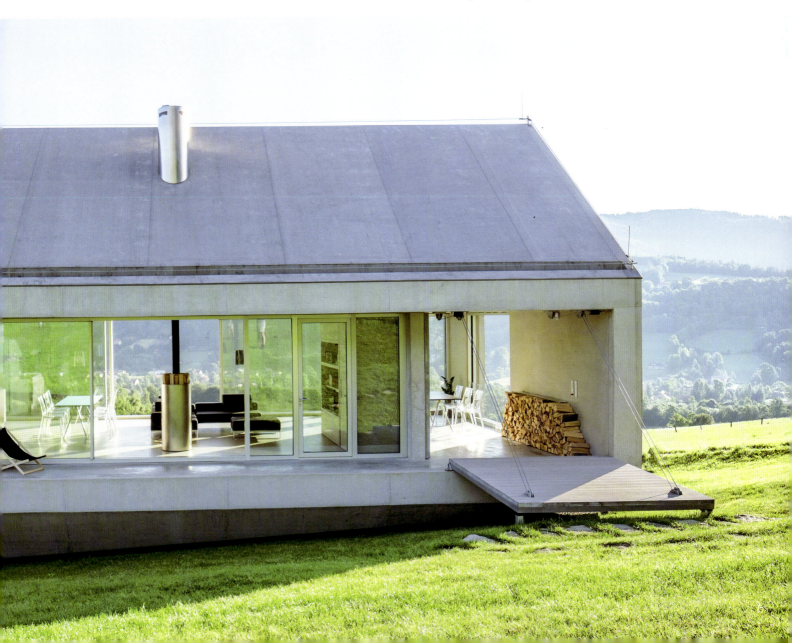

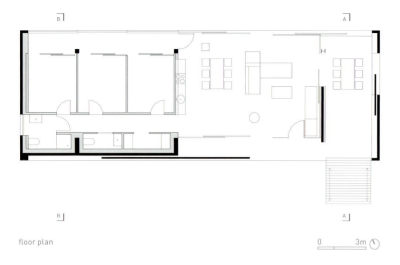

floor plan 0 3m

I placed the bathroom facilities there.

The glazing, from the sunny side of the daily zone,
is pulled back to protect the interior from solar gain.

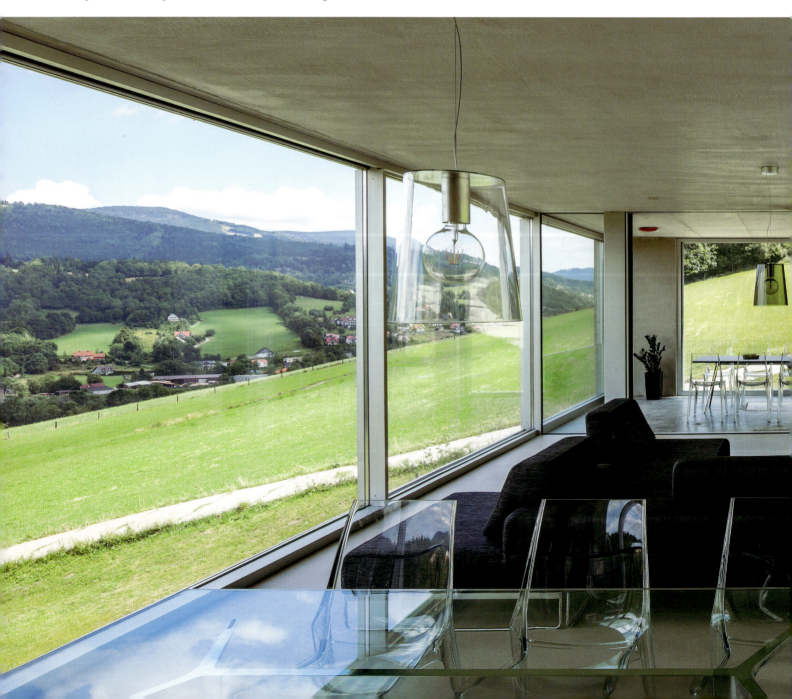

section A-A

In order to simplify the construction, I used the structure as a façade ...

section B-B

... putting the insulation inside.

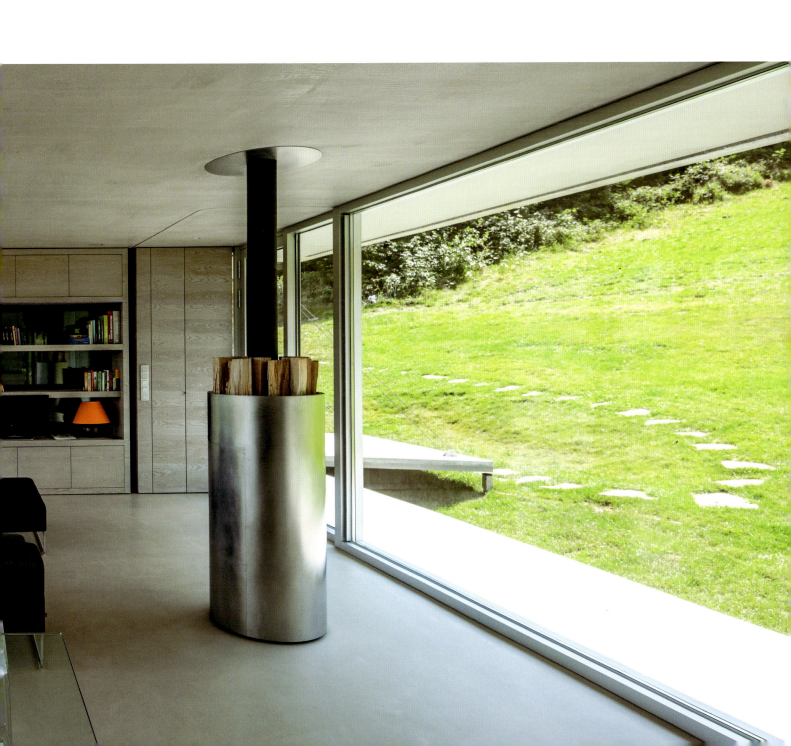

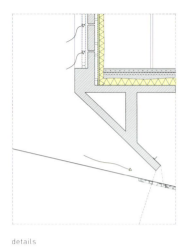
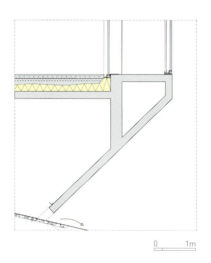

details

0 1m

Incidentally, I came up with an unprecedented system for ventilating the façades.

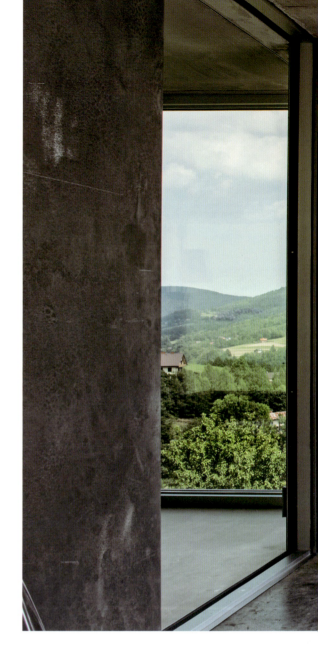

Painting the polyurethane foam, which had been sprayed over blocks of styrodur, turned out to be rather interesting and was probably the cheapest finishing ...

... for the bathroom's interior.

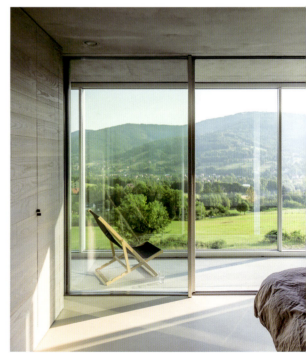

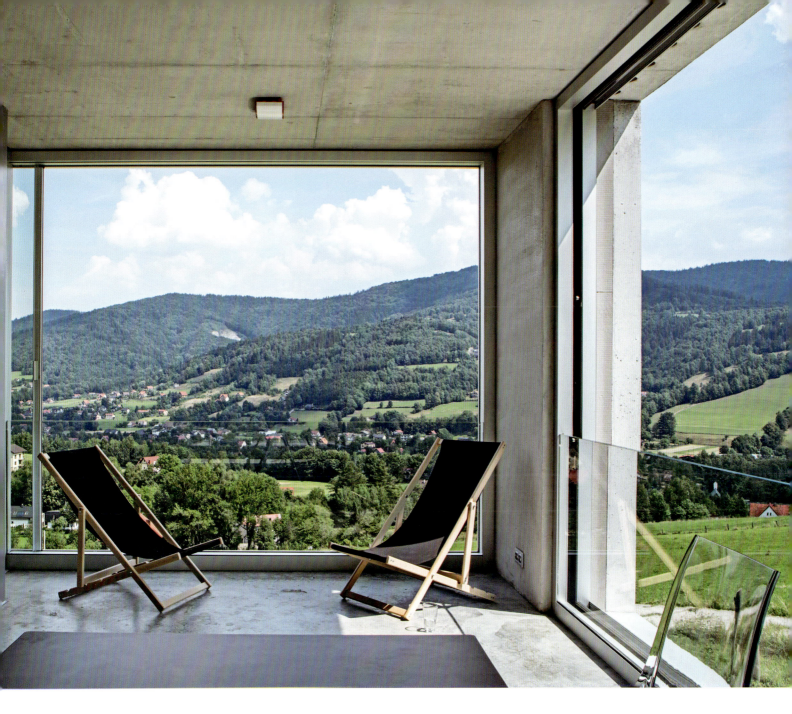

The terraces are protected with sliding windows.

I used timber and stainless steel inside, which make the bedroom look bigger and more spacious, and expands the view as well.

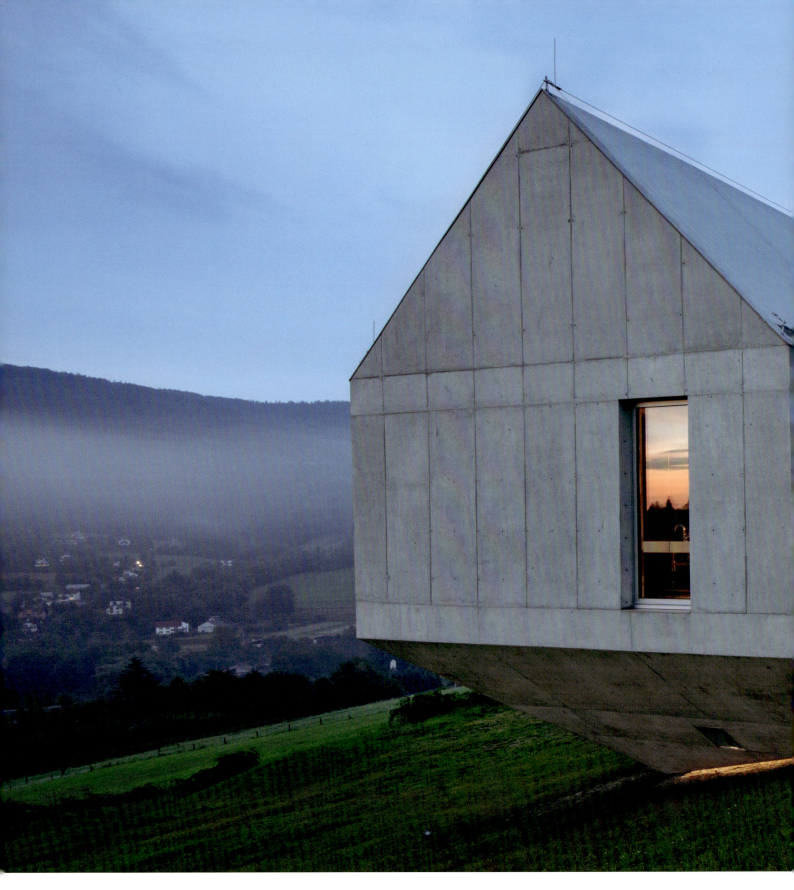

At nightfall, the light coming out of the building makes the house seem to hover or levitate over the slope ...

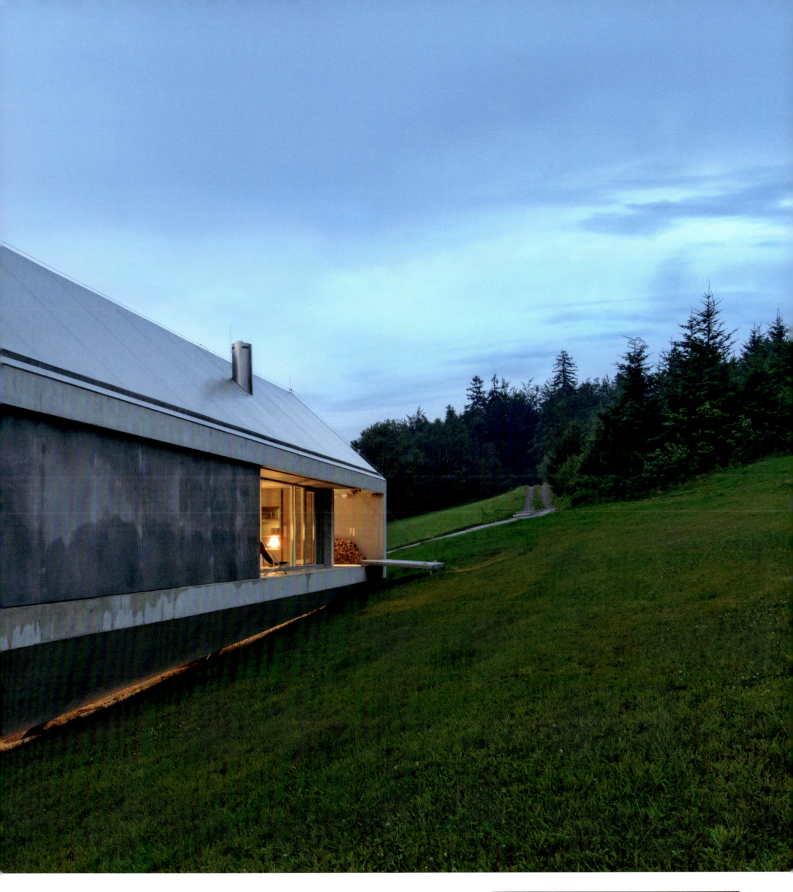

... but it also allows rainwater to flow freely, thus avoiding conditions that cause landslides—the main reason for the change of the design.

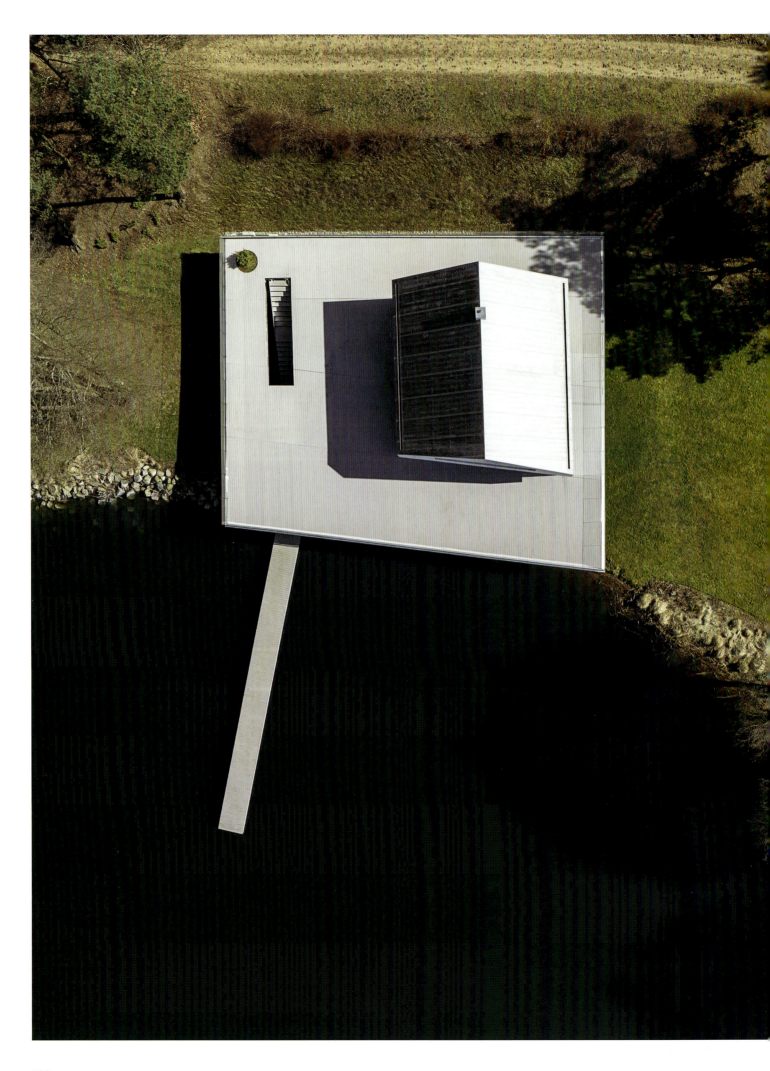

topographic | mobility

Marina in Biały Bór

2011–

The building of the marina was to be combined with a house for a large family. However, this concept posed a problem ...

... since the building's location is set along a coastal strip—by law a common space—this made it impossible to create a separate and private zone there.

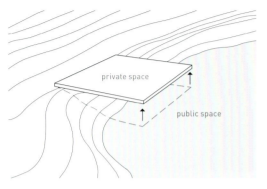

Then I came up with the idea of making an artificial plot that would overhang the site, right on the property boundary.

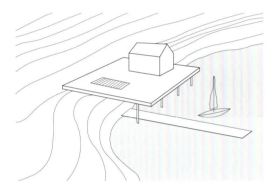

There we placed the house with its closest surroundings, and below it—within the proper area—we located a marina with a storage for water sports equipment and a pier for mooring boats.

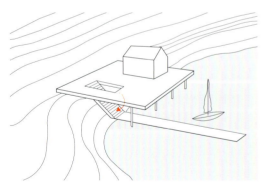

The upper plot can connect to the lower section by a loft ladder that meets the pier when lowered.

The building thus uncharacteristically combines two spaces.

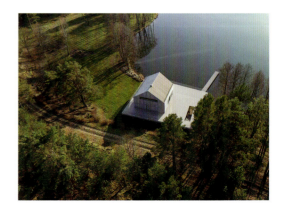

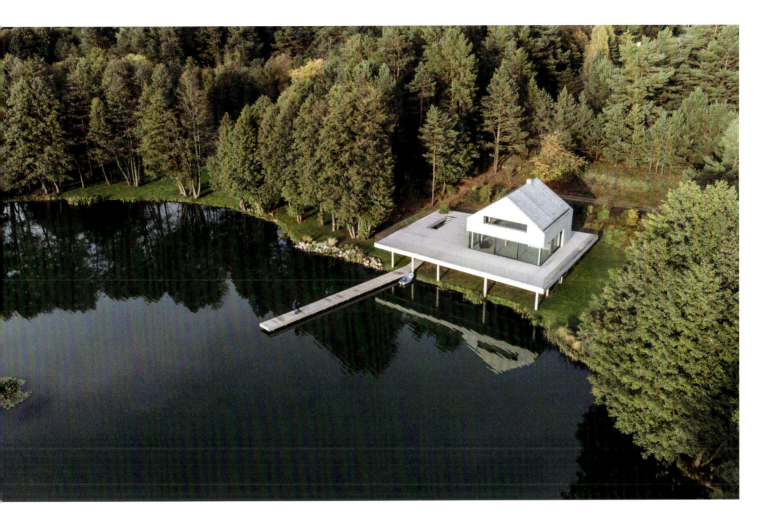

The two spaces consist of a publicly accessible marina with a private plot and a summer house.

This was created for a large family of forty, for whom we had also designed a larger house, called the Meeting House in Biały Bór (p. 27), on the slope above the marina.

site plan

0 15m

level -1

When the owners are present, the entire property can be accessed.

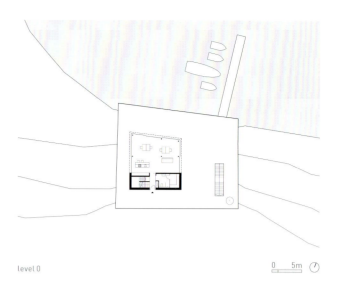

level 0 0 5m

When the residents and their guests leave, the upper plot remains just …

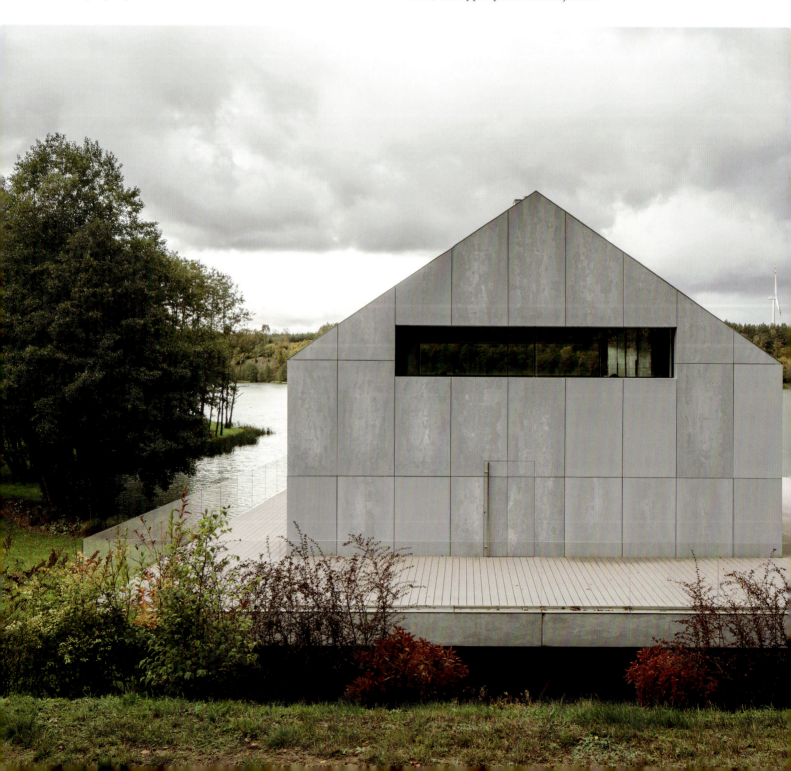

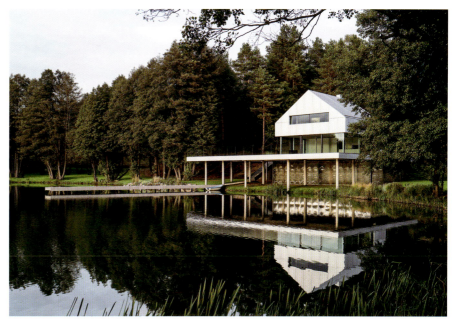

... roofing for the marina and is inaccessible to the public.

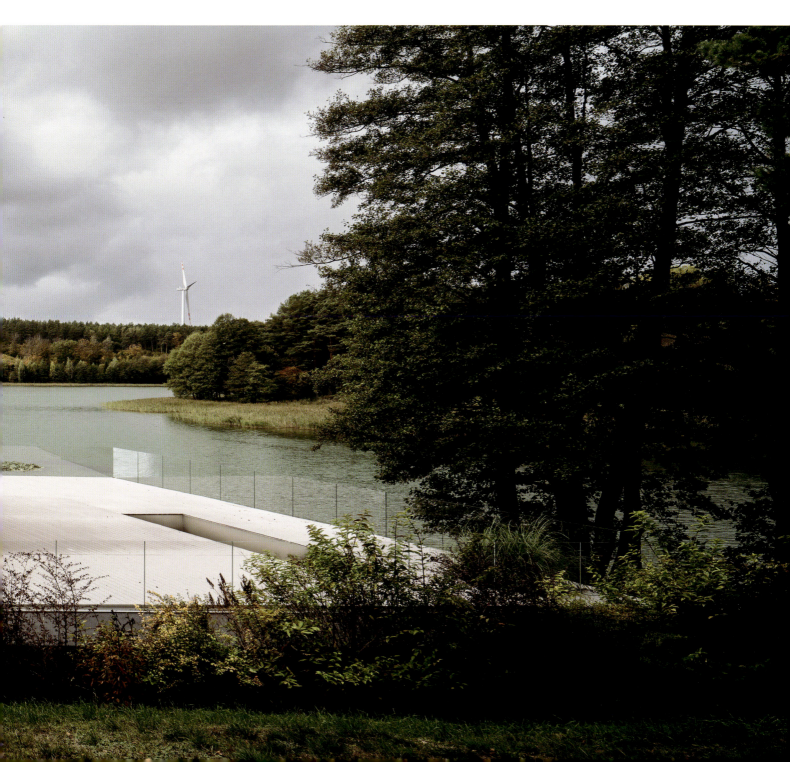

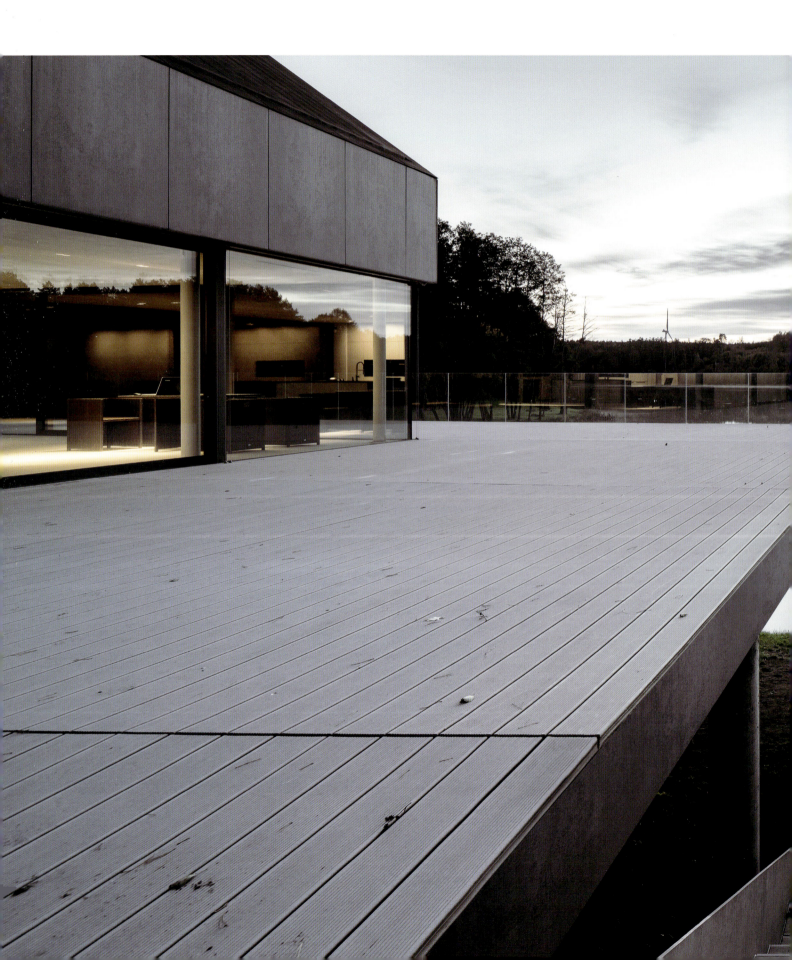

Section 0 5m

A mobile solution such as being able to lower/raise the stairs means that the operation and accessibility of the building can be changed quickly.

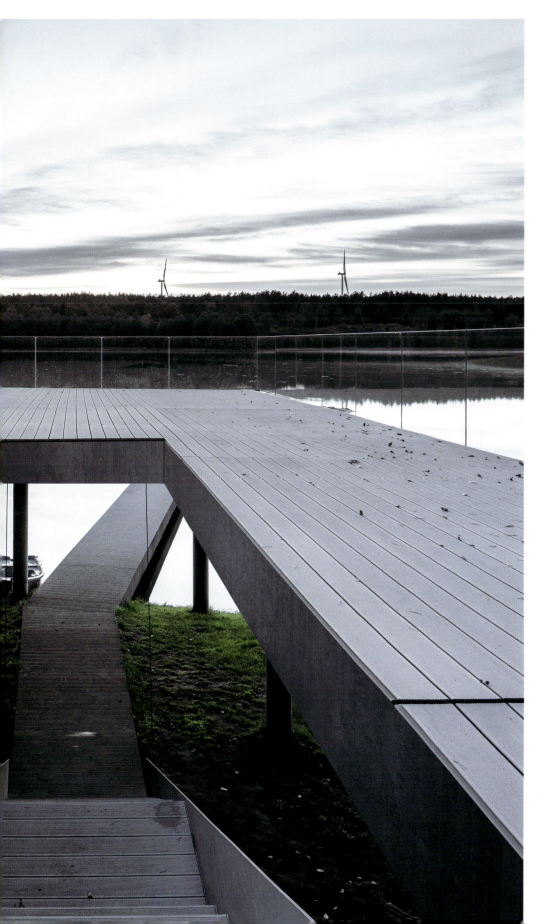

It works similarly to the drawbridge in Konieczny's Ark (pp. 32, 37, 180), where the living space also levitates above the site.

207

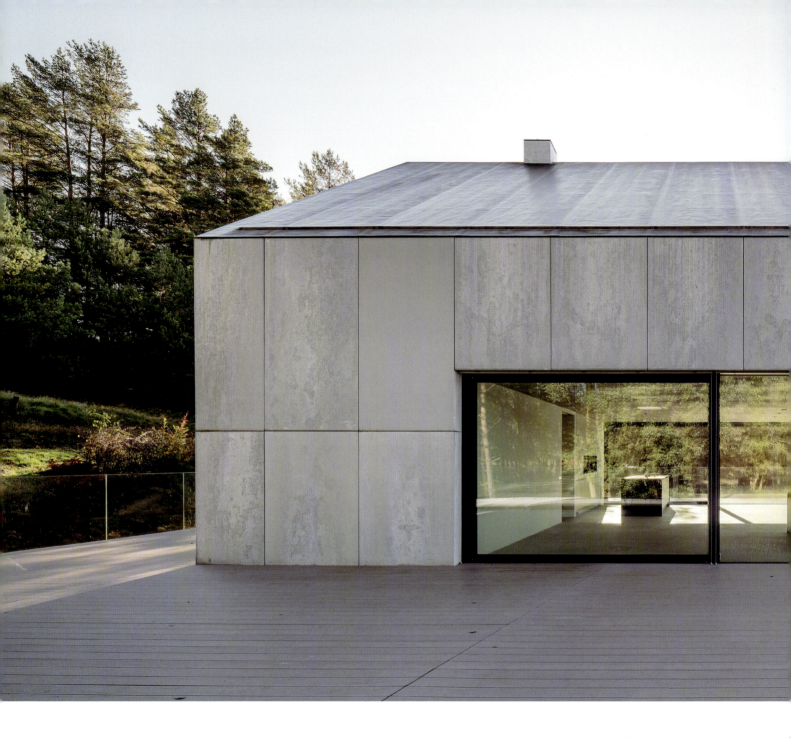

Initially, the house was to be surrounded by greenery and a section of elevated artificial beach. However, the owners asked us to use wood decking because, due to ...

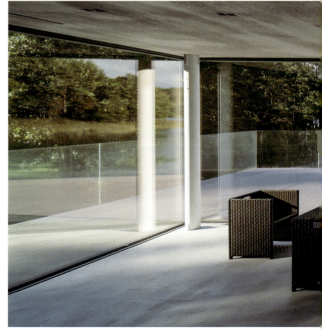

... the home's seasonal use, they were afraid of grass being up to their waist when they would arrive after a long stint away.

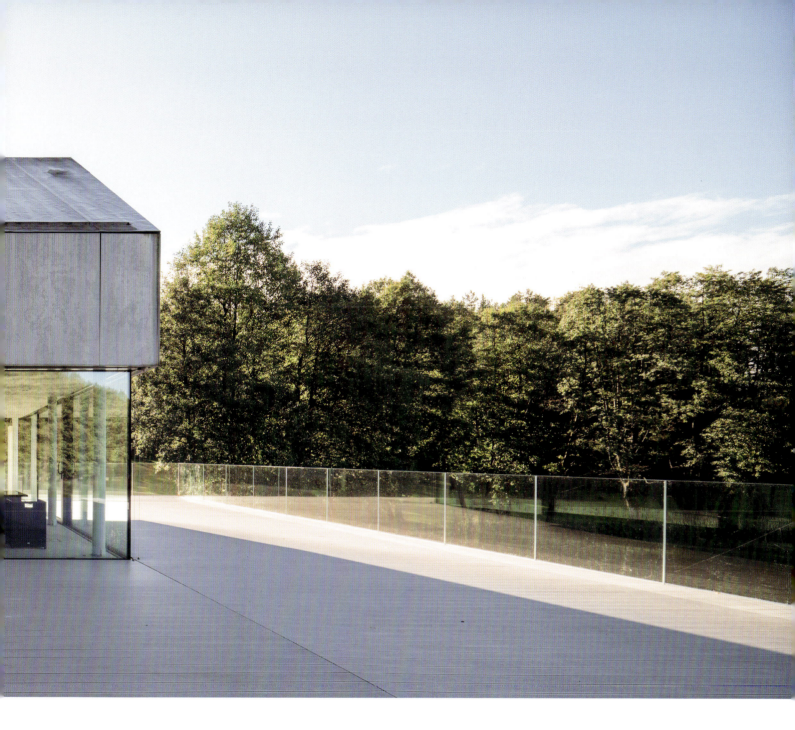
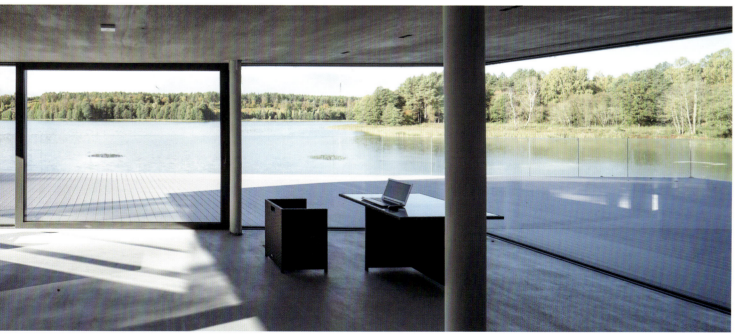

We have designed the first floor with articulating walls so that residents can carve out private spaces for themselves ...

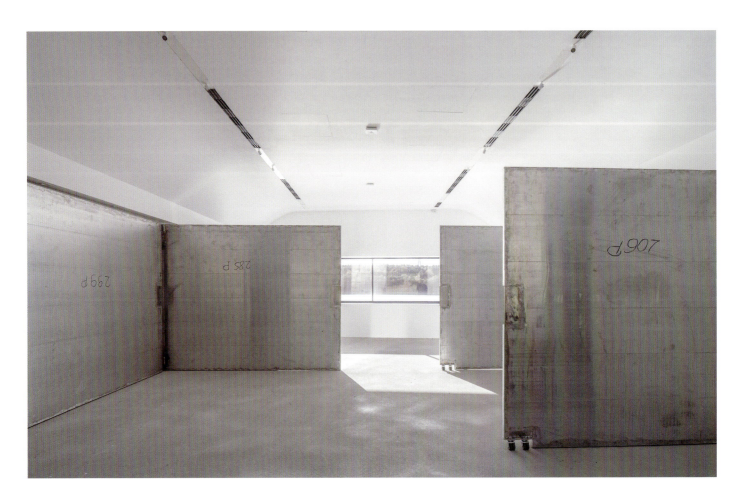

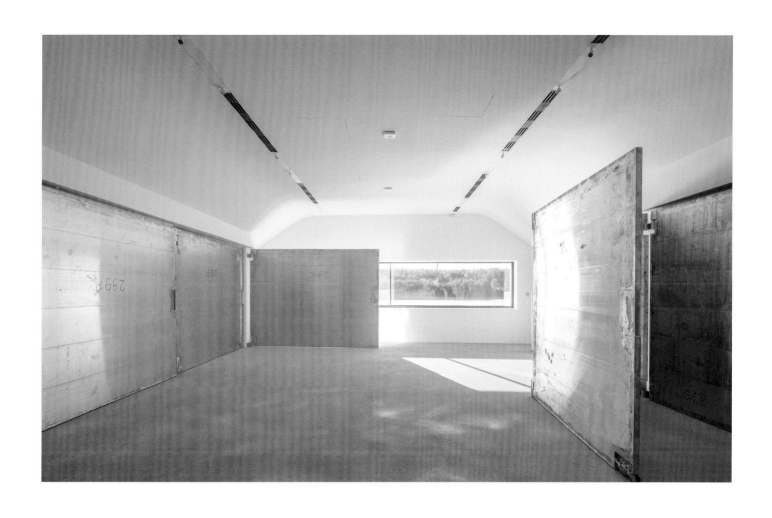

... depending on how many people will be sleeping there.

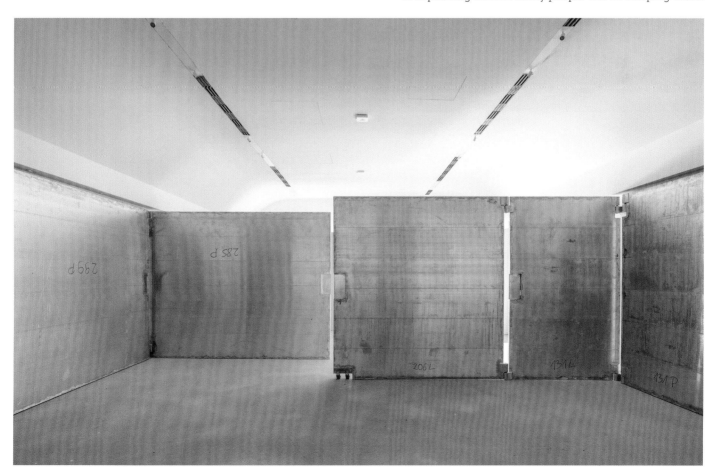

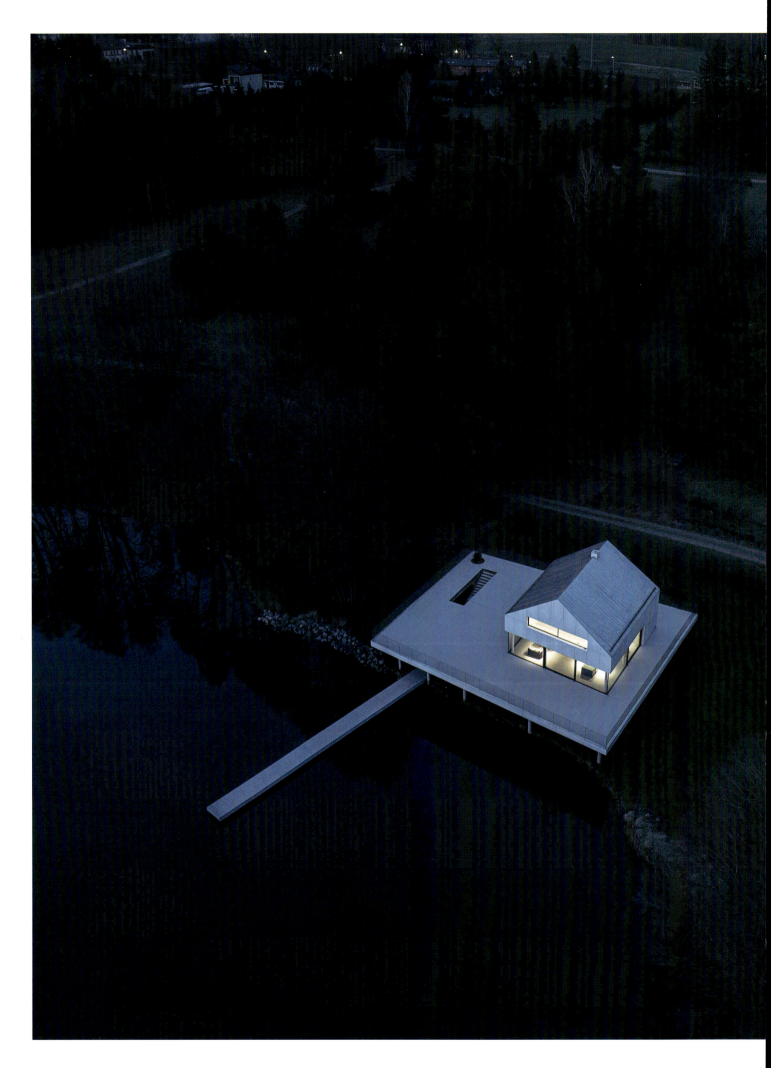

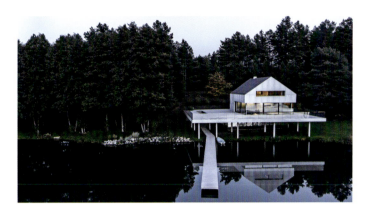

Although the house on the elevated plot is still under construction, the marina is already being used by local residents.

The functional solution of combining public and private functions was applied some time later in Miedzianka Shaft (pp. 39, 262).

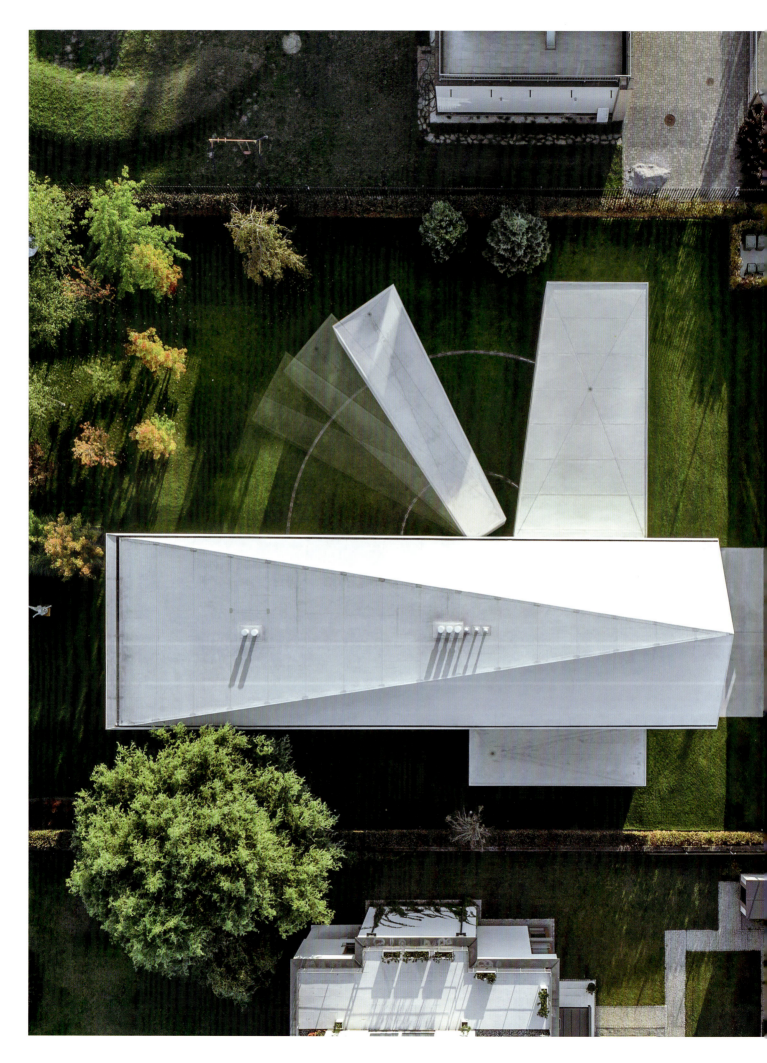

contextual transformation | mobility | immateriality

Quadrant House

2013–2019

The building was intended to respond to the sun and provide a relaxed living space for residents. The clients liked our Safe House, its variability and mechanisms.

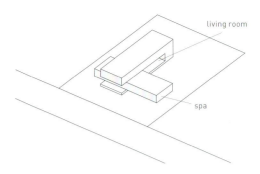

Out of the block aligned perpendicularly to the street (which was the clients' wish) ... →

... we carved out a section of the ground floor and positioned it in such a way as to isolate the garden from a quite busy roadway.

The owners desired a house with a flat roof, but the local master plan imposed a sloping roof. We managed to reconcile these contradictory requirements.

Our clients mentioned the quadrant, an ancient instrument used to determine the position of the stars. Its shape made me think of the part of the garden between the living room and the spa.

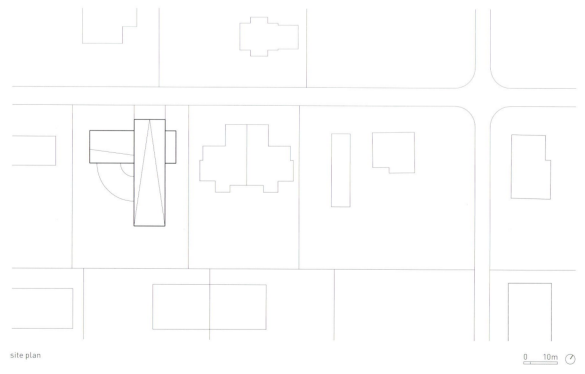

site plan

Hence the idea to turn part of the house into a moving element that reacts to the sun and moves within the garden space.

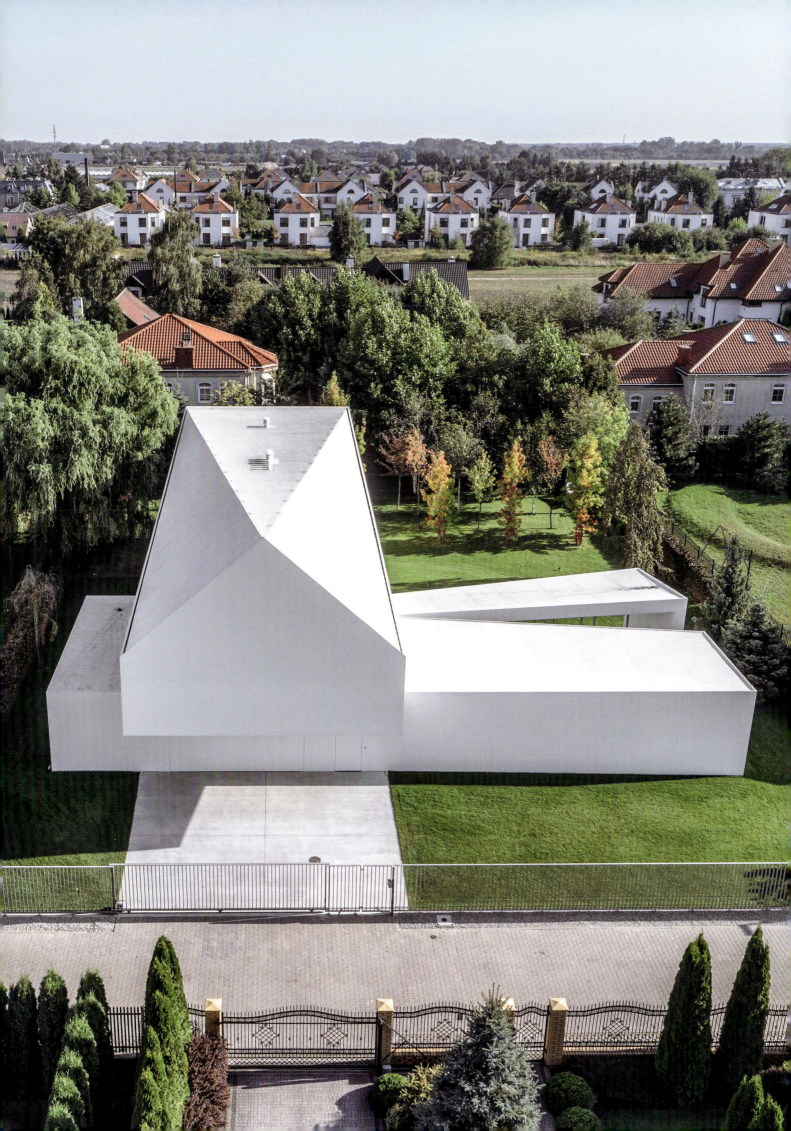

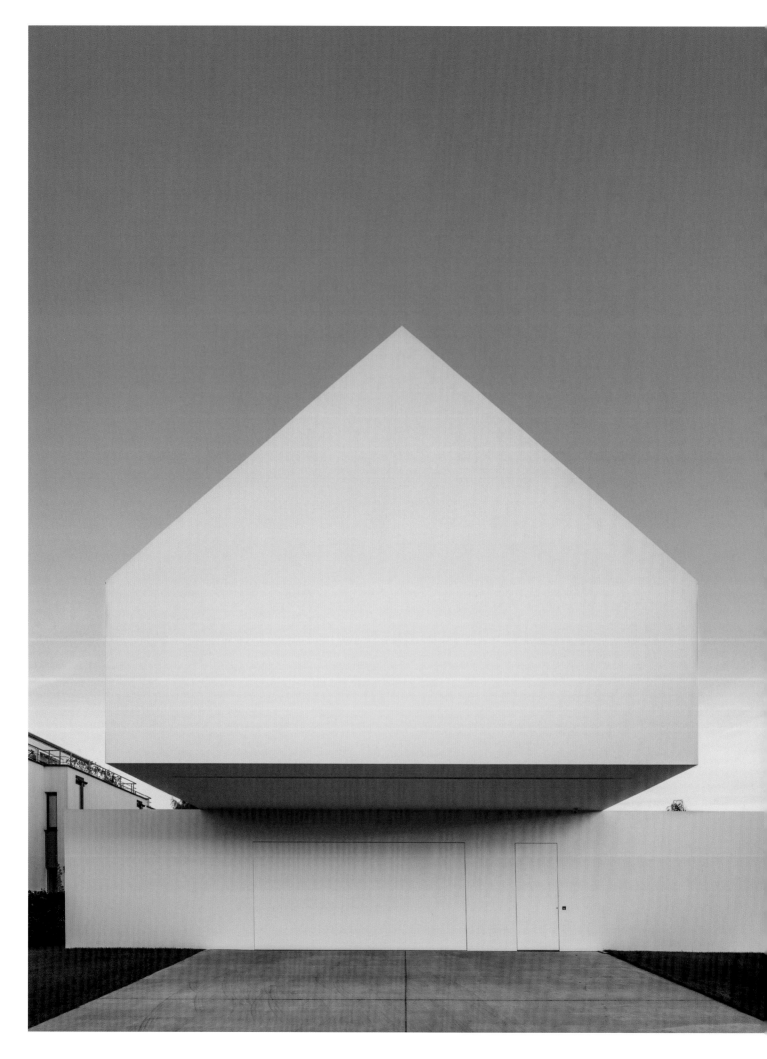

The steep roof on the street side makes the house fit into the context ...

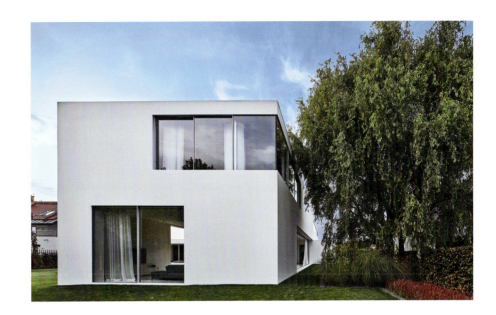

... and on the garden side it corresponds to the wishes of the owners, who wanted the flat roof.

The solution to combine two roof geometries proved to be an ideal patent for those who want to build differently, but without damaging the context.

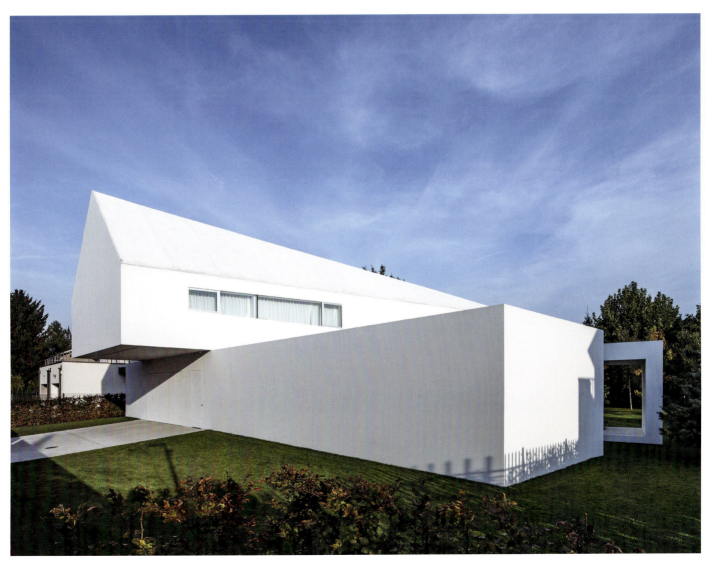

The mobile element of the house can be a free-standing, covered terrace ...

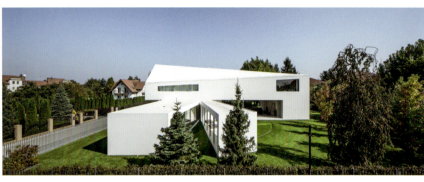

...and when "parked" along one of the elevations it becomes an extension of the house—as a loggia.

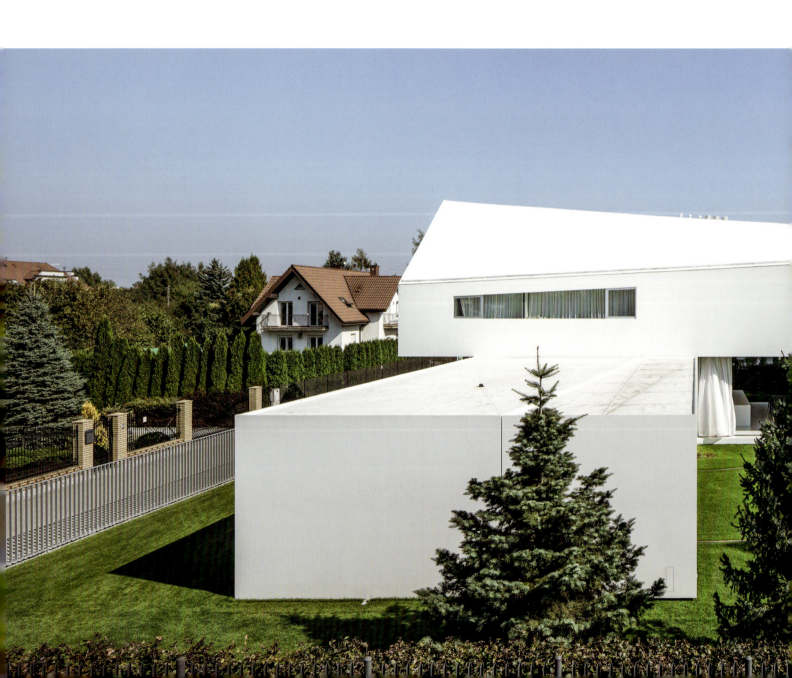

section with terrace in the movement

It's programmed to follow the movement of the sun and ...

section with terrace in the movement

... can be controlled if required.

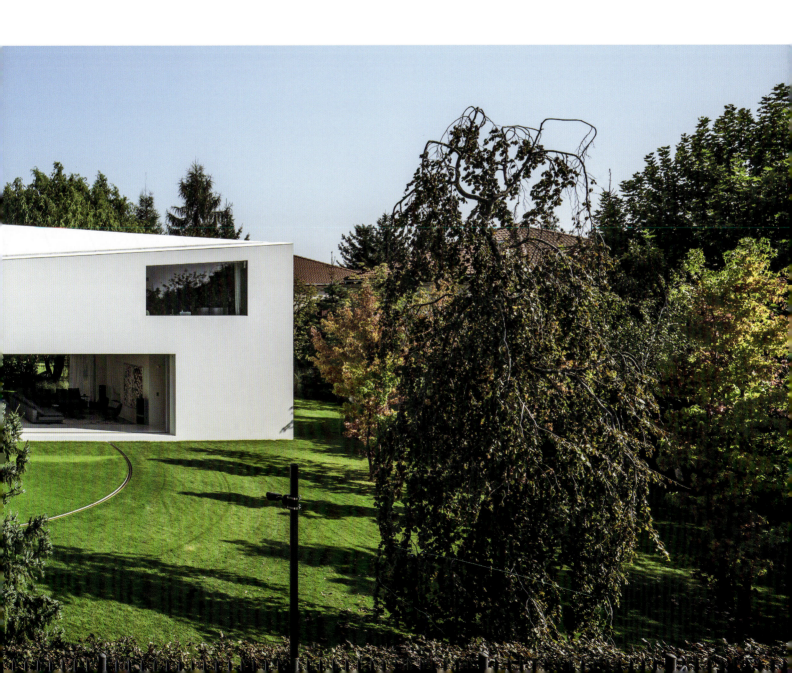

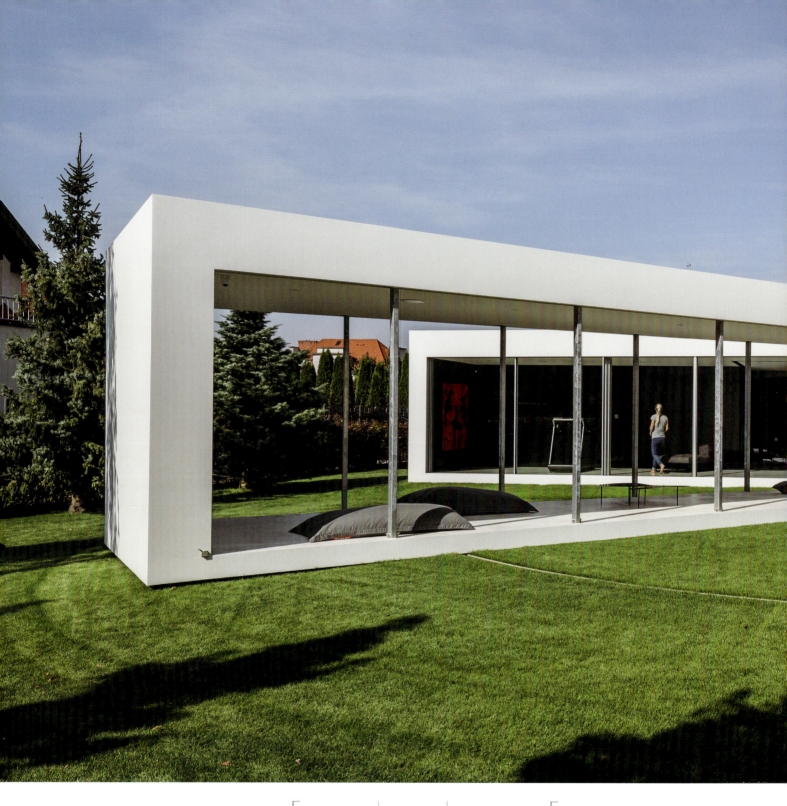

By moving, the terrace allows those sitting inside to enjoy shade and a pleasant breeze. A perfect space for relaxation.

ground floor

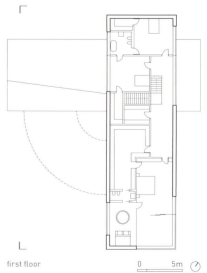

first floor

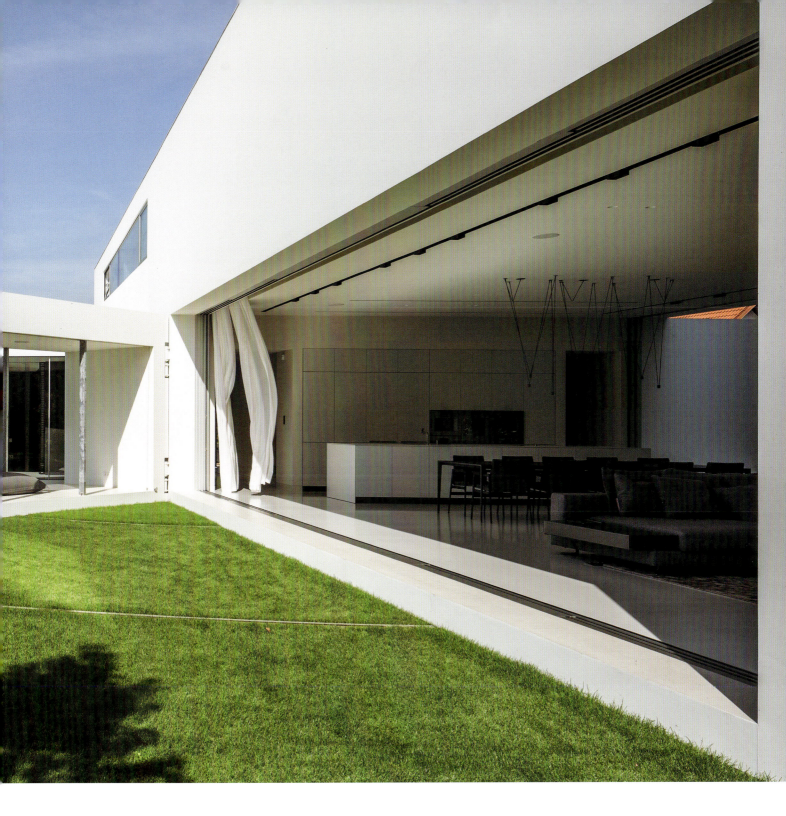

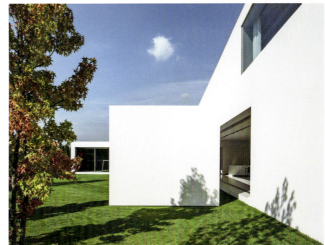

Depending on the season,
the kinetic roof element ...

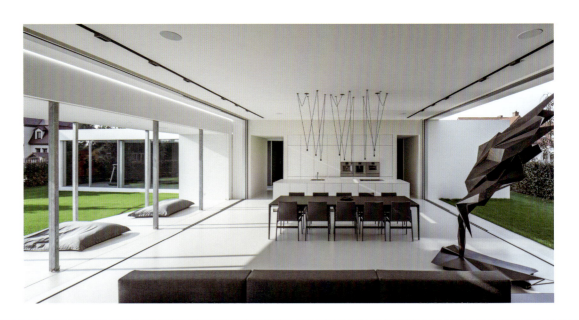

... allows the residents to control the amount of sunlight that enters the spaces of the house to which it adjoins.

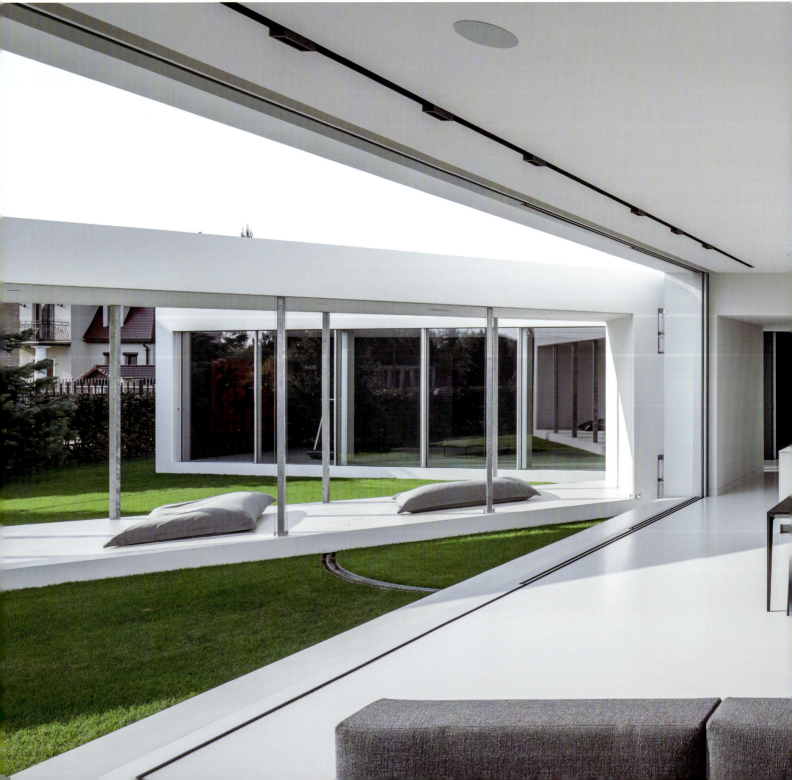

In summertime the kinetic element provides welcome shade in the interior of the lounge or spa ...

... but unlike traditional solutions such as shutters or blinds, here we do not lose the view or contact with the surroundings.

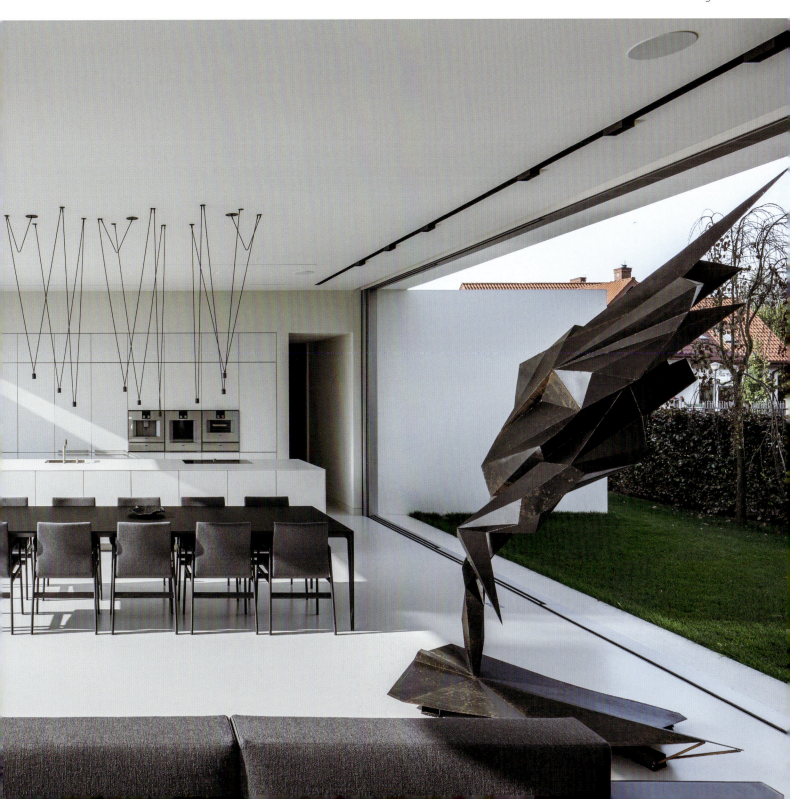

Combined with the possibility to fully open the glazing, the interior becomes a roofed part of the garden on warm days. Thanks to natural ventilation and shade …

… the residents do not need to use air conditioning. And in the colder months, moving the terrace away from the interior allows for better lighting and natural heating by the sun.

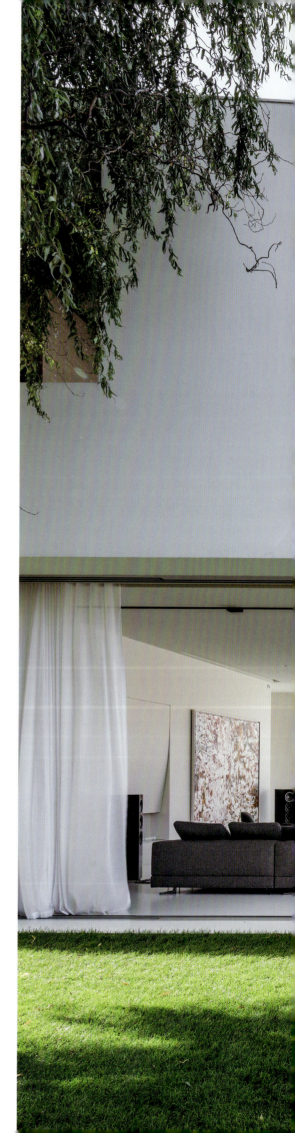

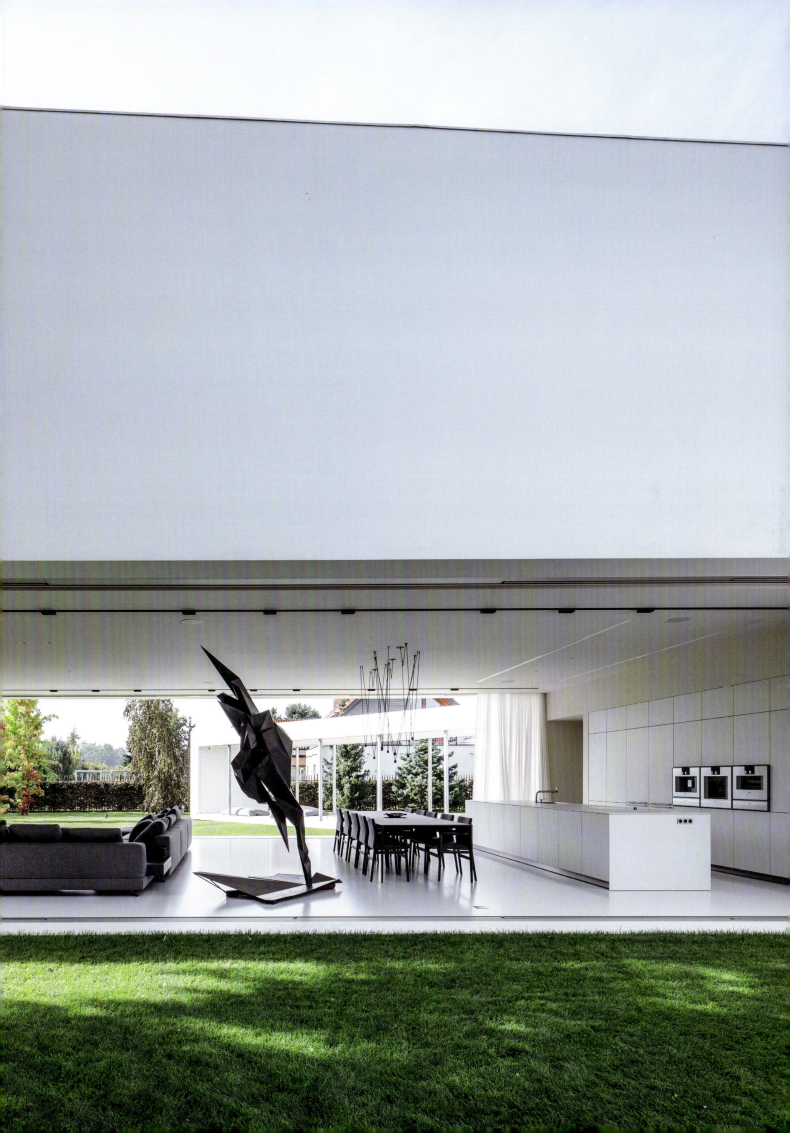

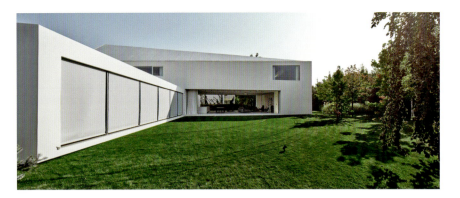

Sometimes the low sun's rays can still be a nuisance, so we also fitted the terrace with retractable roller blinds to protect the interior of the house when the canopy is not enough.

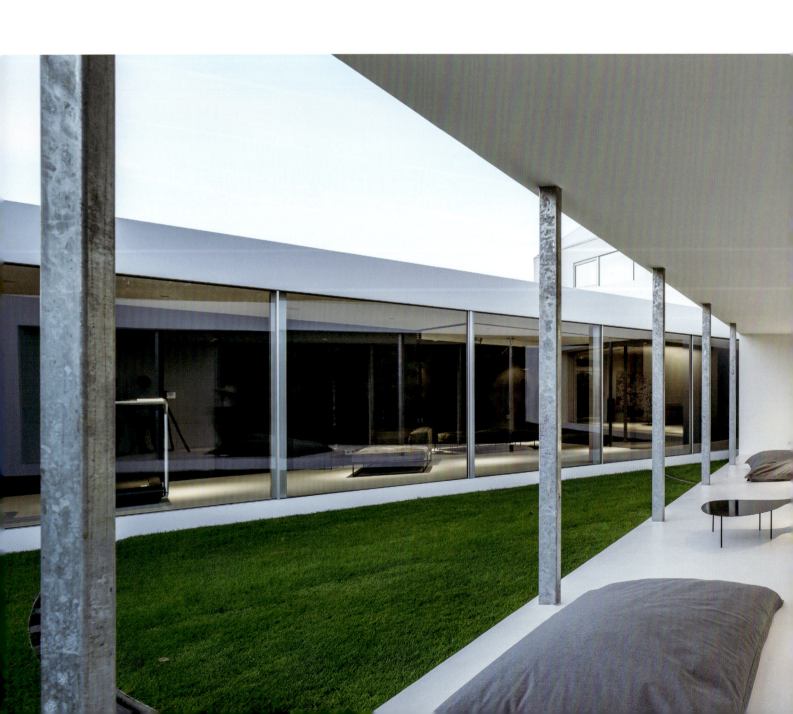

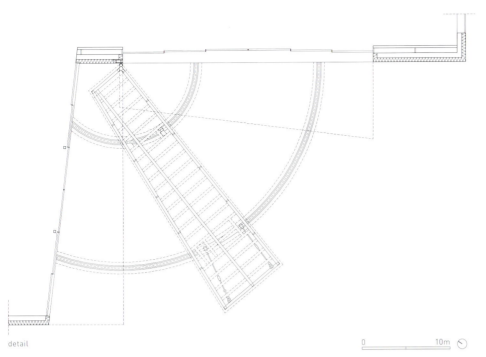

detail

0 ——— 10m

The movable terrace therefore naturally improves the energy balance of the building and brings regular savings.

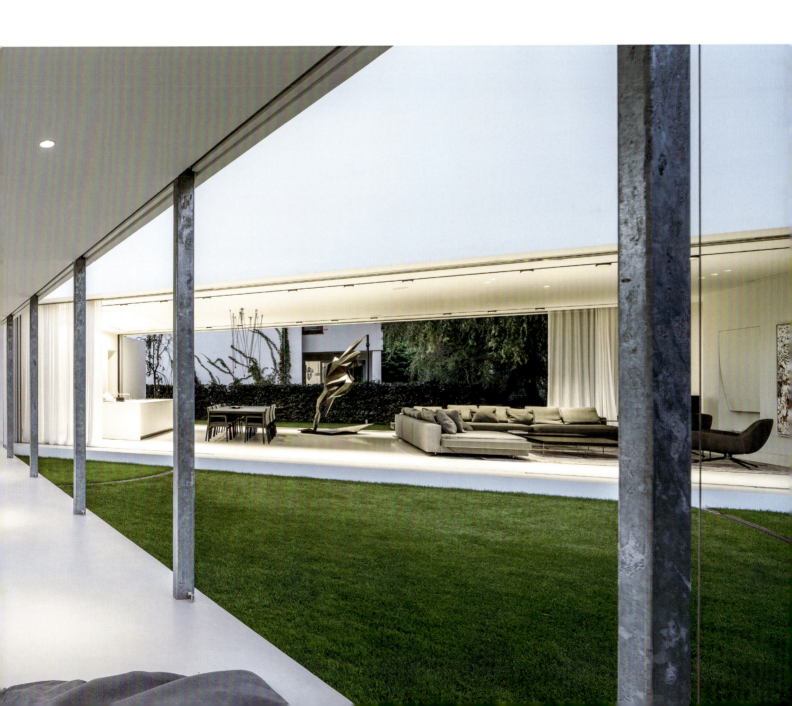

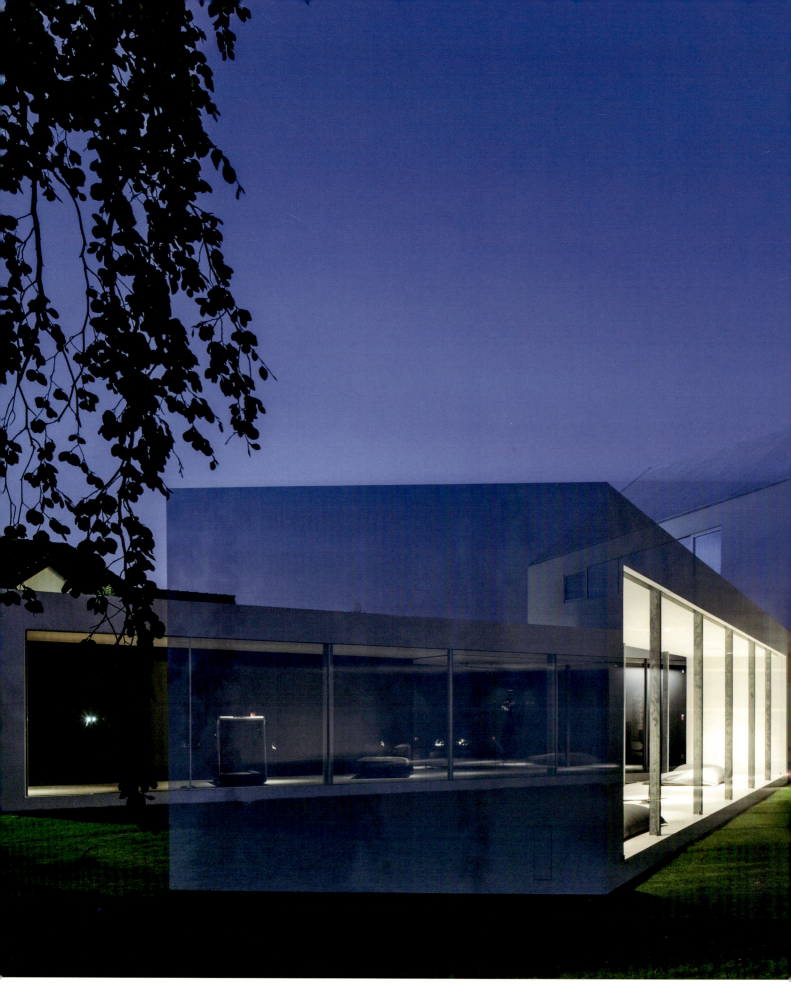

Over time, we realized that this customized solution (which in this building was just an add-on) could become a patent for building in difficult hot weather conditions. This is how the idea of the Sunlite Building (pp. 32, 33, 316) was born.

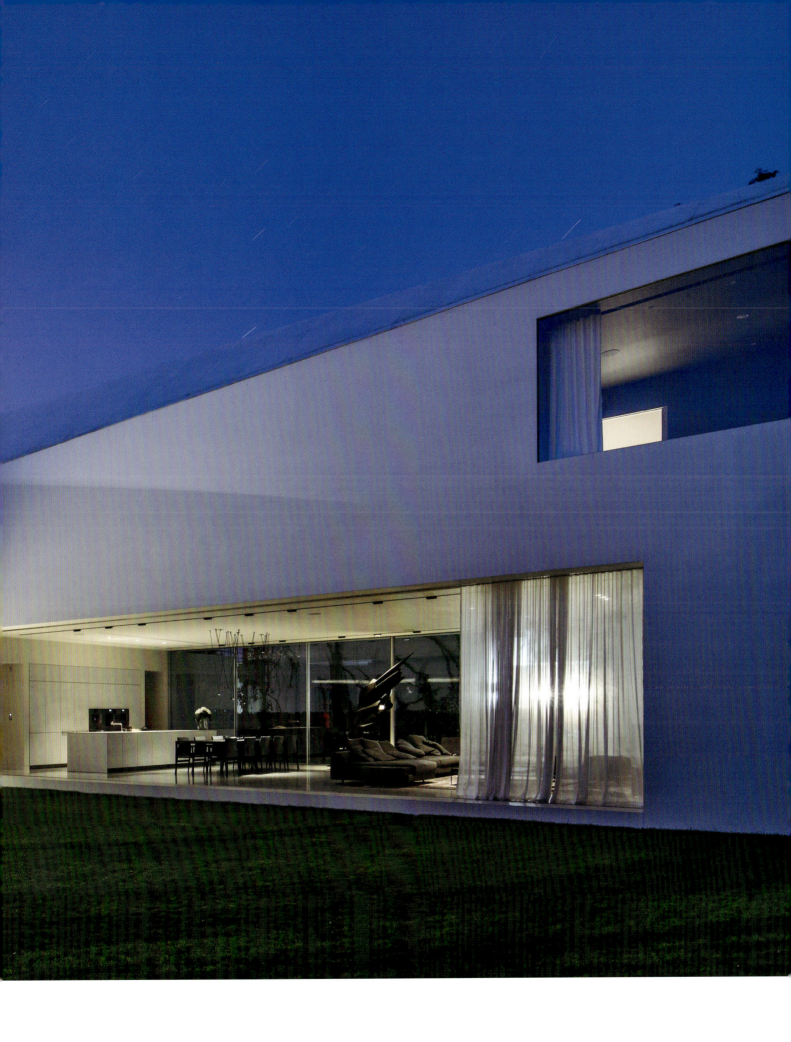

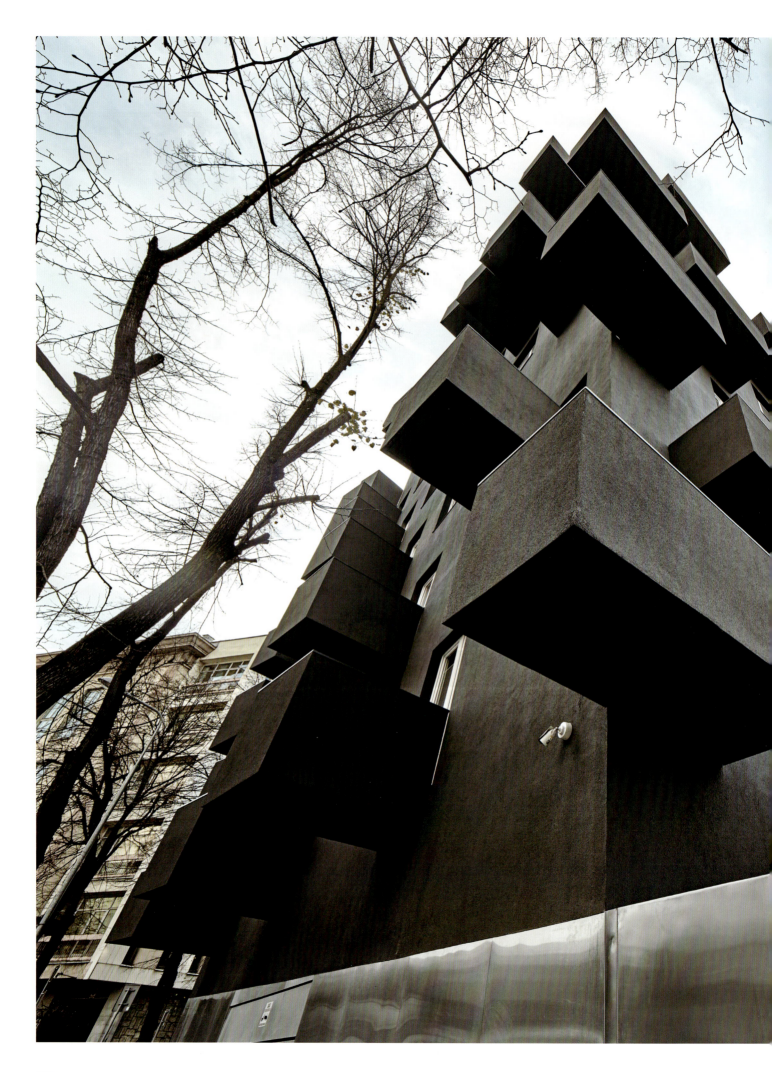

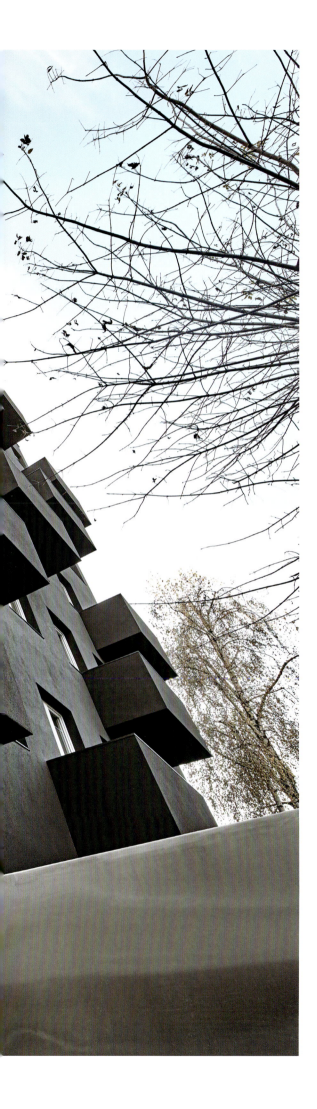

context transformation | historical context

Unikato Housing

2013–2018

We were to design an extremely cheap residential building. There was only enough in the budget for polystyrene foam, plaster, the cheapest white plastic windows, and balconies that were to be used as storage space for the small flats.

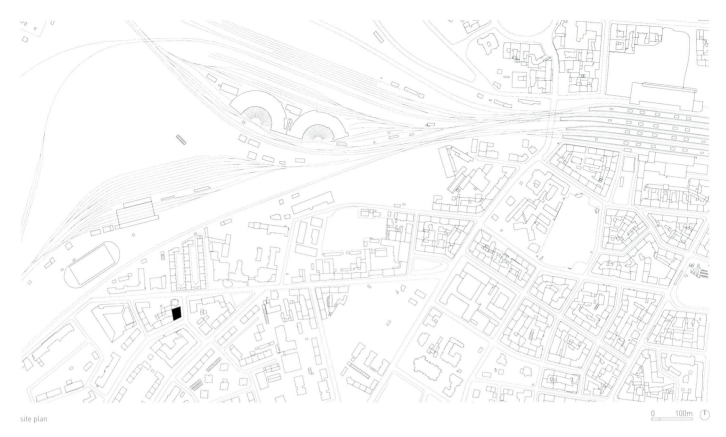

site plan

This multifamily building was constructed in the center of Katowice, a depopulating post-industrial Polish city.

We were inspired by inner-city modernism, which was once a bright architecture, though over the decades smog has since made it almost black.

The color of the neighboring prewar building inspired the dark tones for the Unikato housing façade and the socle at the ground level, as well as the characteristic motifs …

… of matching white windows and balconies. However, we covered the balconies with a solid balustrade to keep the storage clutter out of sight and to provide privacy for the residents.

The design's turning point was pulling the balconies to one side …

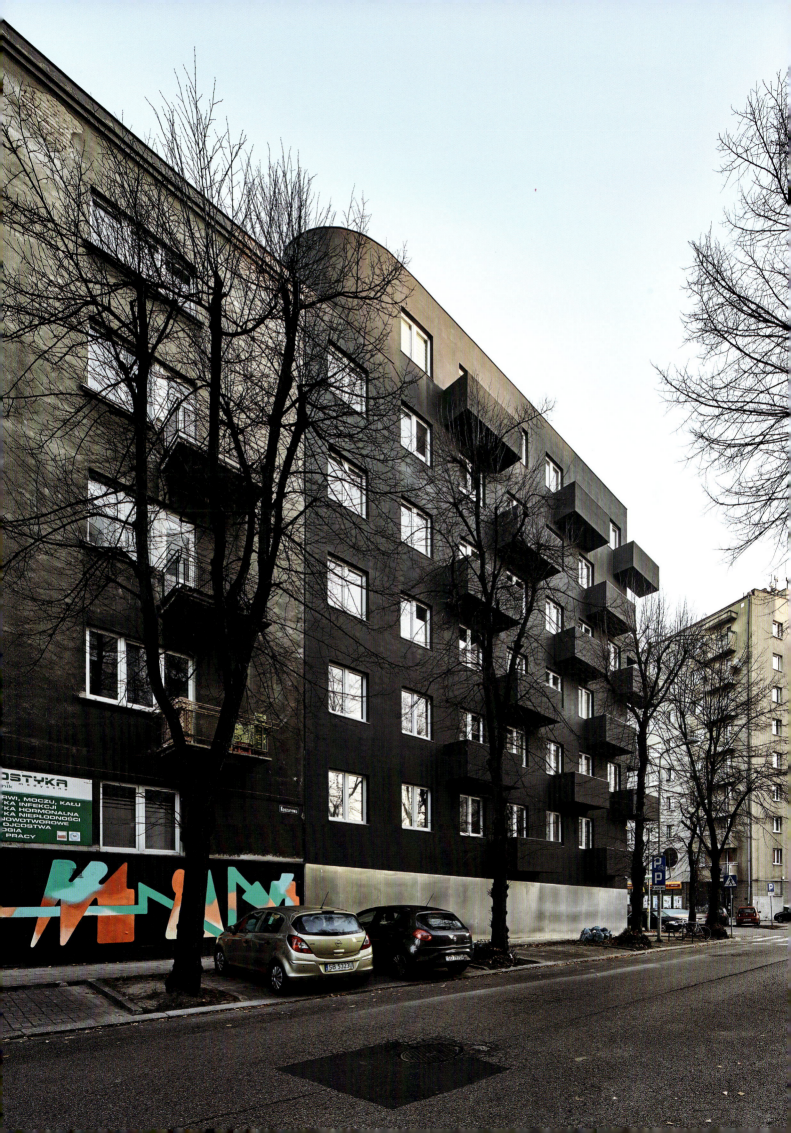

... giving the building a distinctive silhouette, while the jutting balconies allow residents to catch the afternoon sun for an hour longer.

Unikato is a continuation of the street frontage on one side and meets the detached villa surrounded by a fence on the other.

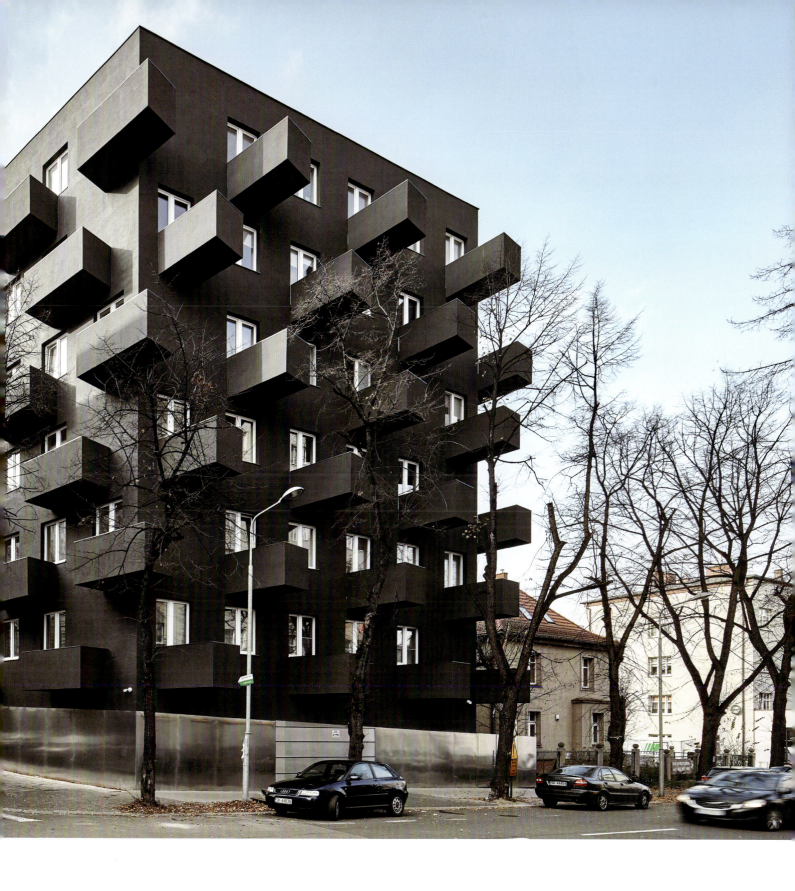

In order to combine these two different typologies of development, the socle of our building extends beyond its contour to become a fence on the villa side.

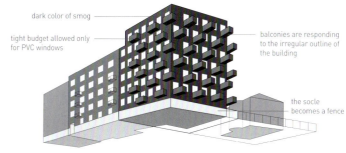

dark color of smog

tight budget allowed only for PVC windows

balconies are responding to the irregular outline of the building

the socle becomes a fence

site plan

As in the neighboring buildings, we located the technical parts on the ground-floor level, since the local master plan excludes commercial use on the ground floor.

level 3

We did so also because very few want to live at street level and thus it is only from the first floor that recurring residential floors begin. →

level 6

The curved façade on the top floor makes the building … ↙

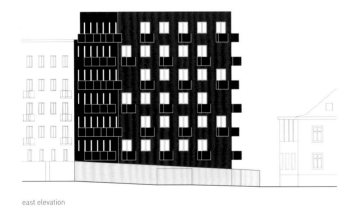

east elevation

… merge seamlessly with the adjoining building. The socle on the ground floor continues with the slope of the street.

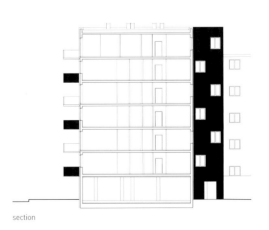

section

To discourage graffiti artists, the socle is made of easy-to-clean steel.

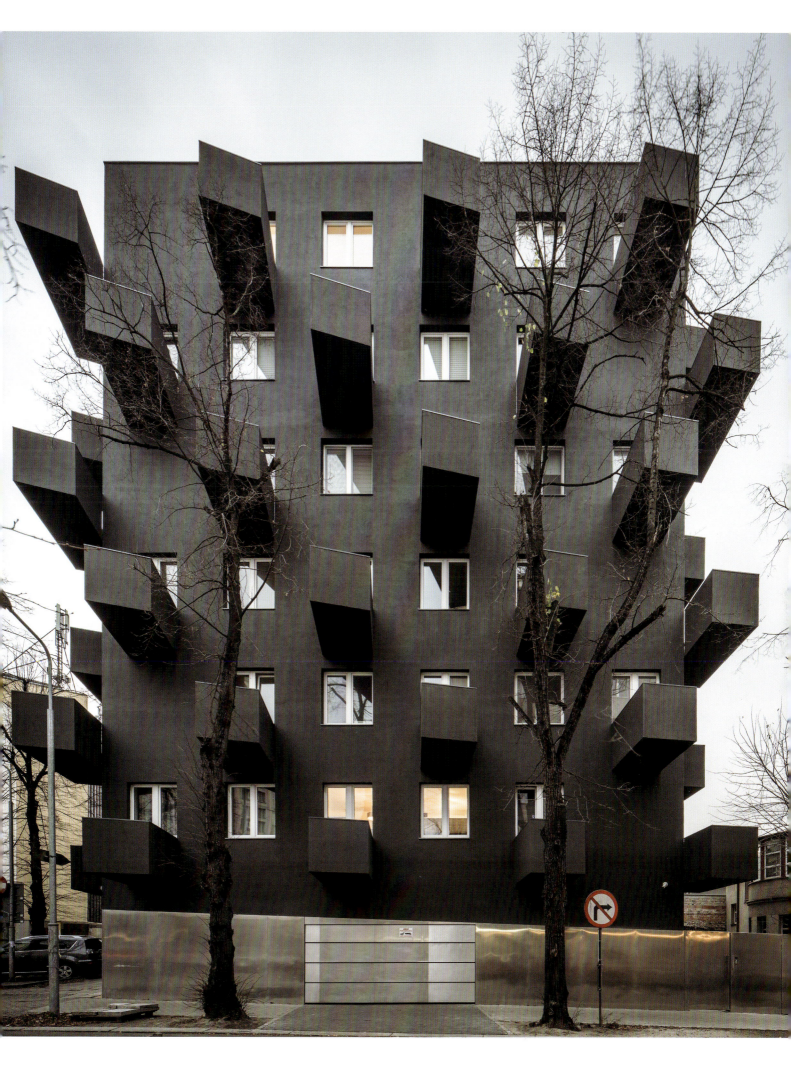

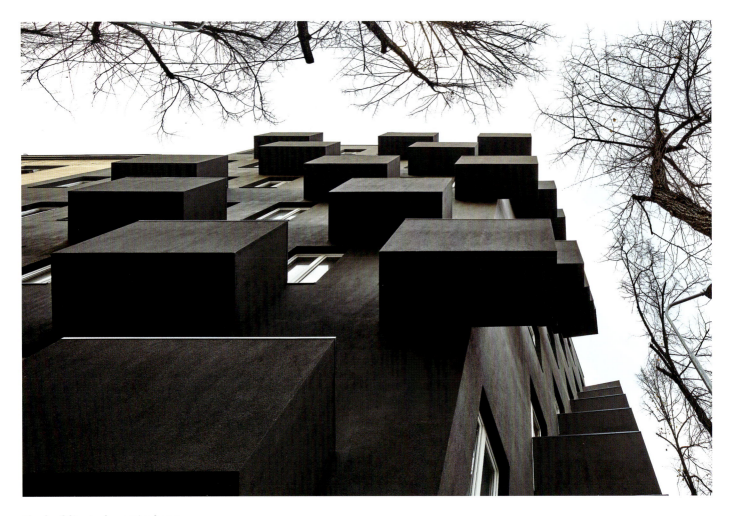

The building's dynamic shape, with its balconies suspended above the pavement, encourages passers-by to take photos …

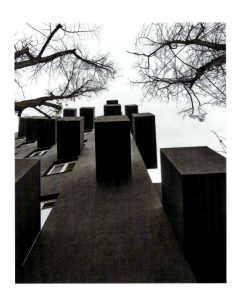

… that can often be seen under the hashtag #unikato.

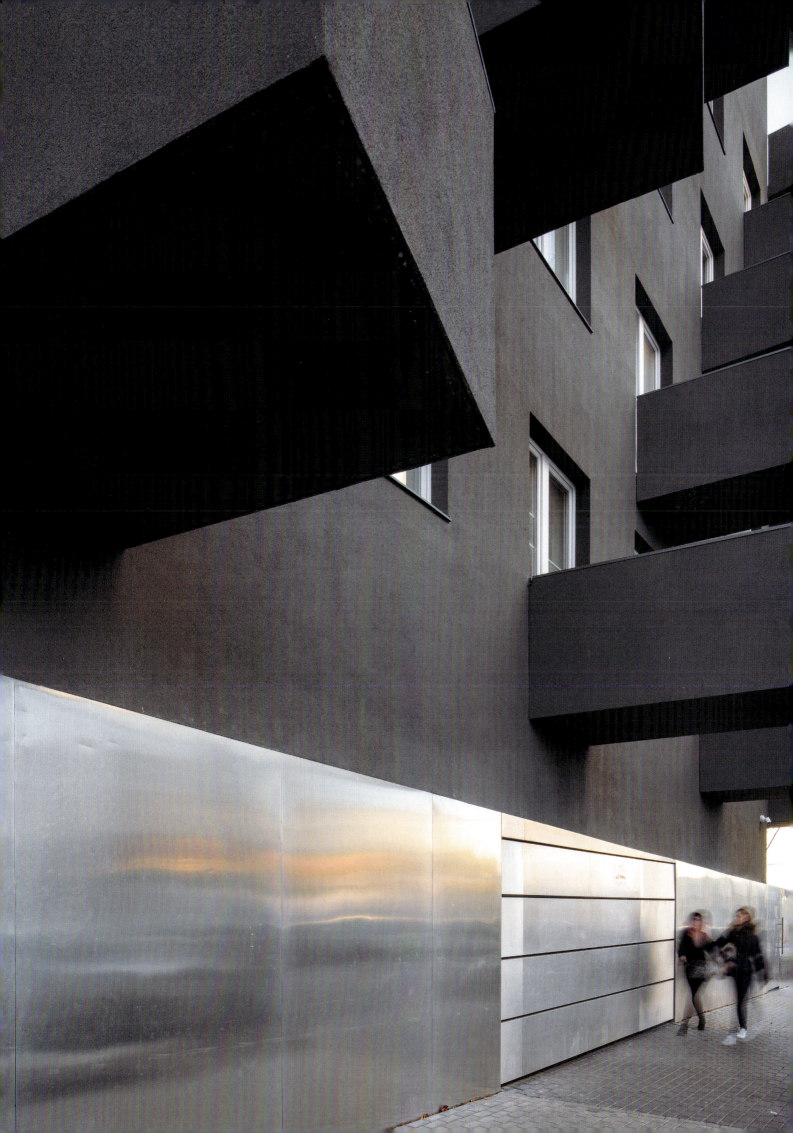

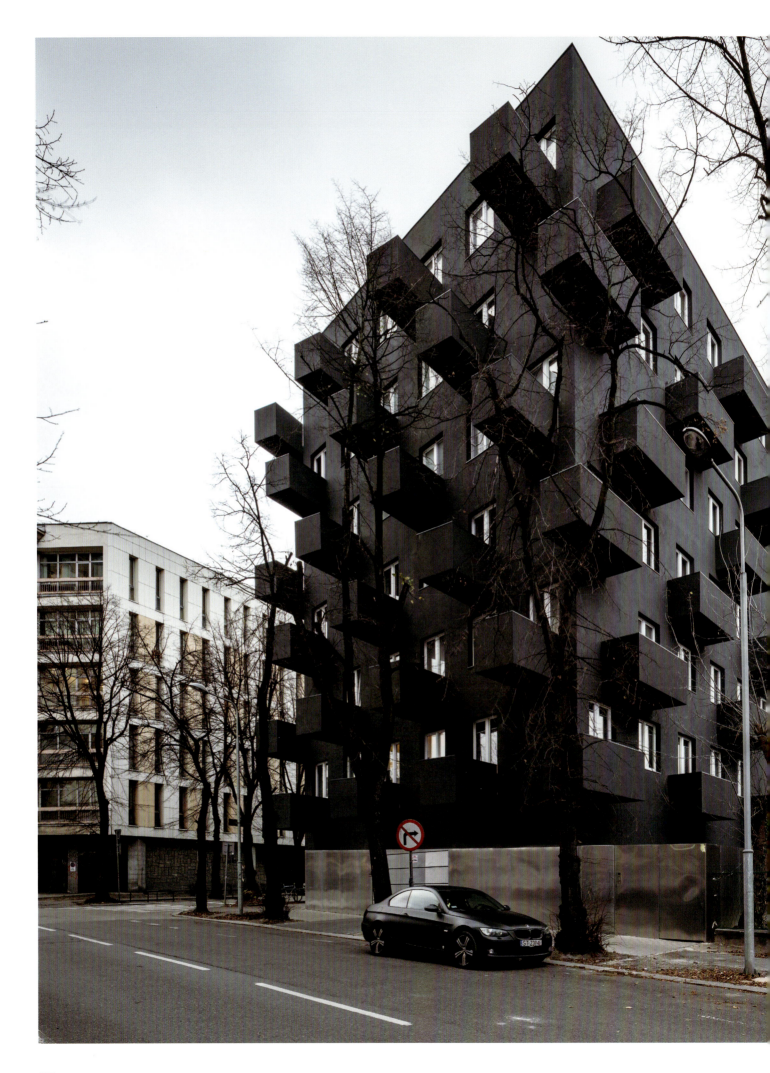

As the socle next to the villa side has been turned into a fence, the entrance to Unikato leads through the inner garden.

The contractors were aware they were required to pour the concrete evenly, as there would be no money for corrections. This staircase is an example of their craftmanship. We finished the floor for just €0.65 per square foot (€7 per square meter).

When we designed and built Unikato, we didn't think then that one day our very own office would be located on the top floor, under the green roof of the building.

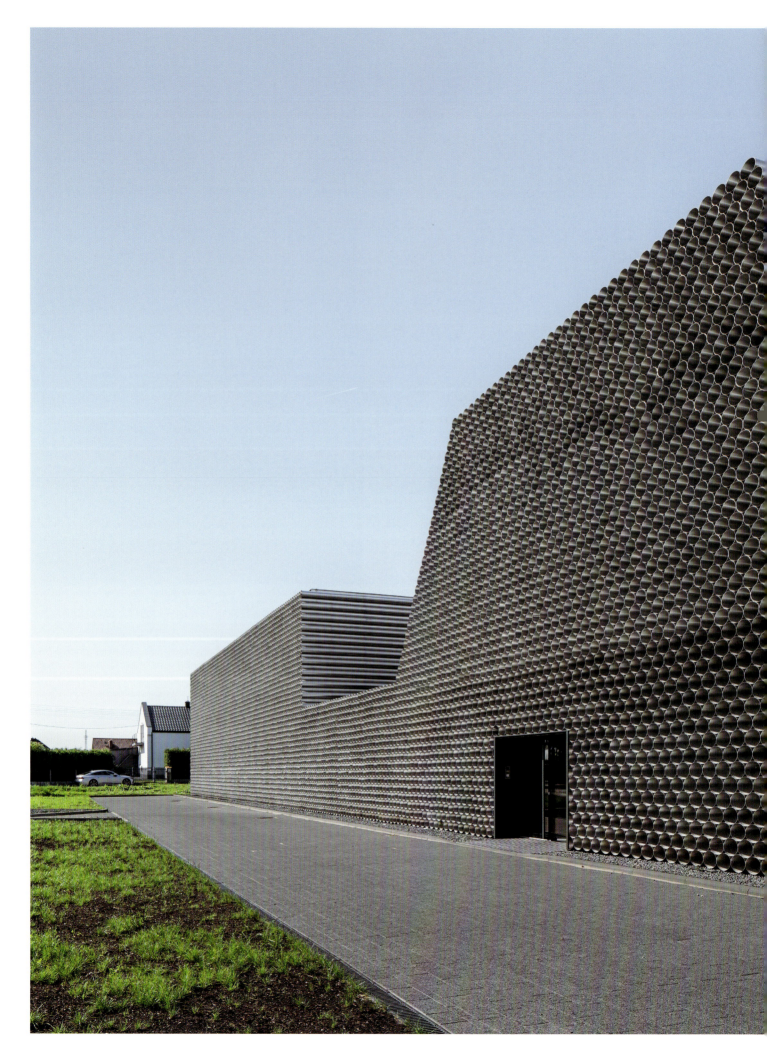

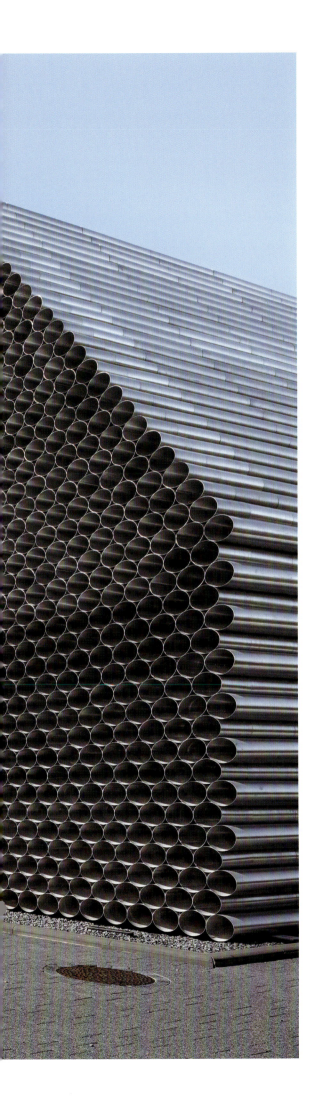

contextual transformation

Gambit Office

2013–2023

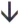

The office building and warehouse that we designed for a pipe trading company was to be their headquarters showcase.
Yet, we were asked to do it as low cost as possible.

The surrounding development has a distinctive layout. The plot is surrounded by residential houses, to which outbuildings are attached ...

... thus we followed this motif for the structure of our building.

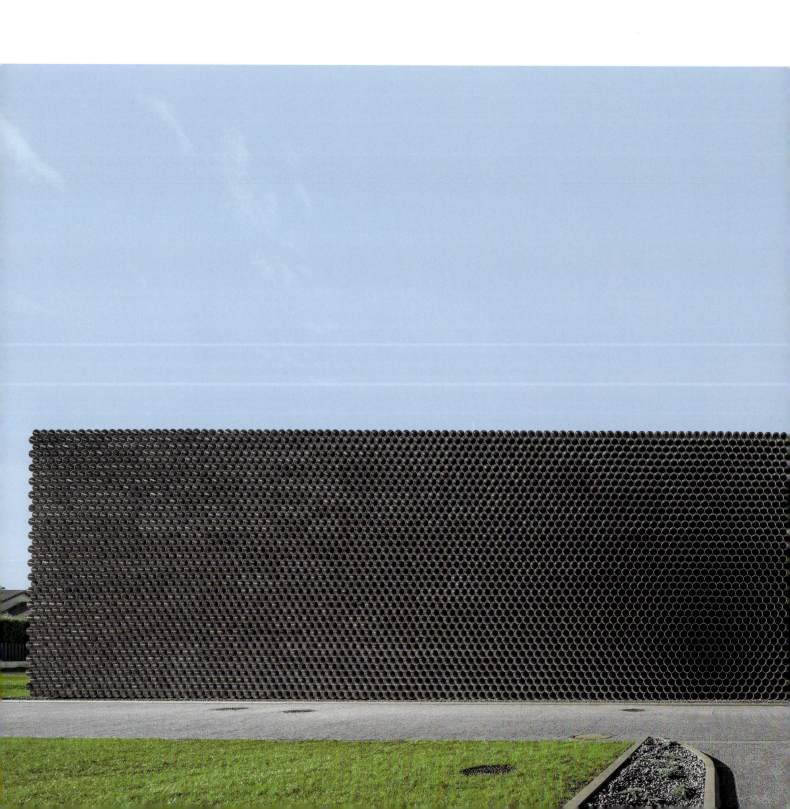

Since the project was going to need to come in at the budget end, I came up with an idea to use the material the company trades in because they have it at cost.

As a result, we designed it to look like a pipe stockpile, which communicates instantly what it is that the company deals with.

The façade is made of cheap raw aluminum sheet. The way the pipes were laid determined the roof pitch.

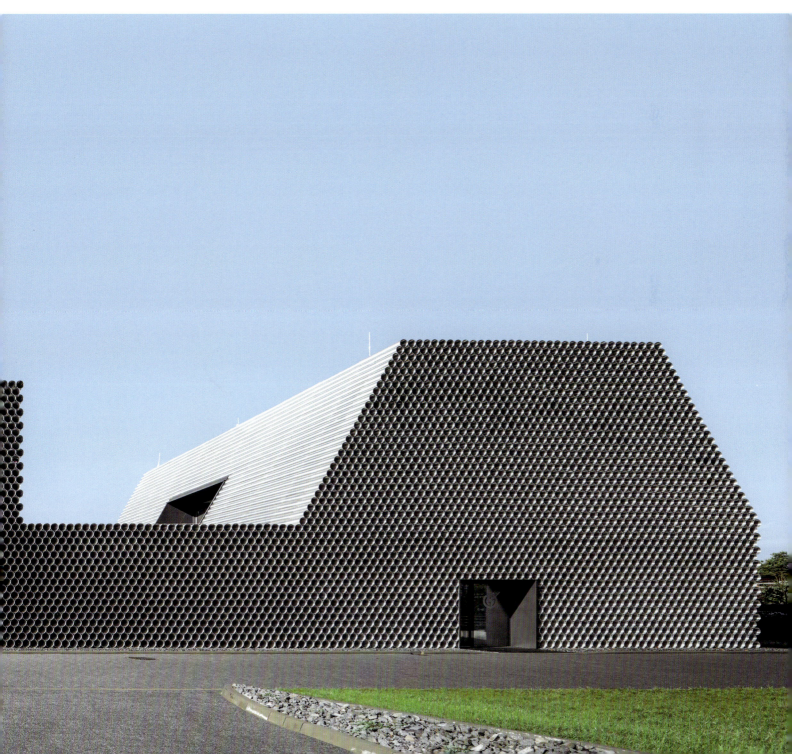

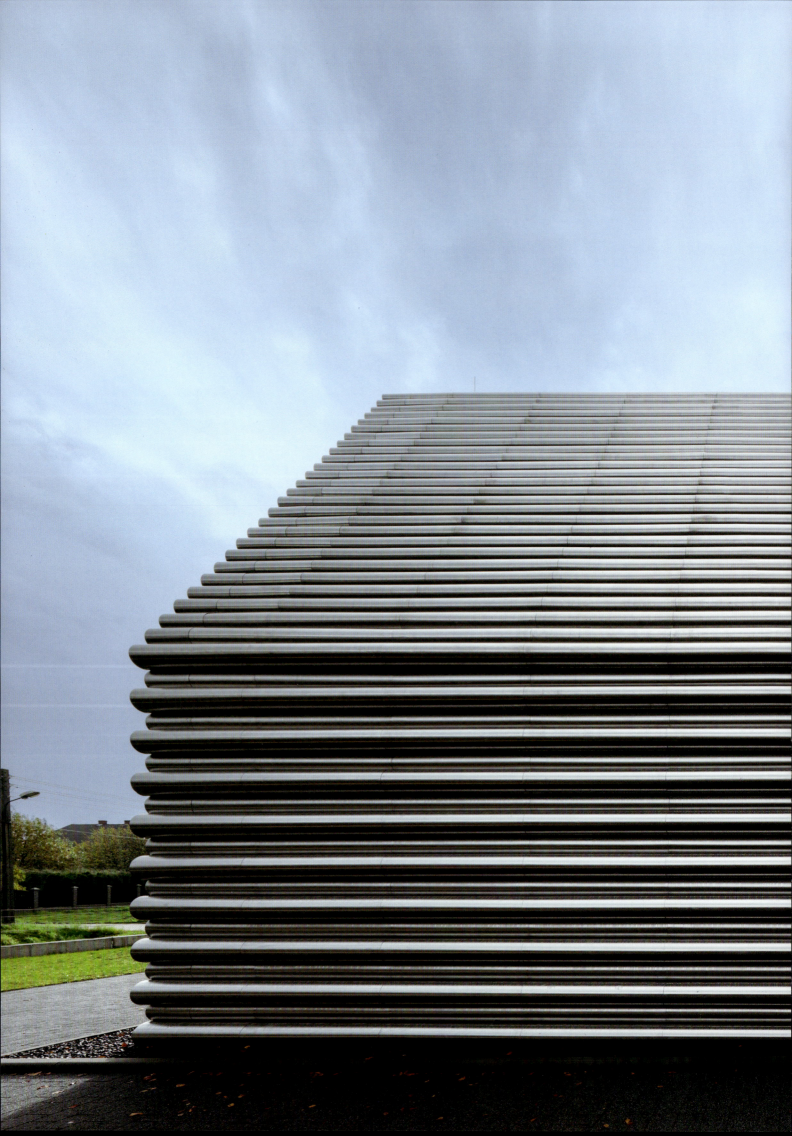

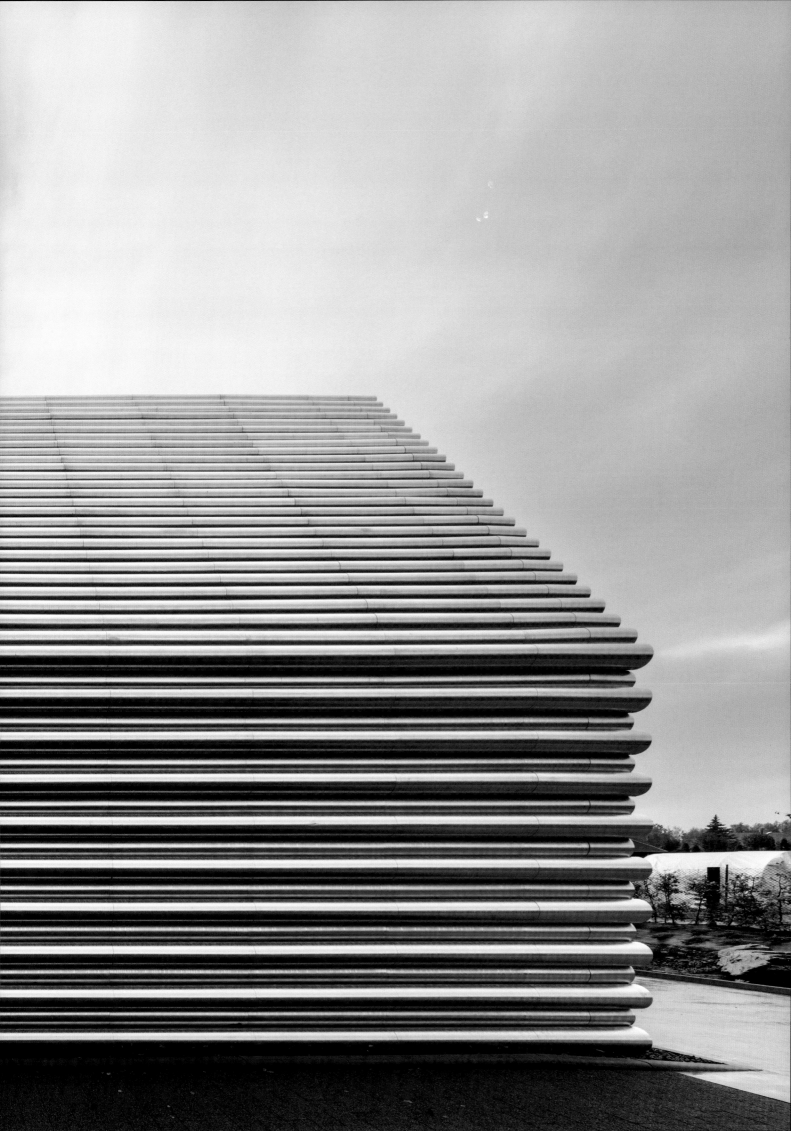

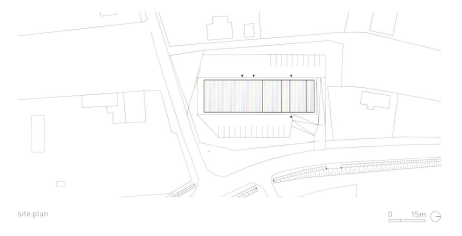

site plan 0 15m

This pipework is clearly visible from the street side ...

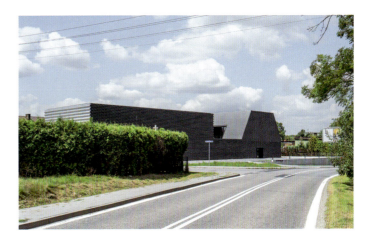

... and forms the building frontage ...

... whereas, when viewed from the side of the housing estate, its disjointed body fits into a diffuse context.

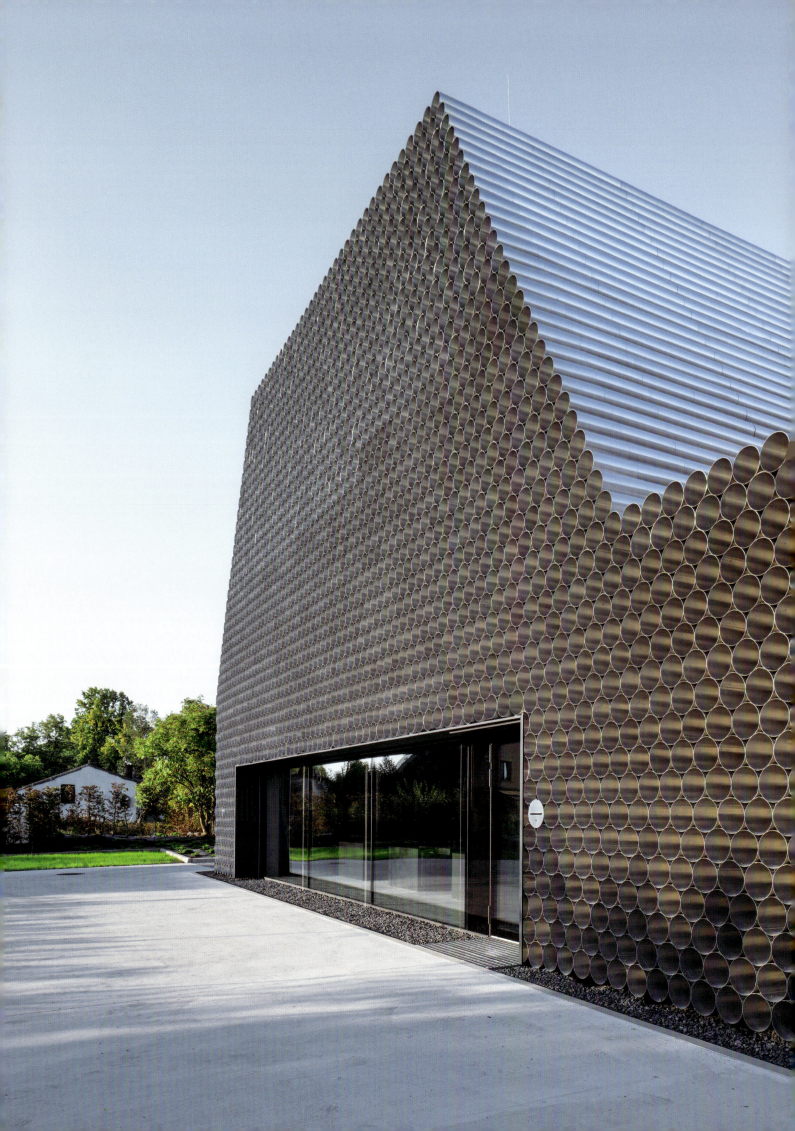

first floor

Just as importantly, we achieved consistency ...

ground floor 0 5m

... between functions that are usually difficult to connect spatially.

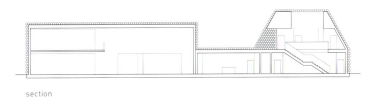

section

It is common in such buildings for the office part to be docked to a large-scale warehouse.

east elevation

Here, instead, they form a unified whole ...

west elevation

... as was done in our earlier design of the MM Petro office building (pp. 38, 40).

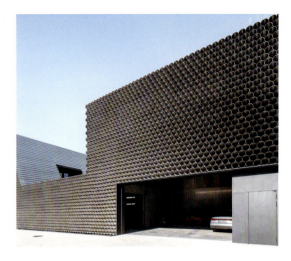

On the other side of the building there is an access to the production and storage areas ...

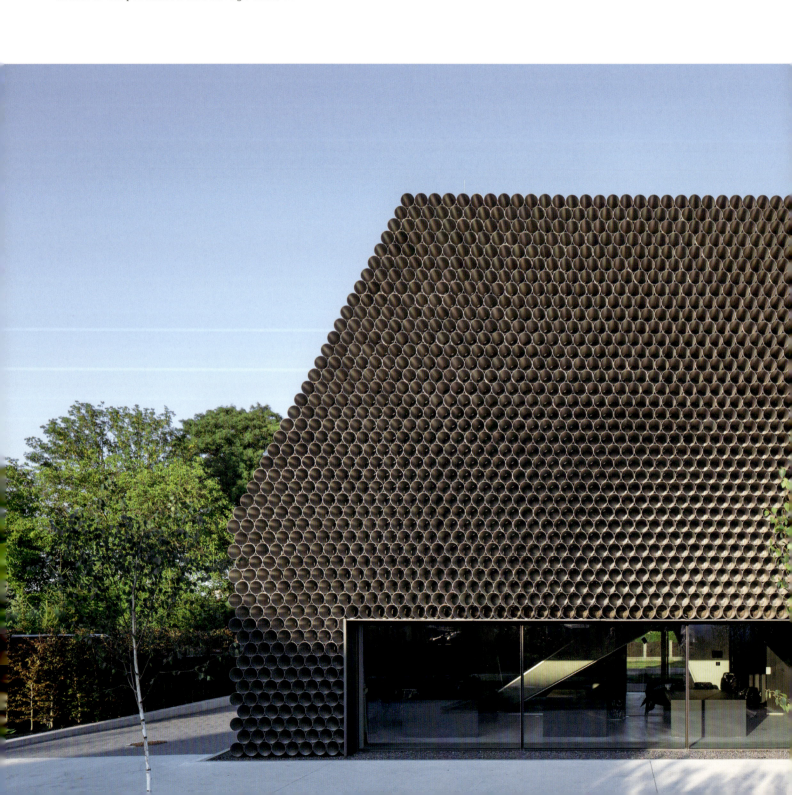

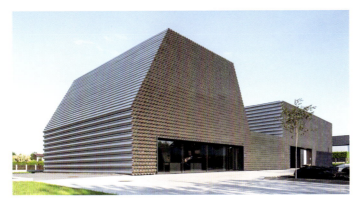

... and the office area opens wide toward the greenery ...

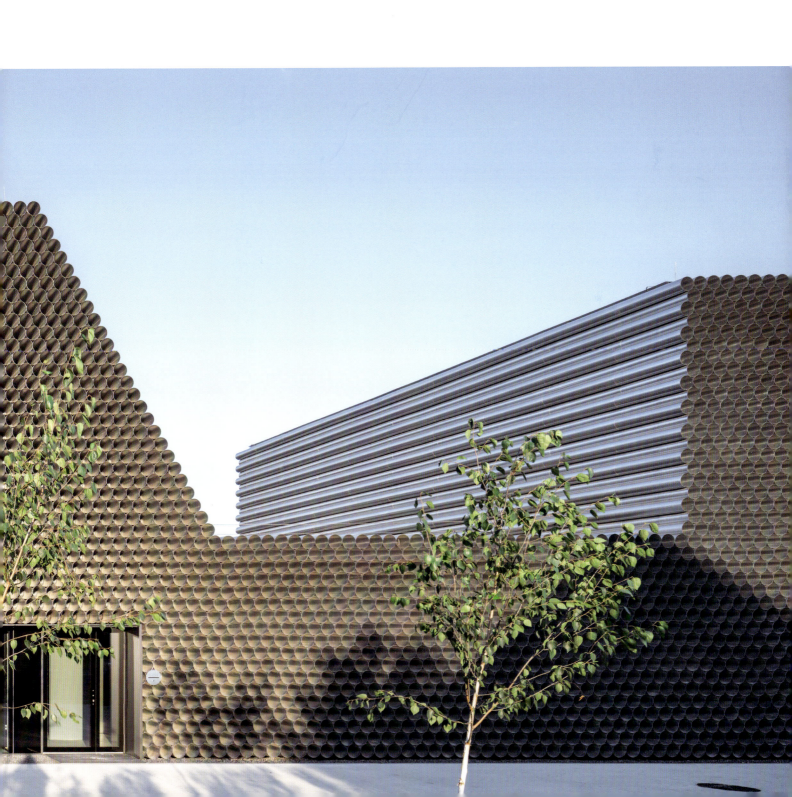

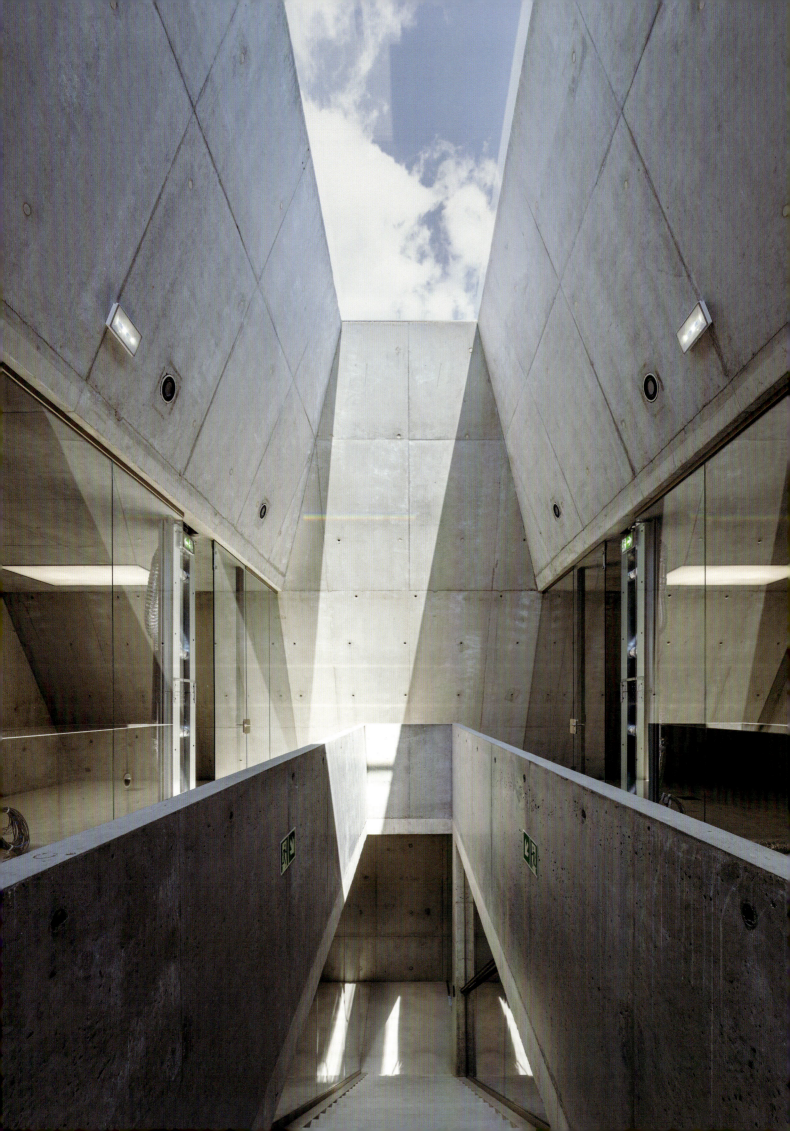

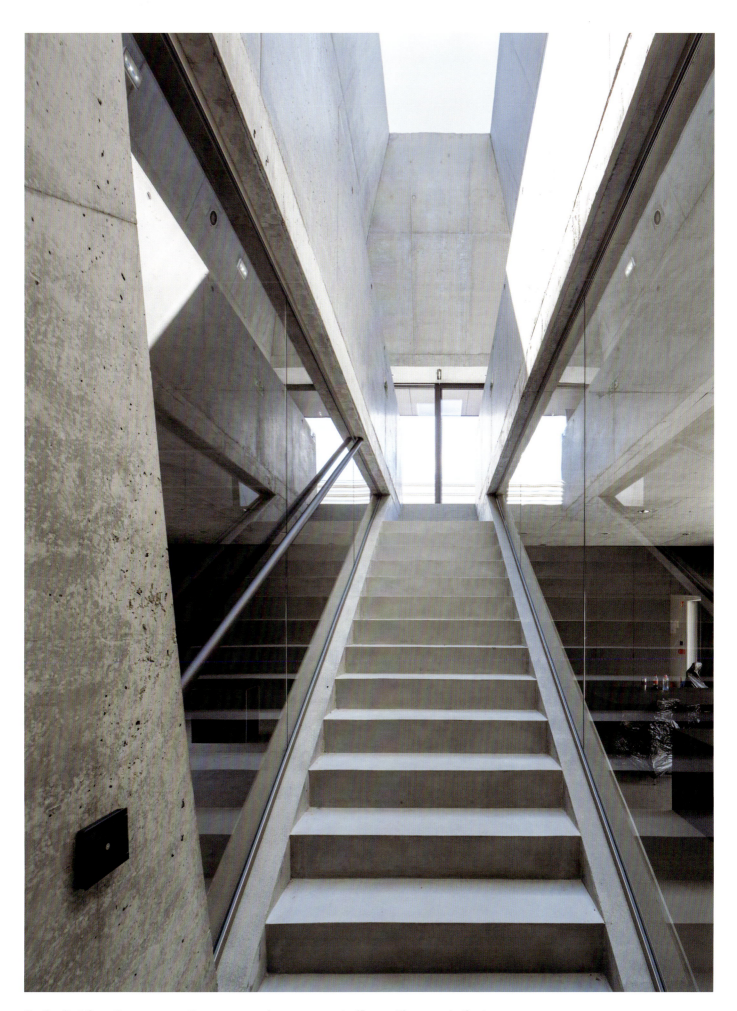

On the first floor there are meeting spaces and management offices with access to the terrace.
The challenge was to design a building that is welcoming and light, while maintaining a monolithic mass.

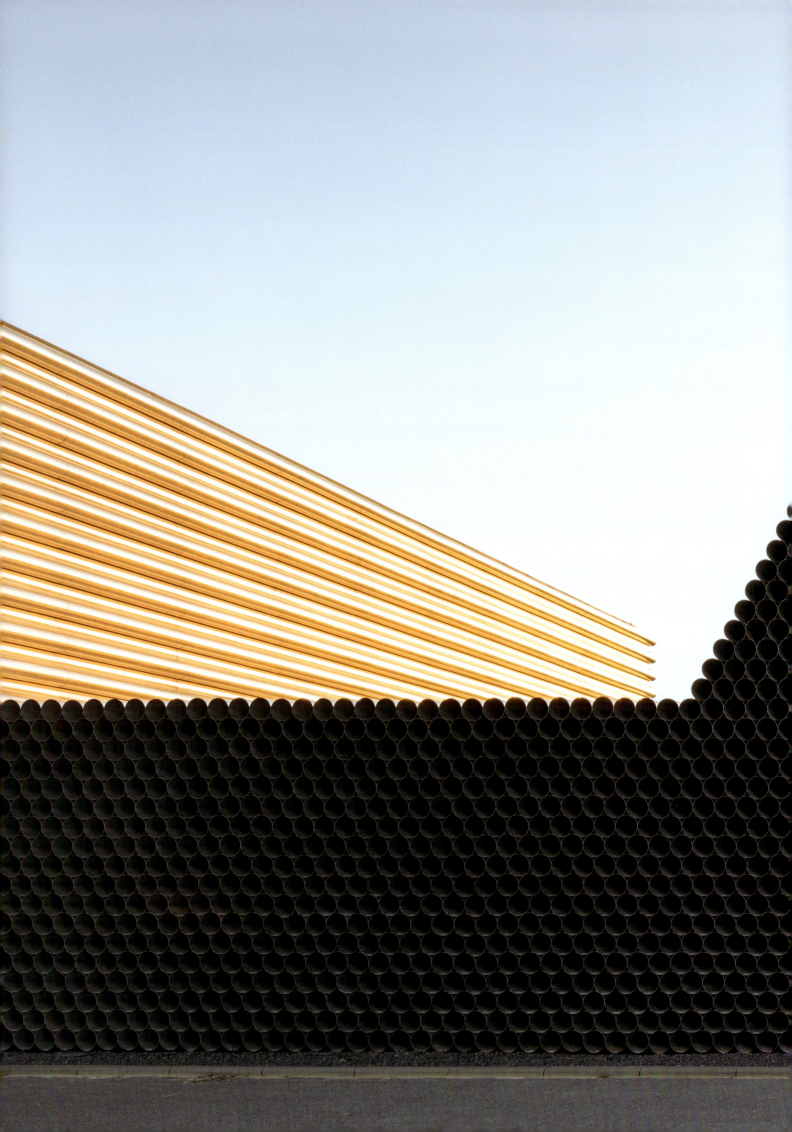

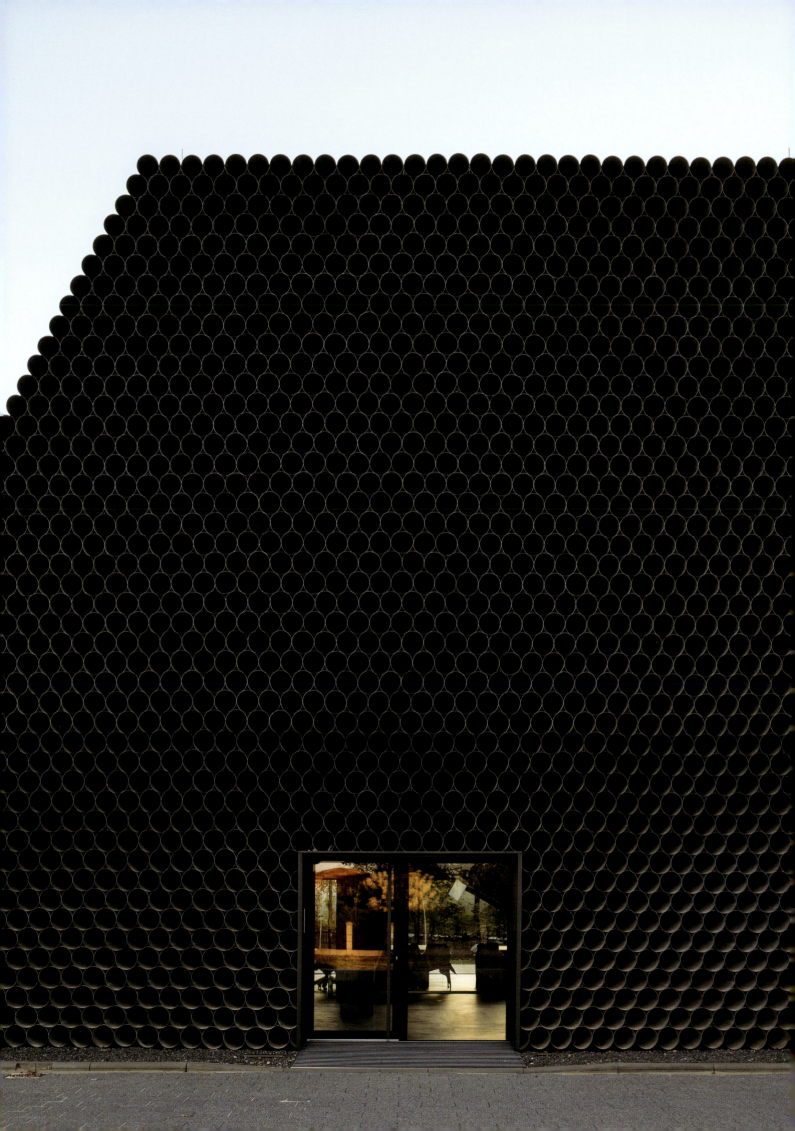

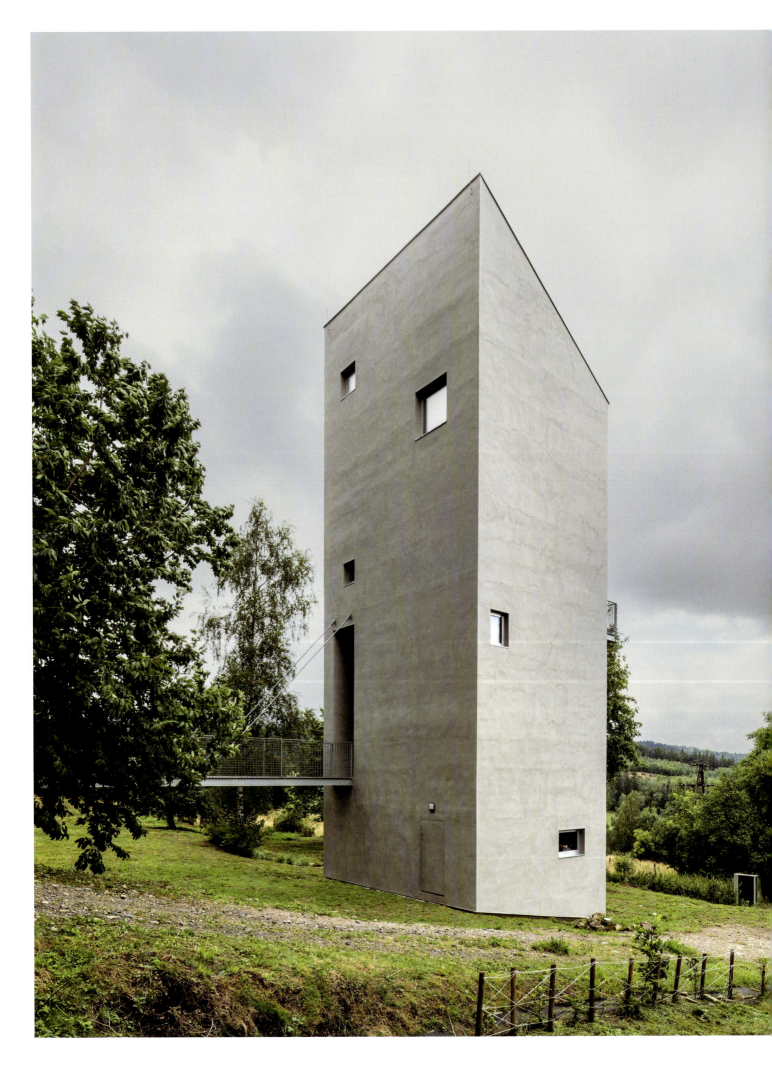

contextual transformation | historical context

Miedzianka Shaft

2016–2022

In a town that no longer exists and has literally sunk into the ground, our clients wanted to build a bookshop, a house, and an artists' cottage.

Today it is hard to picture the numerous mining shaft structures that were present across Miedzianka from the early 1950s to the 1970s. These remained top secret because the Russians ... ↙

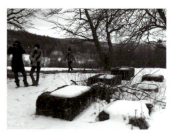

Fifty years on, our clients who have been fascinated by Miedzianka's history are now settling there. On their plot we discovered some mysterious, perfectly geometric stone blocks.

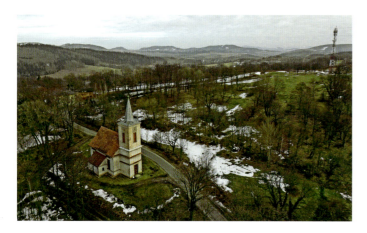

... were mining uranium there, so very little photography exists; mainly maps with two-digit shaft numbers. Some parts of the town were rendered uninhabitable due to mine collapses.

We then found an old map that pinpointed the vast network of underground mines that criss crossed under the site. We realized ...

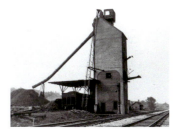

Taking lead from the distinctive roofing shapes of former mine shafts ...

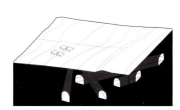 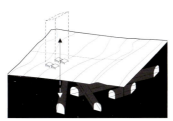 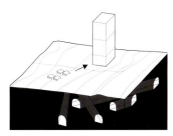 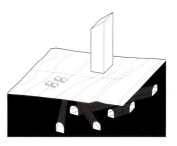

... that the stone blocks were the concrete foundations ...

... for a would-be shaft whose construction had been abandoned, most likely due to lack of uranium deposits.

This discovery inspired the idea of stacking three buildings consecutively on top of each other in a place that wasn't in danger of caving in, of course. ↗

... we decided to roof our building in a similar way ...

... to reflect a historical structure that would have once been a common scene across Miedzianka.

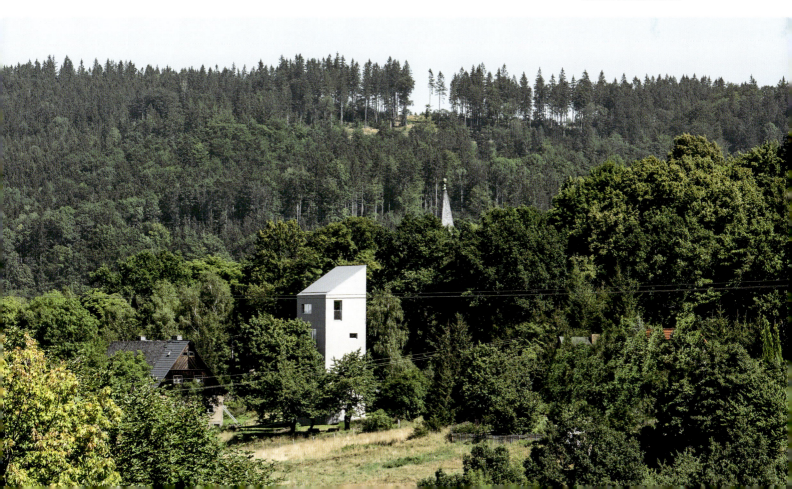

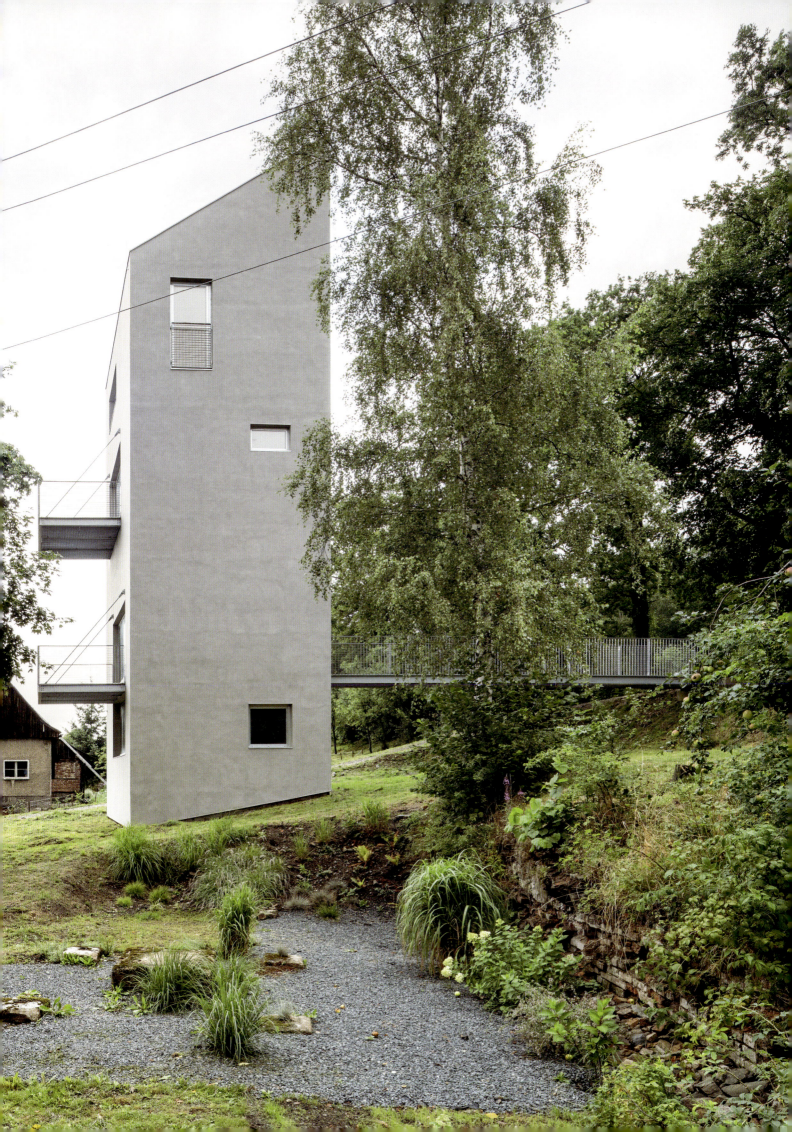

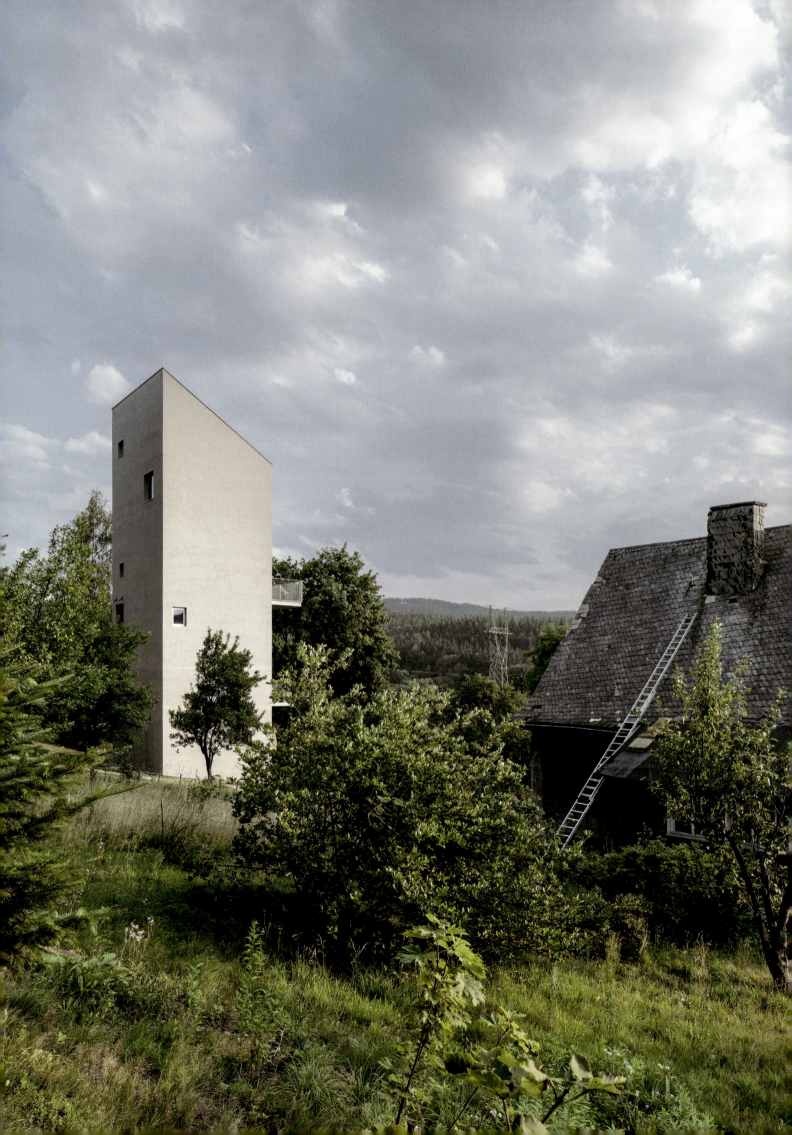

Originally the clients wanted the three functions to be scattered side by side as independent volumes near the school building.

However, it was only the vertical layout that created a good scale for such a small volume in relation to the large old school building.

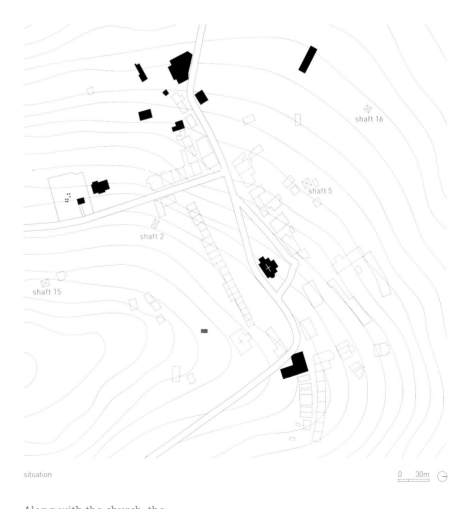

situation

Along with the church, the school is one of the few buildings to survive.

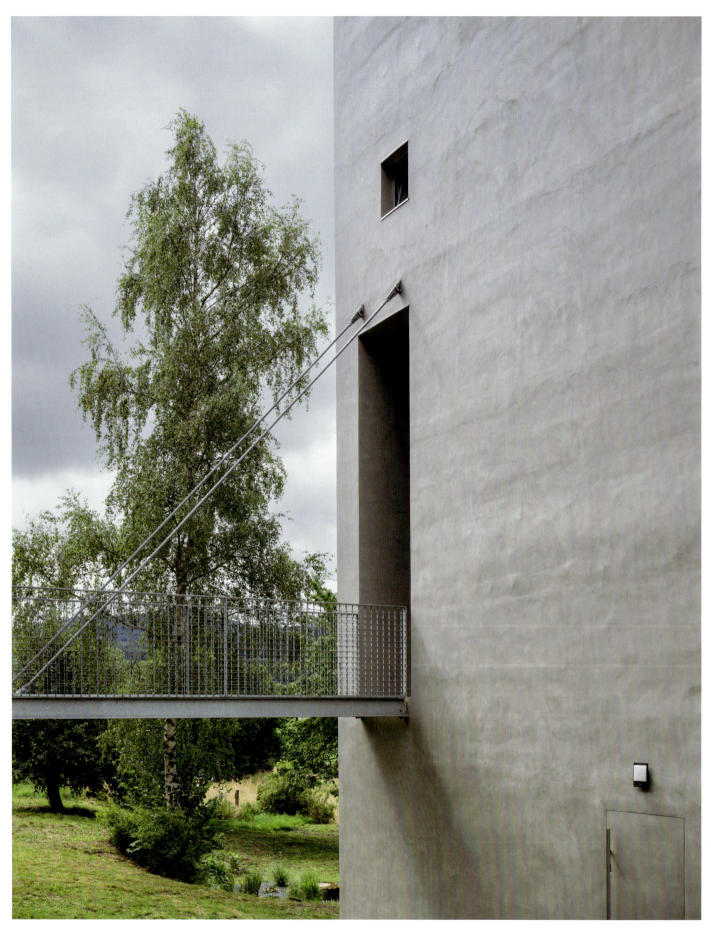

Many of the solutions applied to the shaft are strongly reminiscent of industrial buildings.

The steel cables supporting the entrance bridge and the hanging terraces, and the microcement façades, were effective, simple, and very economical options, too.

Despite combining the three buildings into a tower, we designed a separate entrance for each function.

level 2

The top part of the tower contains …

level 1

… the owner's two-story residence.

level 0

The bridge level houses a gallery with a bookshop …

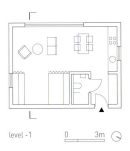

level -1 0 3m

… and the tower's lowest level contains a creative work space for artists and writers.

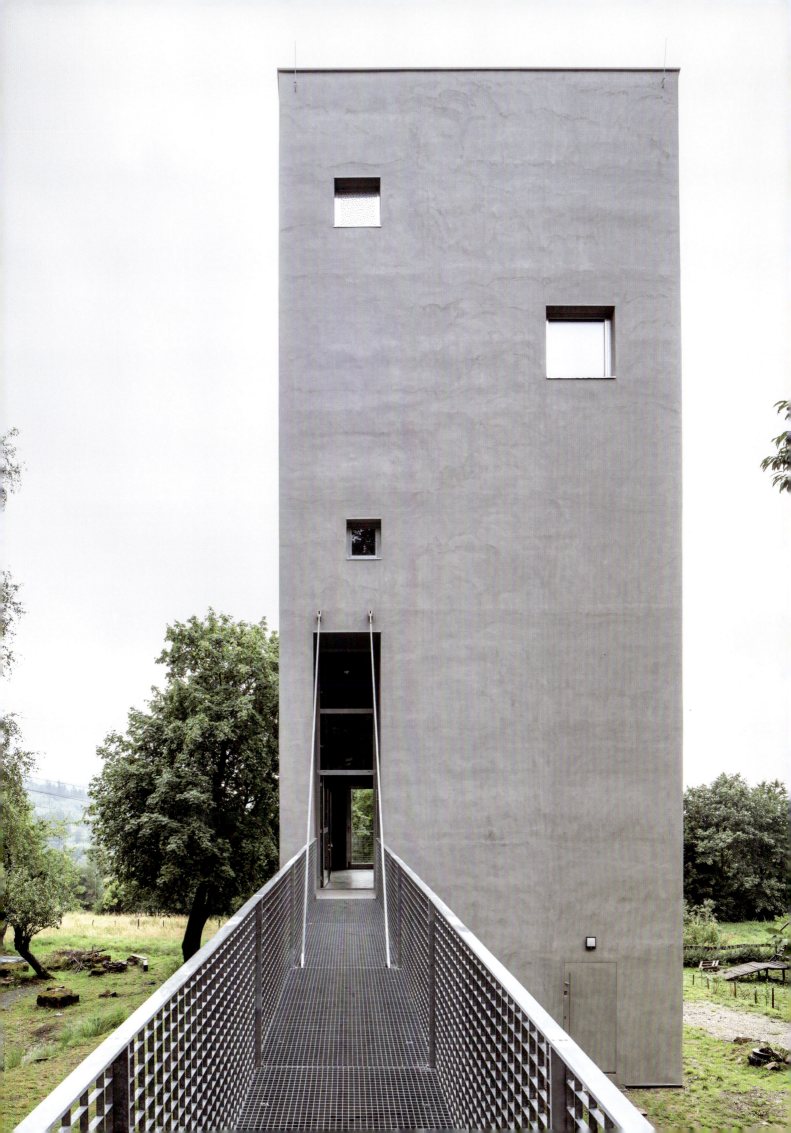

The character of the shaft inspired the owners to continue the industrial feel into the interiors …

… and they designed their internal spaces their own way.

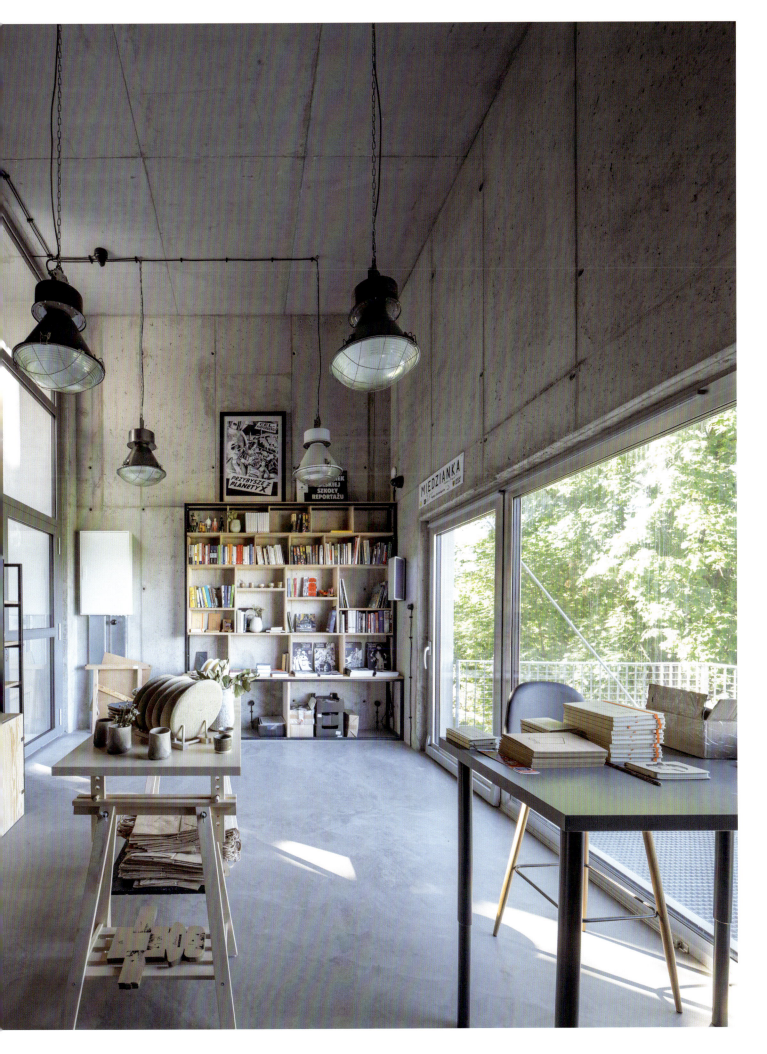

It came as a surprise to them that in these somewhat small spaces ... ↗

... everything fits and functions comfortably.

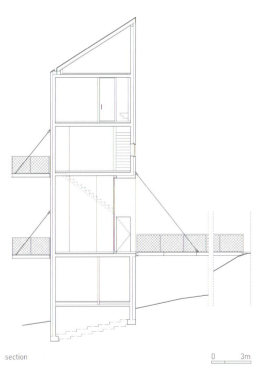

section 0 3m

Each level of the tower has an area of around 323 square feet (30 square meters).

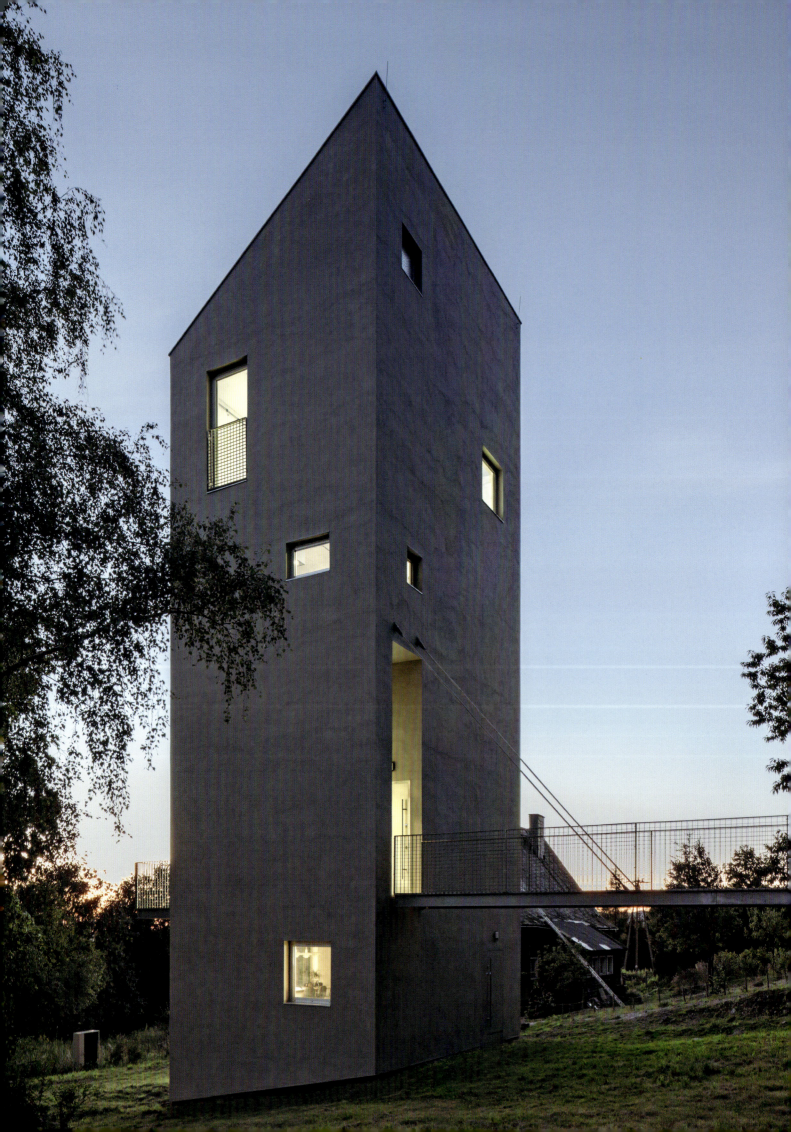

Miedzianka Shaft manages to combine public and private functions, just as was done in the Marina in Biały Bór (p. 200) project, as well as ...

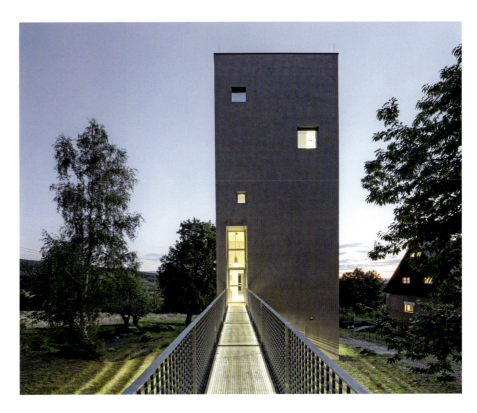

... retain a strong connection between the site's significant historic past and the present nature of the place.

These connections are also experienced during artistic events and literature meetings especially, which are often held among the site's old foundations.

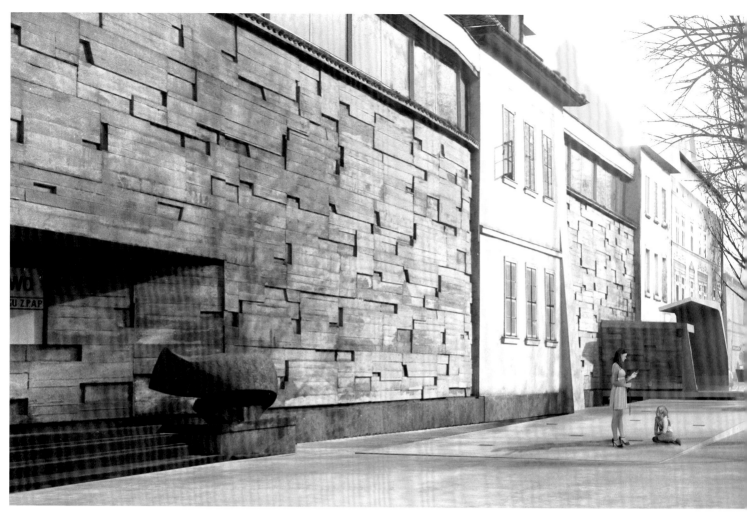
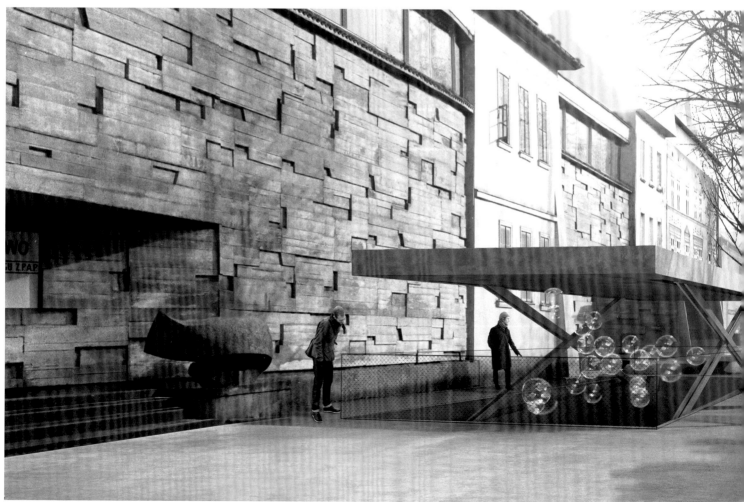

topographic | mobility

Art Bunker

2016–

↓

The new exhibition possibilities I had in mind after the realization of the Przełomy Dialogue Center (pp. 27, 33, 38, 39, 158) were achieved in the winning competition design for the extension of the Bunkier Sztuki Art Gallery in Cracow.

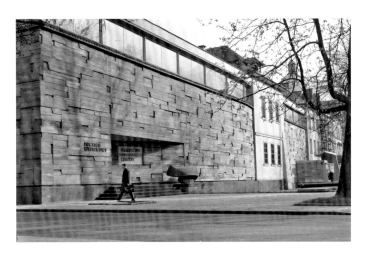

The competition provided for the superstructure of the building, which itself is a unique example of brutalist architecture in Poland.

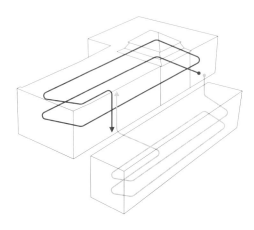

However, as we were unwilling to interfere with the historical body of the building, we hid the new gallery underground.

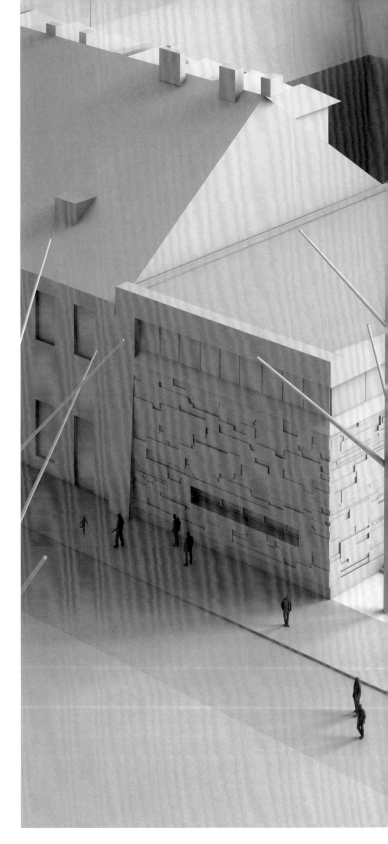

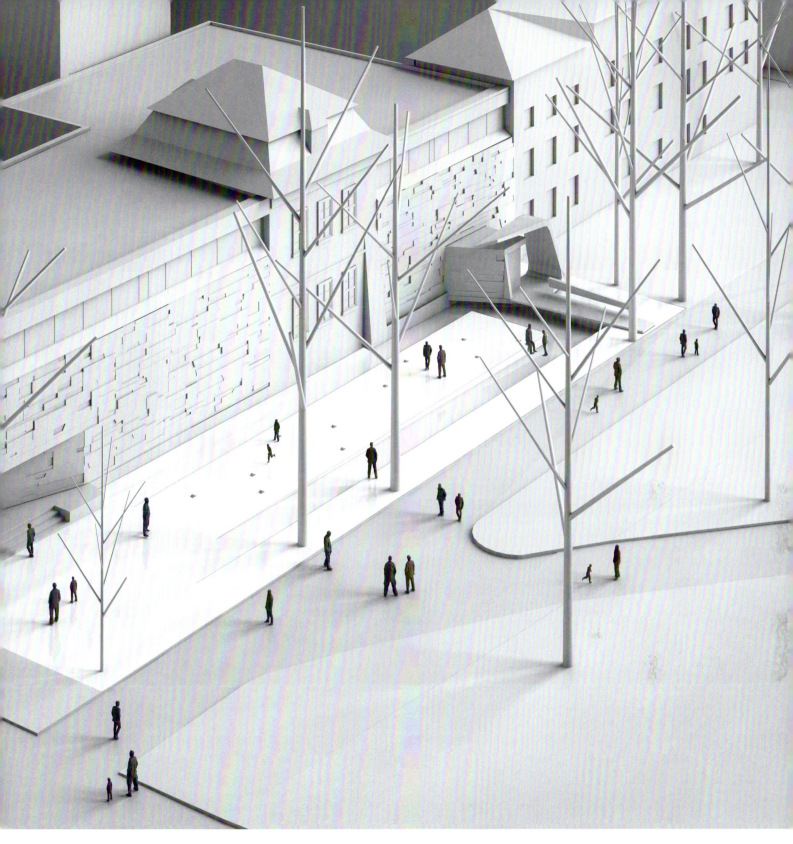

The new part is located under the pavement of the entrance square of the historical structure.

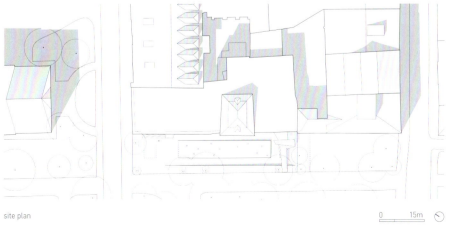

site plan

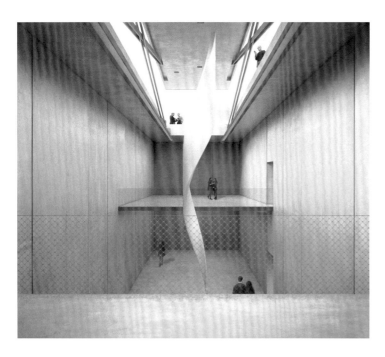

The idea of connecting the underground exhibition halls with the city was realized with a raised roof ...

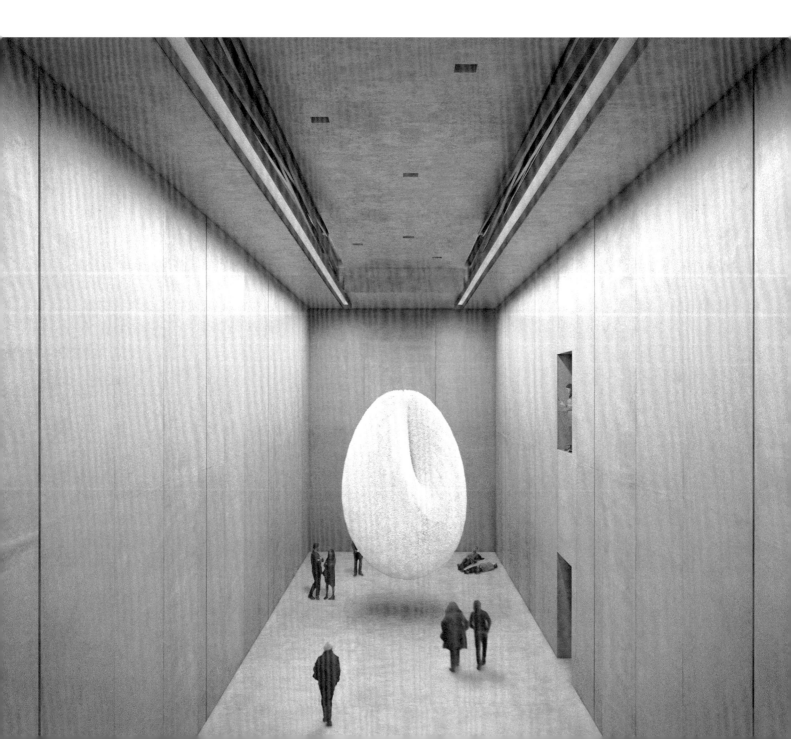

level -1

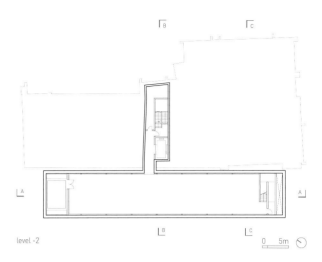

level -2

... which is formed over a large section of the square. →

In this way, artists were given the opportunity to interact with the city with their art, and passers-by could look directly into the interior of the gallery to view the art.

section A-A closed roof

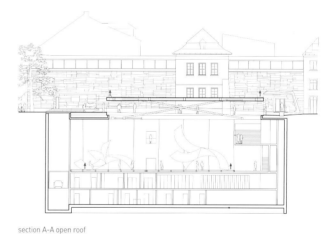

section A-A open roof

There are also mobile elements inside the exhibition spaces. Movable ceilings make it possible to exhibit objects of any size ...

... and create a variety of scenarios impossible to realize in the classic exhibition space.

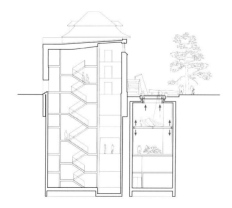

section B-B

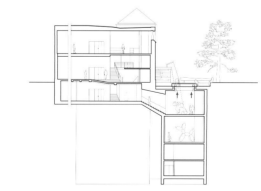

section C-C

An underground building with a movable roof offers a unique visual contact with the art for passers-by. The only thing I missed was direct access to the exhibition.

However, we achieved an entry point in the building redevelopment for the Plato Contemporary Art Gallery (pp. 35, 38, 286) in Ostrava, Czech Republic.

285

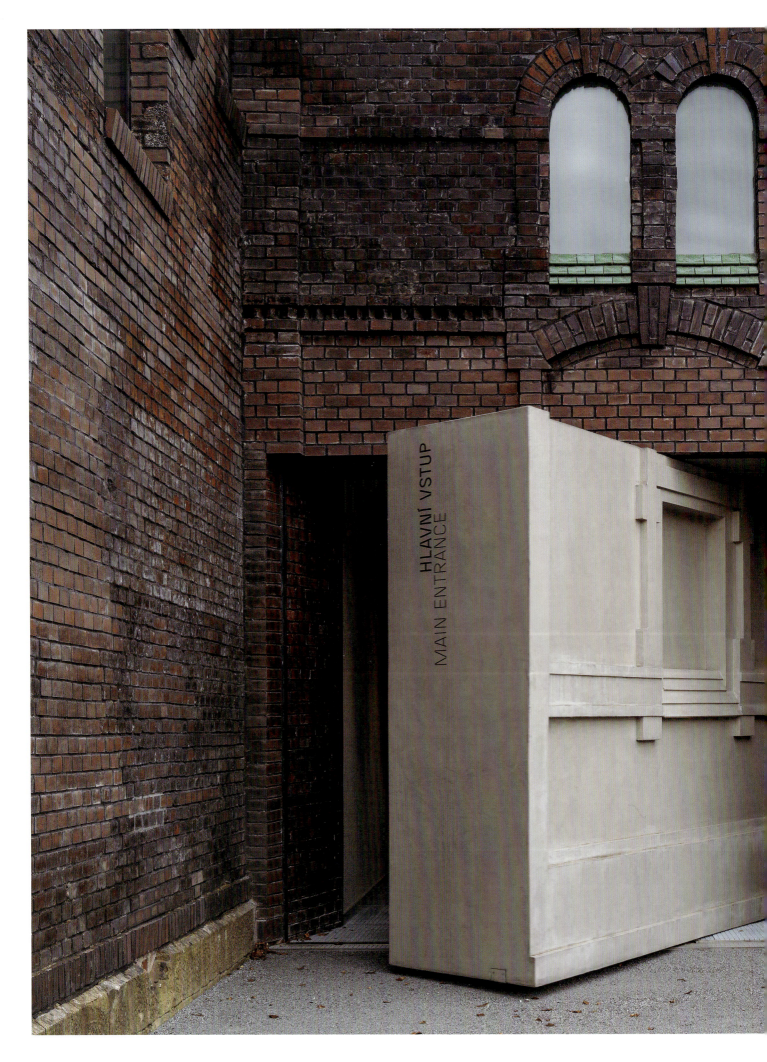

mobility | contextual transformation | historical context

Plato Contemporary Art Gallery

2017–2022

↓

The Plato Contemporary Art Gallery in Ostrava, Czech Republic, came about as an outcome of winning the competition for the redevelopment of an old nineteenth-century slaughterhouse …

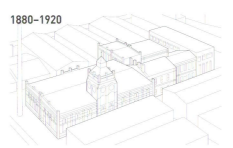
1880–1920

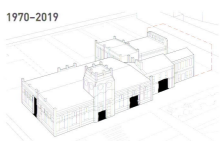
1970–2019

... that was situated in a now partly demolished urban area of the city; an industrial area that had once been densely populated.

When the competition was announced, the walls of the historic slaughterhouse were mangled with huge holes, part of the building had collapsed, and the soot-blackened brickwork had borne witness to the town's industrial history.

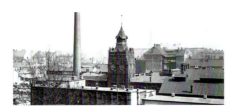

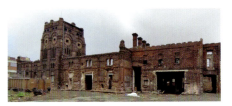

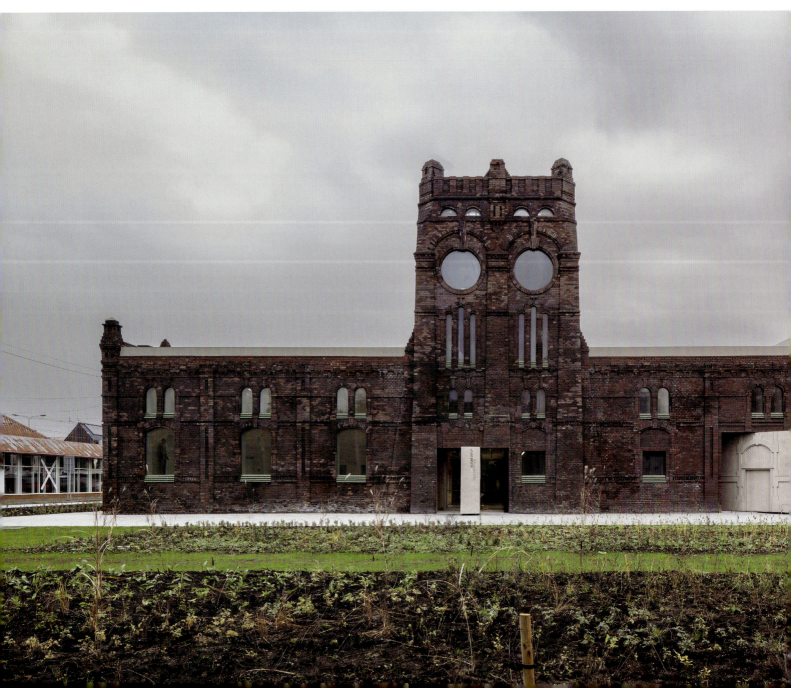

2022

The conservators allowed us to use new material to fill the holes in the walls and restore the collapsed part of the slaughterhouse, while keeping the old ornamentation. This was a significant concept that we wanted to emphasize in this contemporary redevelopment.

2022

The main idea was to preserve the holes to form shortcuts for connecting the building to the city. Hence the idea that their new infill can be rotated to be able to open the exhibition rooms to the square outside.

2023

The outdoor exhibition space is surrounded by greenery and its layout refers to the location of the buildings that used to be situated here.

While we originally envisaged finishing the square with a concrete floor …

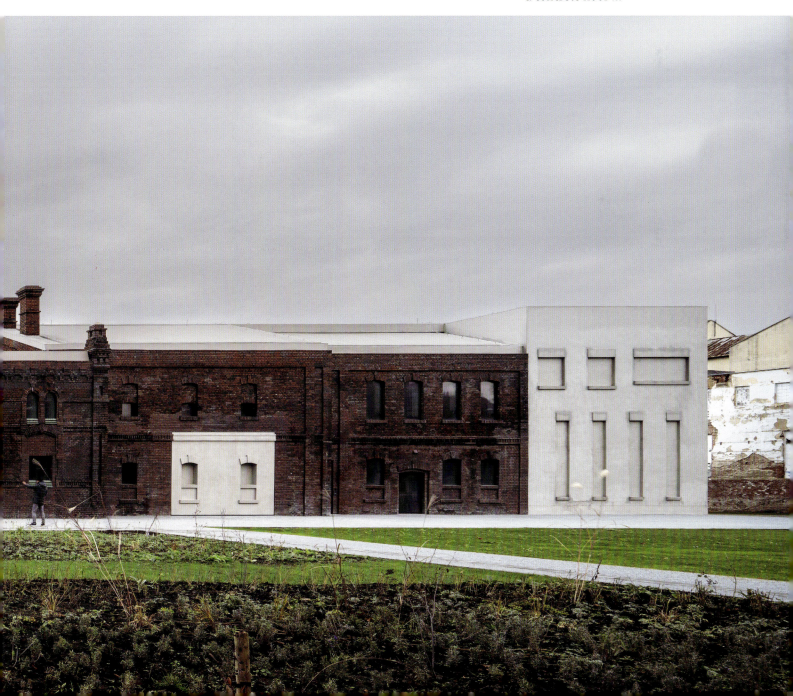

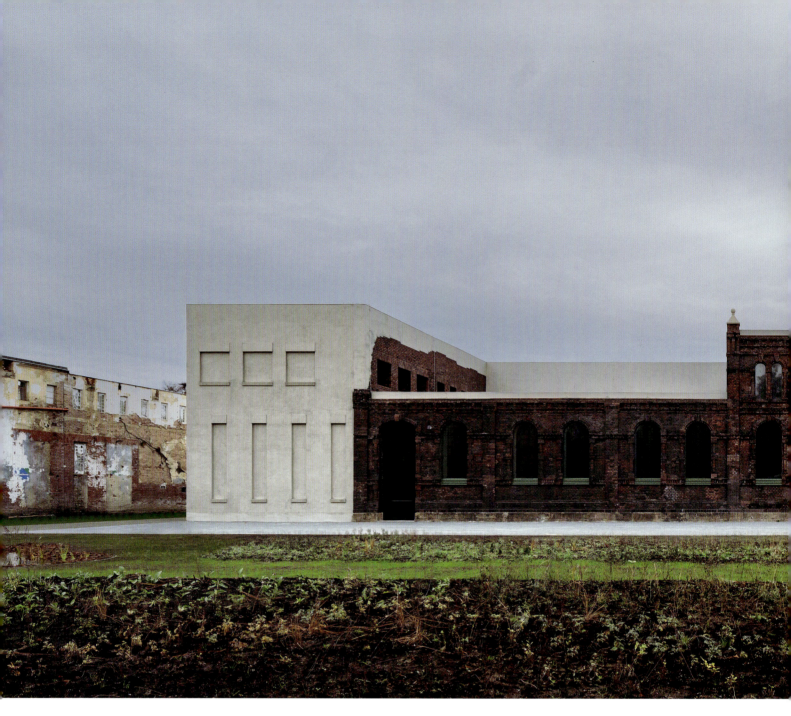

... however, subsequent climate reports prompted us to change the design and we did so during the construction process.

Currently the yard is made up of water-permeable gravel surfaces, grasses, flower meadows and trees, along with a small pond and underground retention basins.

site plan 0 30m

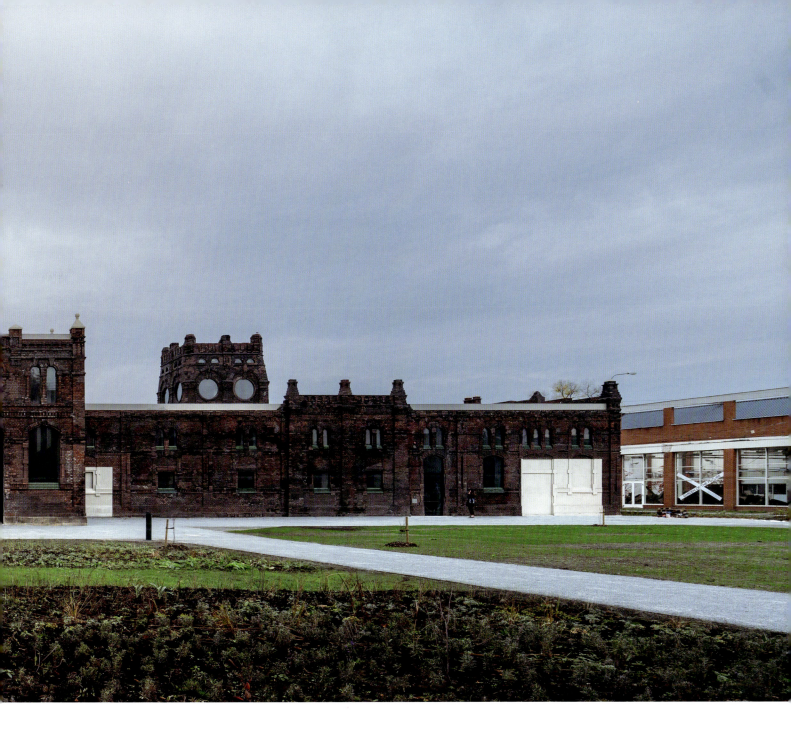

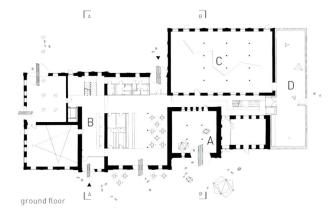

ground floor

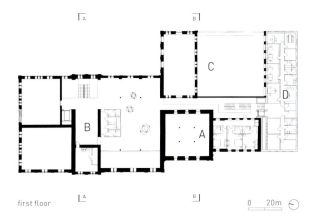

first floor

0 20m

There are two entrances to the gallery building, and of its five exhibition rooms, three open onto the square.

One of these is housed in a reconstructed collapsed building (D).

291

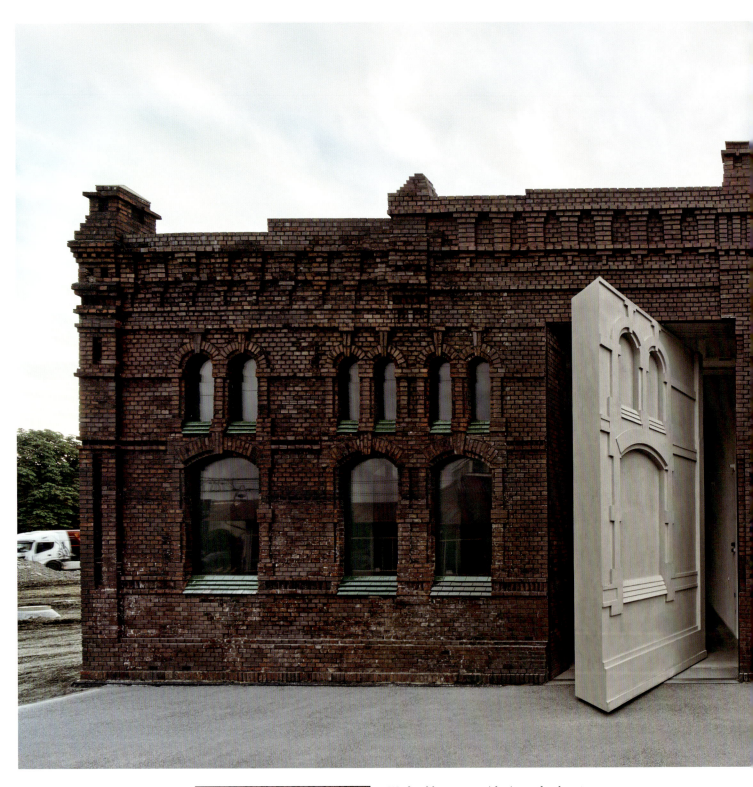

We had been considering whether to re-create the refurbishment in brick so it would easily blend in with the rest of the building ...

... but at the end of the day we felt that would be a disingenuous result, so consequently, like new walls in the breach, we built it ...

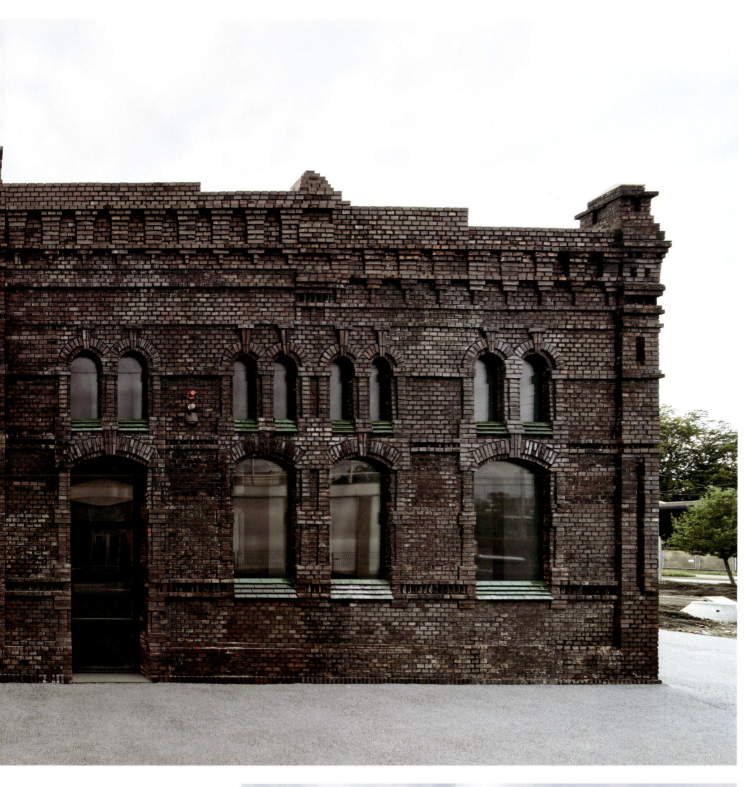

... in a new technology and material while retaining the old façade ornamentation. The plasticity of a microconcrete application was ideal here.

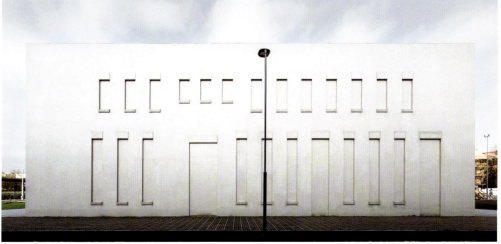

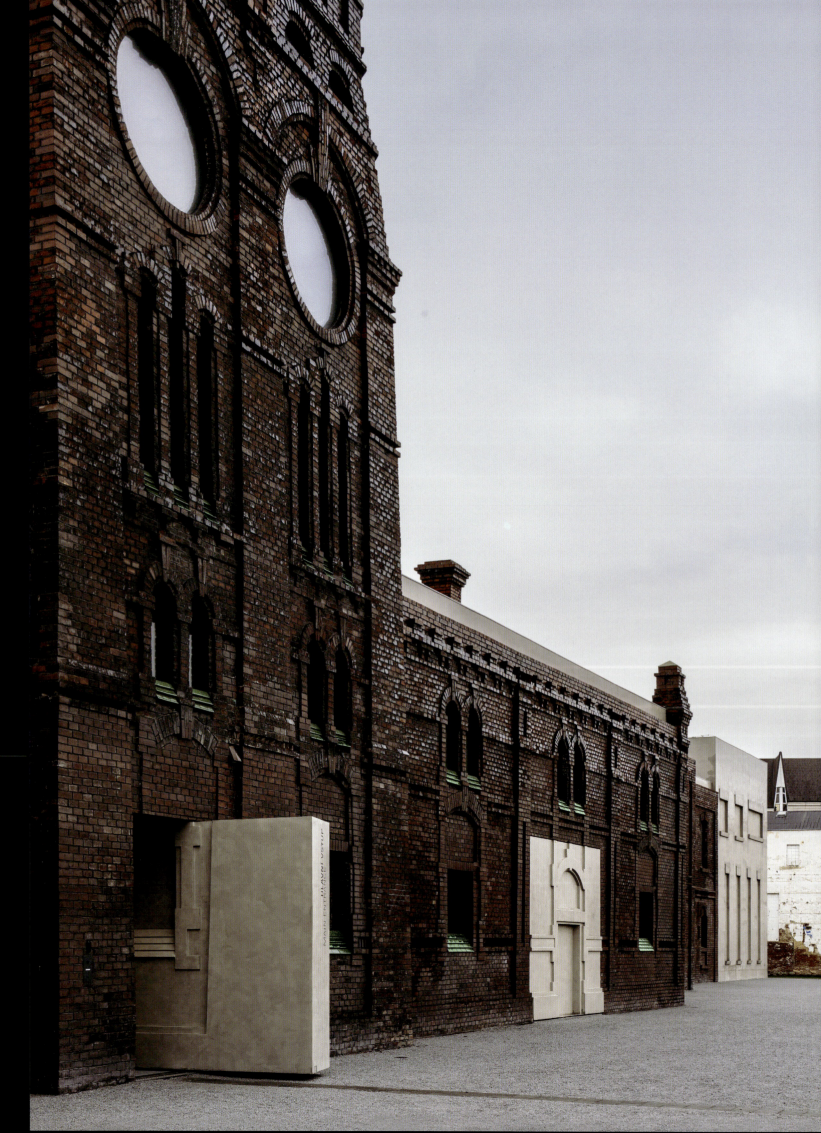

The challenge was to explain to the commissioners that we didn't want to erase the recent past—we wanted to preserve the dirty brick, and thus we should also make the glass dirty.

west elevation

We finally covered them with matt sintered quartz.

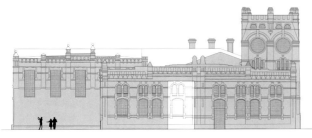

north elevation

The engineers were concerned with the skewness of the building ... →

south elevation

... especially in the context of the complex rotating mechanisms of the walls. ↙

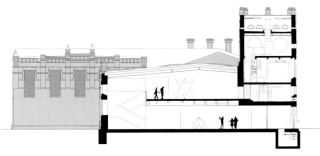

section A-A

It was necessary to insert and conceal the foundation micropiles ...

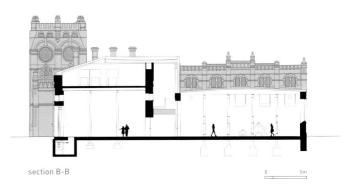

section B-B

... along with the additional steel structures and bracing rims, too.

295

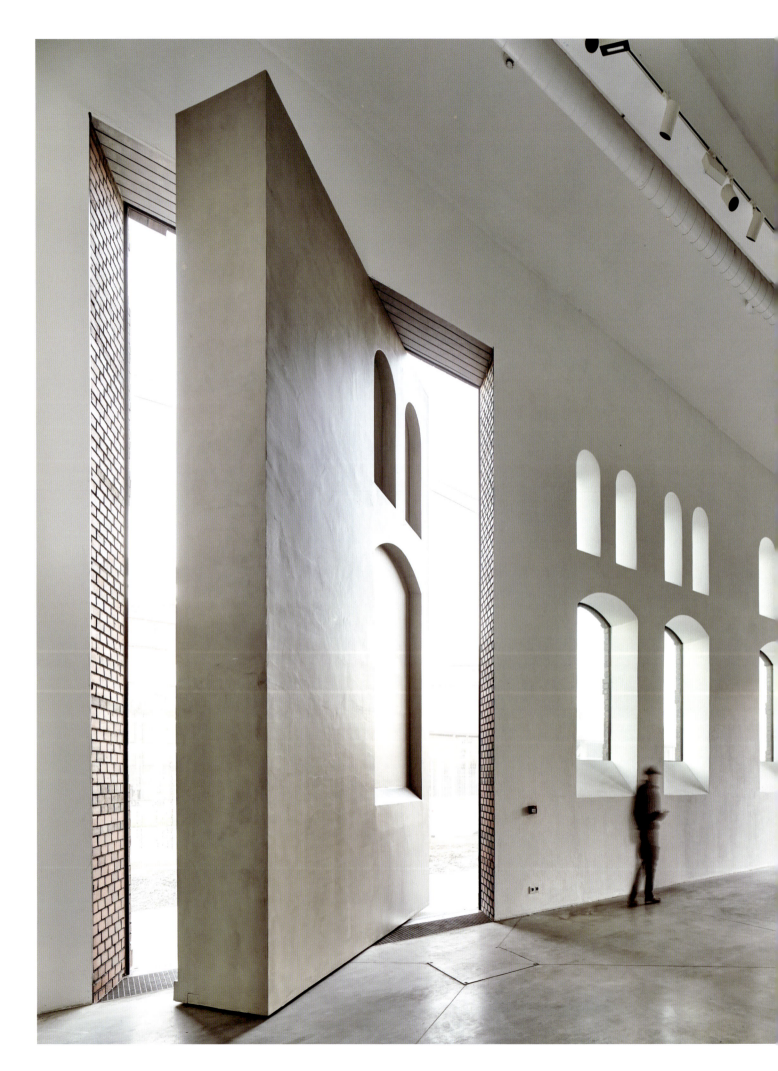

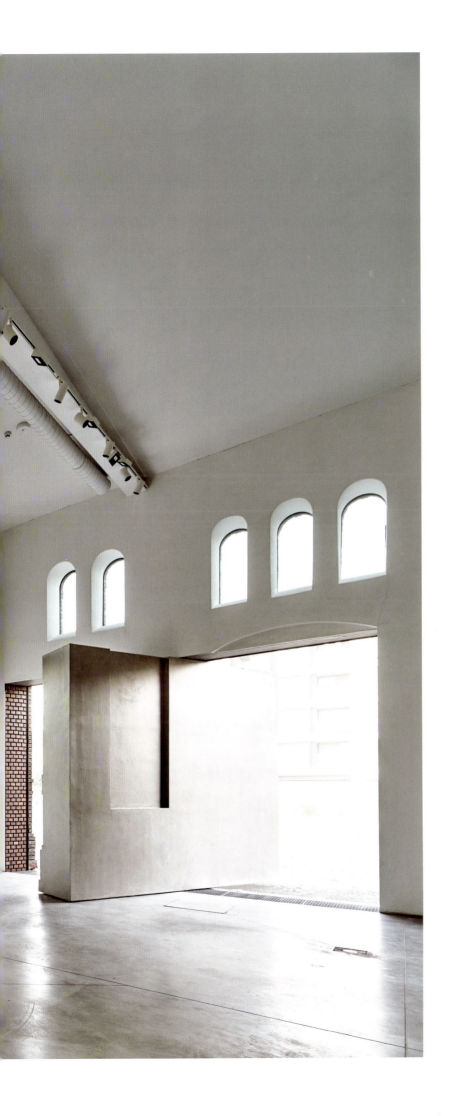

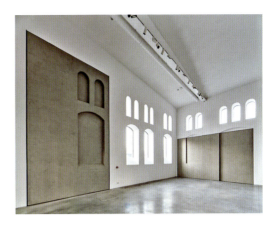

The installation of the mechanisms for converting classic white boxes …

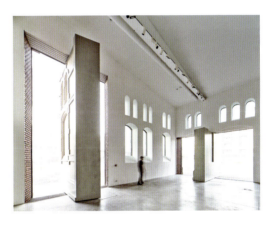

… into galleries opening up to their surroundings coincided with the pandemic and the closing of the Polish-Czech borders.

Our attempt to illegally cross this border to oversee the construction failed. We eventually got there once the borders were reopened.

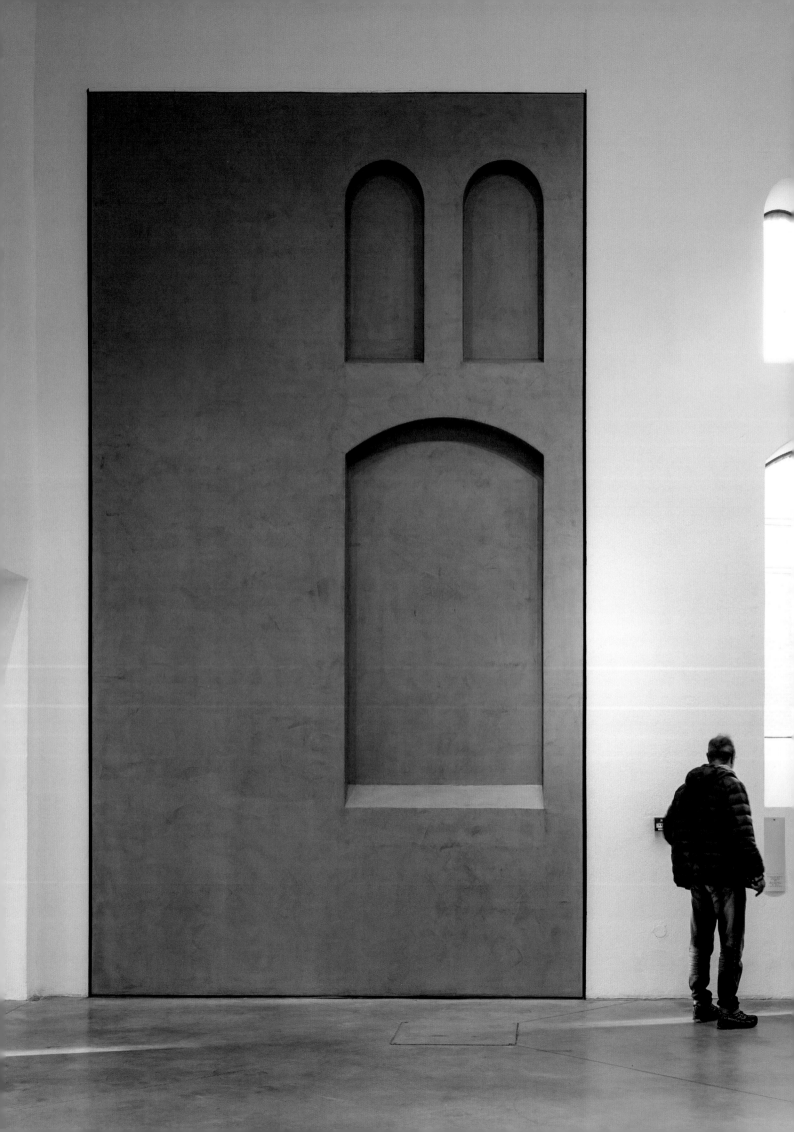

When designing the rotating walls, we also took climate change into account and reinforced them ...

detail section A-A

... for instance, they can be left open even in wind gusts of up to 56 miles (90 kilometers) per hour.

detail section B-B

The widest rotating wall is 19.7 feet (6 meters) and the highest reaches 21.3 feet (6.5 meters) tall.

detail section C-C

In order to make the gates a reality, it was necessary to dig up the basements to hide all the necessary technology.

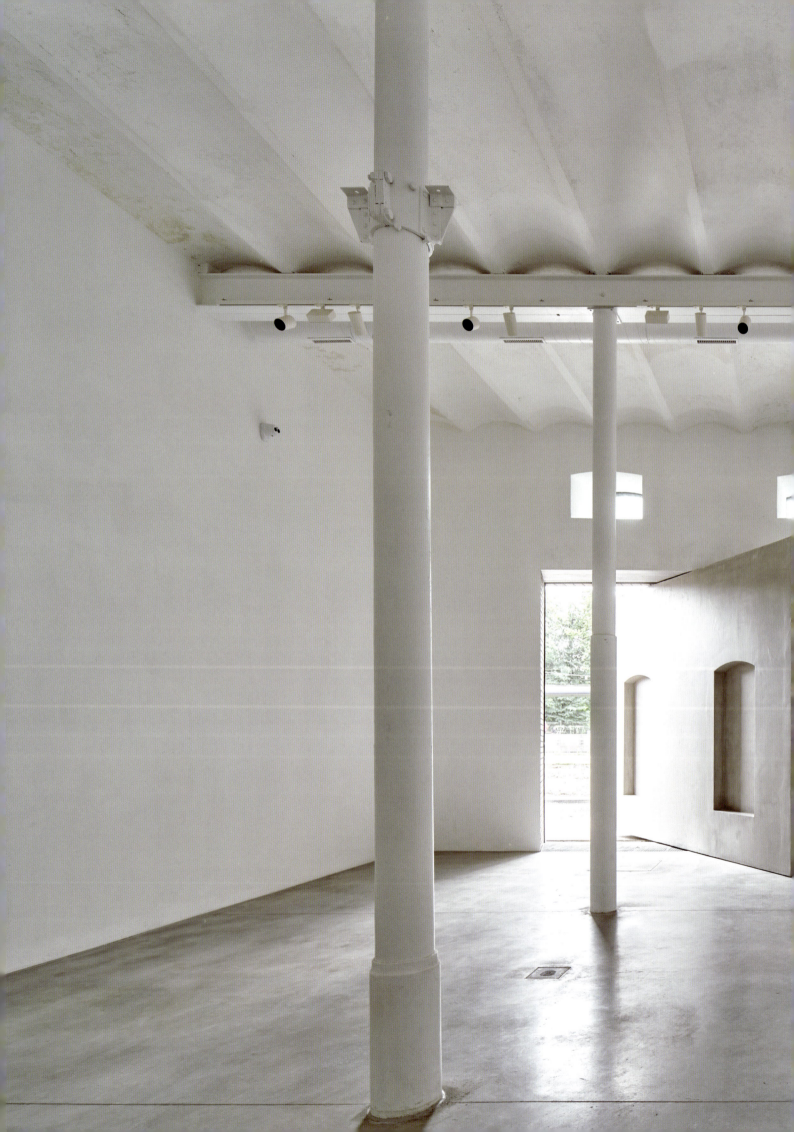

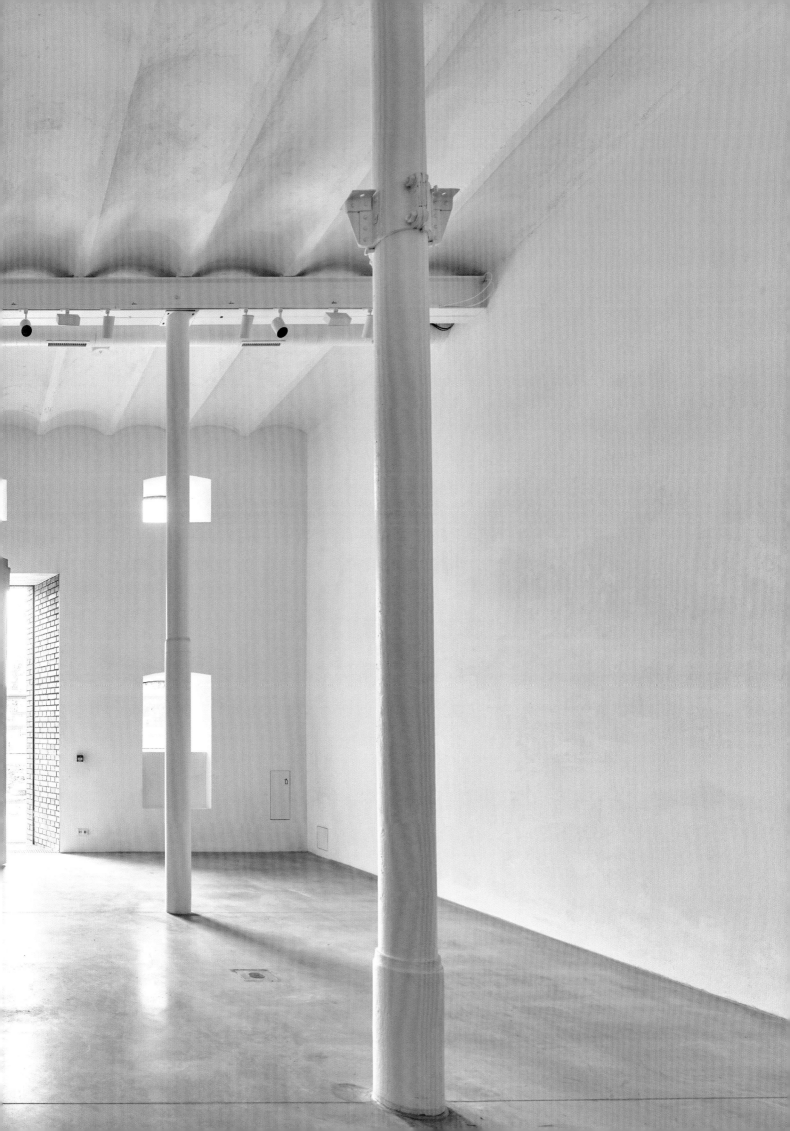

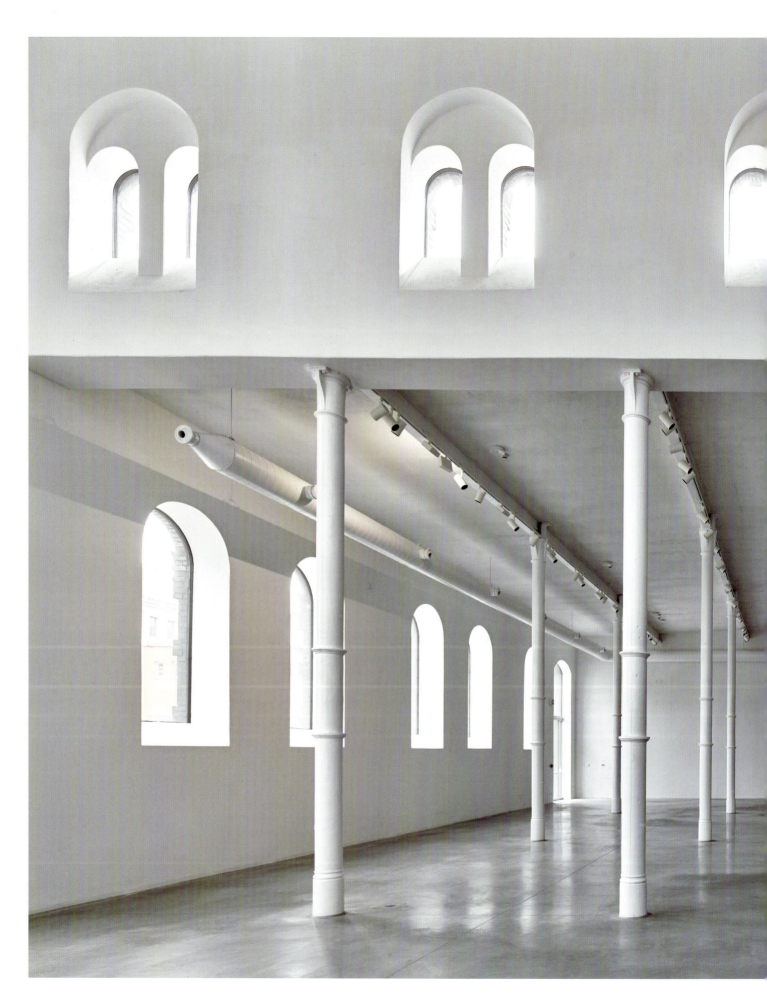

The interiors of the exhibition rooms are offset with white plaster, reflecting the history of the space, which was once an abattoir whitewashed with lime.

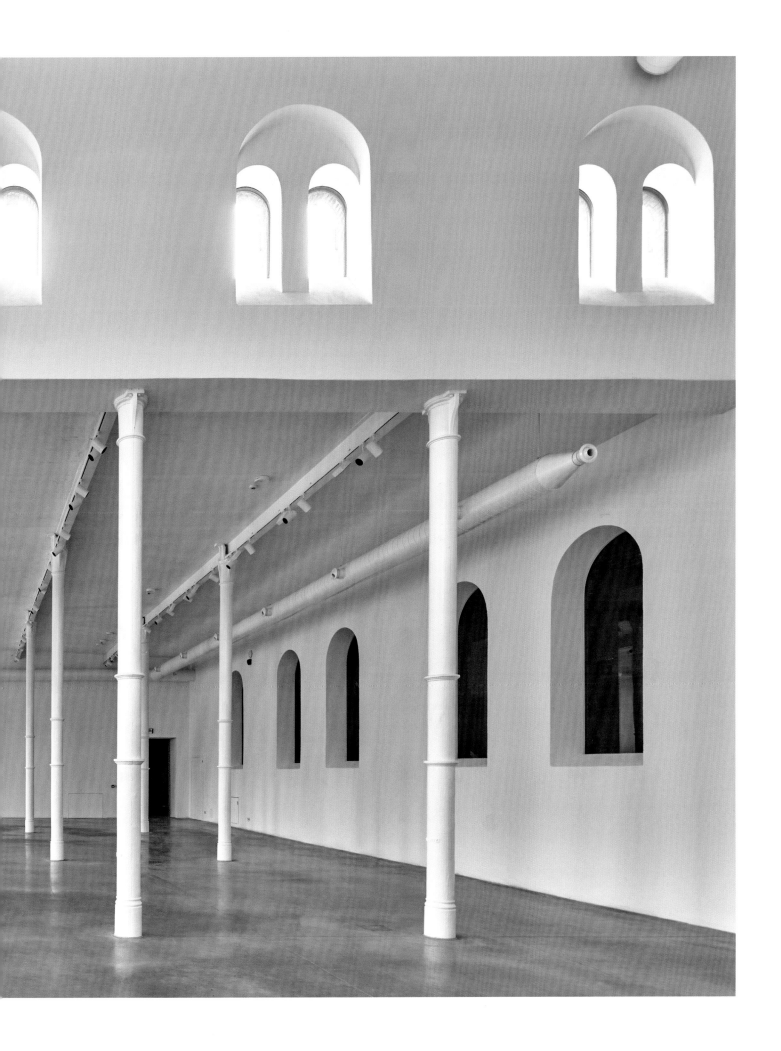

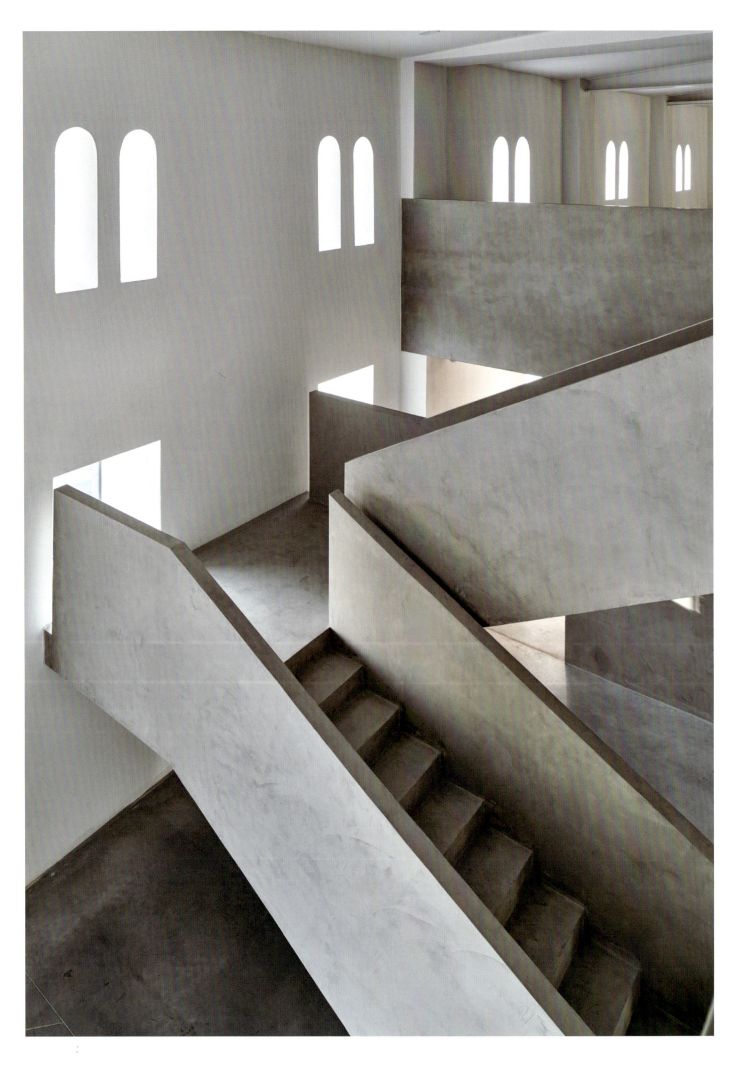

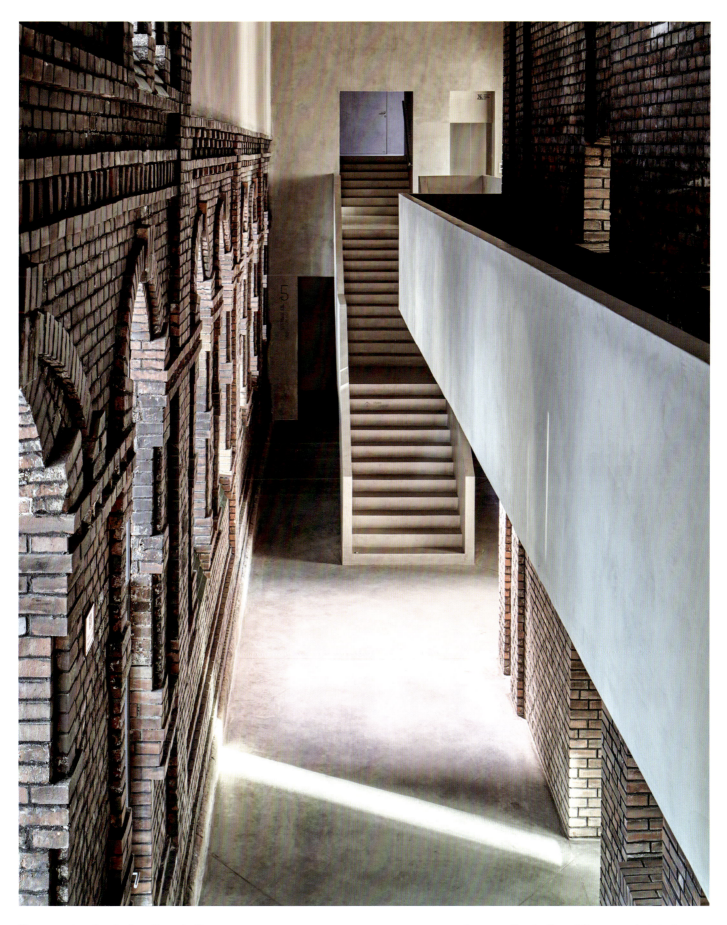

The new structural alterations to the building, as well as to the exterior, were made of microconcrete.

An exception to the white concrete interiors is the brick atrium. The old slaughterhouse used to consist of five buildings from different periods, clustered around a courtyard, which is now a covered atrium and the keystone of all the halls.

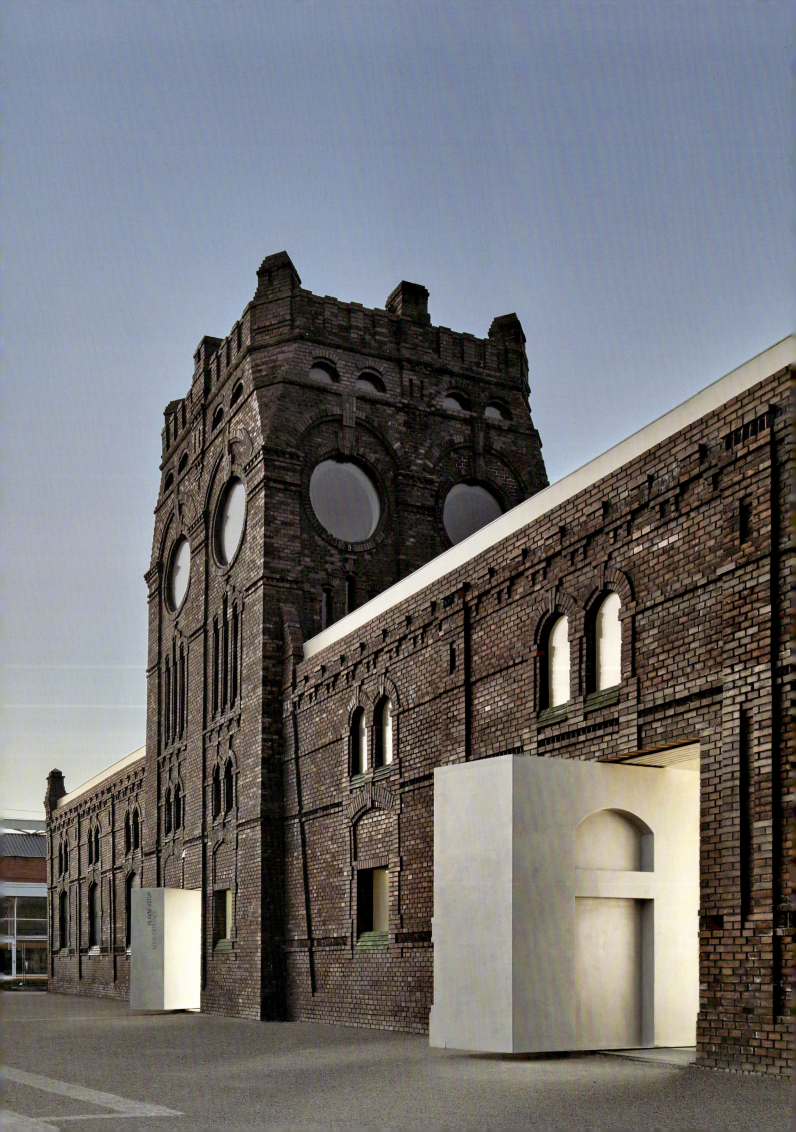

Thanks to the rotating walls, it was possible to achieve a full opening of the cultural facility to the city, something that we weren't able to achieve in the underground extension for the Art Bunker (pp. 27, 33, 280) in Cracow.

In this way, culture and knowledge in the broadest of senses have the chance to become more democratized by making them more easily accessible to new audiences.

Now it's in the hands of the gallery curators to use this unique feature of combining exhibition spaces wisely and creatively.

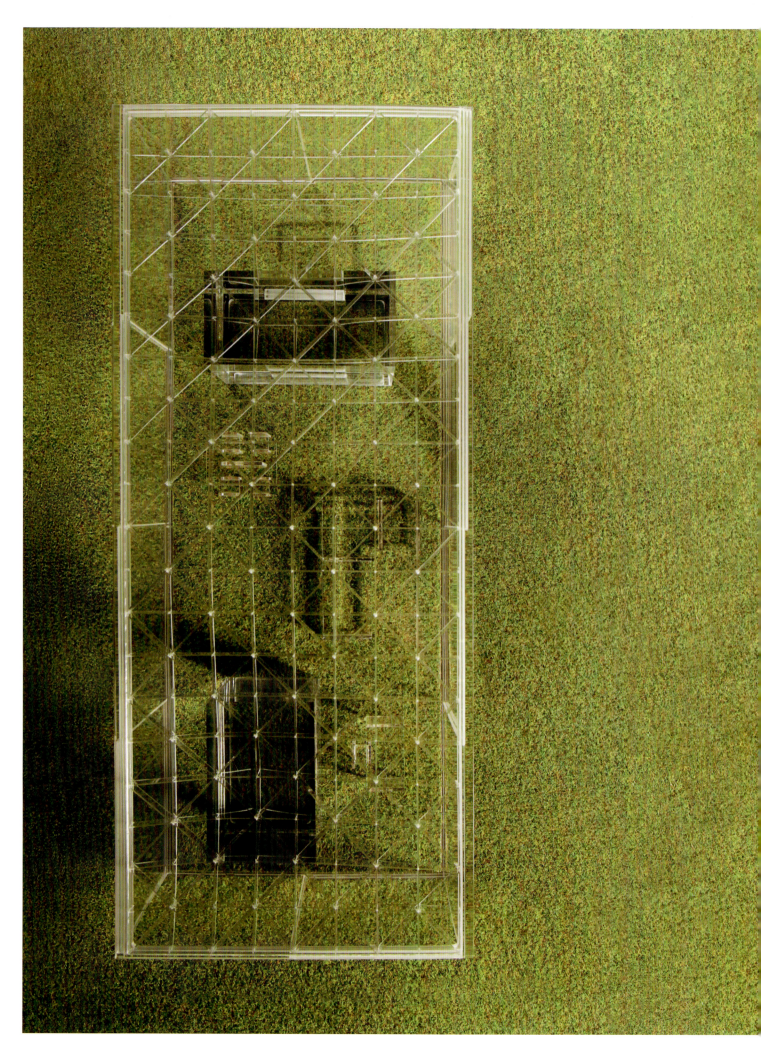

topographic | living-garden

Living-Garden House near Kassel

2017–

After building the Living-Garden House in Katowice (pp. 46, 128) and Living-Garden House in Izbica (p. 46), I imagined I could create a house that gives residents not only the feeling of living in a garden, but really one that includes all that nature provides.

typical house living-garden house **Living-Garden House near Kassel**

It was my dream to bring the garden with its living ecosystem into the whole interior. The opportunity to do so came with an invitation to the project Ways of Life, which involved …

… designing experimental houses around Kassel, Germany, together with nineteen other studios from all over the world. They were to combine living and working facilities.

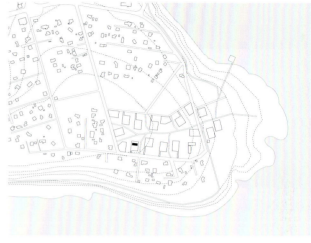

site plan 0 150m

We based the structure of our house on that of a tree. It covers the entire living space, while the stem, like the trunk … →

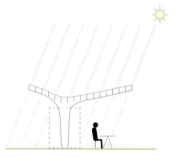

… goes down to the ground. In this way, it frees up the space around it to connect with the garden.

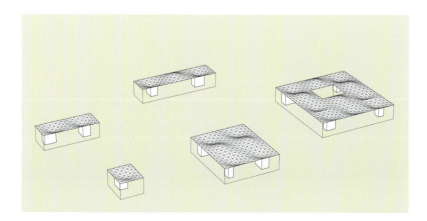

Our aim was to create a flexible structure that would allow us to create buildings with different surfaces.

In this case, with a house of approximately 1,076 square feet (100 square meters) for two adults, we used a form made up of two modules.

310

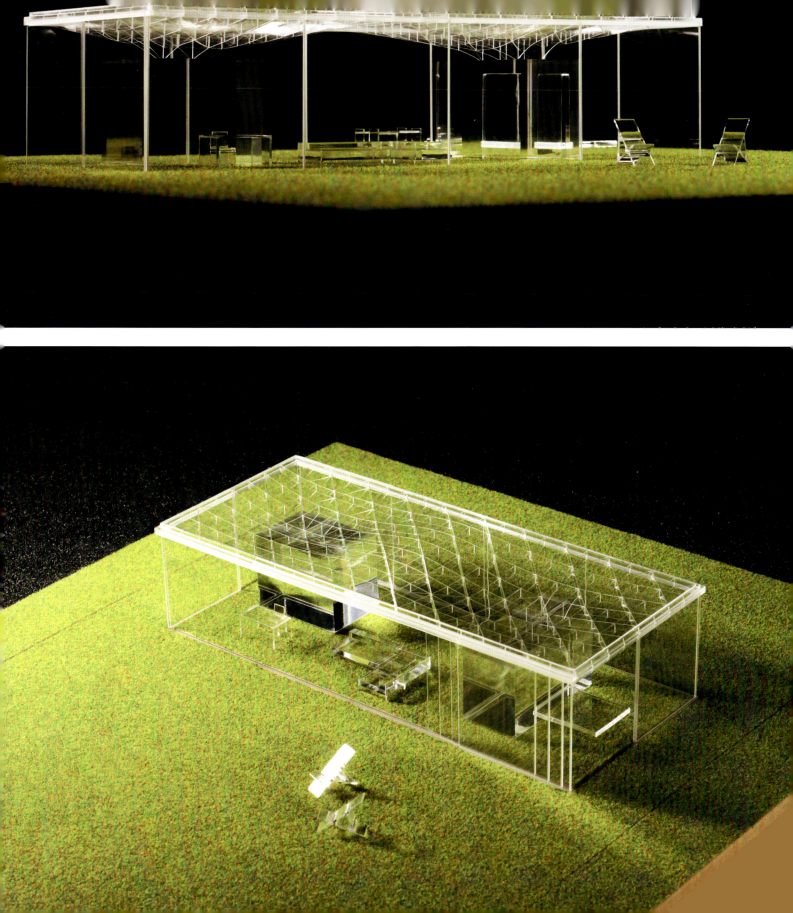

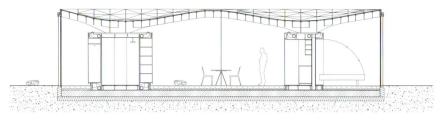
section

In its center we placed the kitchen and the bathroom, which need a standard floor. Other functions are located on the living hybrid grass, so that in addition to the feeling of being in the garden, we gain fresh air and a friendly microclimate.

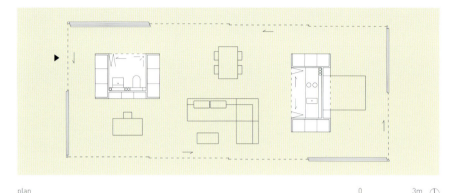
plan 0 3m

The natural grass is reinforced with artificial blades, which gives it great durability and works well for daily use in sports halls. The entire irrigation system is located at root level, so the floor is dry and pleasant to use.

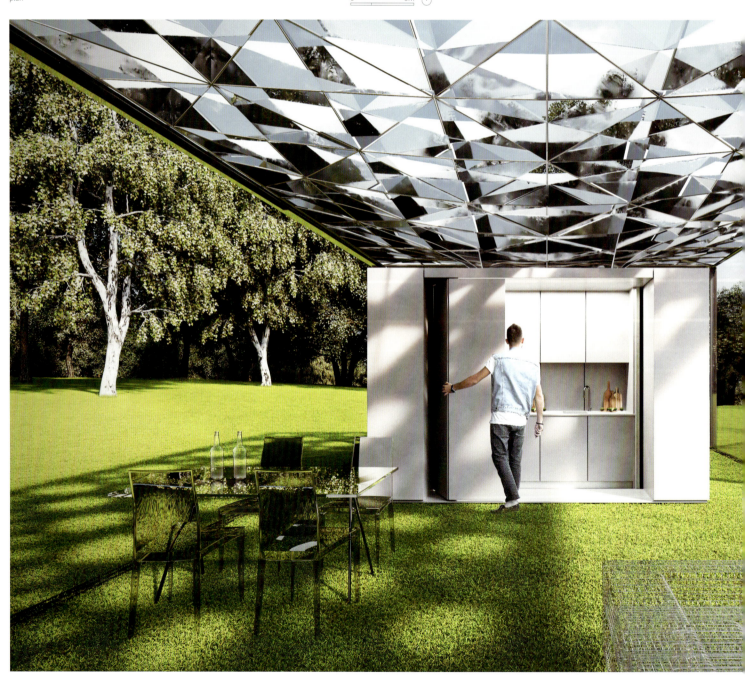

It is looked after by solar-powered robot lawn mowers. Ventilation vents in shafts at floor level give the grass the gentle movement it needs to live. LED lighting eliminates fungal and microbial growth. Transparent furniture allows light to penetrate throughout.

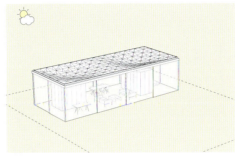

The roof is a steel grate that works like the leaves of a tree and diffuses light. Just like the walls, it is filled with intelligent "SageGlass," which reacts dynamically to changing solar conditions. As the intensity of the sun increases …

… the glass gently transitions to become darker, preventing the interior from heating up. On warm days, open glazing provides a pleasant breeze and essential movement for the grass.

When it is really hot, to keep the optimum temperature of the grass at no more than 77°F (25°C), the air conditioning kicks in. At night, the roller blinds are closed in order to separate the interior from its surroundings.

The design is an extension of the modernist concept of fusion between the inside and outside. Thanks to the latest technology, we can get even closer to nature, while the house itself is almost self-sufficient.

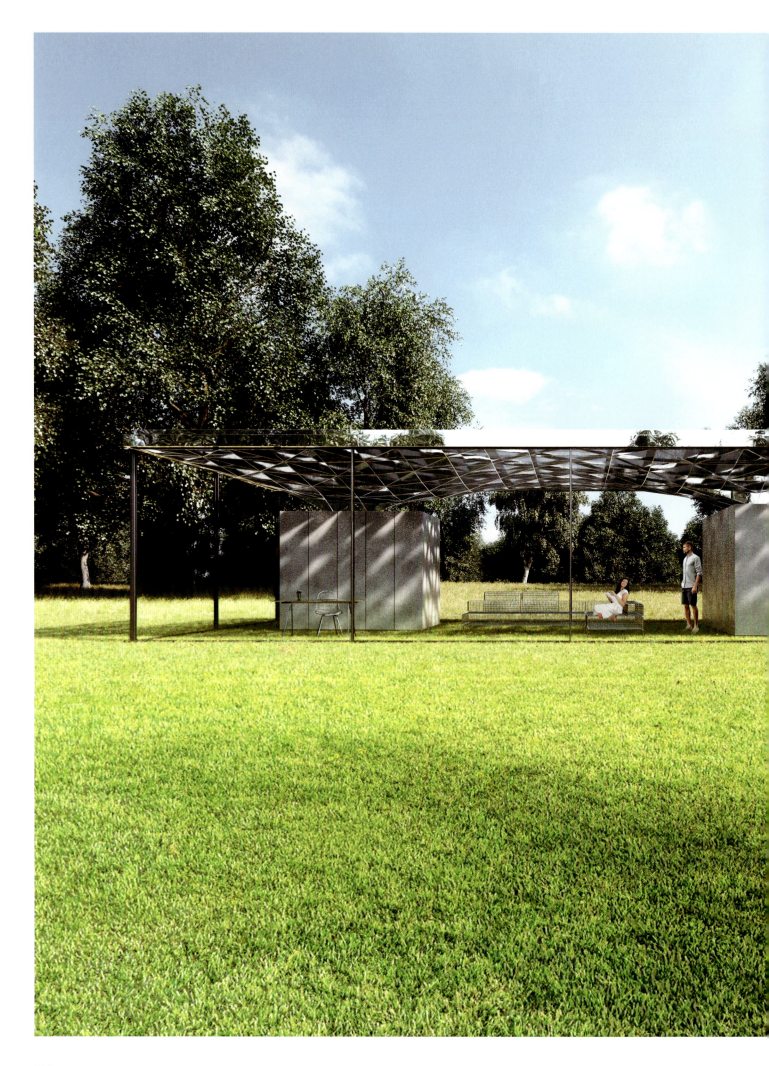

A Living-Garden provides contact with real greenery, which has a positive effect on our health—our mental and physical well being.

At the beginning of 2023, in Scheid am Edersee near Kassel, four houses started to be built from the Ways of Life project by Jürgen Mayer and Anna Heringer, among others.

When doing the project in Kassel, we realised that this concept is universal, thus not only for houses. Most importantly, even if we settle in the city, it is possible to live in nature.

topographic | mobility | living-garden

Sunlite Building

2019

↓

We were invited to create large modern houses in Saudi Arabia, on the outskirts of the city of Neom, a planned and smart city that is to be built from scratch out in the desert.

We approached the project with a smart and universal solution that could serve the general public.

project site

Traditional construction in hot areas tends to be introverted, with few windows and shutters, often which block out views and light.

The contemporary glazed buildings constructed there are very energy-intensive.

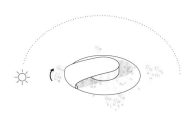 We were inspired by the Quadrant House (pp. 31, 33, 214) solution, to use a kinetic system.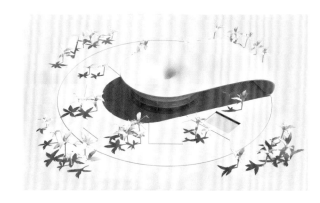

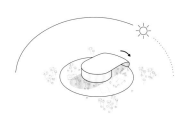 The rotating wing in the Sunlite Building follows the sun, shades the building throughout the day, and …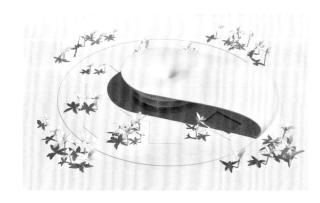

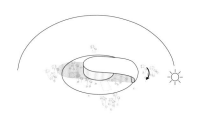 … at the same time, optimally absorbs solar energy. This makes the building more than self-sufficient.

Such a solution means that it is possible to use full glazing and open the interiors completely to the surroundings, as the sun never falls on the glass façades and the building is protected from overheating.

ground floor

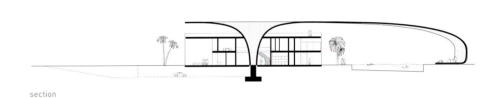

section

The movable element also casts a protective shadow over the site, so that a garden can be established and enjoyed comfortably, in what are usually extremely difficult local conditions.

The wing that shades the building minimizes energy consumption needed for cooling. In addition, on cold days it can be halted to allow the sun's rays to warm the interior, which is all the more effective thanks to the glass façade.

Photovoltaic panels on a rotating wing that always faces the sun make the building act as a self-sufficient, energy in perpetual motion machine. By following the sun, the wing is constantly producing energy for the building, as well as for the movement of its rotating element.

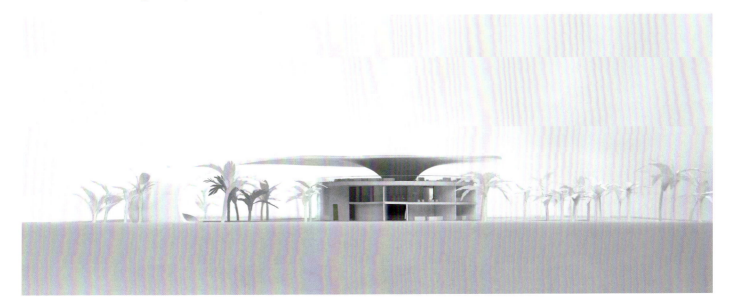

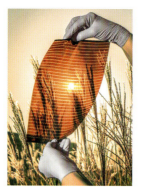

In this particular case, we reached for the new, highly efficient technology of printed photovoltaic panels "Perowskity," which are becoming an integral part of the architecture.

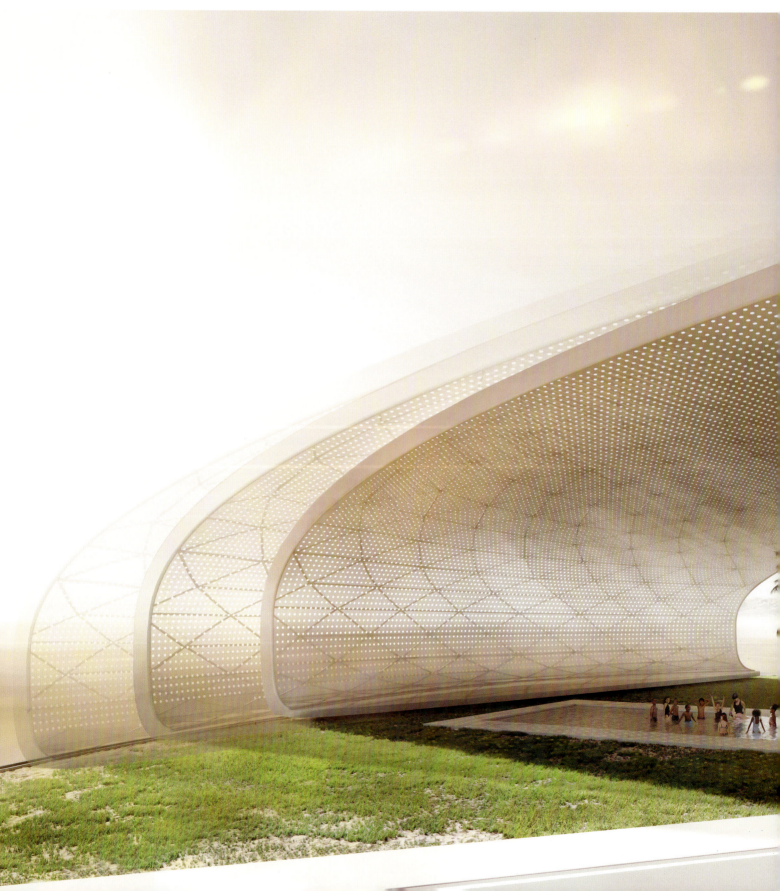

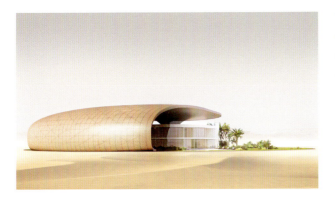

The wing surface can also collect both rainwater and condensation to store and use during dry periods.

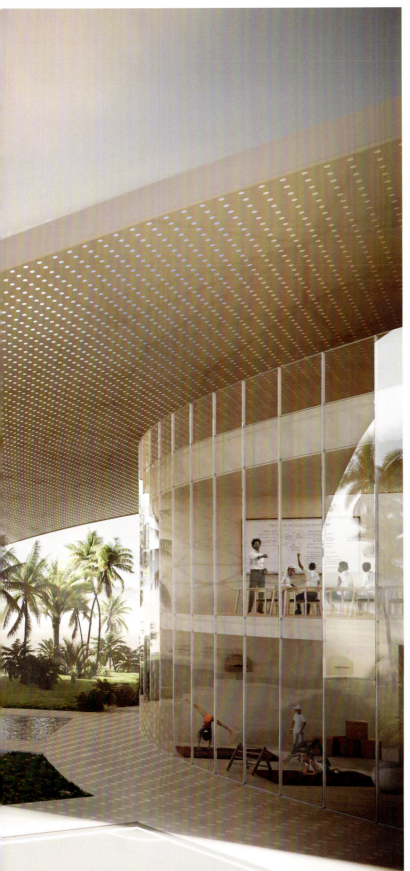

The movable element can be used as roofing over the garden, but it can just as well act as a terrace—as in the Quadrant House—that becomes an extension of the building.

The solution from Sunlite Building can be applied to buildings of all functions, budgets and scales—from small residential houses to skyscrapers. We succeeded in our goal to ensure this design serves everyone.

Sunlite Buildings interconnected into larger complexes can become friendly living spaces and serve as residential energy farms. Solar power plants are usually isolated, mono-functional tracts of land.

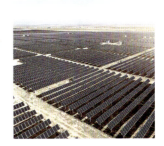

In the case of Sunlite Buildings enclaves, they would create green, multifunctional oases and generate energy not only for their own needs, but also for the neighborhood. As the climate warms up, the Earth's living space is drastically diminishing. We hope that the concept is one of the solutions for constructing in extremely dry and hot areas, which will likely continue to increase in number.

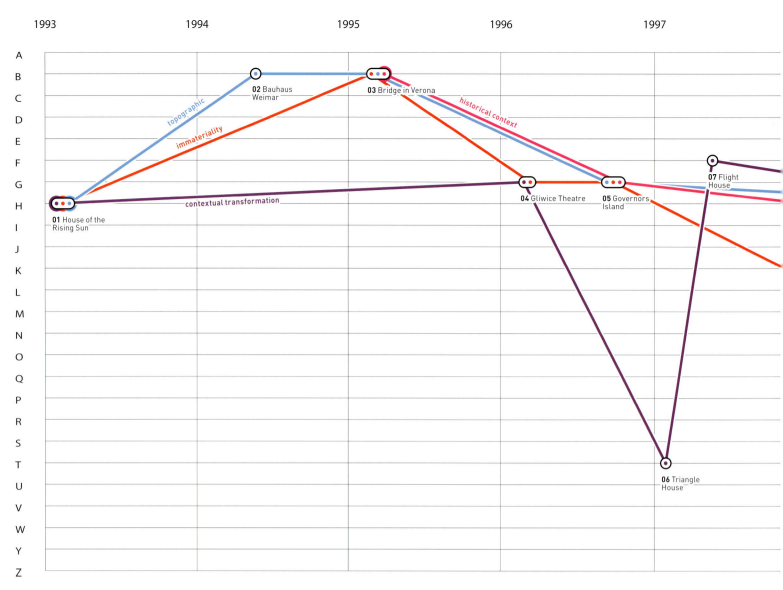

Map of Design Paths + Building Index

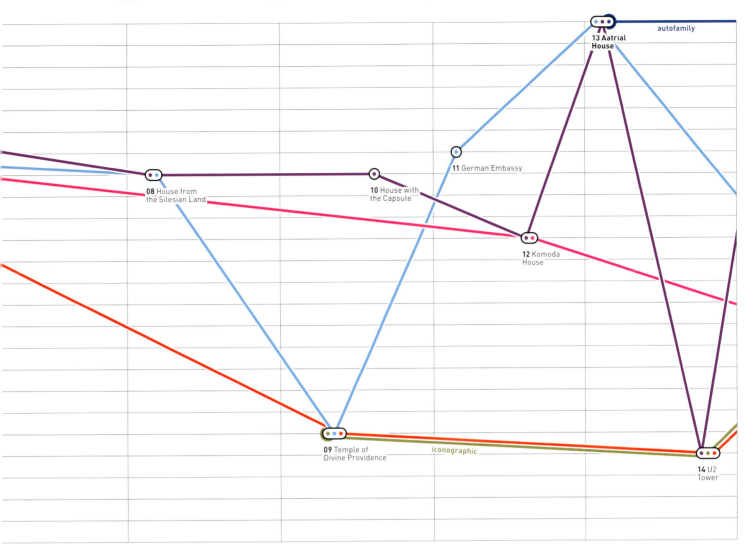

01 House of the Rising Sun
1993
author:
Robert Konieczny

04 Gliwice Theatre
1996
authors:
Marlena Wolnik
collaboration:
Robert Konieczny

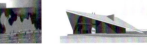
07 Flight House
1997–1999
authors:
Robert Konieczny,
Marlena Wolnik

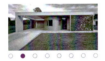
10 House with the
Capsule
2000–2004
authors:
Robert Konieczny

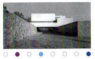
13 Aatrial House
2002–2006
authors:
Robert Konieczny
collaboration:
Marlena Wolnik,
Łukasz Prażuch
(p. 50)

02 Bauhaus Weimar
1994
authors:
Wojciech Gwizdak,
Robert Konieczny,
Sławomir Kostrzewski,
Mikołaj Machulik,
Grzegorz Tkacz

05 Governors Island
1996
authors:
Robert Konieczny,
Marlena Wolnik

08 House from the
Silesian Land
1999–2002
authors:
Robert Konieczny,
Marlena Wolnik

11 German Embassy
2001
authors:
Robert Konieczny,
Marlena Wolnik
collaboration:
Arkadiusz Kulpiński,
Aleksandra Czech

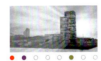
14 U2 Tower
2002
authors:
Robert Konieczny,
Marlena Wolnik
collaboration:
Marcin Jojko

03 Bridge in Verona
1995
authors:
Robert Konieczny,
Marlena Wolnik

06 Triangle House
1997–2000
authors:
Marlena Wolnik,
Robert Konieczny

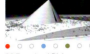
09 Temple of Divine
Providence
2000
authors:
Robert Konieczny,
Marlena Wolnik
collaboration:
Wojciech Śnieżek,
Anna Ciołkiewicz

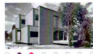
12 Komoda House
2001–2005
authors:
Robert Konieczny,
Marlena Wolnik

323

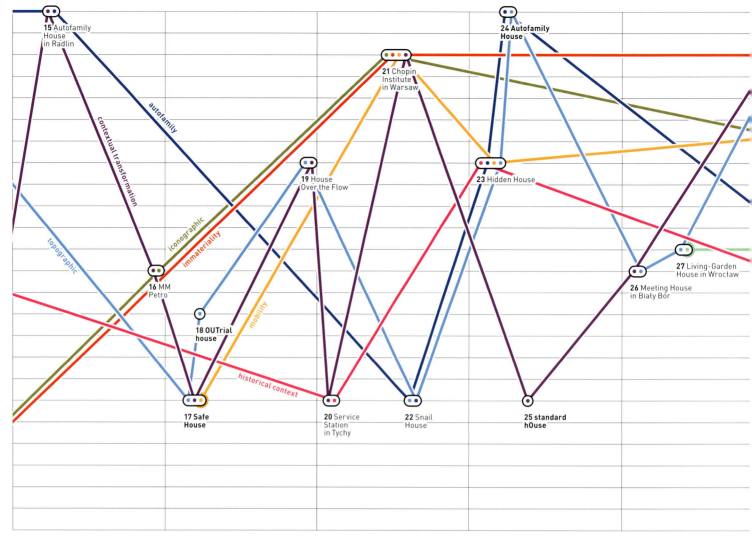

15 Autofamily House in Radlin
2003
authors:
Robert Konieczny
collaboration:
Marcin Jojko

18 OUTrial house
2004–2007
authors:
Robert Konieczny
collaboration:
Marcin Jojko
(p. 80)

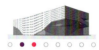

20 Service Station in Tychy
2005
authors:
Robert Konieczny
collaboration:
Łukasz Marciniak, Wojciech Sikora, Dorota Skóra

23 Hidden House
2006
authors:
Robert Konieczny
collaboration:
Dorota Skóra, Adam Radzimski, Łukasz Marciniak

26 Meeting House in Biały Bór
2007
authors:
Robert Konieczny
collaboration:
Katarzyna Furgalińska, Piotr Tokarski, Adam Radzimski, Michał Lisiński, Dorota Skóra

29 Living-Garden House near Cracow
2008
authors:
Robert Konieczny
collaboration:
Adam Radzimski

32 From the Garden House
2009–2021
authors:
Robert Konieczny
collaboration:
Michał Lisiński, Piotr Tokarski, Łukasz Marciniak, Aleksandra Stolecka, Joanna Biedna, Adam Radzimski, Agata Nowak, Damian Florczykiewicz, Marcin Harnasz
(p. 142)

16 MM Petro
2003
authors:
Marlena Wolnik, Robert Konieczny, Marcin Jojko

19 House Over the Flow
2004
authors:
Robert Konieczny
collaboration:
Marcin Jojko, Krzysztof Kawka, Ula Knol, Magda Kuczek, Łukasz Marciniak, Bartek Nawrocki, Aleksandra Pieczara, Magdalena Sikora, Wojciech Sikora, Roma Skuza, Bogna Świerkot, Tomasz Woźny

21 Chopin Institute in Warsaw
2005
authors:
Robert Konieczny,
collaboration:
Marcin Jojko

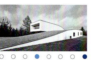

24 Autofamily House
2006–2012
authors:
Robert Konieczny
collaboration:
Katarzyna Furgalińska, Magdalena Adamczak, Łukasz Marciniak
(p. 90)

27 Living-Garden House in Wrocław
2007
authors: Robert Konieczny
collaboration:
Katarzyna Furgalińska, Adam Radzimski

30 Multivilla
2008
authors:
Robert Konieczny
collaboration:
Dorota Skóra, Michał Lisiński, Piotr Tokarski, Adam Radzimski

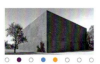

17 Safe House
2004–2008
authors:
Robert Konieczny
collaboration:
Łukasz Zadrzyński, Marcin Jojko
(p. 64)

22 Snail House
2005
authors:
Robert Konieczny, Łukasz Marciniak
collaboration:
Wojciech Sikora

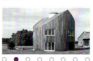

25 standard hOuse
2007–2011
authors:
Robert Konieczny
collaboration:
Katarzyna Furgalińska, Wojciech Sikora, Łukasz Marciniak
(p. 102)

28 By the Way House
2008–2016
authors:
Robert Konieczny
collaboration:
Katarzyna Furgalińska, Izabela Kaczmarczyk, Dorota Skóra, Piotr Tokarski, Magdalena Adamczak, Aleksandra Stolecka
(p. 112)

31 Living-Garden House in Katowice
2009–2013
authors:
Robert Konieczny
collaboration:
Magdalena Adamczak, Katarzyna Furgalińska, Aleksandra Stolecka, Jakub Pstraś, Adam Radzimski
(p. 128)

33 Hotel in Czorsztyn
2009
authors:
Robert Konieczny, Michał Lisiński, Katarzyna Furgalińska
collaboration:
Jakub Pstraś, Piotr Tokarski, Marcin Harnasz,

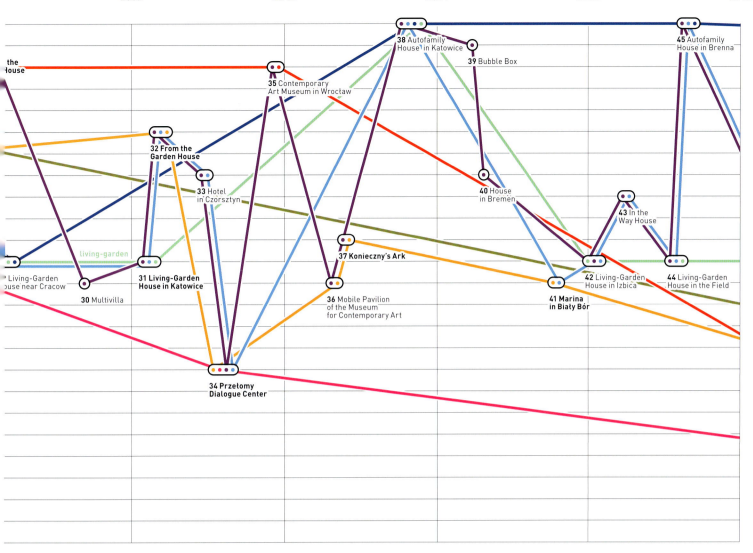

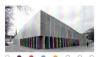

34 Przełomy Dialogue Center
2009–2015
authors:
Robert Konieczny,
Michał Lisiński,
Dorota Skóra,
Katarzyna Furgalińska
collaboration:
Aleksandra Stolecka,
Piotr Tokarski,
Adam Radzimski,
Joanna Biedna,
Magdalena Adamczak,
Aneta Świeżak,
Mariusz Pawlus,
Piotr Wysocki,
Roman Kaczmarczyk,
Michał Czasnojć
(p. 158)

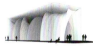

36 Mobile Pavilion of the Museum for Contemporary Art
2010
authors:
Robert Konieczny
collaboration:
Michał Lisiński,
Magdalena Adamczak,
Monika Tasarz,
Joanna Biedna,
Tomasz Żelazko

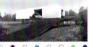

38 Autofamily House in Katowice
2010
authors:
Łukasz Marciniak,
Robert Konieczny
collaboration:
Magdalena Adamczak,
Marcin Harnasz

40 House in Bremen
2011
authors:
Robert Konieczny
collaboration:
Magdalena Adamczak,
Jakub Pstraś,
Adam Radzimski

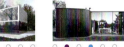

42 Living-Garden House in Izbica
2012–2014
authors:
Robert Konieczny
collaboration:
Magdalena Adamczak,
Aleksandra Stolecka,
Marcin Harnasz

44 Living-Garden House in the Field
2012–
authors:
Robert Konieczny
collaboration:
Grzegorz Ostrowski,
Karol Jackiewicz,
Marcin Króliczek,
Marcin Harnasz

39 Bubble Box
2011–
authors:
Robert Konieczny
collaboration:
Joanna Biedna,
Łukasz Marciniak,
Michał Lisiński,
Karol Jackiewicz,
Krzysztof Kobiela,
Marcin Harnasz

41 Marina in Biały Bór
2011–
authors:
Robert Konieczny
collaboration:
Magdalena Adamczak,
Grzegorz Ostrowski,
Łukasz Marciniak,
Krzysztof Kobiela,
Marcin Harnasz
(p. 200)

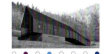

43 In the Way House
2012–
authors:
Robert Konieczny,
Michał Lisiński
collaboration:
Grzegorz Ostrowski,
Marek Frania,
Mariusz Pawlus,
Marcin Króliczek,
Maciej Wójciuk,
Krystian Szczepek

45 Autofamily House in Brenna
2012
authors:
Robert Konieczny,
Michał Lisiński,
Grzegorz Ostrowski
collaboration:
Łukasz Marciniak

35 Contemporary Art Museum in Wrocław
2009
authors:
Robert Konieczny,
Katarzyna Furgalińska,
Michał Lisiński
collaboration:
Magdalena Adamczak,
Adam Radzimski,
Piotr Tokarski

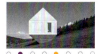

37 Konieczny's Ark
2010–2015
authors:
Robert Konieczny,
Łukasz Marciniak
collaboration:
Marcin Króliczek,
Aneta Świeżak,
Marcin Harnasz
(p. 180)

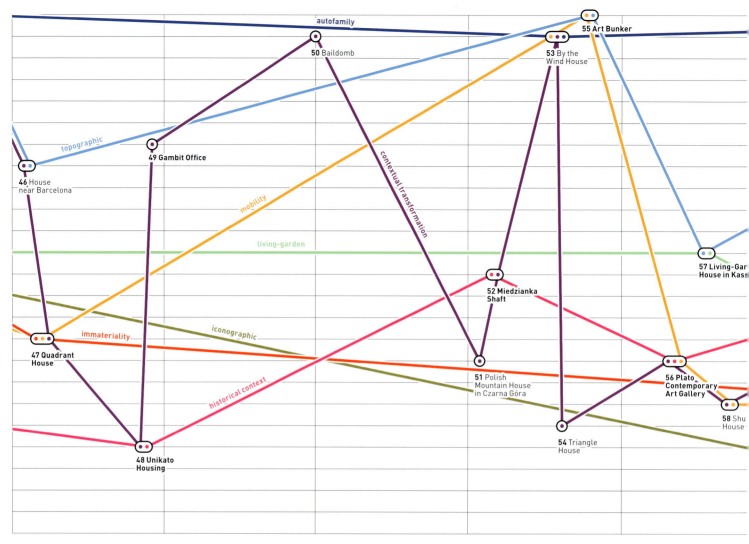

○ ○ ○ ○ ○ ●
46 House near Barcelona
2013
authors:
Robert Konieczny
collaboration:
Michał Lisiński,
Grzegorz Ostrowski

○ ○ ○ ○ ○ ●
49 Gambit Office
2013–2023
authors:
Robert Konieczny,
Michał Lisiński
collaboration: Katarzyna
Pająk, Karol Jackiewicz,
Karol Knap, Krzysztof
Kobiela, Marcin Harnasz
(p. 246)

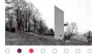

○ ○ ○ ○ ● ○
52 Miedzianka Shaft
2016–2022
authors: Robert Konieczny
collaboration: Krzysztof
Kobiela, Michał Lisiński,
Dorota Skóra, Klaudia
Księżarczyk, Magdalena
Orzeł-Rurańska, Magda
Bykowska
(p. 262)

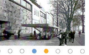

○ ○ ● ○ ○ ○
55 Art Bunker
2016–
authors:
Robert Konieczny
collaboration:
Michał Lisiński,
Dorota Skóra,
Krzysztof Kobiela,
Dariusz Dziwak
(p. 280)

○ ○ ○ ○ ● ○
57 Living-Garden House near Kassel
2017–
authors:
Robert Konieczny
collaboration:
Michał Lisiński, Magdalena
Orzeł-Rurańska, Dorota
Skóra, Marcin Harnasz
(p. 308)

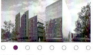

○ ○ ○ ○ ○ ○
60 Mac Maxi
2018–
authors:
Robert Konieczny
collaboration:
Michał Lisiński, Krzysztof
Kobiela, Adam Skrzypczyk,
Magdalena Orzeł-Rurańska,
Dorota Skóra, Katarzyna
Kuzior, Anna Szewczyk

○ ○ ● ○ ○ ○
63 Yaw House
2018–
authors:
Robert Konieczny
collaboration:
Marek Golab-Sieling,
Anna Szewczyk

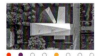

● ● ● ○ ● ○
47 Quadrant House
2013–2019
authors:
Robert Konieczny
collaboration: Michał
Lisiński, Mariusz Pawlus,
Marcin Kroliczek, Justyna
Górnica, Grzegorz
Ostrowski, Marcin Harnasz
(p. 214)

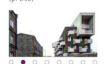

○ ● ○ ○ ○ ○
50 Baildomb
2015–2020
authors:
Robert Konieczny
collaboration:
Michał Lisiński, Łukasz
Marciniak, Marcin Króliczek,
Marek Frania, Sebastian
Rozemberg, Aneta Świeżak,
Marcin Harnasz

○ ● ○ ● ○ ○
53 By the Wind House
2016–
authors:
Robert Konieczny
collaboration:
Michał Lisiński,
Magdalena Orzeł-
Rurańska, Marcin
Harnasz

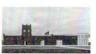

○ ● ○ ○ ○ ○
56 Plato Contemporary Art Gallery
2017–2022
authors:
Robert Konieczny,
Michał Lisiński,
Dorota Skóra
author's cooperation:
Tadeáš Goryczka,
Marek Golab-Sieling
collaboration:
Agnieszka Wolny-Grabowska,
Krzysztof Kobiela,
Adrianna Wycisło,
Mateusz Białek,
Jakub Bilan,
Wojciech Fudala,
Katarzyna Kuzior,
Karol Knap,
Damian Kuna,
Magdalena Orzeł-Rurańska,
Elżbieta Siwiec,
Anna Szewczyk,
Jakub Pielecha,
Kinga Wojtanowska
(p. 286)

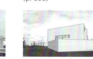

○ ● ○ ○ ○ ○
58 Shutter House
2017–
authors:
Robert Konieczny
collaboration:
Michał Lisiński,
Magdalena Orzeł-
Rurańska, Karol Knap,
Anna Szewczyk

○ ● ○ ○ ○ ○
61 In Touch Houses
2018–
authors:
Robert Konieczny
collaboration:
Dorota Skóra, Magdalena
Orzeł-Rurańska,
Krzysztof Kobiela, Karol
Knap, Marcin Harnasz

○ ○ ○ ○ ● ●
64 Wielkopolska Uprising Museum
2019
authors:
Robert Konieczny
collaboration:
Anna Szewczyk,
Marek Golab-Sieling,
Adrianna Wcislo,
Wojciech Fudala,
Damian Kuna,
Katarzyna Kuzior,
Anita Bierza

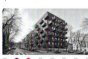

○ ● ○ ○ ○ ○
48 Unikato Housing
2013–2018
authors:
Robert Konieczny
collaboration:
Michał Lisiński,
Marcin Króliczek,
Aneta Świeżak,
Marcin Harnasz
(p. 232)

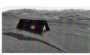

○ ● ○ ○ ○ ○
51 Polish Mountain House in Czarna Góra
2016–
authors:
Robert Konieczny
collaboration:
Mariusz Pawlus, Marcin
Króliczek, Katarzyna Ficek,
Katarzyna Kuzior, Karol
Knap, Marcin Harnasz

○ ● ○ ○ ○ ○
54 Triangle House
2016–2022
authors:
Robert Konieczny
collaboration:
Dorota Skóra, Krzysztof
Kobiela, Michał Lisiński,
Mateusz Białek, Katarzyna
Ficek, Łukasz Marciniak,
Marcin Harnasz

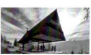

● ○ ○ ○ ○ ○
59 Polish Mountain House in Zakopane
2018–
authors: Robert Konieczny,
Dorota Skóra, Magdelana
Orzeł-Rurańska
collaboration:
Katarzyna Kuzior, Krzysztof
Kobiela, Aleksandra
Staroń-Juźwiak, Katarzyna
Ficek, Marcin Harnasz

○ ○ ○ ○ ○ ○
62 Greenfeld Housing
2018
authors:
Robert Konieczny,
Dorota Skóra
collaboration:
Michał Lisiński, Klaudia
Księżarczyk, Krzysztof
Kobiela, Kinga Kwaśny

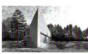

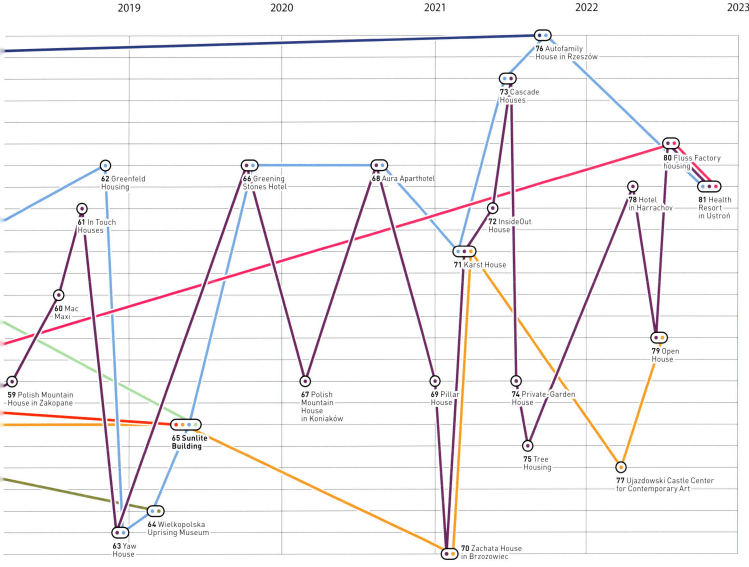

65 Sunlite Building
2019
authors:
Robert Konieczny
collaboration:
Michał Lisiński, Marek
Golab-Sieling, Krzysztof
Kobiela, Adrianna
Wycisło, Karol Knap
(p. 316)

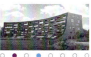

68 Aura Aparthotel
2020–
authors:
Robert Konieczny,
Michał Lisiński,
Marek Golab-Sieling
collaboration:
Krzysztof Kobiela,
Aleksandra Kozłowska,
Adrianna Wycisło,
Anna Szewczyk,
Monika Jokiel,
DEMIURG Project:
Inga Rolek,
Rafał Murat,
Magdalena Jarczykowska,
Wojciech Błażejczak,
Katarzyna Wankiewicz,
Agata Steć

70 Zachata House
2021–
authors:
Robert Konieczny,
Aleksandra Kozłowska

73 Cascade Houses
2022–
authors:
Robert Konieczny,
Krzysztof Kobiela

76 Autofamily House in Rzeszów
2021–
authors:
Robert Konieczny,
Krzysztof Kobiela
collaboration:
Adam Zbroiński

79 Open House
2022–
authors:
Robert Konieczny,
Aleksandra Kozłowska

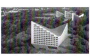

81 Health Resort in Ustroń
2022–
authors:
Robert Konieczny,
Maciej Franta
collaboration:
Michał Lisiński,
Krzysztof Kobiela,
Aleksandra Kozłowska,
Marek Golab-Sieling,
Adrianna Wycisło
Franta Group:
Patrycja Telenga,
Marta Górecka,
Michał Pietrucha,
Jadwiga Bodzęta,
Tomasz Zawitaj,
Joanna Kujda,
Anita Bierza,
Petro Zastavskyi,
Ewa Borowicz,
Kamil Gębczyński

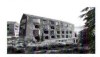

66 Greening Stones Hotel
2019
authors:
Robert Konieczny
collaboration:
Michał Lisiński, Marek
Golab-Sieling, Agnieszka
Wolny-Grabowska,
Adrianna Wycisło, Monika
Jokiel, Anna Szewczyk

71 Karst House
2021–
authors:
Robert Konieczny
collaboration:
Aleksandra Kozłowska,
Natalia Wrzesińska,
Agnieszka Wolny-Grabowska,
Krzysztof Kobiela

74 Private-Garden House
2021–
authors:
Robert Konieczny,
Adrianna Wycisło
collaboration:
Aleksandra Kozłowska,
Paulina Szymanik

77 Ujazdowski Castle Center for Contemporary Art
2022–
authors:
Robert Konieczny
collaboration:
Michał Lisiński,
Aleksandra Kozłowska,
Agnieszka Wolny-Grabowska,
Adrianna Wycisło

80 Fluss Factory housing
2022–
authors:
Robert Konieczny,
collaboration:
Michał Lisiński,
Natalia Wrzesińska,
Adrianna Wycisło,
Agnieszka Wolny-Grabowska,
Adam Zbroiński,
Aleksandra Kozłowska,
Katarzyna Dybała,
Tadeáš Goryczka

67 Polish Mountain House in Koniaków
2020–
authors:
Robert Konieczny
collaboration:
Michał Lisiński,
Aleksandra Kozłowska,
Monika Jokiel,
Jeremi Ciechanowski

69 Pillar House
2021–
authors:
Robert Konieczny,
Adrianna Wycisło
collaboration:
Agnieszka Wolny-Grabowska,
Aleksandra Kozłowska,
Aleksander Swienton

72 InsideOut House
2021–
authors:
Robert Konieczny,
Aleksandra Kozłowska,
Krzysztof Kobiela
collaboration:
Agnieszka
Wolny-Grabowska

75 Tree Housing
2021–
authors:
Robert Konieczny
collaboration:
Krzysztof Kobiela,
Aleksandra Kozłowska

78 Hotel in Harrachov
2022–
authors:
Robert Konieczny,
collaboration:
Michał Lisinski,
Krzysztof Kobiela,
Jeremi Ciechanowski,
Aleksandra Kozłowska,
Natalia Wrzesińska

Image Credits

All images are supplied courtesy KWK Promes, with the exception of those noted below.

7 Juliusz Sokołowski **8–9** Jakub Certowicz **11** (top) Jarosław Syrek; (bottom) Juliusz Sokołowski **13** Juliusz Sokołowski **15–17** Juliusz Sokołowski **18** OLO Studio **19** (top drawing) edited by Elizabeth Mock and published by MoMA, courtesy Robert Konieczny **20** Juliusz Sokołowski **21** (visualization) Adrian Chmielewski **28** (top visualization) Atmo Studio **34** (visualizations) Adrian Chmielewski **35** (photography) Wojciech Kryński **36** (photography) Juliusz Sokołowski **37** (top and bottom photography) OLO Studio **38** (top visualizations) Rafał Barnaś; (model photography) Bartosz Stawiarski **39** (top photography) courtesy New Jersey Institute of Technology; (bottom photography) Jarosław Syrek **44** Jakub Certowicz **46** (photography) Jakub Certowicz **47** Onimo **50–51** OLO Studio **53** OLO Studio **54–59** (photography) Juliusz Sokołowski **60–61** Juliusz Sokołowski **62–63** (bottom) OLO Studio **63** (top right) Juliusz Sokołowski **64–79** (photography) OLO Studio **80–91** (photography) Juliusz Sokołowski **93** OLO Studio **94–109** (photography) Juliusz Sokołowski **110–111** Jakub Certowicz **112–113** OLO Studio **114–117** (photography) Jarosław Syrek **118–119** (top) Juliusz Sokołowski; (bottom) OLO Studio **120–121** (bottom photography) OLO Studio; (top photography) Juliusz Sokołowski **122–123** Juliusz Sokołowski **124–125** OLO Studio **126–127** (photography) Juliusz Sokołowski **128–159** (photography) Jakub Certowicz **160** (archival photography) courtesy Marshall's Office of Zachodniopomorskie Voivodeship **162–163** (photography) Jarosław Syrek **164–177** (photography) Juliusz Sokołowski **178** (top left courtesy Robert Konieczny; (top right) Piotr Rakowski; (bottom left to right) Juliusz Sokołowski; **179** (top right) Daniel Źródlewski; (bottom right) Aneta Popławska-Suś **180–181** OLO Studio **182** (top and middle) courtesy Robert Konieczny; **182–183** (bottom) Łukasz Gardas **185** Jakub Certowicz **186–187** (photography) OLO Studio **188–189** (top left) courtesy Robert Konieczny; (top right and bottom) OLO Studio **190–191** (top) OLO Studio; (bottom) courtesy Robert Konieczny **192–195** (photography) Jakub Certowicz **196–197** (photography) OLO Studio **198–199** (top) Jakub Certowicz; (bottom) OLO Studio **200–201** Jarosław Syrek **202** (bottom photography) Jarosław Syrek **203–211** (photography) Jakub Certowicz **212–213** Jarosław Syrek **214–217** (photography) Jarosław Syrek **218–231** (photography) Juliusz Sokołowski **232–233** OLO Studio **235** OLO Studio **236–237** (top) OLO Studio; (bottom left) Jarosław Syrek **239** Juliusz Sokołowski **240** OLO Studio **241** Juliusz Sokołowski **242–243** (left) OLO Studio; (right) Juliusz Sokołowski **244–245** (left) Jakub Certowicz; (right) Juliusz Sokołowski **246–263** (photography) Juliusz Sokołowski **264** (top left) Poloniae Amici www.polska-org.pl; (middle left and right) courtesy Robert Konieczny; **265** (top right) courtesy Collections of Oakfield Historical Society **264–265** (bottom) Juliusz Sokołowski; **266–267** Juliusz Sokołowski **268–269** (photography) Juliusz Sokołowski; (map) Patryk Nowak **270–278** (photography) Juliusz Sokołowski **279** (top) Juliusz Sokołowski; (bottom) courtesy Robert Konieczny **286–287** Juliusz Sokołowski **288** (middle left) courtesy Statutory City of Ostrava; (middle right) courtesy Robert Konieczny **288–289** (bottom) Juliusz Sokołowski **290–291** (photography) Juliusz Sokołowski **292–293** (top) Jakub Certowicz; (bottom left and right) Juliusz Sokołowski **294** Juliusz Sokołowski **296–297** Jakub Certowicz **298–299** (photography) Juliusz Sokołowski **300–306** Jakub Certowicz **307** (top) courtesy Robert Konieczny; (bottom) Juliusz Sokołowski **308–309** Onimo **311** Onimo **315** (graphic) Christoph Hesse Architects **320** (top left photography) Matteo Chinellato/ChinellatoPhoto; (top right) Perovskite photovoltaic cells by Saule Technologies; **320–321** (visualizations) Adrian Chmielewski; (photography, far right top) Jenson/Shutterstock; (far right bottom) George Steinmetz

Building Index Images
13 Juliusz Sokołowski **15** Juliusz Sokołowski **17** OLO Studio **18** Juliusz Sokołowski **24** Juliusz Sokołowski **25** Juliusz Sokołowski **28** Jarosław Syrek **31** Jakub Certowicz **32** Jakub Certowicz **34** Juliusz Sokołowski **37** Jakub Certowicz **40** Jakub Certowicz **41** Jakub Certowicz **47** Jarosław Syrek **48** OLO Studio **49** Juliusz Sokołowski **50** Juliusz Sokołowski **52** Jakub Certowicz **56** Juliusz Sokołowski **65** Adrian Chmielewski **66** Adrian Chmielewski **77** Adrian Chmielewski **81** Rafał Barnaś

Front Cover
OLO Studio

Back Cover
(1, 2, 6, 7, 8, 9) Juliusz Sokołowski **(3)** OLO Studio **(4, 5)** Jarosław Syrek

Special Thanks
Many thanks to everyone who has worked with us and supported us through the many triumphs and challenges along the way. We especially thank the Statutory City of Ostrava and the City of Katowice for their support, among many contributors, who made the creation of this monograph possible.

Published in Australia in 2024 by
The Images Publishing Group Pty Ltd
ABN 89 059 734 431

Offices

Melbourne
Waterman Business Centre
Suite 64, Level 2 UL40
1341 Dandenong Road
Chadstone, Victoria 3148
Australia
Tel: +61 3 8564 8122

New York
6 West 18th Street 4B
New York City, NY 10011
United States
Tel: +1 212 645 1111

Shanghai
6F, Building C, 838 Guangji Road
Hongkou District, Shanghai
200434
China
Tel: +86 021 31260822

books@imagespublishing.com
www.imagespublishing.com

Copyright © [text] Philip Jodidio and Robert Konieczny (KWK Promes);
photographers as indicated 2024
The Images Publishing Group Reference Number: 1583

All photography is attributed in the Image Credits on page 328 unless otherwise noted.

All rights reserved. Apart from any fair dealing for the purposes of private study, research, criticism or review as permitted under the Copyright Act, no part of this publication may be reproduced, stored in a retrieval system, or transmitted in any form by any means, electronic, mechanical, photocopying, recording or otherwise, without the written permission of the publisher.

A catalogue record for this book is available from the National Library of Australia

Title: Robert Konieczny KWK Promes: buildings + ideas // Philip Jodidio (ed.)
ISBN: 9781864708905

This title was commissioned in IMAGES' Melbourne office and produced as follows: *Editorial* Georgia (Gina) Tsarouhas, *Graphic design* Ryan Marshall, *Production* Nicole Boehringer

Graphics, layout, and text editorials were prepared by the KWK Promes team, namely: Robert Konieczny, Bartłomiej Witkowski, Adrianna Wycisło, Tomasz Malkowski, Iga Czaja, Michał Lisiński, Marek Golab-Sieling, Agnieszka Burnus-Bogusz, Wojciech Fudala, and Marcin Woźnica

Printed on 157gsm Chinese OJI matt art paper (FSC®)
by Artron Art (Group) Co., Ltd, in China

IMAGES has included on its website a page for special notices in relation to this and its other publications. Please visit www.imagespublishing.com

Every effort has been made to trace the original source of copyright material contained in this book. The publishers would be pleased to hear from copyright holders to rectify any errors or omissions.

The information and illustrations in this publication have been prepared and supplied by KWK Promes and Philip Jodidio, and the participants. While all reasonable efforts have been made to ensure accuracy, the publishers do not, under any circumstances, accept responsibility for errors, omissions and representations express or implied.